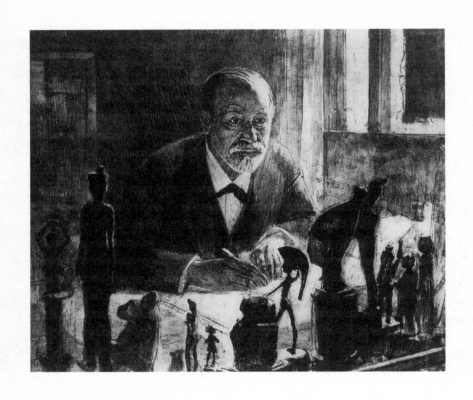

Leonardo's Nephew

Essays on Art and Artists

James Fenton

VIKING

VIKING

Published by the Penguin Group
Penguin Books Ltd, 27 Wrights Lane, London w8 5tz, England
Penguin Putnam Inc., 375 Hudson Street, New York, New York 10014, USA
Penguin Books Australia Ltd, Ringwood, Victoria, Australia
Penguin Books Canada Ltd, 10 Alcorn Avenue, Toronto, Ontario, Canada m4v 3b2
Penguin Books (NZ) Ltd, Private Bag 102902, NSMC Auckland, New Zealand

Penguin Books Ltd, Registered Offices: Harmondsworth, Middlesex, England

First published 1998

First published in Great Britain by Viking 1998
1 3 5 7 9 10 8 6 4 2

Copyright © James Fenton, 1998
The acknowledgements on pp. ix–xiii constitute an extension of this copyright page
The moral right of the author has been asserted

Set in 11.5/14pt Monotype Bembo
Typeset by Rowland Phototypesetting Limited, Bury St Edmunds, Suffolk
Printed in Great Britain by The Bath Press, Bath

A CIP catalogue record for this book is available from the British Library

isbn 0-670-879177

To Howard and Antony
under whose roof

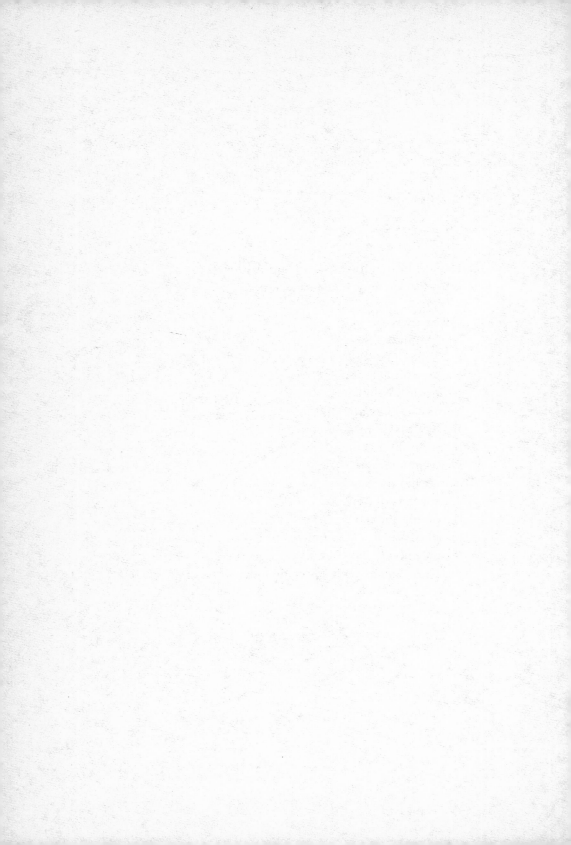

Contents

List of Illustrations

Introduction and Acknowledgements

The essay "On Statues" began life as the Ernest Jones Memorial Lecture of 1996, delivered at the invitation of the Institute for Psychoanalysis in London. "Leonardo's Nephew" was originally a talk given at the National Gallery, London, in 1997. All the rest of these pieces were written for the *New York Review of Books*. They are responses to exhibitions, catalogs, and books which I have encountered in a period of just over two years, and I have made no attempt to disguise their journalistic origins or to impose any overall thesis on the book.

All journalism derives at least part of its character from the periodical for which it is written, and I am well aware that these pieces would have turned out very differently (or not turned out at all) if I had not had the backing and the generous help of the *Review*. I am grateful to Rea Hederman, Barbara Epstein, and Robert Silvers; to Jeff Alexander, David Jacobsen, Robert Karron, and Tony Scott, with whom I deal regularly, as in the past with Pablo Conrad and Marc Romano; Michael Shae gave particular help with some translation problems, and I should like to thank Eve Bowen, Ann Kjellberg, and Jennifer Schuessler.

Two American collectors, Lindy Bergman in Chicago and Robert Lehrman in Washington, DC, kindly let me see their Cornells, and Kate Ganz showed me her parents' collection shortly before her mother's death. In each of these cases I felt privileged to have seen such remarkable works of art in a domestic setting. Staff of the following American museums have helped me in particular: the Smithsonian Institution in Washington, DC, the Art Institute of Chicago, the Institute of Fine Arts in Detroit, the Museum of Fine Arts in Boston, the Fogg Museum at Harvard, and the Museum of Modern Art in New York. In Berlin I owe a debt to Ursel Berger of the Georg-Kolbe-Museum for help on

the subject of Maillol. In Cardiff, Mark Evans turned the pages of a sketchbook of Thomas Jones. At Marbach, in the Deutsches Literatur-archiv, I was assisted by the staff of the Projekt Harry Graf Kessler, including Angelika Lochmann and Heike Schillo. In London, at the National Gallery, I have received help from many people, including Neil MacGregor, Grizelda Grimond, Kathleen Adler, and in particular Nicholas Penny; at the Victoria and Albert Museum, from Paul William-son, Malcolm Baker, and Peta Motture among others. Bruce Boucher, Marco Cianchi, Walter Feilchenfeldt, Linda Konheim Kramer, Francis Haskell, Dominic Montserrat, Robert Rosenblum, and Leo Steinberg are among the scholars to whom I am indebted. At the Ashmolean, Linda Whitely, Eunice Martin and Colin Harrison are among the unfailingly helpful. Finally my greatest obligation is to m'tutor and phone-pal, David Ekserdjian, *il mar di tutto 'l senno*, as Dante calls Virgil.

On Statues

I

In September 1938, Freud moved into his last home at 20 Maresfield Gardens, along with his collection of several hundred antique statuettes. How shocking, how hostile the previous sentence would be if for "antique statuettes" one substituted the phrase "fluffy toys." It's the fluffiness that would shock, though, the frivolity of it—not the idea that Freud had toys, and played with them all his life.

For how could such behavior shock us, in a man known for his belief that happiness consists in the realization of a childhood wish? That was what made Schliemann happy when he discovered Troy. This was the way Freud thought, and if Freud too found happiness among his statuettes, we can hardly be wrong in looking for some infantile component in this happiness.

Did he talk to his statuettes? Did they talk to him? Our metaphors are never far from such assertions, and Max Pollack's etching of 1914 seems to imply a dialogue between Freud and the objects on his desk.[1] Striking too is the fact that, whereas many a horror story has been based on the idea that a toy, a doll, comes to life and acquires a will of its own, Freud himself thought there was nothing uncanny in such an event. He found that "in their early games children do not distinguish at all sharply between living and inanimate objects, and that they are especially fond of treating dolls like live people," and that "children have no fear of their dolls coming to life, they may even desire it."[2]

As for the idea that a marble sculpture might come to life—this is not only the theme of the essay on Jensen's *Gradiva*, it is also consciously evoked in the discussion of Michelangelo's *Moses*. "How often," says

Freud, "have I mounted the steep steps from the unlovely Corso Cavour to the lonely piazza where the deserted church stands, and have essayed to support the angry scorn of the hero's glance! Sometimes I have crept cautiously out of the half-gloom of the interior as though I myself belonged to the mob upon whom his eye is turned—the mob which can hold fast no conviction, which has neither faith nor patience, and which rejoices when it has regained its illusory idols."³

And the statue must come to life, because what Freud wants to know is: What was happening the moment before the moment depicted by the artist, and what will happen next? What was the hand doing with the beard? What will happen to the Tablets of the Law? And it seems that Freud thought that one day he would be given the answer to these questions, if he came cautiously upon the statue, and seized upon its living self, just as a child captures a limpet unawares, by stalking it on its rock.

That was the instinctive inquirer. You will recall that Ernest Jones, in whose honor this lecture is given, provided some scholarly evidence, a proof of Freud's hypothesis, when he sent a copy of the *Burlington Magazine* containing an illustration of a small bronze Moses in the Ashmolean Museum, then attributed to Nicholas of Verdun. And Freud was delighted that Jones had found a Moses that held its beard in the way that he surmised that Michelangelo's had been grasping its own, in that moment before the moment the artist chose. And the earlier, bronze Moses "shows us an instant during his storm of feeling, while the statue in San Pietro in Vincoli depicts the calm when the storm is over."⁴

So these statues are expected to serve in an inquiry into the mind and the emotions of Moses himself, and Freud stands before them in the role of the backsliding Hebrew. Surely if there can be life in such statues, there may be toys, speaking toys, among those several hundred statuettes; and it might well be that those who arranged Freud's possessions in Maresfield Gardens felt, as they set out the statuettes upon the desk, that they were making the old man happy, as one seeks to make a child at home by taking its dolls to the hospital bed. Statuette, doll, statue—they are not synonyms, but they belong to a family of meanings. Change the word a little, the whole sentence shifts to reveal new treasures of truth.

★

In September 1938, Freud moved into his last home at 20 Maresfield Gardens, along with his collection of several hundred *statues*. What an event that would have been! They would have had to pull down the neighboring houses, and lay out new grounds to accommodate the collection. And if we had been standing nearby as the old man arrived with his stone retinue, and if I had asked you who this Freud was, with his hundreds of statues, his thousands of antiquities, you would have been moved to make sense of it thus: this Freud is a foreign prince who has come here to die, and the statues have been brought for his tomb. And what you would have said would have been true, for these antiquities form both his memorial and his tomb—since they include the urn in which his ashes are buried, and since Maresfield Gardens is his mausoleum.

But if, with a final turn of the switch, one were to transform the sentence yet again, and say that Freud arrived in his last home with a collection of several hundred *colossi*—statues so huge that the whole triangle between Finchley Road and Fitzjohn's Avenue and, say, Frognal Lane, would have to be obliterated to accommodate them—and once again we were bystanders, and I asked you for your interpretation of the event, then I think you would say that this Freud must be a magus, and that the king of this country has invited him here and laid out these new avenues and set up these colossi to protect this city and this country from its enemies.

And once again I must congratulate you on the grandeur of your interpretation which, while it seems grossly flattering to our monarchy, reflects something of the grandeur of Freud's own sense of purpose. "After the destruction of the Temple in Jerusalem by Titus," he wrote, "Rabbi Jochanan ben Sakkai asked for permission to open a school at Jabneh for the study of the Torah. We are going to do the same. We are, after all, used to persecution by our history, tradition and some of us by personal experience . . ."[5]

And so we have Freud's permission, his encouragement, to compare the retinue moving into Maresfield Gardens with the Jewish people at the start of the Diaspora, but with this difference—that Rabbi Jochanan ben Sakkai must have taken his books to Jabneh, but Freud's library had been sold. What Freud took into exile we might want to compare with the gods which Aeneas and his father carried from blazing Troy,

were it not that, if we call these statuettes gods, we are in danger of walking straight into the plate glass window of taboo. Freud can be a rabbi on his way to Jabneh, can be Moses leading his people to the promised land—but not with these heathen gods in tow, not with these falcon-headed images, these sphinxes, these idols of Amon-Re and the Baboon of Thoth.

Did Freud worship these images? Did he bow down before the Baboon of Thoth? We know already, because we have had his word for it, that when he comes before Michelangelo's Moses it is as a member of the mob, "the mob which can hold fast no conviction, which has neither faith nor patience, and which rejoices when it has regained its illusory idols." That is what we meant by calling him a backsliding Hebrew. It does not strike Freud as necessary to point out that the statue of Moses *itself* embodies an infringement of Mosaic Law, a particularly bold infringement if the statue is said to represent the moment at which Moses sees his people worshiping the Golden Calf. But this infringement is part of an age-old tradition, most vividly represented by a statue in Bern which shows Moses holding up the Tablets of the Law and pointing specifically to the second commandment:

Thou shalt not make unto thee any graven image, or any likeness of any thing that is in heaven above, or that is in the earth beneath, or that is in the water under the earth: Thou shalt not bow down thyself to them, nor serve them: for I the Lord thy God am a jealous God, visiting the iniquity of the fathers upon the children unto the third and fourth generation of them that hate me; And shewing mercy unto thousands of them that love me, and keep my commandments.[6]

You must not make any representational object, and you must not, having made such an object, venerate it in any way. No other art has been honored with such a general taboo. No other art is of concern to the author of the Ten Commandments. That the fight between art and religion is an ancient and a necessary one we may concede, since all art tends to arrogate authority to itself, and all religion aspires to a monopoly on authority. But the arrogance of the other arts can be contained. Music can be put to good use. Poetry too has been set its tasks around the house of God. Even drama has been allowed to encroach, although

always under profound suspicion. But the representational arts, and particularly that of sculpture, come with such a freight of heathenish memory, such a burden of idolatrous implication, that they have been banned outright . . .

. . . and have won, piecemeal, their appeal against the ban. So we learn that some Jewish authorities "interpret the second commandment as forbidding only those images made by a Jew for worship by a Jew, while at least one commentator asserts that the verse applies even to images a Jew might make for non-Jews to worship. Some take 'sculpted' to mean incised as well as built up; others regard it only as three-dimensional. Some speak of 'image' as referring to the human form; others see it as intending any form." And some, apparently, have tolerated a painted profile, while maintaining a ban on the human face seen fully frontal.[7]

All of which is a tribute to the power of man's desire to represent, and to the ability of his mind to block out an inconvenient injunction—to interpret a text away. Freud was not at the head of a backsliding tradition—he was its heir. Jewish representational art, as seen in the old cemeteries of Europe, has a tradition dating back to the second century before Christ. The taboo had been well broken, and for long. But while Freud seems to have been happy to collect graven images (some of them, no doubt, of precisely the type that the scriptural writers abhorred), he was not as insouciant about the taboo as he seems in the essay on Michelangelo. At least, by the time Freud reached London he had come to the conclusion that the prohibition against worshiping God in a visible form had had a profound effect upon the Jews:

For it meant that a sensory perception was given second place to what may be called an abstract idea—a triumph of intellectuality over sensuality or, strictly speaking, an instinctual renunciation, with all its necessary psychological consequences—

which were that

the individual's self-esteem is increased, that he is made proud—so that he feels superior to other people who have remained under the spell of sensuality. Moses, as we know, conveyed to the Jews an exalted sense of being a chosen people. The dematerialization of God brought a fresh and valuable contribution to their secret treasure.[8]

But this passage leads straight into a reference to the Jews' misfortunes, the destruction of the Temple and, once again, the opening of the first Torah school in Jabneh. It is as if the prohibition had some part to play in those misfortunes, as well as in the strengths of the Jews. It is as if that instinctual renunciation had exacted a heavy price.

And among Christians too, the meaning of the second commandment was subverted, qualified or even reversed to accommodate a possible *duty* to venerate religious images, images which had found their place in worship at least by the time of the establishment of the Church under Constantine—so that there never was a post-classical world without statues and images that were revered. And some classical images were co-opted, as happened to Lysippus' statue of the resting Hercules, which stood in the hippodrome at Constantinople, but which was transformed by belief into Adam. The hero resting from his labors turned easily into the First Man sitting on a basket, contemplating the loss of Paradise—an image which spread throughout the Christian world in portable ivory form.

They were marvelous, those statues which survived being "destroyed or toppled by the blessed Gregory" and which a certain Englishman, Master Gregorius, described in Rome in the thirteenth century. Of a Venus he says:

This image is made from Parian marble with such wonderful and intricate skill that she seems more like a living creature than a statue; indeed she seems to blush in her nakedness, a reddish tinge colouring her face, and it appears to those who take a close look that blood flows in her snowy complexion. Because of this wonderful image, and perhaps some magic spell that I'm unaware of, I was drawn back three times to look at it despite the fact that it was two stades distant from my inn.[9]

That possibility of enchantment, that sense of a statue possessing its own inner life—that could not be contemplated in those days with anything like Freud's equanimity, or a child's eagerness that a doll might come to life. Too much was at risk, too solemn a curse hung over the idolater. So that, in Ghiberti's *Commentaries* (written around 1450), we find an account of the discovery in Siena of a statue also signed by Lysippus, which caused such enthusiasm among the painters and sculp-

tors and goldsmiths of the city that it was set up with great pomp, as the focus of a fountain. But after the city had suffered much in the wars with Florence, the flower of the citizenry came together in council, and it was pointed out that everything had gone wrong since the discovery of the statue, that idolatry was forbidden to their faith, and that even if they buried the statue again on their own territory, their misfortunes would continue. So the statue was taken to Florentine territory, and reburied there.[10]

Such careful ratiocination, such concern for the eventual resting place of the image—such has only rarely been the fate of these dangerous images. Much more typical, at times of iconoclasm, has been a blank, destructive rage, a desire to mutilate and humiliate the object of veneration, a scene such as we glimpse in this account of the destruction of the altarpiece at Sint-Jacobs in Ghent:

The chapel was unlocked (I do not know by what folly) and a lad of fourteen or fifteen came in broad daylight with an iron bar to smash, gouge, and otherwise damage the faces and hands of the little alabaster figures in the altarpiece. No one had the courage to stop even such youngsters (even though there were only one or two involved), because they were all astonished, and afraid that it was done at the behest of some powerful individual. No one knew what led him to commit this act.

This was in the Low Countries, during the second wave of image-smashing in the 1560s, and a sense of that period comes pungently from the page. One child is out of control, smashing images which have hitherto been considered the treasures of the city: but everyone cowers indoors, afraid that something is afoot, some powerful individual has ordered this. It's not like cowering behind your front door as a mob smashes up the housing development, knowing that the destruction is aimless and spontaneous. It's like knowing there is an important power shift in process, but having no clue to what the shift might be—knowing only that at such times the people are helpless.

Or again, in Bruges during the French Revolution, we read that:

The heads of the statues taken from the Town Hall were brought to the marketplace and smashed to pieces by the people who were very extremely angry and embittered. They also burned all traces of the hateful devices that

had previously served the Old Law, such as gibbets, gallows, and whips. Throughout these events the whole market square echoed to the constant cries of the assembled people. "Long live the Nation! Long live Freedom!"[11]

How did the heads of statues from centuries before become implicated in the gallows and gibbets of the day? Their misfortune was to be available to a crowd in search of a symbolic action, a crowd like the soldiers who ravaged Canterbury Cathedral in 1642, who

entering the church and choir, giant-like began a fight with God himself, overthrew the communion-table, tore the velvet cloth from before it, defaced the goodly screen, or tabernacle-work, violated the monuments of the dead, spoiled the organs, broke down the ancient rails and seats, with the brazen eagle that did support the Bible, forced open the cupboards of the singing-men, rent some of their surplices, gowns and Bibles, and carried away others, mangled all our service-books, and books of Common Prayer, bestrewing the whole pavement with the leaves thereof: a miserable spectacle to all good eyes. But as if this had been too little to satisfy the fury of some indiscreet zealots among them (for many did abhor what was done already) they further exercised their malice upon the arras hanging in the choir, representing the whole story of our Saviour; wherein observing divers figures of Christ, (I tremble to express their blasphemies) one said, "here is Christ," and swore that he would stab him: another said, "here is Christ," and swore that he would rip up his bowels: which they accordingly did, so far as the figures were capable thereof, besides many other villainies. And not content therewith, finding another statue of Christ in the frontispiece of the South-gate, they discharged against it forty shots at the least, triumphing much, when they did hit it in the head or face, as if they were resolved to crucify him again in his figure, whom they could not hurt in truth.

And Margaret Aston, who reprints this passage, comments that "images were surrogates or dummies on which were vented some of the anger felt towards inaccessible human agents. Rage against the living might be discharged on images of the dead."[12] But one supposes that rage against the dead came into the story as well, and that what began as pious rage turned into rage against Christ.

2

Generally speaking, religious iconoclasm has reserved a particular hatred for sculpture, rather than the painted or woven image, because it is sculpture that seems to be the target of Moses' wrath. And it is true of statues in general that they are vulnerable to, that they invite, mutilation: noses and hands get lopped off, suffering the punishment of thieves; the male genitals are a target, both for vandalism and for high-minded mutilation—all the erections of the Egyptian god Min seem to have been crudely censored; and heads, finally, are both physically vulnerable and a trophy, and can be valuable booty—as the thieves perhaps thought who sawed off the heads of Henry Moore's bronze king and queen in Scotland in 1995.

And statues are vulnerable when they are made of precious metals, and most metals are precious to someone, particularly in time of war. Where are most of the bronze casts of the greatest statues in Rome, which Primaticcio made for the King of France? Where are the great doors of Saint-Denis? They are field guns. They are the sons of guns, the grandsons of cannons. Who knows where they are? They have suffered so many reincarnations.

Ghiberti tells the following story:

In Germany in the city of Cologne lived a master much experienced in the art of sculpture, he was of the highest genius, his name was Gusmin; he was employed by the Duke of Anjou who had him make a great many works in gold; among other works he made a golden altar and with all solicitude and care he executed this altar very excellently. He was perfect in his works, equal to the ancient Greek sculptors; he made the heads and all the nude parts marvellously well. There was no fault in him, save that his statues were somewhat squat. He was very outstanding and skilled and excellent in his art. I have seen many figures cast after his. He had the most delicate air to his works, he was very skilled. He saw the work destroyed that he had made with so much love and art on account of the public needs of the Duke; he saw his labor had been in vain and he fell upon his knees and raised up his eyes and hands to Heaven saying: O Lord, Thou who governest Heaven and Earth and hast created all things; my ignorance be not so great that I follow anyone but Thee, have mercy on me.

Forthwith he undertook to give away whatever he owned for love of the Creator of all. He went up on a mountain where there was a great hermitage: he entered and did penance as long as he lived: he grew old, he died in the time of Pope Martin. Some young men who tried to gain knowledge of the art of sculpture told me how skilled he was in one art and another and how he painted where he was living; skilled he was and he died in the 438th Olympiad. He was a very great draughtsman and very gentle. Young men who desired to learn went to see him and when they begged him he received them most humbly, gave them skilled advice and showed them a great many proportions and made them many examples; he was most perfect. With great humility did he die in his hermitage. Altogether he was most excellent and of a most saintly life.[13]

This story, this little hagiography, sounds like legend, but is most probably true. There probably was a sculptor called Gusmin, who would have worked for Louis I of Anjou, a great patron of goldsmiths, among whose inventories is listed a very large golden altar, *une très grande table d'autel d'or*, which was either sold or sent to the mint in 1381 in order to raise money for the conquest of the Kingdom of Naples. This war would be covered by the phrase, "the public needs of the Duke."

And it has been calculated that Gusmin would have been born around 1340 and would have worked for Louis from 1360 to the time of the destruction of his work two decades later. And as we see from the story, he took that destruction, that sudden complete loss of value, as a judgment against himself, and he spent the remaining forty years of his life in expiation of his sins. During those forty years, his reputation persisted among goldsmiths and sculptors (the two professions overlapped) and was kept alive by small casts after his work, which were probably not so very unlike the little bronze Moses whose photograph Jones sent to Freud. These figures traveled as far as Florence, and Ghiberti was so impressed by them that he praises Gusmin enthusiastically, as he praises no other artist but Ambrogio Lorenzetti.

But this praise, this tribute, is all that remains of Gusmin. More dramatic still, there is practically nothing left of the work of Gusmin's contemporaries from which we can see precisely what kind of work was done in this period in the royal ateliers, in precious metal. In fact there are three

or four outstanding objects in all from France in these decades. If that number seems low, compare it with an account drawn up of the whole remaining corpus of secular goldsmiths' work from medieval France, which contains around fifty items only.[14]

It is true that plate, the personal silver and gold possessions of a family or institution, both represented wealth and *constituted* wealth, so that it would not, in past centuries, have always seemed so shocking to melt down plate for a purpose well conceived. But Gusmin was shocked that his gold shrine was melted down, and it is shocking to think that not just individual objects but whole classes of object have disappeared. It was calculated somehow that what remains of medieval works of art represents only 2 percent of what there once was.[15] A statistician might say that this is far too small a sample for us to use for any generalizations about medieval art. If so, the case is perhaps no worse than that of Greek tragedy. But still, the category of what has vanished is worth our attention.

Some sculpture, like the centerpieces carved in ice or butter beloved of the luxury cruises, is made to vanish. This genre has a history going back at least to the Rome of the Baroque, when we are told that the food itself would be served in a sculptural context, so that there might be "men throwing trapping-nets over the already roasted partridges, or hunters shooting at the game dishes." Jennifer Montagu writes that

real sculpture would be moulded in butter, or cast in jelly, ice, or sugar; we may note that the Germans also sculpted in turnips and beetroot, though the Italians seem to have drawn the line at this. So important was the making of these objects that a plan of the Vatican kitchens shows a special room labelled "Room in which the *trionfi* are prepared."

These *trionfi*, these triumphs, were made largely of sugar and decorated with edible gilding. Astonishing in their elaboration, amazing in their subject matter: drawings preserved in Stockholm show tables set for a meal where a sugar Christ falls under his cross on one plate, while on others are displayed the flagellation, the *noli-me-tangere*, Saint Veronica with her veil and a Last Supper which you could literally eat for supper. Another table is devoted to angels displaying the instruments of the Passion—the cross, the crown of thorns, the sponge soaked in vinegar, and so forth—tasteless subjects for a banquet setting, you might say.

But when Pope Alexander VII gave a banquet for Queen Christina of Sweden, the sugar sculptures, by Ercole Ferrata, were of scenes of rape and attempted rape.[16]

Such banquets are acts of demolition—we love to say, they *demolished* the meal—and the extravagance of the preparations was such that, in order not to let these acts of demolition pass unnoticed, the public was admitted for two days before, to admire the place-settings alone. But it is in the nature of "triumphs" that they are made for the moment, that they will not be preserved, any more than stage sets will necessarily be preserved. So these rare sculptural commissions are expressions of transience.

But for the most part patron and artist lived under the illusion that their works were made to last. When Horace boasted that his poetic monument would be more lasting than bronze,[17] he at least shared in the idea that bronze itself was durable. And bronze is indeed durable. It is the monument that is not. The antique Roman bronze revetments of the Pantheon doors were durable until Bernini needed bronze in huge quantity for the *baldacchino* in St. Peter's.

To erect a statue is to make a bid for immortality, or for the immortality of the subject. When Freud's admirers wished to honor him on his fiftieth birthday, Jones tells us that they presented him with a medallion with his portrait on the obverse, and on the reverse a Greek design of Oedipus answering the Sphinx, around which was inscribed a line from Sophocles:

ὋΣ ΤΑ ΚΛΕΙΝ᾿ ΑΙΝΙΓΜΑΤ ἩΙΔΗ ΚΑΙ ΚΡΑΤΙΣΤΟΣ ἩΝ ΑΝΗΡ
(Who divined the famed riddle and was a man most mighty)

"At the presentation of the medallion," says Jones,

there was a curious incident. When Freud read the inscription he became pale and agitated and in a strangled voice demanded to know who had thought of it. He behaved as if he had encountered a *revenant*, and so he had. After Federn told him that it was he who had chosen the inscription, Freud disclosed that as a young student at the University of Vienna he used to stroll around the great arcaded court inspecting the busts of the former famous professors of the institution. He then had the phantasy, not merely of seeing his own bust there

in the future, which would not have been anything remarkable in an ambitious student, but of it actually being inscribed with the *identical words* he now saw on the medallion.

And among Jones's posthumous kindnesses to Freud was his presentation, in 1955, of a bust of Freud to be erected in the court, to which the line from Sophocles had been added. Jones says of this that "It is a very rare example of such a day-dream of adolescence coming true in every detail, even if it took eighty years to do so."[18]

I take the anecdote to be true in this sense, that Freud, presented with the medallion, seeing his face in bas-relief, and turning the object to find his achievement so beautifully encapsulated as Oedipus questioning the Sphinx, with such a beautifully apt line chosen by Paul Federn— a line which Freud knew well and recognized—I take it that Freud was overwhelmed by the thought: this line should be my memorial. And I suppose that the "unremarkable" adolescent ambition to have his bust displayed in the great court of the university, the ambition to live forever in this way, grafted its burning memory onto this new desire, so that Freud himself could not distinguish the memory from the will, and he was permitted to fib.

He had foreseen his own death and now he wanted to become a statue in order to survive. But, as it turns out, these statues that we have, these plucky survivors, have had to pass through all manner of danger—war, plunder, the price of bullion, fire, damp, neglect, attention, piety, disrespect, excessive love. And some of them may be compared to those characters in films who, escaping with great difficulty from a series of dangers, and coming back into their homes and slamming the door behind them, and leaning, panting, eyes closed, against the door, open their eyes again to see the greatest danger of all staring them in the face.

To have lain unremarked in the Forum, until covered with vegetation and the detritus of centuries, would have been something. To have escaped the attention of those whose trade was to burn marble for lime—that was an achievement. And to be dug up with respect, and carted off to some cardinal's collection—that might tempt one to bless one's luck, until the first blow of the restorer's chisel. And again, a statue might be well restored, by a great sculptor who knew his business

well, but then the taste of the day moves against restoration itself, and all the restorations have to be removed, leaving the statue slightly worse off than as found.

For taste is a great enemy of art. It was the taste for purity of form and truth to the material that took so many medieval statues—which had had a hard enough time during years of hatred and neglect—and stripped them of their polychromy. Mazzuoli, Bernini's assistant, must have thought he had a prestigious commission when he carved the twelve apostles for Siena Cathedral. He must have thought his works would be there for good. How surprised he would have been to see that cathedral regothicized in the nineteenth century, and his master-pieces sold off as a job lot, to be reerected in London, at the Brompton Oratory. But they had a lucky escape.

In 1413, a statue of Saint Christopher was donated to Notre-Dame in Paris. It was known for its exceptional height—no less than twenty-eight feet—and it stood on the organ screen. In 1784, in the course of restoration work on the organ, a joist from the scaffolding fell on the statue, breaking its head. Because of this, the cathedral chapter ordered the complete destruction of the statue. A guidebook from 1791 refers to it in the words: "This ridiculous monument to the taste and devotion of our fathers has just been destroyed."[19]

The word "vandalism," that useful word which we imagine must have been around since the days of the Vandals, was coined in 1794 to denote this attitude of revolutionary destructive zeal, and it is interesting that the enormous destruction of monuments which took place in the French Revolution gave birth at once to the opposite tendency, the desire to preserve these objects from the past, both in museums and in private collections.[20]

It was once the churches had been ransacked that their dispersed contents regained their value. It was once the monuments were des-ecrated that they began to be thought of as works of art. It was once the tree had fallen that the cry went up for the woodman to spare it.[21]

And what of those statues that *did* survive? You might say they were street-smart, so profound is their capacity to dissimulate, to engage, raise hopes, disappoint. Such was the lost Cupid of Michelangelo, found in a Florentine cellar and brought in triumph to the South Kensington

Museum (the forerunner of the V & A), and which had never looked like a Cupid nor indeed, in our privileged retrospect, like a Michelangelo, but which is now agreed to be a classical statue of a warrior, modified in the sixteenth century to represent Narcissus.[22] Such discoveries, such violent modifications of perception, have not ceased, and those who look into the history of our perceptions come away with the shaken understanding that they will not cease. We shall continue to be surprised, and baffled, and have our minds changed by and about these statues.

The two colossal figures of Alexander and his horse Bucephalus, which stand today in the Piazza del Quirinale in Rome, were thought by Master Gregorius to be the first mathematicians, to whom horses had been assigned "because of the quickness of their intellects." Previously, they had been "two seers who arrived in Rome under Tiberius, naked, to tell the 'bare truth' that the princes of the world were like horses which had yet to be mounted by a true king." And their hands were raised as the hands of prophets are raised in warning.

The Dying Seneca in the Louvre was equipped by a restorer with arms, a cloth around its waist and a missing thigh, and, appropriately for the philosopher, was placed on a stone bath "unhollowed so that it seemed full of water, and reddened in imitation of blood." And one clergyman remarked that "If our sculptors knew how to make a comparably expressive Christ, it could be depended on to bring tears to all Christian eyes, for the expression alone of this dying pagan excites sorrow in all who see him."[23] But not all agreed. To some he looked like a criminal, to others like a slave, and finally a view was settled upon that this was not the dying Seneca slitting his veins, but a Roman copy of a Hellenistic statue of a fisherman. And so, many years later, he was removed from his blood-filled tub, demoted from the highest level of human achievement to your average low-life character.

Christ or criminal, philosopher or fisherman—those opposite interpretations would come as no surprise to these statues, which have lived in a climate of extremes—having been objects of horror, and subject to the intensest covetousness, smashed by the mob, raised up by the connoisseur, having been gouged out of the mountainside, dropped in the sea, dragged the length and breadth of Europe, fought over by princes, so that the great statues of Rome made a journey to

the Louvre, and back, or so that if you want to see the great bronzes of Prague you must take a trip to Sweden, or to London for the great marbles of Athens—just as Schliemann's treasure, the discovery of which made him happy because it constituted the fulfillment of a childhood wish, has been lost again in Germany, and found again in Russia, in our time.

And though they seem incontrovertibly solid, though they look like a matter of fact, these statues can be mere episodes in a game of Chinese whispers, sources of creative misunderstanding. The Callipygian Venus in Naples, which raises its dress to reveal its beautiful buttocks, has an eighteenth-century head which replaced a sixteenth-century restoration, to which it was nevertheless broadly faithful. The original restorer thought that the Venus, as she raised her dress, should look coquettishly over her shoulder. And this coquettish behavior, a source of the statue's popularity, made people think of a classical story in which two peasant girls called a passer-by to judge which of them had the more beautiful buttocks. So that this statue has also been called La Bergère Grecque, and La Belle Victorieuse.

But the evidence of a single piece of ancient cutlery, a spatula, gives us grounds to wonder whether the original statue did not show Venus looking straight ahead as she raised her dress, oblivious to any crowd or any judge. And that might make one think that a goddess raising her dress to reveal the beauty of her buttocks might, in some age past, have been the occasion for solemn awe. The statue might be a peasant girl, or a goddess, or a *hetaira*, a classical geisha. And while it is a well-known failing of some men to consider women as either goddesses or prostitutes, there remained the possibility, for the Greeks, of religious prostitution, or the possibility that goddess and prostitute were not opposites.

One supposes that the *anasyrma*, the gesture of lifting the dress, is as complex a symbolic act as could be depicted. I recall that at the end of a certain war, the women of the city lifted their dresses to shame the young soldiers of the victorious army. Humiliation, invitation, various kinds of biological need, the sexual defiance of the cancan—here I am and damn your hypocrisy—one could go on forever listing the various ways of lifting a dress.

The King of Sweden, Gustavus III, had the idea of copying the Callipygian Venus but giving it the head of one of his court beauties, Countess Ulla von Höpken, and this statue was made by Sergel and placed in the Hall of Mirrors, where the King used to lunch, and where, as a shocked courtier noted, the lower functionaries of the household were wont to resort. The King no doubt felt that his affection for the Countess was appropriately expressed. The household no doubt did a great deal of sniggering.[24]

But if they sniggered, if they thought the statue obscene, they too take us back to a classical precedent of some beauty. You will recall that when Persephone was abducted by Hades, Demeter lost all her gaiety, refused all food and drink, and went wandering for nine days and nine nights, inconsolable. On the tenth day she came to Eleusis, and it was there that the lame daughter of the King, Iambe, after whom the iambic meter is named, tried to make her laugh with lascivious verses. And there was an old woman called Baubo, who tried to persuade Demeter to drink barley-water, flavored with mint. And the old woman succeeded in the following way. She began groaning as if in labor. Then suddenly, unexpectedly, she lifted her skirt, and out jumped Demeter's own son, Iacchus, "who leapt into his mother's arms and kissed her." And once she had laughed, Demeter drank the barley-water—not just a cup of it, she drank the whole pitcher—and when the King's son said, "How greedily you drink," Demeter "threw him a grim look, and he was metamorphosed into a lizard."[25]

We understand that the passage of the seasons is reflected in Demeter's mourning for Persephone, and that, unless Demeter drinks that barley-water, winter will go on forever. Unless Baubo, the old crone, manages to make Demeter laugh, civilization will cease. Everything depends on this obscene gesture, and it is said that the Eleusinian mysteries reenacted this crucial moment, that they kept the obscenity going.

"You have to laugh." That catchphrase is true. I remember in Borneo, when we needed the river to rise so that we could get back downstream, our guides involved us in a rain-ceremony, in which we placed salt on the riverbank at the height we wished the river to reach by the next morning. Then we were instructed to get into the river and beat it with branches and shout at it at the tops of our voices. I

apologized for laughing as we did so. My guide said, No, you *must* laugh; if you do something funny you must laugh, otherwise the magic won't work.

I think it misleading of Freud to refer to animistic societies as displaying the omnipotence of thought. There may be that aspect to magic, but an animist also, by the very act of attributing spirit to everything, giving every element of the landscape its own point of view, shows himself alive to the fact that there are other powers in the world. Something must be done to make the river cooperate, but indeed the thing that must be done may be absurd, like giving a cigarette to a rock, or a coin to a stream. It is not a fantasy of omnipotence. It is a matter of doing your best in a difficult, hostile world.

And the world of statues, which is characterized at the start by the presence of these gods, these heroes and saints, is one in which the spectator is alive to forces of a complexity we can barely grasp. Is Aphrodite raising her dress to attract us, to amuse us, to ask for our opinion on the beauty of her buttocks? Or does she stand looking ahead, while she removes her robe? Is she simply undressing, because Aphrodite has to undress, just as we have to laugh, or the world will cease?

Freud, when his father died, began a collection of objects from the classical and pre-classical age, objects which might resemble statues, or toys, or idols of various kinds, but which for the most part come under the general rubric: grave-goods. And the people at the Kunsthistorisches Museum in Vienna did Freud the kindness of undervaluing his collection, so that on payment of a small sum he could take his valued grave-goods with him into exile and death. And the Greeks had a word for statues, they called them *agalmata*, which meant things wherein one delights; glories, delights, ornaments; statues in honor of a god, any statue or image; and a sculptor was an *agalmatopoios*, a maker of delightful things. And we know that Freud was thinking: maybe this instinctual renunciation, this hatred of images, has made us proud, has made us superior. And we believe that he perhaps felt that the ancient persecution of the Jews had something to do with this pride. But when he saw Maresfield Gardens, and the beauty of the *garden* at Maresfield Gardens, he was moved to say *Heil Hitler*, in thanks for his good fortune. And his son unpacked his collection, and set it out on his desk. Death and

delight were mingled there, among meanings and resonances we cannot hope to unravel, just as we will never unravel what all these statues mean, or what they once meant to those who delighted in them.

The Mummy's Secret

I

In May 1888 a passenger ship, the *Thebes*, brought William Flinders Petrie and his luggage from Alexandria to Liverpool. Both the man and the luggage were remarkable. Petrie was one of the first scientific archaeologists, but his science was placed firmly at the service of his religion. On the one hand, his first essay into Egyptology caused a mild shaking of heads among the British Israelites (believers that Britons were descended from the Lost Tribes) of his acquaintance, because he had conducted an accurate survey of the Gizeh pyramids, and undermined their belief that the Great Pyramid was perfect and therefore the work of God. On the other hand, his friend the Reverend A. H. Sayce recalled: "While I was with him Petrie discovered the actual brick-platform on which Nebuchadrezzar's throne was erected during his invasion of Egypt, and of which the prophet Jeremiah has preserved the record." (43:10)[1]

A great mortifier of the flesh, Petrie had lived, during his pyramid survey, in an ancient tomb, working at night, naked, guarded by a single (and no doubt quite hysterical) slave. By daylight, he shocked his female British visitors by not wearing socks. He pioneered a disgusting kind of field cuisine whose influence can still be detected in Egypt today ("Why hasn't he died of ptomaine poisoning?" asked Lawrence of Arabia admiringly, as he scraped the green crust off the week-long-opened tinned kidneys). But Petrie was practical. When Amelia B. Edwards of the Egypt Exploration Fund conceived the idea that her subscribers might like to receive a genuine brick made without straw by an Israelite in bondage, and asked Petrie to send her a thousand such from Tell el Maskhuta, Petrie, for whom this would have been "trading

in relics," pointed out that one Egyptian brick was very much like another, and that they were frequently made without straw. Also, think of all the packing cases required . . .[2]

Since the beginning of 1888 Petrie had been working in the Fayum region in the north of Egypt, west of the Nile, and he had had great luck. The least of it was that he had found a papyrus manuscript of the *Iliad*, Book II. He had also found—in itself a modest object, but one to which great significance would be attached—the first framed painting to survive from antiquity. He had found the tomb of a painter and his paint-pots, which he was bringing home with him, along with the painter's skull (he hoped to find out whether he was Egyptian or Greek). And most importantly he had found a large cache of mummy portraits. These were naturalistic Greek paintings in wax on wooden panels, dating from the Roman period—mainly from the second and third centuries AD—and most of them were in startlingly fresh condition. They had all originally been attached to mummies.

These mummy portraits, of which today about a thousand are known, were at that time extremely rare. Only twenty had found their way into museums or other collections, although the first had been discovered as long ago as 1615 by the Italian traveler Pietro della Valle.[3] In the previous year, however, an Austrian dealer called Theodor Graf had managed to buy up another cache of portraits from the same period (although many of them were in tempera rather than wax, and therefore of less interest). Petrie knew of these, and he knew that they had already been offered in Paris and London for fantastic sums.[4] Most probably he had not yet seen them. Nor would he have known that, at the time of his voyage home, a Munich newspaper was running a series of articles by the "poet-Egyptologist" Dr. Georg Ebers, in which the portraits were described, incorrectly, as belonging to the Ptolemaic period (which ended with the Roman takeover of Egypt in 30 BC). Petrie was aware— and despite his uprightness he was not immune to rivalrous feelings— that Henry Wallis of the South Kensington Museum (as the Victoria and Albert was then known) had gone to Egypt expressly to look for the kind of portrait he, Petrie, had stumbled upon by chance. During the course of his excavations in the Fayum, he had done his best to keep quiet about the nature of his finds.

But now there seems to have been a race on. Petrie's private backers (with whom he would split his finds three ways) had already booked a gallery in the Egyptian Hall, Piccadilly, and Petrie had written ahead to his father asking him to prepare forty oak frames in which to display the best of the portraits. He had already acted to preserve these, in the field, by a technique of his own devising, involving an alarming-sounding portable brazier:

The wire-grating was filled with red-hot charcoal, and then the frail portrait was slid beneath it, a few drops of melted wax laid on it, and watched. In a few seconds the fresh wax began to spread, and then at once I ladled melted wax all over the surface; a second too long, and it began to fry and to blister; too sharp a tilt to drain it when it came out, and the new wax washed away the paint.[5]

Arriving in Liverpool at the beginning of June, he went straight to London, where he had two weeks to unpack his finds, set up the display, mount and frame the portraits himself, write the labels for these and all the numerous exhibits, write the catalog, and organize the pre-publicity. The show opened on June 18.

The Egyptian Hall was an imaginative building, dating from 1812, and supposedly designed in imitation of the temple at Dendereh. It was a strictly commercial venture, and had nothing originally to do with Egypt or Egyptology beyond the style of its façade, although it did house, in 1821, Belzoni's exhibition of the sarcophagus of Seti I, with replicas of two chambers from his tomb. It was a place to show anything sensational: a huge painting, a freak, a model of the Battle of Waterloo — anything that would draw a crowd prepared to part with a shilling. In 1820 Géricault showed *The Raft of the Medusa* there, and it was supposedly seen by fifty thousand people. Géricault made between 17,000 and 20,000 francs out of the event, which sounds like a handy sum. In the same year, to the delight of Hazlitt and the dying Keats, Benjamin Robert Haydon showed his *Christ's Triumphal Entry into Jerusalem* there; 31,000 visitors came, but Haydon's creditors pounced on the proceeds. Among the freak shows seen at the Egyptian Hall were a family of Laplanders, the original Siamese Twins, and P. T. Barnum's American midget General Tom Thumb. One of the later successes of the hall in 1896 was the first moving picture show to play in London before a paying audience.

★

Such was the setting for Petrie's exhibition. The classical scholar Dominic Montserrat, who has generously allowed me to draw on his unpublished research, points out that throughout the period of the exhibition the Egyptian Hall was advertised on the front page of *The Times* as "England's home of mystery and the arcana" offering "expositions of automata-mental telegraphy, so-called thought transference, and ventriloqual sketches."[6] And it is as well to remember this context when we think of the original viewing public and their enthusiastic response. Egyptology has always had its mystical undertow. The reviewer in the *Illustrated London News* did not call Petrie an archaeologist—he called him a traveler "gifted with all the instincts of an explorer." And when he summed up the message of the mummy portraits it was in terms of thought transference: " 'Think not of the wan, sunken face within,' the artist seems to say to us: 'but remember your dear one as she lived, with the glow of life quivering on her cheek and the light of life beaming from her eye.' "[7]

The illustration shows a part of the exhibition as it was laid out, with coffin lids held half open by string, permitting a glimpse of the linen-wrapped mummies. (Many of the objects illustrated were on display in the British Museum's exhibition *Ancient Faces*.) On the walls, in between complete standing mummy cases, hang the portraits which Petrie had detached from their often disintegrating mummies, mounted on the appropriate shade of cardboard, and framed. From the moment Petrie first found the portraits, he thought of them as works of art which should be seen in the context of the European tradition. As he wrote half-jocularly in his journal:

I have the notion—beside any special exhibition that we make of these—that it would be a grand joke to send in all the paintings that I bring home to the winter exhibition of Old Masters at Burlington House [i.e., the Royal Academy]. Most would go in readily for their art alone, apart from their history; and for technical interest I should think a dozen or more would be most welcome here.[8]

This early sense that what he had found came into the category of high art was soon elaborated. What he had found was the best evidence so far for what Greek painting had once been like:

Though only a sort of undertaker's business, in a provincial town of Egypt, and belonging to the Roman age, when art had greatly declined, yet these paintings give us a better idea of what ancient painting was, and what a high state it must have reached in its prime, than anything yet known, excepting some of the Pompeian frescoes. Mannerism is evident in nearly all of these, and faults may be easily detected; yet there is a spirit, a sentiment, an expression about the better examples which can only be the relic of a magnificent school, whose traditions and skill were not then quite lost . . . If such was Greek painting still, centuries after its zenith, by obscure commercial artists, and in a distant town of a foreign land, we may dimly credit what it may have been in its grandeur.

Petrie took a genuine pride in the fact that "the National Gallery now begins its history of paintings far before that of any other collection; the finest examples left, after the selection of the Bulak Museum [the forerunner of the Cairo Museum], being now at Trafalgar Square."[9]

Today the National Gallery's "history of paintings" begins in 1260 and ends in the year 1900. But for a while the Gallery not only began, in the foyer, with Fayum portraits. It continued with Byzantine icons. The story of ancient painting was thus linked to Gothic and Renaissance art. But by the 1930s this disposition was no longer convincing, and in 1936 the Fayum portraits were first lent, then more recently for the most part given, to the British Museum, along with the icons. A typically Victorian sense of the connectedness of things—a sense of the present being rooted in the classical past—had lost its grip on the imagination.

2

The Victorians were not, of course, the first to speculate about the origins of classical painting, nor were their artists the first to set their practical minds to its reconstruction. The humanists were always using examples from stories of ancient art, and it is not surprising that Botticelli and Mantegna should, independently, have produced compositions called The "Calumny" of Apelles, based on a description by Lucian of a lost work by that famous master. Two other subjects, The Family of a

Centaur and *Alexander's Marriage to Roxane*, have their origin in a description by Lucian of lost works.[10] The earlier artists who painted them had to rely entirely on their imagination, since they knew nothing at all of Greek painting style, and the outcome of this leap of the imagination is likely to be more satisfactory than that of a too-slavish attempt to follow archaeological evidence.

But perhaps this is no more than to say that Botticelli is a better artist than a certain Carl Robert who, in the late nineteenth century, attempted to reconstruct the very detailed and full account Pausanias gives of paintings by Polygnotus at Delphi. Robert used Greek vase painting as his guide, and ended up with something that looks like the sum total of a large number of vases, set on a flat plane. One may ask why a wall painting should resemble a vase painting at all, when the one has to involve paint laid on some form of stucco, while the other has to be fired onto clay. Generally speaking, our idea of Greek painting is dominated by all those vases. If there was no French painting left from the last few centuries, but only a mass of French ceramics, we would have a strangely skewed notion of what French painting might have been like.

Nor is it only a matter of trying to imagine Greek wall paintings. There is plenty of evidence that the Greeks adorned their houses and public buildings with panel paintings of all kinds: images of the gods, portraits, landscapes, seascapes, still lifes, battle scenes, and mythological scenes. There is evidence for all of these genres either in ancient literature, or in the fictive paintings visible in Pompeian murals, or in the mosaics that reproduce Greek paintings.

A recent exhibition that began in Amsterdam and went to Leeds took as its subject the related question of *The Colour of Sculpture*, charting the history of the perception that ancient sculpture had often been polychrome.[11] The catalog dates this perception back to the latter part of the eighteenth century, to the researches of the archaeologist Quatremère de Quincy, who in the 1770s accompanied the painter David on a trip to Paestum. Ten years later, and perhaps in part as the outcome of their conversations, David included in his *Brutus* a statue of the goddess Roma which, though shown in shadow, was quite definitely polychrome. From then on, in various countries of Europe, the contemplation of art from other epochs became a regular

subject for painting. *The Colour of Sculpture* catalog shows several paintings of this genre. What did a medieval sculptor's studio look like in operation? In what circumstances were the Tanagra figurines made and sold? What did the Parthenon look like for the *vernissage* of the Elgin Marbles?

The last-mentioned scene is the subject of a painting (now in Birmingham) by Lawrence Alma-Tadema, who balanced extensive archaeological research with an imagination that said: What the heck, why *shouldn't* Phidias have invited the citizens of Athens, and their wives, to look at the frieze while the scaffolding was still in place and the paint all fresh? And why *shouldn't* the sculptor have remained at hand, to answer questions or receive compliments? Perhaps the past is not so very different from the present after all.

In another of these works of imagination underpinned by scholarship, *The Picture Gallery* (Burnley Museum, Lancashire), Alma-Tadema asked, in 1874, what a Roman art dealer's premises would have been like. The figures in his composition, all portraits of contemporaries, include the dealer Ernest Gambart and, apparently, Paul Durand-Ruel. The pictures on the gallery walls are learned and teasing references to works of art recorded by Pliny, a *Sacrifice of Iphigenia*, a fragment of the famous Battle of Issus, whose appearance is known from the copy in mosaic that was discovered in Pompeii, and a picture of an ox, which we must imagine to resemble one painted by Pausias.

In other words, Alma-Tadema was interested in more than simply letting his imagination rip—he was keen to harness all the evidence he could for the accurate reconstruction of antiquity in every detail. He amassed a large photographic archive for this purpose. It is hardly surprising that he and his fellow artists should have been enthusiastic about Petrie's exhibition: it answered questions which had been posed, time and again, by the artists of the previous century. The show provided the opportunity for Petrie to meet, and form a friendship with, Holman Hunt. Edward Poynter also came, and Sir Frederick Burton, a painter who had laid his brushes aside on becoming director of the National Gallery, was enthusiastic enough to persuade his trustees to buy four portraits (for a total of £95). The Gallery was given seven more by Petrie's backers.

The show was a success, and yet one has to admit that it fell short of total success in that it did not fully change the general idea of classical painting. Just as the campaigners for the historicity of colored sculpture may have won the argument but failed in the long run to change the general idea of Greek sculpture as consisting of pure white marble forms, so the Fayum portraits have not taken a central place in our notion of classical painting. They appear rather like a single episode in the history of art, an anomaly.

Even in Petrie's estimate, which I quoted above, the paintings are almost apologized for, on account of their provinciality and distance from the zenith of Greek art. One has to remember that this idea of a decline in Greek painting has its origins in historical theory rather than archaeological evidence. Take, say, "Isidora," the portrait of a young woman from the Getty Museum, one of the very best in the *Ancient Faces* exhibition: Who is to say that it is provincial? What force does the word have when applied to an artist who could perfectly well have been trained in Alexandria? And who is to say that this work belongs to the nadir rather than the zenith of its tradition?

3

Only once in his journal of the 1888 Fayum excavations does Petrie indulge in that speculation about the characters of the sitters which became so typical of the Victorian responses to the portraits: he finds "a young man who was no beauty anyhow: he looks as though he would have made a very conscientious hard-working curate, with a tendency to pulpit hysterics."[12] As far as I can tell, it was not Petrie who began the tradition of racial speculation to which the portraits give birth, nor was he (unless I have missed something) responsible for the notion that a large number of them were representations of Jews.

In a way this is odd. Petrie was absolutely fascinated by the races of the Middle East, and a year before his Fayum finds he had published a volume of *Racial Photographs from the Egyptian Monuments*, undertaken at the request of Francis Galton (the theorist of inherited genius). Professor Sayce, mentioned above, was the author of a book called *The Races of the Old Testament*. Petrie, besides being a premature

campaigner against smoking, was an ardent anti-Communist and wrote a book called *Janus in Modern Life*, in which, besides banning sport and "amusements" (excepting for those incapable of work), he

advocated limitation of the birthrate by the State, by encouraging the "best stocks" to breed by means of grants and privileges and penalizing the "lower class of the unfits" with compulsory work; their women would be encouraged to seek voluntary sterilization. The higher the social organization and reward of ability, the more intense will be the weeding of the less capable, and the more highly sustained will be the general level of ability.[13]

Petrie and Sayce and Amelia Edwards and their kind were—to coin a phrase—Old Testament Christians. What fired their imagination was the thought of all those tribes and races wandering around Egypt and Palestine, leaving proof of their passing, above and below ground. Petrie, just after the London show, was in Jerusalem, at Bishop Gobat's orphanage school, when, his biographer tells us, he noticed two "decided Hittites," boys who came from east of Jordan. In next to no time he was trying to organize English residents of Palestine to take racial portraits up and down the country. "If this succeeds," he wrote, "we may learn a great deal as to the distribution of the Amorite, Hittite, Hyksos and of the races in Palestine."[14]

In 1933 Petrie became a Palestinian citizen and went to live in Jerusalem. His attitude to the Arabs is dismissive: "We hear that 1,300 years of occupation is to be remembered, but what occupation? Only to destruction . . . For 1,300 years the land has been desolate; is that a title to have the right to keep it so? . . . All that the Arab does is destroy to reduce it again to a desert; and then requires 30 acres for a family while the Jew only needs five."[15]

Petrie had many of the makings of a Nazi, but not the love of sport, and not the anti-Semitism. Rather the opposite. And Amelia Edwards, the "Queen of Egyptology," who seems to have been one of the pioneers of the racial reading of the Fayum portraits, was rather more down on Egyptians than she was on the Jews. Here is one of the portrait descriptions from a series of lectures with which she toured America:

She is probably of Romano-Egyptian parentage. The eyebrows and eyelashes are singularly thick and dark; the eyes long and of Oriental depth and blackness; and the swarthiness of the complexion is emphasized by the dark down on the upper lip. It is a passionate, intense-looking face—the face of a woman with a history.[16]

Edwards believed that the young man depicted in cat. 24 was a Jew, Diogenes the flute player. This misunderstanding arose from the fact that she thought the wooden label (cat. 238) and fragment of mummy wrapping (cat. 239) belonged to this portrait, whereas in fact they had been found beneath it. The label she translated as "Diogenes of the Flute of Arsinoe," the wrapping as "Diogenes who abode at the Harp while he was alive." So she imagined a Jewish flute player who lived at the sign of the Harp in Arsinoe:

There is a set look in the face as of some solemn purpose to be fulfilled; and the eyes arrest us, like the eyes of a living man. The hair is very thick and curly, and the features are distinctly Jewish in type. That he should be a Jew would be quite in accordance with his profession for the gift of music has ever been an inheritance of the children of Israel.

But she had the wrong label, and translated it wrongly.

This urge to make a good story out of the portraits has its parallel in the reception of the Oxyrhynchus papyri, which were found in the same period and which soon inspired a literature of their own. As Dominic Montserrat points out in his admirable and entertaining study *Sex and Society in Graeco-Roman Egypt*, papyrus fragments seem at once sexy and exciting. In 1890, Anatole France published a novel called *Thaïs*, about a prostitute who becomes a saint. This was followed by *Les Chansons de Bilitis* (1894) by Pierre Louÿs, "a selection of sensual prose-poems with a Lesbian theme, purported to be translations from Greek texts found in the Egyptian tomb of a woman called Bilitis, who left her home in Pamphylia to have all kinds of sexy adventures, including one with Sappho."[17]

The urge to make a romance of the past affected even Petrie, who probably never read a novel but who wrote some pages from the journal of Cleopatra. So Amelia Edwards was by no means alone. In 1890 she

became the first person to tour America with her account of the Fayum portraits, a strenuous tour which she insisted on completing even though she fell downstairs in Columbus, Ohio, and sustained a compound fracture of the arm. On she went, lecturing in her slightly racy style: "The man is somewhat on the wrong side of fifty. His face is deeply furrowed, probably by business cares, and he looks straight out from the panel with the alert and resolute air of one who is intent on a profitable bargain . . ."[18]

In 1893, New Yorkers and visitors to the World's Columbian Exposition in Chicago were able to see the collection of the Austrian dealer Theodor Graf, which had already toured Germany and Austria, and which seems to have stayed together much longer than Petrie's because the prices asked were extortionate (and also there was some feeling that the works might not be authentic). The guidebook to the exhibition was by Georg Ebers, a Jew who had converted to Catholicism and who was, according to Montserrat, particularly interested in picking out the Jews among the portraits. One learns of one man whose features were "of an unmistakeably Semitic cast" whom the Berlin public called by Jewish names. Another was "a woman of wealth and splendid tastes. The public, it is said, believed she was the bedizened wife of a butcher . . . She too, perhaps, was of Semitic race." In addition there were men of "truly Greek features," "men of Ethiopian blood," and "a half-breed" who owed "his clear brown skin, thick whiskers, lips by no means thick, and expressive eyes to a father or mother of a nobler race."[19]

Montserrat quotes two of Ebers's steamier descriptions of young, bare-shouldered males—portraits whose implied nudity seems to suggest that they are members of a gymnasium. Pliny mentions such portraits of athletes, and Euphrosyne Doxiadis, in her book *The Mysterious Fayum Portraits*, quotes this wonderful passage from the *Oneirocritica* (Interpretation of Dreams) of Artemidorus of Daldis:

A man dreamt that he went into a gymnasium in his home town, and saw his own portrait actually hanging up there. Then he dreamt that the whole frame surrounding the picture disintegrated. When another man asked him what had happened to his portrait, he seemed to say: "There is nothing wrong with my portrait, but the frame is broken." Unsurprisingly, he went lame in both

feet: for the gymnasium symbolized the good health of his entire body, while the portrait represented the area around his face, and the frame surrounding it meant the other parts of his body.

Here then are two portraits of youths, probably members of the gymnasium (and therefore of the elite). One is, according to Ebers,

the dark-olive son of rich parents, of Egyptian race, and perhaps of princely birth, for gold foliage is twined with his black hair. Defiance and sensuality accentuate his full lips, self-reliance sparkles in his large dark eyes, and . . . still enables us to look into the soul of a youth untroubled by any thought of death, who enjoyed all the pleasures of his age and was already satiated with some.

The other, by contrast, has

a face of light complexion, with hair cut straight off over the forehead. Softer boyish features are hardly conceivable, and yet this youth was not easily led . . . His tutor may have found it hard to discipline this pupil, for a faint tinge of melancholy shrouds this sweet, purely Greek countenance. It would be easy to believe that this delicate blossom of manhood foresaw its early end.

Montserrat comments that "Ebers's physiognomic and racial preconceptions turn the adolescent boys into either dissipated, hot-blooded sensualists (Oriental) or romantic, languid flowers who embrace death (Greek)."

The tradition of looking at the Fayum portraits and finding a gallery of Jews was led decisively in the direction of anti-Semitism by one Hans F. K. Günther in his *Rassenkunde des jüdischen Volkes* (1930). Günther, who had already written a popular account of the German people from the point of view of racial science, turned his attention to the Jews, and assembled a great photographic archive of mug shots, covering Jews or supposed Jews from every part of the world and every period from, practically, prehistory to the Marquis of Reading, Rufus Isaacs. He presents seven Fayum portraits, and provides them with abbreviated racial analyses of some elaboration: "*eines griechägypt. Mischlings . . . vorw. orient. od. vorw. hamit. m. neger. (u. vorderasiat.) Einschlag.*" (A Greek-Egyptian half-breed . . . predominantly Oriental or predominantly

Hamitic with negroid – and Near-Asian – coloring.) Günther is out to prove that Jews are a product of a very early racial mixture (including negro blood), that their hatred of, and alienation from, the societies in which they live is such that they really ought to go somewhere else, perhaps Israel, that there are far too many of them in Germany and Eastern Europe, and so forth.

The last document in this tradition is the most extraordinary. Published in Hamburg in 1943 in a series of studies on the Jewish question (which looked into such issues as: What are the earliest caricatures of Jews to survive from antiquity?), *Das Antike Weltjudentum* included an analysis of eighty mummy portraits. The authors believed that of a population of eight million in the Egypt of the period, around one million were Jewish. These 12 to 13 percent belonged to the upper levels of society, and probably included "intellectuals," tradespeople, civil servants, a sort of *nouveau riche* that had risen swiftly to the upper echelons of society, "just like the Eastern Jews in the most recent past with us." But in 1943 that recent past has been disposed of. The Jewish journalists, art critics, politicians, lawyers, "cultivated Jews with intellectual and artistic interests" are no longer around. Looking at the Fayum portraits, the authors are reminded of what the Jews used to look like—"rich Jewesses, women of the type one used to see ten years ago in Kurfürstendamm."[20] One realizes the utility of this scholarship in the instruction of the young, who after ten years of Hitler might well not know how to recognize a Jew, and indeed the authors go into some detail about this problem.

At the time of the publication of this study, Petrie's head was sitting in a glass jar in a hospital in Jerusalem, awaiting the outcome of the war. He had donated it in the belief that the Royal College of Surgeons in London might conduct a histological examination of his brain, and his doctor agreed in the hope that examination might "reveal some of the reasons for the remarkable capacity and retentive memory he had, even up to the day he died, for the most minute facts." It was indeed a remarkable brain. Petrie, if he wanted to make a complicated calculation, could imagine a slide rule, and work out his calculation on this imaginary instrument. But he also believed that Stonehenge was the burial place of the ancient kings of Britain, and that the dates in the Old Testament

could be justified, as long as one allowed for imperfect transmission of the text. Applied science and pure barminess were thus closely interwoven. People like H. F. K. Günther read the works of Petrie and Sayce and Galton with some attention. They were something worse than barmy, and they took from this scholarship whatever they fancied, and used it for their own bleak purposes.

<div align="center">4</div>

All over the classical world there were people wearing clothes, but if we want to study ancient cloth we look to the Fayum. All over the classical world people were writing on papyrus, but most of the papyrus that survives comes from the Fayum region or the nearby town of Oxyrhynchus. And all over the classical world there were artists painting pictures, and framing them, and hanging them on walls, but the ones that have survived come from the Fayum. We have to remember that the things that survive in the Fayum are both typical of the classical world—in the sense of being common objects—and untypical, in the sense that the garbage dumps of Oxyrhynchus can hardly be supposed to be the same as every other garbage dump in every other town. The Fayum portraits are typical classical products used in a highly untypical way. That is why they survived.

The portraits differ according to the medium in which they are painted. Those that are in tempera tend to look like folk art of a more or less formulaic kind. The ones executed in wax are the startlingly realistic ones, often said to be in encaustic, a word which Pliny mentions in Book 35 of his *Natural History*, and which he explains as meaning a "burning in." You might burn the wax in, to fix it in place, by using a hot metal tool, or by some version of the method Petrie used to preserve the Fayum portraits, with his little charcoal brazier. But nobody, according to Morris Bierbrier, the coauthor, with Susan Walker, of the British Museum catalog, has succeeded in replicating the method used in painting the portraits. It could have involved some other way of softening the wax than by heat.

The portraits are painted on wood, and a large number of them (the old books are often misleading on this point) turn out to be on lime

wood. That would have been imported from the northern Mediterranean, and was therefore no doubt relatively expensive. Mummification itself was not for the poor. Petrie said that out of any hundred mummies he exhumed at the Hawara site in Fayum he might expect to find portraits on one or two. So we are talking about a minority of a minority using painted wax portraits on their mummies—although there is no reason to assume that this minority of a minority is determined by money. It could be, after all, that the practice was simply not very popular.

Of the one thousand or so surviving mummy portraits, about one hundred are still attached to their mummies. Some of these are wrapped in linen bandages with gilded studs. Others come in stucco casings covered with traditional Egyptian deities. In both types, there will be a footcase or representation of the feet, and it was traditional for the footcase to depict two or four enemies, as in the example Petrie records in his journal: "On the bottom the four races painted, kneeling and chained together; a pink European, brownish Semite, yellowish Maghrabi, and greenish grey Sudani."[21] The symbolism of triumph over one's enemies had in earlier centuries been associated with royal burials. Here it seems to have been translated into religious terms for non-royals. Triumphing over one's enemies in death, one was assured the royal advantages of the afterlife.

Whatever form the mummy takes, it will be plain to anyone that the painted mummy portrait of the Fayum type comes from a different iconography. It has not even been adapted. The mummy portraits are not made to fit a traditional Egyptian shape. Rather they stare out at us as if through a window in the wrappings. Nor do the figures always face us squarely, as the corpses inside may be presumed to do. The figures in the paintings sit quite often at an angle to the viewer, turning their heads toward us. It is a pose elementary to portrait photography: the turning of the head toward the viewer implies the bestowing of attention; the torsion of the neck gives interest to the composition; the pose distinguishes the portrait from police mug shots and passport photographs.

This pose alone signals to us that we are looking at a painting produced by an artist with a living sitter, and that signal is more than reinforced

by the depiction of the eyes. Iris and pupil are carefully distinguished, and in the vast majority of cases there is a highlight, a patch of reflected light, indicating the moist surface of the eyeball. The eyes in the Fayum portraits have always struck viewers as unusually, perhaps unnaturally, large—but always intensely lively. The largeness has been explained in different ways. Petrie must have told one of the original reviewers that the skulls of the sitters had unusually large eye sockets. Others have said that because the portraits are posthumous, the artist miscalculated the size of the eyes. But most people find it hard to believe that these portraits are posthumous.

The simplest explanation of the size of the eyes is that large eyes were considered beautiful: this is the one element of unconscious idealization in a body of work that values specific detail, idiosyncrasy, individual characteristics above all else. There is a Fayum portrait in the Metropolitan Museum labeled "Boy with Damaged Eye." The surface of the paint is itself damaged, but there is no doubt that the label is correct: the boy's right eye has been damaged in such a way as to render the face asymmetrical, and the lower part of the socket seems to show exposed flesh. One has to suppose that sitter and artist valued accurate representation above all to produce such works. A posthumous portrait would be most likely to have the face tidied up.

Despite all this, the British Museum's experts, Bierbrier and Susan Walker, have come to the conclusion that the portraits were made around the time of the death of the sitters. I asked Bierbrier himself, during a special showing of the exhibition, to go through his reasons for this conclusion. He told me that it was based on the following considerations. A number of the portraits depict children, but these must surely be sudden or unexpected deaths. There are the portraits on shrouds, which must be made for funereal purposes. A high proportion of the mummies which have been investigated by CAT (computerized axial tomography) scans show that the apparent age of the sitter corresponded closely to the age of the corpse. Finally, it had been Petrie's idea that the portraits had hung, during the sitters' lifetime, in their houses. When the sitter died, his portrait was taken down, removed from its frame, and cut into an appropriate shape to fit the mummy. Thus, what we were looking at was essentially domestic portraiture.

But Bierbrier and Walker both point out that the actual framed portrait Petrie found, which they call "the only surviving framed portrait," is much too small to have been used as a mummy portrait; such portraits are normally close to life size.

I asked Bierbrier whether he really imagined that the artists painted these individuals from their corpses. He did indeed think that that would have sometimes been the case, although he added that the artists might well have known the sitters. He also told me that the painting had to be done quickly (because it was in wax). It is clear that Bierbrier and Walker are strongly wedded to these theories, and since their theories fly in the face of common sense I have wondered a great deal since why on earth they should have come to such perverse conclusions.

Taking the arguments in order again, if we begin by allowing that not everyone in the period who could afford mummification was buried with a portrait, the problem of the children disappears. One can say: in cases where a portrait had been painted, this was available for incorporation into the child's mummy. Children often died young. Some of them also had their portraits painted young, *but not necessarily all of them*. In the case of the shrouds, it seems to be assumed that no living Greek would want to have his or her shroud made. But these people might well have been as happy to commission a shroud as a Florentine merchant to commission his tomb.

The CAT scans have been performed on eight mummies at the museum, and before going through the results one might mention what is known of a few other mummies. Petrie himself was once opening a child's mummy casing when

on pulling away the dummy sandals I found—not infantile toes, but a man's knee joint. I then pulled it to pieces, & found that the undertaker had not troubled to mummify the little brat at all; but had picked up, three old leg bones, & an old skull full of mud, & with scraps of old wraps on it; & the rascal had done them up tidily to satisfy the parental feelings, & put on a little gilt head-piece and sandals to look proper.[22]

In the museum in Pretoria, there is a mummy portrait showing a man with beard and mustache, but the associated body is female. In

the Ny Carlsberg Glyptotek in Copenhagen there is a portrait of a middle-aged man on linen wrappings, but the body inside is much older, suggesting, as does the body of Demetrius in the Brooklyn Museum, that those who did live to a ripe old age had their portraits done years if not decades before their death: an inscription on Demetrius says he died aged eighty-nine, but his portrait is middle-aged.

The above four examples, three of which are cited by Joyce Filer, another member of the British Museum staff, in her essay on the CAT scans in *Portraits and Masks*, are enough to show that the contents of the mummies do not always correspond to the portrait. In two of the cases cited, there was surely some sharp practice on the part of the morticians. In the case of the Copenhagen body, Filer believes that the portrait on the wrappings must be "a copy of a portrait painted some considerable time before the man's death." Brooklyn's Demetrius seems a clear-cut case of the portrait being painted long before death.

So what about the British Museum's new CAT scans? It turns out that they have no bearing at all on the question of when the wax portraits were painted, since in one instance the mummy is without a portrait, in another the head is in a gilded case, and three others are on shrouds. Nor does Joyce Filer herself make anything like the claims that Walker and Bierbrier try to deduce from her evidence. Several of the mummies are of children, but in those cases a CAT scan cannot even ascertain the sex of the child. One is left astonished at the poor quality of the argument from CAT scans.

What then about the "only surviving framed portrait"? It is a fascinating object, which must have made a startling find since the frame is of a type that was common in Victorian England. Petrie calls it an Oxford frame. The mortice joints allow the component pieces of wood to overlap, creating a cross at each corner, and perhaps for this reason a frame of this kind was commonly used for devotional texts ("Thou God Seest Me") on parlor walls. The frame was made without nails, held together with wooden wedges which Petrie was able to remove in order to clean and reassemble it. The portrait is held in place by an internal frame, and there is also an extra groove in the main frame which Petrie concluded would have held glass. He had, on a previous dig at Tanis, found a piece of glass that would fit. Finally, a piece of

twisted cord was still tied to the upper part of the frame as if to illustrate how it would have been hung.

This is not the only such framed picture to survive from the Fayum. Another, found in a house rather than a cemetery, used to exist in Berlin until it was destroyed in World War II. A slightly cruder version of the same Oxford frame, it contained a panel painting in tempera depicting two seated gods. And in Brussels there is another of these Oxford frames, also an icon, representing the Greek military god Heron with a figure at his side making a sacrifice to him. In the bottom left-hand corner, the woman who dedicates the picture is represented in miniature, just like a donor in an altarpiece, and in the right corner there is a slave.[23]

All three of these (and there is another in Providence, Rhode Island) are presumably what the Greeks of the time would have called *eikones*—likenesses—and it is surely quite possible that the little portrait Petrie found was part of some domestic shrine. Why would it have needed glass, if indeed it was glazed, unless it was placed near lamps?

In the same case in the exhibition, astonishingly enough, we find an object from the Getty Museum that can only be understood as a once-framed portrait, part of a triptych in which, as it happens, the wings have also survived. David L. Thompson, in his discussion of the way this picture would have been framed, reprints seven technical illustrations of the way the folding pictures of antiquity would have been constructed. In this case, the central panel was set in an Oxford frame, to which the unframed wings would have been attached by "pintle hinges" (of which the remains exist). The central portrait was flanked by panels depicting Isis and Serapis, and the whole ensemble obviously constitutes some kind of shrine.[24]

It was always a bad idea to argue that because one remaining framed portrait is of the wrong size, therefore none of the mummy portraits can originally have had a domestic use. Petrie had never argued that the Hawara portraits were the only kind of domestic icon. The Getty triptych is quite obviously another, and directly related to the mummy portraits in tempera. The other icons further flesh out the picture, giving us an idea of a humble devotional genre.

The most spectacular evidence of the non-funerary portrait is the

"Tondo of the Two Brothers," the round painting found in Anti-noöpolis, and now in the Cairo Museum, which Doxiadis reproduces on her title page. Montserrat tells us that "in the ancient world, the tondo seems to have been the format *par excellence* for portraits of the living, and the Antinoöpolis tondo probably did not start out as a funerary portrait as such, although it is supposed to have been found in a tomb and the gods depicted on it certainly suggest that its subjects are dead."[25] The puzzle of the tondo is that it bears a single date, and beside each brother there is a faint depiction of a statue of a god, the composite figures of Osirantinous and Hermanubis. Montserrat suggests that the date is the day the brothers drowned, and that the image commemorates the fact that their bodies were not recovered.

This seems ingenious, with perhaps more than a whiff of the perfume of Amelia Edwards. It is interesting that the tondo was used for family portraits—there is one of the Emperor Septimius Severus and his family. And in another medium altogether—in what might be called a miniature version of these wax paintings—there are the gold-glass portraits, tondos that were sometimes incorporated into bowls, and that appear to com-memorate family occasions. The technique of the best of these is astonishing: the gold leaf was laid on the glass, stuck to it with perhaps honey, and the minute drawing was done by means of scraping the gold away, before a layer of molten glass was poured over the top, to seal it in.

C. R. Morey, who cataloged the Vatican collection of these wonder-ful objects (and included examples from other museums as well), tells us that

the arresting portraits of the earlier class are most like those of the Fayum, and the labels on the earliest of them show peculiarities of Egyptian Greek. They date from the early third century into the early fourth, and are the work of craftsmen trained in the Alexandrian techniques but probably domiciled in Italy, and planting there a tradition of miniature portrait-making which gradually lost its fine technique as time went on . . .[26]

The greatest of these seems to be the family portrait on the great cross in the Museo Cristiano in Brescia.

5

"Petition to Zenon from the painter Theophilos. Since the work for you [decorating the house] is finished and there is nothing more to do, and I am left without the wherewithal, you will do good if there are any paintings [*pinakes*] to be made, to give them to me to do, so I can have work and the necessary. But if you don't give me them, you will do well to give me some money for the journey, so I can go back to my brothers in the city. Greetings."[27]

The letter dates from 260 BC; it is from the Fayum, but centuries before the mummy portraits, and the word *pinakes* means paintings rather than portraits. But don't you think that this is the way it happened? The painter comes from Alexandria, paints the interior, spins the job out a bit, sizes the place up, says: Look, this has taken so long I'm out of pocket—give me a couple of portraits to do, so I have enough for the return journey.

And you think: Why not? It'll get him off my hands. And come to think of it, I might regret it if I don't. Let him paint the wife and children.

(Or does this sound too much like Amelia Edwards?)

Pisanello: The Best of Both Worlds

I

In 1862 the historian of Veronese painting Cesare Bernasconi cast doubt on the idea that all the works of Pisanello that were once admired in Rome, Florence, Venice, Milan, Pavia, Mantua, and Naples could have disappeared altogether. Some of them, surely, must be languishing under misattribution to some other painter. No other artist from the fourteenth or the first part of the fifteenth century, with the possible exception of Giotto, had been so praised by his eminent contemporaries. Something more must have survived.[1]

And Bernasconi was quite right. A couple of years before, the *Portrait of an Este Princess* now in the Louvre had appeared in a Paris sale as a Piero della Francesca. The *Vision of St. Eustace* now in the National Gallery in London spent much of the nineteenth century under attribution to either Dürer or Jean Fouquet. But most spectacularly of all, a large and representative collection of Pisanello's drawings had been purchased by the Louvre in 1856 as being by Leonardo da Vinci.

This was the so-called *Codex Vallardi*, named after the collector and dealer Giuseppe Vallardi, who had acquired it in 1829 from "a noble family living near Piacenza and related to the Archinto family of Milan." Vallardi had published his own descriptive catalog of the "codex" (which was actually more of an album than a codex, and had been assembled in the sixteenth century) a year before selling it off for a hefty-sounding 35,000 francs. There were 318 drawings, of which one turned out to be a Holbein, a few more to be indeed by Leonardo and his followers.

The bulk of the volume, however, is now thought to be by Pisanello and his workshop.

So what sort of a mistake was it that the Louvre made? It is hard to imagine what the mid-nineteenth-century Leonardo oeuvre looked like, as a whole, if it contained such diverse objects as a Flemish *Medusa* from around 1600 and these drawings from the first half of the fifteenth century. One has to remember that there is very little overlap between, for instance, the oeuvre of Leonardo as conceived by Carlo Amoretti in 1804, which has more than sixty paintings, and the recent "complete catalog" by Pietro C. Marani (1989), which lists twenty-five items, more than a third of which bear later nineteenth- or twentieth-century attributions. And then there is the question of what Leonardo's drawings would have looked like, if known through the medium of engravings.[2]

Set this beside the paucity of works known in the 1850s to be by Pisanello: the portrait medals he designed; the two important frescoes in Verona, the *Annunciation* in St. Fermo and the *St. George* in St. Anastasia. What else? Moldering away in the collection of a certain Marchese Gian Battista Costabili in Ferrara, among what had once been a superb collection of largely Ferrarese paintings, now mostly in a shocking condition, there was Pisanello's portrait of Lionello d'Este (now in Bergamo, Accademia Carrara) and his only signed panel, the *Virgin and Child with St. Anthony and St. George*. The latter, now belonging to the National Gallery in London, was described in detail by Sir Charles Eastlake in his diary for 1858, where we read that the blue of the sky had been almost rubbed to the ground and "the armour and dress of St. George [were] once beautifully finished, but now almost obliterated" and that the St. Anthony was in less good condition still.[3]

What we are looking at, in this famous picture, is a magnificent piece of restoration by a nineteenth-century Milanese expert, Giuseppe Molteni, to whose hands Eastlake consigned the picture after purchasing it in 1860. The catalog of the *Pisanello* exhibition in Paris (1996), edited by Dominique Cordellier, tells us that Molteni was a friend not only of Eastlake and Otto Mündler (the National Gallery scout who located the painting for Eastlake), but also of Giovanni Morelli and Giovanni Battista Cavalcaselle, the founders of connoisseurship. A good man,

then, no doubt, and one who kept the company of good men, but when we read that Molteni not only made the picture legible, he also gave it a connoisseur's interpretation, and that after his work very little of the original paint surface is visible except perhaps the face of St. George (which had been well preserved)—and that even there there has been repainting under the eye, on the cheek and the chin—then we begin to feel just a little giddy.

Enough has been said, perhaps, to establish that the man who persuaded the Louvre to buy the Vallardi drawings, Frédéric Reiset, was not being stupid when he accepted the attribution to Leonardo. Nor had he neglected to observe a connection with Pisanello—the drawings of medals. But what he thought was that, in the Pisanello material, he had the *early* drawings of Leonardo, and that the young Leonardo had been an admirer of Pisanello. This theory lasted for at least ten years—Reiset's 1866 general inventory of the Louvre drawings lists nothing by Pisanello—but gradually the doubts crept in.

Reiset and his friend the Vicomte Both de Tauzia began to wonder whether it might not be a good idea to restrict Leonardo's drawings to those executed in his habitual style. To do so involved saying goodbye to this immensely elongated Leonardo—who began drawing on parchment in the manner of the early fifteenth century and ended painting in oils in the manner of a seventeenth-century Flemish admirer of Caravaggio—or at least chopping off a section of this abnormally long-lived artist. The whole process of groping and deliberation took twenty years, and at the end of it the modern, encyclopedic artist, the genius of naturalist observation, was born.[4] Reiset and Both de Tauzia went back to the documents, to the early accounts of Pisanello, and found that he had been praised for painting precisely the subjects for which the Louvre had the sketches—these boars, deer, dogs, leopards, these wonderful horses, these birds. And so they passed through disappointment to a sense that these drawings were among the museum's great treasures. Today it is said that the scholars who wish to examine the Pisanellos may do so once—but only once in the whole of their lives. All the more reason, then, to profit from the current exhibition, either at the Louvre or in Verona.

Or both.

2

The taste for Pisanello's work, although quickly established once the oeuvre had been assembled, perhaps lagged a little behind the admiration for his Tuscan equivalents. Berenson wrote his essay on the Northern Italian School in 1907. He is full of praise, but what he singles out for censure is often something we would rather admire. Here he is on Pisanello's predecessor, Altichiero: "Altichiero reduces the Crucifixion to something not far removed from a market scene, and the spectator is in danger of forgetting the Figure on the Cross by having his attention drawn to a dog lapping water from a ditch, a handsome matron leading a willful child, or an old woman wiping her nose."[5] But we are children of Auden—we find truth in that dog, that willful child, and our curiosity is immediately aroused by the old woman wiping her nose (disappointingly, I don't think that *is* what she is doing, but if it were, we would think it fine).

Berenson thought Pisanello unsurpassed in his rendering of single objects: "He painted birds as only the Japanese have painted them, and his dogs and hounds and stags have not been surpassed by the van Eycks themselves." But Berenson had a criterion, which he states and applies boldly: "The human figure must furnish the principal material out of which the graphic and plastic arts are constructed. Every other visible thing should be subordinated to man and submitted to his standards." The art of Pisanello and the early Flemings, says Berenson, was "too naive."

In their delight in nature they were like children who, on making the first spring excursion into the neighbouring meadow and wood, pluck all the wild flowers, trap all the birds, hug all the trees, and make friends with all the gay-coloured creeping things in the grass. Everything is on the same plane of interest, and everything that can be carried off they bring home in triumph.[6]

Apart from the tree-hugging, this describes fairly well what we admire in Pisanello. Everything is on the same plane of interest, in the sense that everything is subjected to enthusiastic analysis. There is a drawing of what must be a flayed greyhound (cat. number 246). One could attempt to rescue Berenson's criterion by saying that man is the measure

in this drawing in the sense that man is the inquiring spirit that found the dead dog, skinned it, and drew it.

But Berenson would never wish to be rescued from his teleology. Pisanello, he says, "draws more accurately, he paints more delightfully," than Masaccio, Uccello, or Fra Angelico, but they are the greater artists because they are "the forerunners of the new movement, the begetters of artists as great as themselves, or even greater," while Pisanello "remains essentially medieval, a little master, and his art dies with him."

And Huizinga seems to agree with Berenson in *The Autumn of the Middle Ages*—he is not actually talking about Pisanello, but he could well have had him in mind when he argues against the tendency to identify Renaissance elements in the art of Claus Sluter and the brothers van Eyck:

If certain historians of art have discovered Renaissance elements in it, it is because they have confounded, very wrongly, realism and Renaissance. Now this scrupulous realism, this aspiration to render exactly all natural details, is the characteristic feature of the spirit of the expiring Middle Ages. It is the same tendency which we encountered in all the fields of the thought of the epoch, a sign of decline and not of rejuvenation. The triumph of the Renaissance was to consist in replacing this meticulous realism by breadth and simplicity.

In other words, when Pisanello sets a dead wolf in front of himself, and arranges its limbs as if to show it running, but proceeds to draw it with such scrupulous realism that we can tell that what we are looking at is in fact a dead wolf—this is a sort of inquiry typical of the declining Middle Ages. But when Michelangelo dissects a human corpse, something else is going on. When Pisanello goes to the city gate, sits down, and draws a group of hanged men, from which we may learn what happens to the hanged body in progressive states of decay, this is an artistic endeavor that will "die with him." But when, half a century later, Leonardo goes down to the Bargello to sketch the hanged Pazzi conspirator—that's the Renaissance.

I don't get it. I don't see the force of the distinction. But still, to read *The Autumn of the Middle Ages* when your head is full of images from the Paris exhibition is to see Pisanello illuminated again and again, but

by intermittent flashes. The savage splendor, the "barbarity" of the northern courts evoked by Huizinga, the world of chivalry, of jousts and tournaments and heraldry, of war deemed beautiful, the world of Arthurian fantasy shaping actual bloody events—this, too, is Pisanello's world. Giovanni Paccagnini, in his monograph, quotes a letter from Lodovico Gonzaga to his wife in 1453, in which he describes a battle against his own brother:

Yesterday morning the enemy came, in fine battle array, to the country between Valeggio and here; having received word that they had come to do battle, we resolved together with Messer Tiberto that it was time to act, so we mounted our horses and set off towards them. When we reached them, although they had the great advantage over us of being on top of a hill, we fought with them with the grace of God, of Our Lady and St. George. The battle was fought closely and bitterly for about two hours, and many men and horses were slain on both sides. It was one of the most beautiful battles we have ever seen, and we watched it from a fine vantage point, for there were neither trees nor rocks in the way . . .[7]

Huizinga has a section on the savagery of the vows made by the nobility in the Middle Ages. Paccagnini's book describes the discovery, in the late 1960s, of Pisanello's Mantua frescoes, which tell a story from the prose *Lancelot* in which the knights make vows such as: "In this month I shall fight no knight without beheading him. I shall send you the heads of those I defeat."[8]

In an essay in the Paris catalog, Michel Pastoureau lays emphasis on the Arthurian culture within which Pisanello worked, and reminds us that it is false to take the Medicean court in Florence as the model for our idea of court life in the Renaissance throughout Italy. The Arthurian legends were the basis for the games the courts played in Milan, Verona, Mantua, Ferrara, Rimini, Urbino, and Naples. But it is wrong to posit, on the one hand, a late medieval court culture, backward-looking and chivalric and Arthurian; and, on the other hand, a forward-looking, modern, neoplatonist, humanist-inspired court. Pastoureau says that, in the middle of the fifteenth century, in all of princely Italy, the figure of Lancelot is certainly no less actual, no less influential, than that of Plato.

One cannot disentangle the Gothic from the classicizing culture.

There were not two sets of artists—the ones who hadn't yet heard the bad news, and who looked to the North, and the others who had tuned in to the Renaissance, and who looked to classical antiquity. This is another point that takes us back to Huizinga:

The image of antiquity was not yet disentangled from that of the Round Table. In his poem *Le Cuer d'amours espris* King René depicts the tombs of Lancelot and Arthur side by side with those of Caesar, Hercules and Troilus, each adorned with its coat of arms. A coincidence in terminology helped trace the origins of chivalry to Roman antiquity. How would it have been possible to realise that the word *miles* in Roman writings did not mean what it did in medieval Latin, that is to say, "knight," or that a Roman *eques* was not the same as a feudal knight?

In common with Pastoureau, the writers who show the greatest affinity for Pisanello's work are those who have had, in some way, to drop the old terminology or to look at it afresh. Michael Baxandall is like that, both in *Giotto and the Orators* and in *Painting and Experience in Fifteenth Century Italy*. He pays attention to the classicizing way the humanists wrote about the act of painting, the way they understood what it had been in antiquity, and what they praised in their contemporaries. So a passage from Aristotle, much elaborated on by the humanists, becomes for Baxandall an appropriate introduction to the art of Pisanello: "Things which in themselves we view with distress, we yet enjoy contemplating if they are represented with great accuracy—the forms of the basest creatures, for example, and even of dead bodies." This becomes a way of looking at the celebrated British Museum drawing of the hanged men, and the fresco in Verona in which the study is used. A city gate is depicted. It is characteristic of city gates that you find hanged men beside them. So the artist gives pleasure by depicting this distressing sight.

(Not that it was always distressing. Donne has a passage in a sermon in which he records the relief one would feel on arriving at a gibbet:

As he that travails weary, and late towards a great City, is glad when he comes to a place of execution, because he knows that is neer the town: so when thou comest to the gate of death, be glad of that, for it is but one step from that to thy *Jerusalem*.)[9]

Baxandall quotes passages such as the following from the Byzantine humanist Manuel Chrysoloras, which seem to capture the excitement of Pisanello perfectly.

And it has often occurred to me to wonder about this: how it is that when we see an ordinary living horse or dog or lion we are not moved to admiration, do not take them for something so very beautiful or reckon seeing them as something of very much importance. The same is true of trees, fish, and fowl, and also of human beings, a fair number of whom indeed we actively dislike. Yet when we see a representation of a horse, or ox, plant, bird, human being, or even, if you like, of a fly, worm, mosquito, or other such disagreeable things, we are much impressed and, when we see their representations, make much of them.[10]

And Baxandall says that "it is one of the most disconcerting facts of Quattrocento art history that more praise was addressed to Pisanello than to any artist of the first half of the century; in this sense—and it seems a reasonably substantial one—Pisanello, not Masaccio, is the 'humanist' artist." What was praised was the variety of Pisanello's realism. Here is a passage from a poem by Guarino da Verona:

You equal Nature's works, whether you are depicting birds or beasts, perilous straits and calm seas; we would swear we saw the spray gleaming and heard the breakers roar. I put out a hand to wipe the sweat from the brow of the labouring peasant; we seem to hear the whinny of a war horse and tremble at the blare of trumpets. When you paint a nocturnal scene you make the night-birds flit about and not one of the birds of the day is to be seen . . .[11]

Among the things Bartolomeo Fazio singled out for praise in Pisanello's lost fresco in the Doges' Palace in Venice depicting Barbarossa with his son as suppliant was a scene in which a priest distorted his face with his fingers, to amuse some boys: "this, done so agreeably as to arouse good humour in those who look at it." It was details like that—exactly the kind of thing Berenson objected to in Altichiero—which appealed to the Neapolitan humanists of the mid-fifteenth century. Fazio's *De Viris Illustribus* praises four painters—Gentile da Fabriano, Jan van Eyck, Pisanello, and Rogier van der Weyden—and three sculptors—Ghiberti, his son, and Donatello. This is, as it were, what great art looked like in 1456. This is one humanist canon.

Both in critical estimation and in purely historical understanding, Pisanello has had a bumpy recent ride. It was only in 1908 that it was discovered that his first name was Antonio and not Vittore. His date of birth has still not been established; the Paris catalog is so austere as not even to speculate on it. The first reference is a document dated 1395, which is why there is a sort of sixth centenary to mark. A catalog of his drawings published in 1966 was rendered swiftly out of date by the dramatic discovery of the Mantuan frescoes for the Ducal Palace. It had anyway been severely restrictive as to what it assigned to the artist himself, and what to his school.

The Paris catalog and exhibition take a much broader view of the autograph oeuvre. One has to suppose, though, that Pisanello is not in a stable state—he may expand again, or contract again, as dramatically as he has done in the last century or so. And this, in a way, is part of the excitement. He is something of a newcomer, something of a disruptive influence, something of an exception to the old categories and rules.

Even the medals, by which he has been principally known for so long, have their unsolved problems. What do they mean, these blindfolded cats, these nude men with their enormous flower baskets held aloft, these faces of triple visage? And what put it into Pisanello's head to make these things in the first place? In their scale and design they are practically without precedent. Scholars have considered models as widely divergent as Etruscan mirror-backs, the circular designs on Roman lamps, and the motifs of medieval seals. They have even asked whether Pisanello actually would have made these medals, rather than merely providing the drawings—what the division of labor would have been between designer, sculptor, and founder.[12] Certainly he is praised by his contemporaries as a sculptor (do other kinds of relief, or free-standing works by his hand, languish under false attributions, as all those drawings and paintings did?) and signs himself as a painter. The prominence of those signatures, on something not so different from a coin, something made to the glory of a ruler, would never have been tolerated by other rulers, in other places, in other times. That speaks a lot for his status in those days, and for the willingness of his patrons to bask in some of his reflected glory.

Verrocchio: The New Cicerone

I

Not long ago, a terracotta bust of a woman passed through the London auction rooms, leaving a little puzzlement and worry in its wake. Once, in its glory days, as a work of Andrea del Verrocchio, it had graced the collection of J. Pierpont Morgan. That interesting scholar W. R. Valentiner, who earlier this century was lured from Berlin to the Metropolitan Museum in New York (his career forms a link between Bode's Berlin and, via Detroit, the Getty Museum in Malibu), compared the profile of the bust with a drawing by Leonardo in Windsor Castle. He thought that the master (Verrocchio) and his most famous pupil (Leonardo) might have used the same model.[1] But other voices were raised to denounce the work as a fake. Or, if not a fake, as a portrait of a nineteenth-century sitter in Renaissance costume. This low opinion prevailed over Valentiner's, and the bust was disgraced, deaccessioned, without chance of reprieve.

But that was not the end of the story, for the auction room catalog announced that the bust had recently been subjected to a thermoluminescence test, which proved that it had last been fired in or around the fifteenth century. Whatever it was, there was no reason to call it a fake. And if it was not a fake, perhaps Valentiner's opinion might merit further consideration. For, when it came to Verrocchio scholarship, Valentiner was not nobody. In 1933 he was able to show that a candelabrum in the Schlossmuseum in Berlin was a documented work of Verrocchio. This is now one of the treasures of the Rijksmuseum.[2]

★

There are not many known surviving works by Verrocchio. Andrew Butterfield's new book, *The Sculptures of Andrea del Verrochio*, lists thirty, of which four are uncertain and others seem more the work of the studio than of the master. That makes Verrocchio as rare as Vermeer, but with this exciting difference: Verrocchios—real ones—have turned up, both through inspired acts of reattribution and as objects previously unknown to scholarship. What is more, it is quite certain that there are others waiting to be found. In the 1980s, a terracotta *modello* for the figure of the executioner of John the Baptist turned up on the London antiques market. But other sketch models for the same relief scene were once known. If the heirs of Baron Adolphe Rothschild would just investigate their cupboards a little more carefully, they might yet find them.

One might think that with so many art historians crawling over every inch of its surface there would be nothing left to discover in Florence. But Butterfield, if he is right, has found a Verrocchio in the Bargello itself. And meanwhile a curator of that museum, Beatrice Paolozzi Strozzi, has made a particularly fascinating discovery. Taking a second look at an unprepossessing crucifix, which had already been logged as nothing in particular, she decided to have it cleaned. What emerged from beneath centuries of filth was the original polychromy of a Verrocchio Christ. This discovery was published in 1994.[3]

If an item such as a crucifix has spent all its life in a church, and has been considered as a liturgical object rather than a work of art, the chances are that it will have built up a surface consisting of alternate layers of candle soot and repaint. Nobody ever thought of stripping it, only of touching it up. But if a dealer, a collector, or (in some cases worst of all) a museum has been involved, then the likelihood is that at some point in its career the object will have been stripped of what was considered inauthentic polychromy. A terracotta will have been soaked in solvent, scrubbed with steel wool, "taken back" to a "pure" original state. And if this state was found to be aesthetically unsatisfactory (supposing the object turned out to be incomplete or cracked or broken), then the restorer will have made up the deficiencies and covered his work with a layer of a substance much resembling an item which used to appear on British menus—Brown Windsor Soup. This soupy, lustrous, gravy finish was at the height of its popularity around the turn of the century, in the heyday of J. Pierpont Morgan's collecting.

In the fifteenth century, a terracotta bust—say, a portrait produced for a domestic setting—would, after firing, have had any kiln cracks or other deficiencies made good. It would then have been coated with a thin layer of gesso before being painted, and perhaps partially gilded. Even marble sculptures were sometimes painted and gilded, and there is a beautiful surviving example of this technique in the recently opened gallery that the Metropolitan Museum has devoted to the sculpture of this period. The world of the Florentine plastic arts was not entirely composed of monochrome effects in marble, terracotta, and bronze. Sculptures were glazed and fired. They were painted and gilded. They were produced by means which other ages would have abhorred—portrait busts being made from death masks, for instance—and in such "unclassical" materials as papier-mâché or wax or plaster. There were works in mixed media. Verrocchio's crucifix is one such: parts of it are built up with pieces of cork; the loincloth or perizonium is made of fabric dipped in plaster. An object of this kind, placed in a damp cellar, will soon disintegrate. A flood would be fatal to it. That is one reason why so little of this kind of work has survived. But another reason is that the history of taste turned so decisively against it.

The Pierpont Morgan bust was intriguing because it was known that the Brown Windsor surface concealed a fifteenth-century ceramic core. But nobody knew what else it concealed. Were there the remains of some wonderful polychromy, or was it a horrible botch-up? Why had it once been so admired as a Verrocchio, then so detested as a fake? During the days of its display people turned it over and shone torches in its eyes, frowned at it, made notes on its condition, and, after all this attention, bits of brown surface flaked off—as if the curious had picked at the scab. One felt sorry for it, in this protracted humiliation. And then it sold . . . but for a modest sum. One way or another it had failed to convince.

But who knows what it will look like on its next public appearance? Who knows what the next episode of its critical fortune will be?

2

Verrocchio's own critical fortune had to endure two and a half centuries of silence, during which we have to assume that a great deal of his work either disintegrated or was deliberately destroyed. It was only in the nineteenth century that he returned to the prominent position he had once occupied. Born in the 1430s, he died in 1488, the greatest sculptor in the Florentine tradition between Donatello and Michelangelo. And to be one of the greatest artists in that tradition, in the eyes of the nineteenth century, was like being one of the greatest artists in Periclean Athens.

Here is Ruskin in 1853, evoking the early Renaissance:

For the first time since the destruction of Rome, the world had seen, in the work of the greatest artists of the fifteenth century,—in the painting of Ghirlandaio, Masaccio, Francia, Perugino, Pinturrichio, and Bellini; in the sculpture of Mino da Fiesole, of Ghiberti, and Verrocchio,—a perfection of execution and fullness of knowledge which cast all previous art into the shade, and which, being in the work of those men united with all that was great of former days, did indeed justify the utmost enthusiasm with which their efforts were, or could be, regarded.

And Ruskin goes on to say, of what he calls "cinque-cento work":

When it has been done by a truly great man, whose life and strength could not be oppressed, and who turned to good account the whole science of his day, nothing is more exquisite. I do not believe, for instance, that there is a more glorious work of sculpture existing in the whole world than that equestrian statue of Bartolomeo Colleoni, by Verrocchio.[4]

It was praise like this that sent generations of tourists to the Campo de SS. Giovanni e Paolo in Venice to gaze up at the features of Verrocchio's stern *condottiere* there. And it was praise like this that inspired dealers, collectors, and museum directors to seek out and acquire such works as they could. Meanwhile it was the job of scholars in the first part of this century to denounce and eliminate the numerous fakes and mistakes that had found their way into the corpus. They wanted a leaner Verrocchio, incapable of inferior work. In a way, such

decisions must always have an element of the arbitrary. The connoisseur sets his own standard for what is to be tolerated as an autograph work. He conducts his own calibration. Butterfield sets the standard high, perhaps severely so. But the quality of reasoning, the depth of documentation, and above all the knowledge and sense of cultural context make this monograph quite different from anything else ever written about its subject. This is less of a compliment than it sounds, because the literature on Verrocchio is curiously thin. But to put the matter plainly, this is a book with no rivals.

Verrocchio was born into the artisan class of Florence: his father was a *fornaciaio* (which means that he worked with a kiln) and a member of the stoneworkers' guild. Later he became a customs agent. Verrocchio could have received some instruction from him in the working of stone and clay. Vasari, whose high opinion of Verrocchio is tempered by the observation that his manner was "somewhat hard and crude" and the product of infinite study, calls him "a goldsmith, a master of perspective, a sculptor, a woodcarver, a painter, and a musician." Of his goldsmith's work, he mentions buttons for copes and "particularly a cup, full of animals, foliage, and other bizarre fancies, which is known to all goldsmiths, and casts are taken of it." He made a copper ball to go on the cupola of the Duomo (it was later destroyed). Butterfield says that "Renaissance artists who trained initially as goldsmiths often later became painters, architects, and bronze sculptors, but almost never achieved distinction in carving marble" and that Verrocchio is one of the few exceptions to this rule. What survives of his sculptural work shows us the full range of activity for an artist of his day—with one exception, that of the free-standing figure or group in stone. In the following *cicerone*, based on Butterfield's work and my own recent travels, I have tried (not wholly successfully, as will appear) to consider each object in the new canon, in situ.

3

Washington

That the founders of the great American collections were initially pessimistic about their ability to acquire major works of European art may strike one as quaint, considering what was in the end achieved. But in the case of sculpture, by which they meant preeminently Italian Renaissance sculpture, that pessimism was not far wrong. Consider what eluded them. No sculpture by Michelangelo or Ghiberti was acquired. One major Donatello, the luminous marble relief of the Madonna of the Clouds, entered the Boston Museum of Fine Arts. Also in Boston one major bronze by Cellini, the wonderful bust of Bindo Altoviti, came to the Isabella Stewart Gardner Museum. There are minor works attributed to both of the latter artists in American collections: but in this context the word rare means rare.

Washington's National Gallery once had half a dozen Verrocchios. Of these, three find their way into Butterfield's book, two of them as doubtful and the other as possibly made in the master's shop. This last (cat. no. 25) is the marble relief of a warrior, known as Alexander the Great. It is a classic Renaissance image, not least because, as an image, it seems to be the twin of a famous profile drawing of a warrior by Leonardo. Verrocchio made two bronze reliefs of Alexander and Darius for Lorenzo the Magnificent to give to the King of Hungary, Matthias Corvinus. They are now lost. In the Washington marble, and in the Leonardo drawing, we feel very close to what these reliefs must have been like. The word fantastic, applied to the armor in this and related images (the conch-like helmets, the dragon and bat wing designs, the medusa heads), seems appropriate. Vasari says that Verrocchio designed the armor for the reliefs *"a suo capriccio."* Unlike most architectural caprices, Italian armor of a ceremonial kind falls not far short of Verrocchio's and Leonardo's wild imaginings.

It is good to begin a journey into Verrocchio in front of this marble relief, because it gives an opportunity to say goodbye to the problem of the relationship between Leonardo and his master. Butterfield refuses to get bogged down in this issue, which is rather like the question of

the dedicatee of Shakespeare's sonnets, in that it can drive a person unproductively mad. A tendency in the past was to find something good in the Verrocchio *oeuvre* and to attribute it, therefore, to Leonardo. Leonardo was certainly a sculptor, but the best way to go batty is to start looking for a sculpture by him.

Of the "uncertain" candidates, the bust of Giuliano de' Medici (cat. no. 29) is apparently much restored and altered. It is a highly desirable trophy sculpture, sold by the Duveen brothers to Andrew Mellon. It is a perfect example of the Pierpont Morgan taste. More extraordinary is the *putto* (cat. no. 39) in unfired clay. Unfired clay! How could such an object have survived half a millennium, and why would it have been left unfired? The only reason I can see is that one would hesitate to fire a clay model (in case it exploded) before one had copied it into whatever medium one had chosen. The longer you leave a model to dry, the less likely it is to explode. But if you happen to die before making your copy of the model, then of course it is up to your heirs whether they send it to the kiln or not.

Butterfield cites a document which indicates that in the sixteenth century copies after fifteenth-century Florentine works were made in unfired clay, but he does not speculate about the reason for this practice. Whatever the *putto* is, and however you rate its modeling, it is astonishing that it has survived.

New York

Henry Clay Frick never owned a Verrocchio, but John D. Rockefeller did, and in 1961 he bequeathed it to the Frick (cat. no. 4), whose collection, in its perfectionism, suits it especially well. It is a marble bust of a young woman. There is a delicate problem relating to the sitter's identity. Butterfield writes:

It has often been said that she is a member of the Colleoni family, perhaps even Medea, the beloved daughter of Bartolomeo Colleoni. This hypothesis is based solely on the premise that the pattern on the brocade of her sleeves includes testicles (*coglioni*), but the testicles in Colleoni's heraldry have a distinctive shape (similar to an inverted comma) and clearly differ from the forms in the brocade. Consequently, this hypothesis is incorrect . . .

And in the catalog section of his monograph Butterfield repeats that "No known stemma of the Colleoni family has testicles in the form used in the heraldry of the present sculpture." The layman is bound to feel provoked into replying, in the face of all this testicular certainty, that if the girl is wearing testicles on her sleeve (correct or incorrect), she must be trying to say something thereby. I assume, although Butterfield does not say so, that these brocade sleeves, with their decorative surfaces, could well have been colored and gilded.

The last of the American Verrocchios is in private hands, in the collection of Michael Hall, Esq. It is a bust of Christ (cat. no. 9), made apparently by a hybrid method, in which the clay is pressed against the sides of the mold, but the surface is later worked by the artist before firing. I have not seen it. It was Verrocchio's achievement to create an image of Christ which proved extraordinarily influential and tenacious. The features are based on an apocryphal description attributed to Publius Lentulus, a Roman administrator of Palestine. The shoulder-length hair, the middle parting, the large nose, and the short divided beard all derive from this description, to which Verrocchio added high cheek-bones and heavy eyelids. Once Verrocchio had developed this facial type, he seems to have stuck to it and to have promoted it in studio copies, of which around a hundred survive (indicating that perhaps thousands were once made). But this particular example seems to Butterfield to show the master's intervention. And it does not show the intervention of the restorer, being both painted and gilded.

London

In London there are no finished objects by Verrocchio on view, only sketch-models—each one unique, and each illustrating a different aspect of a sculptor's working practice. The first (cat. no. 24) is a plaster cast of a terracotta sketch which used to be the pride of the Kaiser-Friedrich Museum in Berlin, but which was destroyed in the Second World War. Or perhaps it was not destroyed. Perhaps it is even now in Uzbekistan. It represented the Entombment, and it was only ever known, in modern times, in a fragmentary condition. Perhaps it was always unstable or incomplete, one of those accidents of the kiln. The top half of the

composition has come away—as if in great flakes. Two features of the relief would have convinced the early scholars of its authenticity—the type of features of Christ, and the beautiful elaboration of the folds of the garments. Verrocchio made intense studies of anatomy (and that generally means, in this period, the male anatomy), the results of which can be seen in the figure of the dead Christ. And he was obsessed with the expressive qualities of drapery, which he explored both in sketches such as this and in his drawings on linen.

Sometimes the bare notes on the provenance of an object are full of resonance for the history of our culture, and the career of this object tells us a poignant tale. It was bought in Florence by an Austrian collector in 1865. It was purchased in Vienna by Wilhelm von Bode in 1888 and published soon after. I was told that it was placed for safety in some kind of artillery base during the attack on Berlin, and that this precaution ensured its destruction. Its survival in London as a plaster cast tells us what an exemplary object it was held to be.

The collections of the Victoria and Albert were inspired by an interest in the manufacturing process. That is why there are so many terracottas, and why an object such as the sketch-model for a memorial to Cardinal Forteguerri (cat. no. 22) would have been acquired. It has not always been much liked, and sometimes has been denounced as a fake. One would have to imagine a forger interested in re-creating an artist's original design for a monument later built (in Pistoia) in quite a different way. Perhaps the reason people had their doubts was that if Verrocchio had lived to finish the monument in the way indicated by this sketch, it would have been a design without precedent, a dramatic scene in which a vision of Christ and the angels appears to the cardinal, in a manner prefiguring the Baroque.

Last in London is an object in a private collection we may not see, the terracotta *modello* for the executioner in *The Beheading of St. John the Baptist* (cat. no. 17). It emerged on the market in the eighties, failed to sell, and has since been (like an actor) "resting." This object is somehow connected with the silver relief made for the altar of the Florence Baptistry, but in contrast to Anthony Radcliffe, who first published it, Butterfield leaves some doubt as to what that relationship is.[5] The object looks like a sketch-model. A *garzone*, a studio assistant,

poses for the figure. He is nude, and in his right hand he holds a cloth (where the sword will go in the relief itself). Butterfield unfortunately does not illustrate the illuminating side view of this terracotta, which shows how Verrocchio conceived the figure in such a way as to fit onto the sloping plane of the relief. It is fascinating to see the sculptor solving a technical problem of this kind at the same time as he is making his sketch. But where Radcliffe was quite clear what happened next (a piece-mold would have been taken, from which the figures could be cast), Butterfield introduces a major doubt. He tells us that the other figures in the relief (all of them made separately and then attached to the perspectival base) were not cast, as is often said, but *repoussé*, that is, beaten. About the figure of the executioner, he cannot be sure. But it seems extraordinary that a fundamental issue like this (the nature of the manufacture of an object) should still be in the balance.

Amsterdam

Telephone in advance to the Rijksmuseum. Not long ago, a Japanese visitor (who has probably since died of mortification) backed into Verrocchio's 156-centimeter tall candelabrum (cat. no. 10) and knocked it over, damaging the rim. It is currently being restored. It was made for the chapel of the audience room of the Palazzo Vecchio, and bears a prominent inscription, "May and June 1468." One document says that Verrocchio designed it in the form of a certain vase, but neither a vase nor a similar classical candlestick has been found. A sculptor's job, if he had the skill to work in bronze, included the task of making bells, mortars, firedogs, cannon perhaps: any of the objects for which the same casting technique might be used. That is why, looking at objects such as this candelabrum, it is not entirely helpful to have a mind that makes a distinction between sculpture and the decorative arts.

This was an important commission, and a solemn object. The date refers to the two-month term of the Signoria, the chief magistrates. Butterfield tells us that during those two months there was only one important event, the signing of a peace treaty that brought to an end the Colleoni War in which Florence, Milan, and Naples fought against

Venice and its *condottieri*. For Florence, the significant outcome of the war was the defeat of a group of Florentine exiles, and the consequent consolidation of the power of the Medici. Presumably for the *gonfaloniere* who inspired the commission and set the fee, the simple dates alone would signify to all who saw them the defeat of conspiracy and the evolving destiny of the ruling family. The sculptor appears, then, as the agent of Medici propaganda—an aspect of his work which Butterfield's study brings very much to life.

Paris

There are two little terracotta plaques of angels (cat. no. 23) in the Louvre. Many experts say that they must be by different hands. I wish I could see this difference. When the plaques were restored in 1959, they were found to be of irregular shape and to have had pairs of holes drilled in them—to hang them up in the shop, no doubt. They were working ideas (although brought to a wonderful finish: they are among the loveliest terracottas of their century) and were very probably produced during the work on the Forteguerri monument, although the label in the Louvre says that this is not so. Butterfield says that the one on the left is by Verrocchio, but that the one on the right should be attributed to an anonymous member of the workshop, being too weak to be by Leonardo, as one scholar had hoped.

The assumption here is that Leonardo was a very good sculptor indeed. No doubt he was, but there is no comparative work by him to go on.

Berlin

The German capital has one Verrocchio left, a terracotta statuette of a sleeping youth in the Staatliches Museum (cat. no. 12). It has periodically been offered a title—this is Adam, this is Abel, this is Endymion. But it seems wrong to seek a nude sleeper as a subject. Just as he did with the executioner, Verrocchio could have been studying in the nude a figure who would later be clad. That is why it is not far-fetched to suppose

that this might be a study for a sleeping soldier in a Resurrection—even if it does not conform to the Resurrection relief Verrocchio actually produced (see p. 65). Some terracottas from this period survived because they proved useful in churches or chapels. The fact that this one survived indicates that there were collectors who were happy to give it house room, since it would never have fitted in a church.[6] Giving it a title such as *Endymion* suggests that it was the practice of sculptors to make such statuettes, for art's sake, for a domestic setting. But it is by no means certain that this was yet the case. It is so easy to forget that our idea of early Florentine interiors is formed by clever turn-of-the-century reconstructions—the Horne Museum, the Bardini, the Palazzo Davanzati. In such a setting, it would seem quite natural to take a statuette such as this one and place it on a table, on a piece of plausible brocade. But that might well be an anachronism, startling to Verrocchio's generation, although less so to the one that followed.

Venice

"When it has been done by a truly great man, whose life and strength could not be oppressed . . ." But the Equestrian Monument to Bartolomeo Colleoni (cat. no. 26) proved the death of Verrocchio, according to Vasari (he died of a cold caught during the casting). What is more, in Butterfield's estimation, rather more of the statue can be attributed to Alessandro Leopardi than has always been recognized. Leopardi signed the monument prominently, in what I had always assumed to be an act of outrageous appropriation. But if Butterfield is right, Leopardi did all the casting and would have prepared the wax casting models. Though most of the horse is by Verrocchio, the tail is by Leopardi. Though the pose and conception of the figure is Verrocchio's, the decorative surface of the armor and saddle and the finish of the head itself are, Butterfield thinks, in the Venetian rather than Florentine idiom.

Butterfield is more disparaging about the face than one might expect—it is after all one of the most famous faces in statuary. It was modeled on that of the emperor Galba, but is given an expressiveness that surely links it to the aesthetic Verrocchio shared with Leonardo.

Butterfield tells us that the word for *condottiere* in the Latin texts of the time is *imperator*—the same as the word for emperor, and the *condottieri* were considered the equals of the great Roman generals and emperors— a level of esteem that vanishes in modern English if we translate *condottiere* as mercenary captain. The popularity of the Colleoni monument with the Victorians (the head can be examined at close quarters in plaster cast at the V & A) no doubt has something to do with that whiff of villainy emanating from the features. A *condottiere* could and would change sides—an act no Victorian soldier could begin to contemplate for himself, but might enjoy imagining in the past, that villainous Italian past which flashes from the pages of Ruskin and Browning.

But the Colleoni statue is not a monument to villainy. It is one of a series of equestrian monuments, painted, in stone and (in the most closely comparable, Donatello's *Gattamelata* in Padua) bronze, which were epideictic in character. They were exhortations to virtue, examples for the citizenry to follow. Colleoni had wanted his statue erected in St. Mark's Square, but the Venetians had a general ban on monuments to individuals either inside St. Mark's or in the piazza. The idea that they circumvented the terms of the will (a piece of Venetian villainy) by placing it in front of the Scuola di San Marco (in the Campo SS. Giovanni e Paolo) seems undermined by Butterfield's observation that the Dominican Convent served, during the Renaissance, as the Pantheon of the Venetian Republic. By the time of the Colleoni monument, fourteen doges were buried there. Though it now seems a little off the beaten track, in its day the site would have been one of immense prestige.

Pistoia

Bad lighting and the long lunch hours of the sacristan (12 to 4), plus the fact that it was never finished by Verrocchio but was later cobbled together in an inappropriate baroque framework—all this has led to the neglect of the Forteguerri monument in the church of San Zeno (cat. no. 21). But the photographs in Butterfield show it off admirably, and we have already seen in the terracotta models in London and Paris what the ensemble was supposed to look like and how its component

parts were developed. It has no forebears in funerary sculpture, and Butterfield suggests that Verrocchio enjoyed a certain freedom partly because he was making a cenotaph rather than a tomb, and partly because Pistoia was provincial, and smaller cities tended to be less restrictive. The cardinal was to be seen kneeling in prayer, while above his head Christ appeared in a mandorla, held aloft by angels in the ultimate swirling robes, while Faith, Hope, and Charity dance attendance on the prelate. Because the figure of Forteguerri was not satisfactorily completed, we cannot tell how far Verrocchio intended to push the drama of the scene, but it is this sense of drama in what remains that makes one think forward to the Baroque. Blame Lorenzo di Credi for not carrying out his commission to finish it.

Florence

Bells were among things a sculptor might expect to make—anything from handbells to full-size church bells, involving immense amounts of work (and investment). The lost bell Verrocchio made for a Vallombrosan foundation took four years to complete. A bell in San Marco, Florence (under restoration when I tried to see it), has been attributed to Verrocchio (cat. no. 2). It was known as La Piagnona, because it was used to call the followers of Savonarola—the *piagnoni*—to San Marco. Butterfield points out that during the Bonfires of the Vanities of 1497 and 1498, a great many works of sculpture were destroyed, particularly busts of beautiful women. So it is highly likely that this, a work of Verrocchio's, summoned the *piagnoni* to destroy works by Donatello, Verrocchio, and many other great artists of the early Renaissance. The bell did not go unpunished. In 1498 it was taken down and carted through the streets, whipped by the city's executioner, and sent into exile for ten years.

Another pointless quest at the moment is the viewing of the tomb of Fra Giuliano Verrocchio in Santa Croce (cat. no. 27). The theory is that Verrocchio, who was born Andrea di Michele Cione, might have made the tomb of this friar, and for some reason (such as that the tomb had made him famous) taken the man's name. Like most floor slabs of the period, the tomb has taken much wear and tear. But still there are

optimists who say that the bony feet are bony like other Verrocchio feet. Unfortunately the bony feet are currently buried under planks and scaffolding.

One of the loveliest and most popular works of the Florentine Renaissance is the bronze statuette of the *putto* with a dolphin in the Palazzo Vecchio (cat. no. 20). This was brought in from a villa to the courtyard of the palazzo, where it was installed by Vasari on a fountain. Like so many Florentine sculptures which used to be in the open, it was later taken indoors and now sits in a small room upstairs in the Palazzo Vecchio, a room so small that one is unable to walk around it. And this is a particular shame in that rather empty set of rooms, because the statue in question is the first *figura serpentinata* of the Renaissance. That is to say, its turning form was designed to make it a perfect composition from all points of view. Butterfield rejects the idea that it once had a mechanism that caused it to revolve, and this seems a pity, although he is no doubt correct.

Less and less of the art of Florence is allowed to remain where it used to be. The silver altar from the Baptistry sits in the Museo del Opera del Duomo, almost unrevered, and one can examine it at leisure. Verrocchio's panel (cat. no. 16) tells a story not from the Bible but from a fourteenth-century life of John the Baptist:

The officer went to the prison and with him an extremely base youth with a very sharp sword . . . and crying he said: "Servant of God, forgive me for the injustice that I must do, and pray to God for me telling him that I do this unwillingly." And Saint John kneeled down with a cheerful face and said: "Brother, pray to God that he forgive you, and I will forgive you as much as I can . . ." And he stretched out his neck, that gentle lamb, and his head was cut off. And all the prisoners and all the guards began to cry with the loudest wails, and they began to curse the girl and her mother, for they heard how she had asked for [his head].

The "extremely base youth" is the figure for which the terracotta was found in London. The reluctant officer, resplendent in his fantastic armor, places his hand on his chest in a gesture which Butterfield tells us elsewhere always indicates intense emotion. His model, and that of the youth with the salver who raises a hand in a gesture of compassion, are the ones that used to belong to Baron Adolphe Rothschild, which

the family refused to have photographed, and which have been apparently lost.

The Orsanmichele, half church, half grainstore, is having all its original statuary (including works by Ghiberti, Donatello, Verrocchio, and Giambologna) removed from the niches on its façade to a room above church level. Christ and Saint Thomas (cat. no. 8) were cleaned and restored as part of this process and are already upstairs. Those who saw the group when it was exhibited at the Met in 1993 will know that the figures are reliefs rather than statues in the round, but they were so constructed as to make this impossible to guess, even though they boldly overflow their allotted space.

Cast bronze emerges from the mold with a rough surface—the bell of San Marco, could we see it, is what Verrocchio looks like unchased: i.e., with the surface rough as it would emerge from the mold. The restored figures of Christ and Saint Thomas set the standard, show us what the very best Renaissance bronze came to look like when its surface was laboriously smoothed by the chaser's art. Where the right foot of Saint Thomas has protruded from the niche, that luxurious surface is lost to verdigris. But for the most part the chocolate richness of the bronze has been reinstated, the gilding rediscovered, and the folds flow luxuriously. The statue of Colleoni, even if restored (which it has not been in this century), will never come back with this intensity.

One enters the Verrocchio room of the Bargello to be greeted by a sight seldom seen today—a shaft of winter sunlight falling directly onto the painted surface of the crucified Christ (cat. no. 14). For a moment one is too dazzled to see this newfound sculpture clearly. One turns away, and one's gaze falls at once on the Careggi Resurrection, a painted terracotta relief showing the same type of face of Christ, as if offering confirmation of the genuineness of the crucifix. The relief (cat. no 11) is painted, not glazed. Much damaged, it is another example of that "non-classical" approach to using different mediums; if we were able to see the relief in the full freshness of its paint, it might yet shock.

The Resurrection scene depicted is apocryphal. Nowhere in the Bible do the soldiers actually see the resurrected Christ. But in an account called the Acts of Pilate they do, and it is a scene that found

its way into the liturgical dramas of Verrocchio's day. Butterfield quotes a stage direction from one of these:

Suddenly Christ is resurrected with earthquakes and explosions. Each of the soldiers is like a dead man and Christ appears with the pennant of the Cross between two angels.

So the scene represented in the relief is one that would have been familiar from popular drama. That connection between popular drama and the representational arts must have been intimate (there is another clear example in Donatello's relief of the Ascension), but it is easy to forget. People must have looked at such reliefs and thought: I know what this is because I have seen it performed.

Turning back to the crucifix, which is displayed at an angle to allow you to examine it from close to, but as if it were high on a wall, you see (what is not obvious from the photographs) that its mouth is open and its teeth visible. Is Christ intended to be calling out the last words from the Cross?

A third of Verrocchio's *oeuvre* is held by the Bargello, but if you take Butterfield as a guide you have a slightly different list from the one indicated by the museum labels (astonishingly enough there is no proper catalog of the Bargello's sculptures, although the minor art of plaquettes is admirably served). The bust of a lady holding flowers to her breast (cat. no. 15), which with the Frick bust belongs to that category of portraits of contemporary beauty that got chucked onto the Bonfires of the Vanities, should be an object of secular pilgrimage. This is what Florence meant by beauty. The terracotta Madonna and Child (cat. no. 13) is another exemplary work (the marble version of the same subject is relegated to the workshop).

A striking marble bust of Francesco Sassetti, labeled in the plinth as being by Antonio Rossellino, was assigned by John Pope-Hennessy to Verrocchio's early years. Butterfield follows his teacher and mentor in his view, although his reasoning has shifted. A part of Pope-Hennessy's case was that the heavily drilled irises and lightly incised pupils were characteristic of Verrocchio, and he compares them to the "penetrating glance" of the Colleoni. But that same "penetrating glance" is seen by Butterfield as typically Venetian work.

A more striking disagreement between teacher and student is over

the attribution of the little bronze known as "Il Pugilatore" (cat. no. 19) but labeled "Uomo di Paura." Is it a pugilist or a man of fear? And who is it by? The earliest attribution was to Pollaiuolo. Subsequently everybody has had a go, and it has been a Bellano, a Camelio, a Riccio, and a Sperandio, successively or simultaneously. Pope-Hennessy knew that Donatello had made small bronzes, and he thought this the best candidate for a surviving statuette by his hand. Butterfield, not unconvincingly, finds affinities with Verrocchio. But the statuette remains a puzzle. Small bronzes *are* a puzzle.

Verrocchio's David (cat. no. 5) suffered an interesting fate. The detachable head of Goliath at its feet (and in the wrong position perhaps) was separated from it during the seventeenth century, and the figure was identified first as Mars, and later as a young warrior. Only in the mid-nineteenth century did it turn back into a David, and get back its Goliath trophy. Millions of students and tourists must have gazed on this iconic work thinking it one of the eternal verities of art. But these eternal verities have a checkered history.

Few works by Verrocchio have remained in their allotted place. The monuments in Venice and Pistoia have not been moved; neither has the *lavamano*, an elaborately carved basin (cat. no. 1) to which he contributed a section, which has remained in the Old Sacristy in San Lorenzo, although the problems of its plumbing have meant that it was always being mucked around with. But two more of Verrocchio's works remain where they always were, and always were supposed to be. One is that mysterious tomb of Giovanni and Piero de' Medici of which one side looks into the old sacristy and the other onto an adjacent chapel, from whose regular offices the dead might find benefit.

The last is the tomb of Cosimo de' Medici (cat. no. 6). Ruskin said of the Doges' Palace in Venice, "It is the central building of the world." But San Lorenzo was the central building of the Medici world, and surely the central building of the Renaissance. And Cosimo's supposedly modest monument, a design of ellipses within a circle within a square, placed on the floor in front of the high altar, lies at the center of that central building—the universe in a diagram of marble, bronze, and porphyry.

Leonardo's Nephew

We can tell from a letter he wrote to his half-brother Domenico that Leonardo da Vinci never wanted a nephew. "My beloved brother," it begins:

This is sent merely to inform you that a short time ago I received a letter from you from which I learned that you have an heir, which circumstance I understand has afforded you a great deal of pleasure. Now in so far as I had judged you to be possessed of prudence I am now entirely convinced that I am as far removed from having accurate judgment as you are from prudence, seeing that you have been congratulating yourself on having created a watchful enemy, who will strive with all his energies after liberty, which can only come into being at your death.[1]

You might put this sourness down to Leonardo's illegitimacy. Remember the terse note with which he records his father's death:

On Wednesday, the ninth of July, 1504, my father, Ser Piero da Vinci, notary at the Palazzo del Podesta, died; he was eighty years old; he left ten sons and two daughters.[2]

As far as I can see, Leonardo is hereby excluding himself from the list of sons.

But illegitimacy might not be the only factor. Some artists have the desire to pass their skills on to a new generation, to sons or substitute sons; others want the line to end with them. Raphael, who had no sons, nevertheless surrounded himself with real artists younger than himself, at least half a dozen of them, who might be considered his sons. Vasari has him never leaving home surrounded by less than fifty artists. Michelangelo's assistants, on the other hand, were mostly

68

nonentities, and it seems clear that Michelangelo wanted the line to end with him, which is why he himself destroyed all the remaining cartoons for the Sistine Chapel, and all the other working drawings he had with him in Rome at the end of his life.

Leonardo was disposed to gather around himself a court of young men—"L'Accademia Leonardi Vinci," they called themselves—including the sons of noble families along with rather less reputable types. He wanted them to succeed in the arts for which he trained them, but none of them approached him in talent in the way that Giulio Romano could compare with Raphael. Perhaps he needed them for company as much as anything else. In Rome he complained that his young friends all deserted him, running off to play with the Swiss Guards among the ruins, hunting birds with slings.[3] Leonardo took the view that it was a poor pupil who did not outstrip his master, just as he, in painting, had outstripped Verrocchio. If he thought of a son as a watchful enemy, this was perhaps because he knew what sort of son he had been.

Nevertheless, life went on. People took pleasure in producing sons and heirs. Ser Piero, Leonardo's father, had twelve legitimate children by two wives, and it was the second youngest of these (not the youngest, as Vasari says), Bartolommeo, who, desiring to have a male child, "spoke very often to his wife of the greatness of the genius with which his brother Leonardo had been endowed, praying God that He should make her worthy that from her there might be born in his house another Leonardo, the first being now dead." Leonardo had been dead for a decade when Pierino was born in 1529. Three years later, an astrologer and a chiromancer looked at the forehead and hand of the boy, and predicted that "in a short time he would make extraordinary proficience in the mercurial arts, but that his life would be very short."[4]

It sounds like the beginning of a fairy story, but Vasari's life of Pierino is not a fairy story, and where it cannot be proved wrong it might be as well to extend it to a kind of cautious trust. It is certainly true that without Vasari's Life, and the evidence that comes from the remaining pages of Vasari's collection of drawings, we would know precious little about Pierino today. Even at the beginning of this century, a great expert on Italian sculpture, Wilhelm von Bode, could dismiss Pierino's

reliefs out of hand. The artist as he is known today is the product of recent decades of research, but no one has yet put that work together in a definitive way. The modern Pierino is still coming into being.[5]

Pierino's father brought his son to Florence and placed the boy, aged twelve, in the workshop of Baccio Bandinelli, "flattering himself that Baccio, having once been the friend of Leonardo, would take notice of the boy and teach him with diligence." It didn't work out, says Vasari; and at once we remember that Bandinelli was the great enemy of Vasari, and that Vasari's life of him is a devastating document, which accuses him not only of tearing up Michelangelo's *Battle of Cascina* cartoon, but also of destroying various unfinished marbles and models by the master. So we read this passage cautiously.

But we also remember that Vasari tells us that both Leonardo and Michelangelo had a high opinion of Bandinelli as a draftsman—not as a painter (he could hardly paint) but as a *disegnatore*. Bandinelli took in pupils. There is a drawing by him in the British Museum in which we can see young boys at work who may perfectly well include the young Pierino. Bandinelli's academy is supposed to have been the first art school of its tradition.

Bandinelli is often mocked as a sculptor, on the basis of his *Hercules and Cacus*, which vies for attention with the replica of Michelangelo's *David* in front of the Palazzo Vecchio. But few these days are inclined to mock the relief he executed for the choir of the Duomo, and nobody mocks the self-portrait as Nicodemus with the dead Christ, even though in this group, executed toward the end of his life, Bandinelli is pitting himself directly against Michelangelo. However detestable the character portrayed by his rivals Vasari and Cellini, Bandinelli was a wonderful draftsman. And there was something else about him which must have been impressive to the young Pierino: he had known Leonardo.

"Thus," as Marco Cianchi puts it,

we would like to imagine Pierino listening to Baccio's stories about his illustrious uncle and experimenting with sculpture, keeping in mind Leonardo's appreciation for the reliefs of Donatello; or imagine him absorbed in consulting that unique graphic legacy constituted by the drawings of Leonardo, for example of the *Battle of Anghiari*, which were probably still in circulation, or

some other invention that Bandinelli must certainly have recorded (as shown by his design for the *Angel of the Annunciation*, obviously inspired by Leonardo).[6]

One thing missing from Vasari's life of Pierino is any account of how he trained as a metalworker, but it is obvious from details in the sculptures that he had an interest in this kind of work. In 1938 Ulrich Middeldorf was able to show that a design in a collection of drawings in Cheltenham matched a candelabrum base in the British Museum.[7] This is one of several sketches for decorative work that came from the pages of Vasari's own album of drawings. Although they no doubt come from a later part of his career, it is worth mentioning here that Bandinelli's father had been a goldsmith, and Bandinelli himself trained first in that art. The Cheltenham drawings, which are now in the British Museum, appeared to Middeldorf as if Vasari had picked them up "in the corner of the sculptor's workshop, where old designs, sketches for work then being carried out and ideas for decorations had been carelessly thrown together." He could have added that this workshop would have been in the Pisan home of a certain Luca Martini, of whom more in a moment.

Pierino's father took him away from Bandinelli's workshop and, Vasari says, entrusted him to Niccolò Tribolo, the sculptor, engineer, and garden designer, "who appeared to make more effort to help those who were seeking to learn, besides giving more attention to the studies of art and bearing even greater affection to the memory of Leonardo." Pierino was in his mid-teens, and it is here that his brief career truly begins, for he had been entrusted not only to a man who needed work from as many assistants as he could find, and was therefore liable to bring him on, but also to a circle of artists and scholars who very quickly sensed his exceptional talent.

A decade later, Vasari painted this group for a ceiling in the Palazzo Vecchio; Cosimo de' Medici, Duke of Florence, sits in the center. On his left is Tribolo, holding models of the fountains which he and Pierino worked on to beautify the gardens of the Medici villa at Castello. On his right is a woodcarver and architect called Giambattista del Tasso; he is holding the Mercato Nuovo (what is now called the Mercato del Porcellino or the Straw Market, just north of the Ponte Vecchio). Surrounding Cosimo are his military architects, Nanni

Unghero and Sanmarino, plus Bandinelli, Cellini, Luca Martini, and Ammannati.

Luca Martini was superintendent of the Mercato Nuovo project, part civil servant and part engineer. He was a rising star in Cosimo's administration, a notary by profession, a scholar and poet by inclination, a friend of Cellini, a correspondent of Michelangelo, and a close friend and dining companion of Bronzino and Pontormo.

Tribolo was not only chief sculptor at Castello. He was the engineer in charge of diverting the streams to supply the fountains. He was creating one of those complex and playful water gardens of the period in which the fountains played their own sort of music, and there were water squirts which suddenly drenched the visitors. The fountains themselves were very tall, in the Mannerist taste. The bronze figure surmounting the Fountain of the Labyrinth is by Giambologna, but done to a design by Tribolo; when it is turned on, the woman appears to be wringing out her hair, and the water flows from her tresses. Vasari's life of Tribolo is full of details about the way these fountains worked: one of the tricks was that the figures of little children around the shaft of the fountain remained dry as the water poured down, as if the children really were sheltering from the water as they played around the shaft. They looked out at you and laughed through the downpour.

Pierino studied hard and was eventually given a small piece of marble by Tribolo, with which he was told to make a figure of a urinating boy. First he made a model in clay (lost), then he carved a cheerful piece which survives in the museum in Arezzo. The joke is that the child is pissing through the mouth of a grotesque mask, which sticks its tongue out at us. The piece was well received, and so Tribolo gave Pierino a piece of sandstone from which to make a support for a Medicean coat of arms, the kind of thing that goes above a doorway, called a *mazzocchio*. Vasari says he made it "with two children with their legs intertwined together," which led the American scholar James Holderbaum to suggest that a fragment now in the store of the Victoria and Albert Museum might be the remains of Pierino's second recorded piece.[8] If so, it reminds us how, in the life of any work of art, there is often a danger period in which it suddenly loses value. If only it can get through this period unmolested, it may survive. This *mazzocchio*

survived on the building mentioned by Vasari until the eighteenth century, and everyone knew what it was. Then suddenly they didn't, and it became a piece of architectural scrap.

The next work Vasari records is a boy squeezing a fish, another of those fountain figures which were probably simply variations on themes already set forth by Tribolo. It was while working on this sort of thing in Castello that, in his spare time, Pierino started to devise his figure of Bacchus. First he made a model in clay, then he began working on a piece of gray stone. Vasari says it was "a figure of Bacchus, who had a satyr at his feet, and with one hand was holding a cup, while in the other he had a bunch of grapes and his head was girt with a crown of grapes."

This bring us to a painting which, earlier this century, was supposed to represent St. Luigi Gonzaga. Then it was cleaned, and the saint's halo, and the standard he had been bearing, came off, revealing a wonderful Bronzino portrait of a young man. In 1960, when this painting was exhibited in London, Holderbaum put forward the theory that the statuette in the background might be the clay model Pierino made for his lost Bacchus.[9] Vasari says that, until Pierino made his Bacchus and Satyr, few people knew that he was Leonardo's nephew, but after his success with this work, he became known, "both for his connection with his uncle and for his own happy genius, wherein he resembled that great man, he was called by everyone not Piero, but Vinci."

So, if Bronzino had been commissioned to paint Pierino's portrait, it might make sense to identify him by reference to the statue that had made his name. The clay model (if it is indeed supposed to be clay) shows the Bacchus without its right arm. One might fancy that the broken statuette refers to the recent death of the sitter. On the other hand, in other portraits of the period where sculpture has been included, the sitter is often being identified as a collector or connoisseur.[10] Pierino's stone statue was bought by Bongianni Capponi, and Vasari says that "his nephew Lodovico Capponi now has it in the courtyard of his house." Equally, then, one might suspect the portrait to show some member of the Capponi family. In Bronzino's portrait of Ugolino Martelli, we see the courtyard of the Casa Martelli, with the still-existent "Martelli David" (then thought to be by Donatello) in the background.

Membership of the family is established by reference to one of the family's prized possessions.

Not only, then, does the appearance of a possible Pierino in a portrait not prove, of itself, that the sitter is Pierino. The fact is that when in 1960 the scholars sat around and discussed Holderbaum's idea, they came to the conclusion that the statuette in the picture didn't look like a Pierino anyway. It fitted Vasari's description of the Bacchus perfectly, but didn't look like Pierino's work.

However, Pierino was changing shape before everyone's eyes, first as a result of Middeldorf's attributions, then through Holderbaum's insights. Next, in 1974, Peter Meller made a great discovery.[11] It had been known since 1896 that there was in Venice, in the Ca' d'Oro, a socle with the inscription "Works of Pierino da Vinci," and two coats of arms, and the date 1547. Meller discovered that not only did the arms belong to Luca Martini, Pierino's patron. There were also, in the collection, two small bronzes that had originally fitted onto this base (a miniature version of the one designed by Michelangelo for the statue of Marcus Aurelius on the Capitol). There now existed, for the first time in centuries, a pair of signed and dated bronze statuettes by Pierino.

Many years after this discovery, Holderbaum had a brainstorm: the head of the little bronze Bacchus in Venice, he realized, looks just like the statuette in the Bronzino portrait. And so he revived his theory. It did not find favor at the National Gallery in London, where the picture now hangs. But it seems perfectly reasonable to follow the theory so far, and say that the statuette in the Bronzino portrait follows an invention by Pierino, which Bronzino would have seen either at the Palazzo Capponi or in the home of his chum Luca Martini.

Bronzino was thick as thieves with Luca Martini, and dedicated a very interesting poem to him, in which he describes being ill at home in his room in Florence, and hearing all the noises from the workshops in the quarter where he lived, and longing for Luca's knock on the door, and his voice saying "*Apri, son'io*"—Open up, it's me. Bronzino also wrote a poem called "The Paintbrush," which is apparently full of in-jokes of a homoerotic kind, and which suggests that this group of friends formed a milieu.[12] A relief in which the young Pan flees from the amorous embraces of Olympus (in the Bargello) was attributed by Middeldorf to Pierino. It would appear to have been commissioned

from the same milieu—a lighthearted treatment of an interesting theme.

To return to Vasari's narrative, Pierino decided that he would like to go to Rome, to study not only the ancient sculpture there but also the works of Michelangelo himself, and even perhaps, Vasari says, to behold the master himself, who was then alive and residing in Rome. He was more than alive and well—he had just finished the tomb of Julius II, and embarked on his work on St. Peter's.

But Michelangelo is one of the puzzles of this story—he is the dog that didn't bark in the night. Pierino went to Rome, Vasari tells us, and then came back to Florence "having seen Rome and all that he wished," and "having reflected judiciously that the things of Rome were as yet too profound for him, and should be studied and imitated not so early in his career, but after greater acquaintance with art." One can't help speculating that this formulation is a cover-up for some disappointment, and either that perhaps Pierino was turned away from Michelangelo's door or indeed that he was sent away by the Master himself, and that he felt this rejection rather bitterly. He had become— this is my speculation—so used to being made welcome in Florence as being Leonardo's talented nephew that it came as a shock to discover that Michelangelo hadn't actually liked his uncle at all, rather the reverse. Perhaps Pierino was rewarded with a sudden, unwelcome insight into that old rivalry.

He returned to Florence to work again for Tribolo on the Fountain of the Labyrinth, for which he made the shaft. He also made clay models of putti, which were cast in bronze by Zanobi Lastricati and can still be seen. And it was during this period of his career that Luca Martini met Pierino and became his patron.

The first thing Luca did was buy Pierino a piece of marble on which the young sculptor carved a Christ being scourged at the column. This (although the dimensions are different from those given by Vasari) is probably the relief now in the Nelson–Atkins Museum in Kansas. The next thing Luca did was introduce him to Francesco Bandini, who was a close friend of Michelangelo—so close that toward the end of his life Michelangelo gave him not a drawing (as was his wont) but an actual statue, the Lamentation that is now in Florence.

Bandini commissioned Pierino to make a wax model for his tomb (now lost). Then it was decided that Pierino was ready after all to return to Rome, so Bandini took him along, and Pierino stayed in Rome under Bandini's protection for a year. Once again, we expect him to meet Michelangelo, but Vasari neither says nor implies that he did so. True, he says that Pierino carved a crucifixion in low relief, from a drawing by Michelangelo, and that he made a wax copy of the *Moses* to send as a present to Luca Martini. Pierino was clearly there to study Michelangelo—it is one of the ironies of the story that the boy brought up to emulate his uncle should have fallen so completely under the influence of his uncle's great rival. One feels that if Pierino had met Michelangelo even only briefly there would have been an anecdote in it somewhere. Also, if Vasari's life of Pierino were simply a hagiography, then he would surely have yielded to the temptation to make a set piece out of their meeting. The fact that he is silent on the matter makes one suspect that not even Michelangelo's best friends could persuade him to meet this aspiring sculptor.

All year, Luca Martini remained in correspondence with Pierino. Vasari says he wrote to him by every courier. Presumably Luca himself offered this fact to Vasari; if so, it is a strikingly intimate detail. When Luca landed a very important job, *provveditore* at Pisa, he wrote at once to Pierino saying that he was preparing a room for him and would provide a block of marble three *braccia* in height. And Vinci, Vasari tells us, "was attracted by this prospect and by the love he bore for Luca." Pierino was in luck. His patron—his lover, perhaps—had become Cosimo's representative in Pisa, where he would live in some magnificence, and keep open house, Luca's establishment being the Pisan outpost of Cosimo's court.

Pisa was, to the Florentines, a ghastly place. Cellini (who dedicated a poem to Luca Martini)[13] tells how the bad air there gave him a fever. It was Luca's ambition to improve Pisa by draining the marshes, thereby reducing the fever (it was malaria), and making the land productive. Luca is called a notary in the old documents and an engineer in the modern ones. He was also a scholar who spent his time researching into Tuscan philology and preparing a critical text of Dante. The American scholar Jonathan Nelson identified three diagrams as having

been drawn by Luca himself, in order to illustrate the astronomical meaning of certain passages in the *Purgatorio*.[14] There was, at the time, a cult of the old Tuscan writers. The scholars of the period are comparable roughly with those English editors of the eighteenth century whose work on Shakespeare helped to found the cult of the Bard of Avon.

Whether eyebrows were raised at Luca's inviting a seventeen-year-old sculptor to live under his roof is not known. It was unusual for an artist to live with a patron, and to travel around with him as Pierino later did. What was not unusual—it was the homosexual norm in Florentine culture—was for an adult male to take a teenage lover.[15]

The block of stone Luca had ordered for Pierino turned out to have a crack which reduced it by one third. Vasari says that this caused Pierino to turn his proposed river god from a standing to a recumbent figure. However, there is a statue of a standing river god in the Louvre which, as Middeldorf pointed out, is clearly by Pierino and which corresponds in other ways to the description Vasari gives: ". . . he made a young river god with a vase that is pouring out water, the vase being upheld by three children, who are assisting the river god to pour the water forth; and beneath his feet runs a copious stream of water, in which may be seen fishes darting about and water-fowl flying in various parts."

Pierino gave the river god to Luca, who presented it to the duchess Eleanor of Toledo, to whom, Vasari says, "it was very dear." The duchess gave it to her brother, Don García of Toledo, who accepted it for his garden in Naples. (The Louvre statue came from a garden in Naples.) So the likelihood is that Vasari never saw the statue he describes. This passing of the gift from hand to hand—from artist to patron to duchess to don—would have done nothing but good to Pierino's reputation. The courtly gift increases in value at each transaction— quite the reverse of the case of a modern gift passed from hand to hand.

While Pierino was working on his river god, Luca, after a hard day draining the marshes, and a magnificent meal, and all business seen to, would retire to his study and write poems—all these people were poets—about how ghastly the Pisans were. Then (sitting no doubt under the portrait of six Tuscan poets he had commissioned from Vasari)[16] he would take out his copy of Dante and read about . . . how ghastly the Pisans were, how cruelly they had starved to death Count

Ugolino della Gherardesca and his sons by locking them up in the Tower of Famine, a building which still existed but which was no longer in use because it was so pestilential that prisoners confined to it would die "before their time."

This seemed a good subject for Luca to suggest to Pierino. The art which Luca commissioned was propagandistic in tendency. One portrait of him by Bronzino showed him as a donor in the presence of the Virgin, holding a basket of fruit and vegetables (including a prominent broad bean which, in Nelson's view, might have been designed to provoke some discreet ribaldry in his circle), referring to the abundant wealth his work had brought to Pisa; another shows him holding a map, depicting the system for draining the marshes in a stretch of land owned by Cosimo. The bronze figures of Bacchus and Pomona had the same connotation of abundance, and Pierino was to carve a stone figure of Abundance herself to go in the market in Pisa.

Wherever Pisa was represented allegorically in Medici propaganda, she seems to have been depicted as being grateful to Florence—but of course the Florentines were aware that, so far from being grateful, Pisa was always ready to rebel. The concerted efforts of Cosimo to improve agriculture and trade in Pisa were part of a pacification program: tax exemptions for those who returned to cultivate silk, refuge for Jews fleeing persecution in Portugal, guarantees of religious freedom and protection for foreign traders, an urban campaign of reconstruction, the draining of the marshes, establishment of a botanical garden, moving the court to Pisa for four months a year—it was a wholehearted attempt at permanent annexation. Luca and Pierino catch and express the spirit of it.[17]

Pisa was now prosperous, and grateful for her prosperity—that was what most of the propaganda says. But there was also a place for reminding oneself of the dark side of Pisa's past. When Luca chose the subject of Count Ugolino there was no tradition of representing individual scenes from Dante in sculpture, or indeed in painting. There had been representations of the poem as a whole, but as far as Nelson could discern no individual, independent representation of a whole canto.

The translation of the Dante passage below is not the earliest version in the English language: that distinction belongs to Chaucer's "The

Monk's Tale." But this version played an important role in the dissemi-
nation of both Dante's version and Pierino's illustration of it, since it
occurs in the painter and theorist Jonathan Richardson's *Discourse on
the Dignity, Certainty, Pleasure and Advantage of the Science of the Connoisseur*
(1719). Richardson begins by recounting a prose version of the story,
one also known to Luca Martini—the historian Villani's account of
Ugolino's death: he was imprisoned for treason against Pisa, and his
sons with him. The Pisans threw the keys of the prison into the Arno,
and refused to allow any priest or monk to confess Ugolino. So he and
his sons died of starvation, and the prison became known as the Torre
di Fame.

Now Richardson wants to show how a poet treats the same theme
as the historian, carrying it further "by revealing what happened in the
prison." Ugolino tells Dante:

> The ancient tower in which I was confin'd,
> And which is now the tower of famine call'd,
> Had in her sides some symptoms of decay,
> Through these I saw the first approach of dawn,
> After a restless night, the first I slept
> A prisoner in its walls; unquiet dreams
> Oppress'd my lab'ring brain. I saw this man
> Hunting a wolf, and her four little whelps
> Upon that ridge of mountain which divides
> The Pisan lands from those which Lucca claims;
> With meagre hungry dogs the chace was made,
> Nor long continued, quick they seiz'd the prey,
> And tore the bowels with remorseless teeth.
>
> Soon as my broken slumbers fled, I heard
> My sons (who also were confin'd with me)
> Cry in their troubled sleep, and ask for bread:
> O you are cruel if you do not weep
> Thinking on that, which now you well perceive
> My heart divin'd; if this provoke not tears
> At what are you accustomed to weep?

The hour was come when food should have been brought,
Instead of that, O God! I heard the noise
Of creaking locks, and bolts, with doubled force
Securing our destruction. I beheld
The faces of my sons with troubled eyes;
I look'd on them, but utter'd not a word:
Nor could I weep; they wept, Anselmo said
(My little, dear Anselmo) What's the matter
Father, why look you so? I wept not yet,
Nor spake a word that day, nor following night.

But when the light of the succeeding morn
Faintly appear'd, and I beheld my own
In the four faces of my wretched sons
I in my clinched fists fasten'd my teeth:
They judging 'twas for hunger, rose at once,
You, sir, having giv'n us being, you have cloath'd
Us with this miserable flesh, 'tis yours,
Sustain yourself with it, the grief to us
Is less to die, than thus to see your woes.
Thus spake my boys: I like a statue then
Was silent, still, and not to add to theirs
Doubled the weight of my own miseries:

This, and the following day in silence pass'd.
Why, cruel earth, didst thou not open then!

The fourth came on; my Gaddo at my feet
Cry'd, father help me! said no more but died:
Another day two other sons expir'd;
The next left me alone in woe: their griefs
Were ended. Blindness now had seiz'd my eyes
But no relief afforded. I saw not
My sons, but grop'd about with feeble hands
Longing to touch their famish'd carcasses,
Calling first one, then t'other by their names,
Till after two more days what grief could not
That famine did.

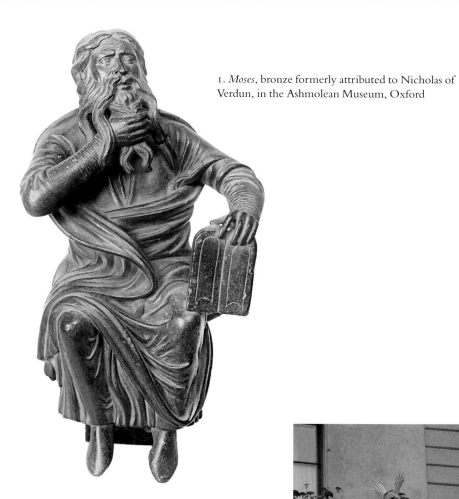

1. *Moses*, bronze formerly attributed to Nicholas of Verdun, in the Ashmolean Museum, Oxford

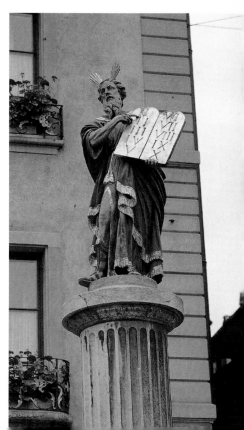

2. Statue of Moses holding the Tablets of the Law and pointing to the Second Commandment, 1790, Bern, Switzerland

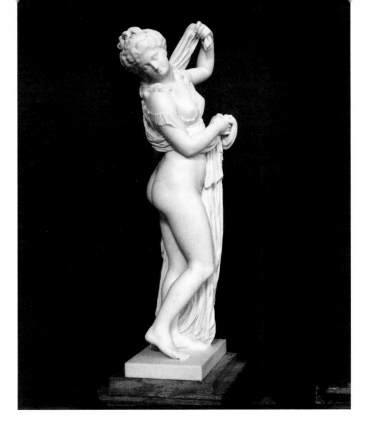

3. *Venus aux belles fesses*, c. 1780, marble by Johan Tobias Sergel, in the Nationalmuseum, Stockholm

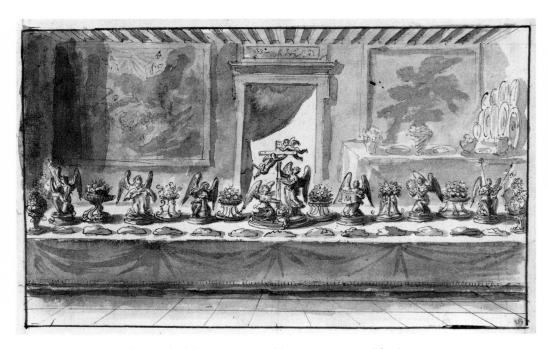

4. A Banquet Table with Trionfi of the Instruments of the Passion, arranged for the Pope for Maundy Thursday 1667, pen and brown ink with grey wash, drawing by Pierre-Paul Sevin, in the Nationalmuseum, Stockholm

5. *Sir William Matthew Flinders Petrie*, 1900, oil on canvas by George Frederic Watts, in the National Portrait Gallery, London

7. *Egyptian, Greek and Roman Antiquities Discovered by Mr Flinders Petrie*, from the *Illustrated London News*, June 30, 1888

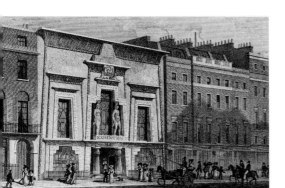

6. *The Egyptian Hall, Piccadilly*, engraving after drawing by Thomas H. Shepherd from *Metropolitan Improvements*, Vol. I, published 1827

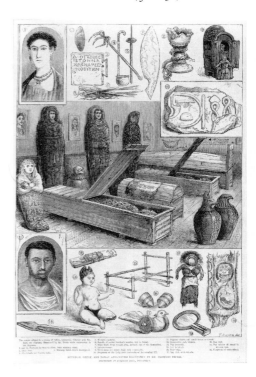

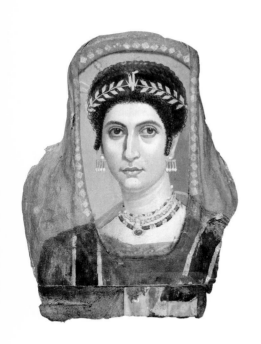

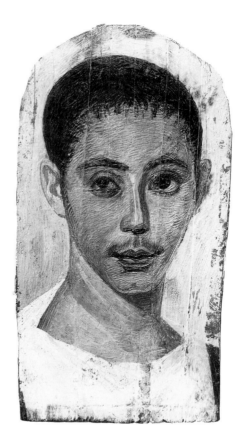

8. *Portrait of a Woman* (Isidora), *c.* AD 100–125, encaustic and gilt on a wooden panel wrapped in linen from a Fayum mummy, in The J. Paul Getty Museum, Malibu, California

9. *Portrait of a Boy with an Injured Eye,* *c.* second century AD, encaustic on a wooden panel from a Fayum mummy, in The Metropolitan Museum of Art, Rogers Fund, 1909 (09.181.4)

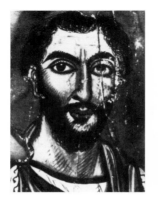

10. Illustration from *Forschungen zur Judenfrage: Das Antike Weltjudentum* by Eugen-Fischer and Gerhard Kittel, published by Hanseatische Verlagsanstalt, Hamburg, 1943

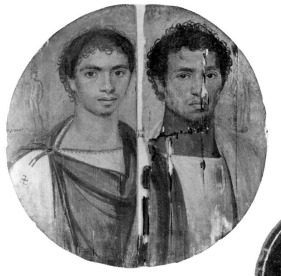

11. *Tondo of the Two Brothers*, after AD 130, from Antinoöpolis, in the Egyptian Museum, Cairo

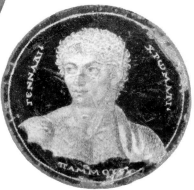

12. *The Musician Gennadios*, third century AD, glass and gold leaf medallion from Asia Minor, in The Metropolitan Museum of Art, Fletcher Fund, 1926 (26.258)

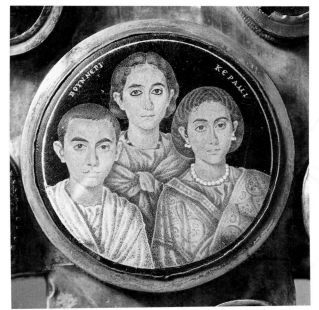

13. Family portrait detail from the Cross of Galla Placidia, *c.* third century AD, in the Museo Civico dell' Etá Christiana, Brescia

14. Flayed greyhound, 1433–8, black chalk with traces of red chalk,
drawing by Pisanello, in the Musée du Louvre, Paris

15. Dead wolf, fifteenth century, watercolor over metal point heightened with
white (oxidized), drawing by Pisanello, in the Musée du Louvre, Paris

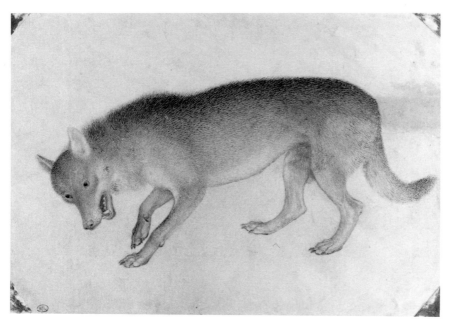

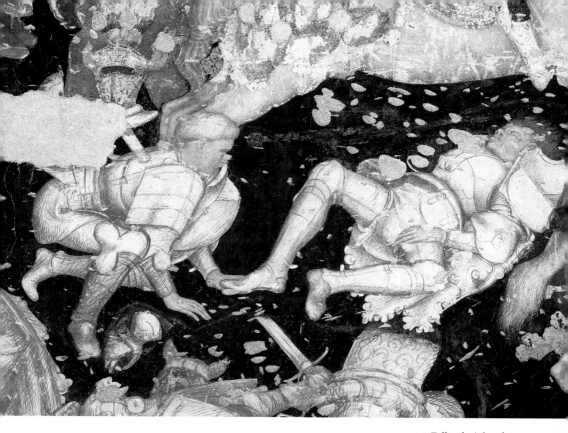

16. Fallen knights, late
1440s, a detail from a
fresco by Pisanello in the
Palazzo Ducale, Mantua

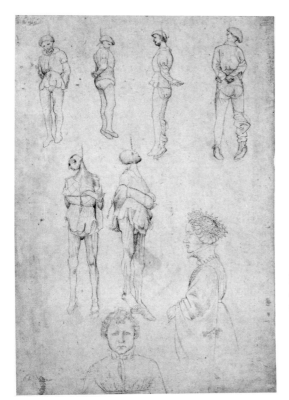

17. *Hanged Men*, pen and
brown ink over black chalk,
drawing by Pisanello, in
the British Museum, London

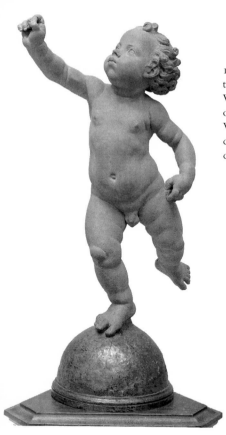

18. *Putto Poised on a Globe*, 1480?, terracotta, attributed to Andrea del Verrocchio, in the National Gallery of Art, Washington, DC/Andrew W. Mellon Collection. (Butterfield considers this a sixteenth-century copy.)

19. Bust of a young woman, *c.* 1460, marble by Andrea del Verrocchio, in The Frick Collection, New York

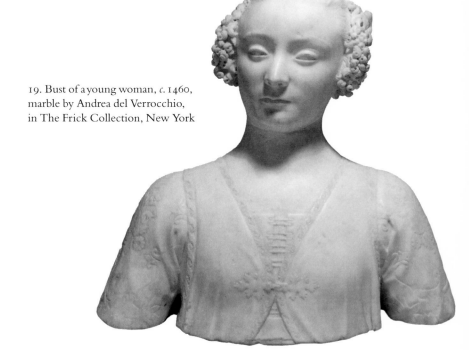

20. Sketch-model for a memorial to
Cardinal Forteguerri, the late 1470s, by
Andrea del Verrocchio, in the Victoria and
Albert Museum, London

21. Candelabrum, 1468,
height 156 cm, in bronze
by Andrea del Verrocchio,
in the Rijksmuseum,
Amsterdam

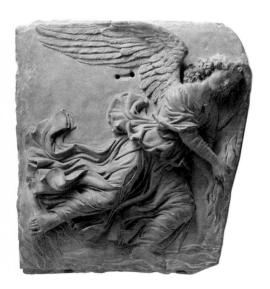
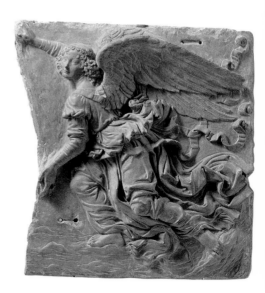

22. Two angels, 1480, fragments of a monument to Cardinal Forteguerri, terracotta plaques by Andrea del Verrocchio, in the Musée du Louvre, Paris

23. *A Sleeping Youth*, *c.* 1465, terracotta statuette by Andrea del Verrocchio, in the Staatliche Museen, Berlin

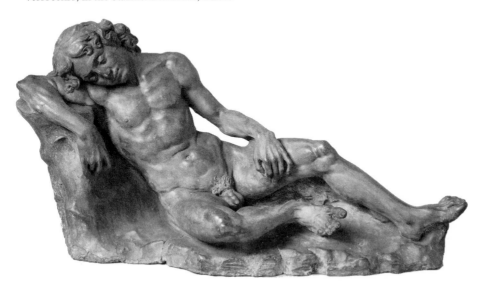

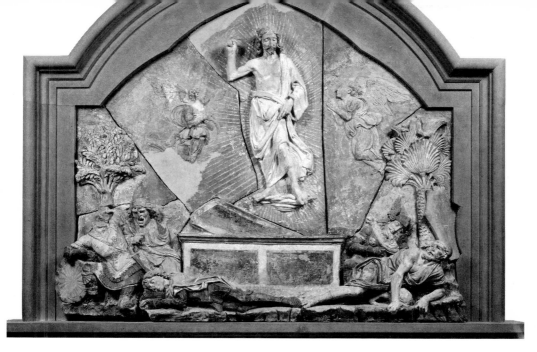

24. *Careggi Resurrection*, c. 1470, painted terracotta relief by Andrea del
Verrocchio, in the Museo Nazionale del Bargello, Florence

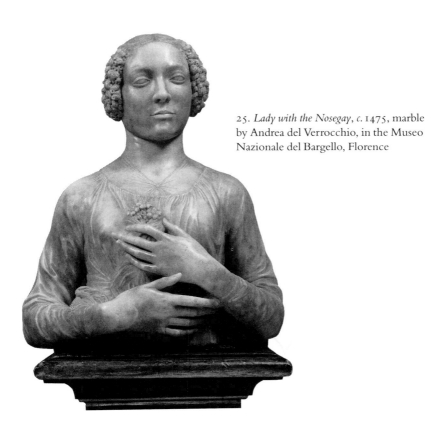

25. *Lady with the Nosegay*, c. 1475, marble
by Andrea del Verrocchio, in the Museo
Nazionale del Bargello, Florence

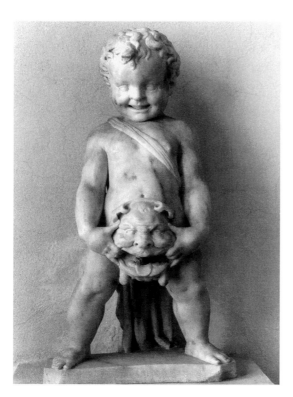

26. Child urinating through
grotesque mask, *c.* 1544, marble
by Pierino da Vinci, in the
Museo Statale d'Arte
Medievale e Moderna, Arezzo

27. *Pan and Olympus, c.* 1548,
marble relief by Pierino da
Vinci, in the Museo Nazionale
del Bargello, Florence

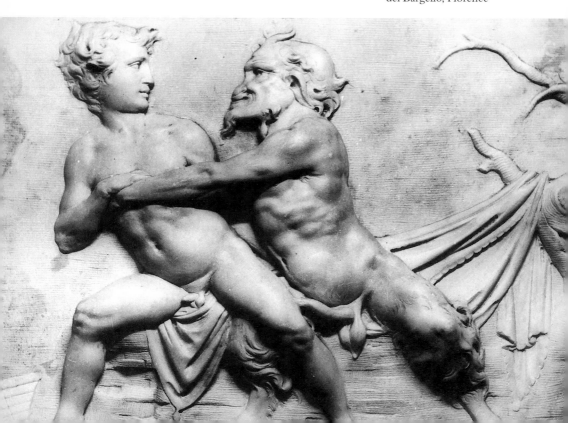

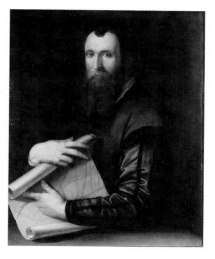

29. *Portrait of Luca Martini*, oil on wood by
Studio of Bronzino, in the Galleria Palatina,
Florence

28. *Portrait of a Young Man* (detail), probably
1550–55, oil on wood by Bronzino.
On loan to the National Gallery, London

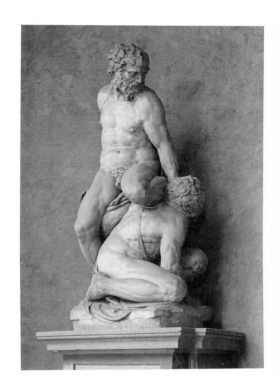

30. *Samson Slaying the Philistine*,
1552, marble by Pierino da Vinci,
in the Palazzo Vecchio, Florence

31. *The Death of Count Ugolino and His Sons,*
c. 1550, wax relief by Pierino da Vinci, in the
Ashmolean Museum, Oxford

32. *The Death of Count Ugolino and His Sons,*
c. 1550, bronze relief by Pierino da Vinci, in
the Devonshire Collection, Chatsworth

33. Study for *The Death*
of Count Ugolino and
His Sons, c. 1550, drawing
by Pierino da Vinci,
in the British Museum,
London

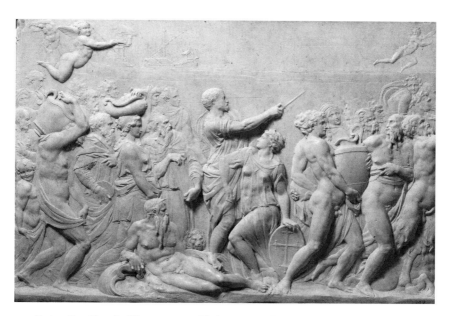

34. *Cosimo Expelling the Vices*, 1552, marble by Pierino da
Vinci, in the Pinacoteca, Vatican

35. Study for *Pisa Restored*, c. 1552, pen and brown ink over
preliminaries in black chalk, drawing by Pierino da Vinci,
in the Devonshire Collection, Chatsworth

36. *The Ecstasy of Saint Teresa,*
c. 1645, terracotta by
Gian Lorenzo Bernini, in
the State Hermitage Museum,
St Petersburg

37. *Saint Longinus, c.* 1628,
terracotta with gesso and gilding
by Gian Lorenzo Bernini, in
the Fogg Art Museum, Harvard
University Art Museums,
Alpheus Hyatt and Friends of the
Fogg Art Museum Funds

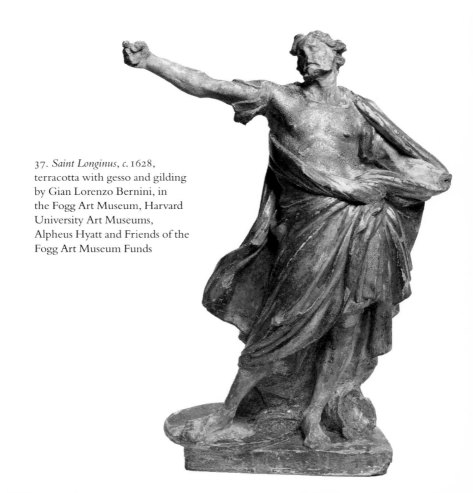

From very early days this last passage has given rise to speculation that Ugolino did indeed, in the end, eat his dead sons. But I believe Dante meant that grief could not finish him off—only famine could.

Vasari describes the work Pierino made as follows:

He set his hand to making a scene in wax more than a *braccio* in height and three-quarters in breadth, to be cast in bronze, in which he represented two of the Count's sons already dead, one in the act of expiring, and the fourth overcome by hunger and near his end, but not yet reduced to the last breath; with the father in a pitiful and miserable attitude, blind and heavy with grief, and groping over the wretched bodies of his sons stretched upon the ground. In this work Vinci displayed the excellence of design no less than Dante the perfection of poetry in his verses, for no less compassion is stirred by the attitudes shaped in wax by the sculptor in him who beholds them, than is roused in him who listens to the words and accents imprinted on the living page by the poet.

This seems to imply that Vasari had seen the wax, but it does not actually strictly do so. The attitudes were *shaped* in wax only. Vasari goes on:

And in order to mark the place where the event happened, he made at the foot of the scene the River Arno, which occupies its whole width, for the above-named tower is not far distant from the river in Pisa; while upon that tower he placed an old woman, naked, withered and fearsome, representing Hunger, much after the manner wherein Ovid described her. The wax model finished, he cast the scene in bronze, and it gave consummate satisfaction, being held by the Court and by everyone to be no ordinary work.

We can guess that Pierino would have made a cast from his first wax model, so that he would have one in reserve, in case anything went wrong with the bronze casting. So that the wax version of the relief, which is in the Ashmolean Museum in Oxford, could well date from Pierino's day, and be finished by his hand. Vasari could have seen it along with the bronze.[18]

But how to account for the marked differences between the quite definite description by Vasari and the relief as it has come down to us in different media (wax, terracotta, bronze, and marble)? The father is not groping over the bodies of his sons, but sitting upright. Only one of

the sons could be said to be dead or dying. The old woman representing Hunger is not in a tower—indeed no tower features in the relief. One could call all this sloppiness on Vasari's part, but it doesn't seem like sloppiness so much as wrongness.

There are two possible explanations. One, put forward by Nelson, is that the memory of Dante's lines proved more powerful in Vasari's mind than the sculpture he saw, and that is why he has the father groping around.[19] Vasari could easily have known whole slabs of Dante. Benedetto Varchi says that Bronzino knew the whole of Dante by heart. Then there is the question of an *aide-mémoire*. There exist preliminary drawings by Pierino (they used to be attributed to Michelangelo) in the British Museum, but there is also a puzzling and unpleasant sketch in the Ashmolean which comes nearer to what Vasari describes. We know that Vasari owned drawings by Pierino; surely he must have owned a sketch of some early version of the composition, which included the woman sitting in the Tower of Hunger (a tower Vasari knew well—he worked as an architect in Pisa, and was responsible for incorporating the remains of the tower into an infirmary).

Here then is an elegant piece of anti-Pisan propaganda. Pierino and Luca have chosen the moment described in lines 67–70 of Canto XXXIII of the *Inferno*.

> Poscia che fummo al quarto dì venuti,
> Gaddo mi si gittò disteso a' piedi,
> dicendo: 'Padre mio, ché non m'aiuti?'
> Quivi morì . . .

(When we had come to the fourth day Gaddo threw himself outstretched at my feet, saying, 'Father, why do you not help me?' There he died . . .)[20]

The suffering father realizes he can do nothing to save his sons. The group is depicted in the nude, and it comes with an allegorical apparatus: Famine, with her withered breasts, flies overhead, pointing a long thin finger at something (death, presumably). The personification of the River Arno lies at the base of the scene, with the Marzocco, the lion of Florence, just peeping out from under his left hand. The figures appear to be on an island in the river. It would seem that Pierino, rejecting

the obvious idea of depicting them inside the tower, nevertheless gave them a setting where one might plausibly starve to death.

Frances Yates suggested that the island was a reference to "Dante's imprecation against Pisa at the end of the Ugolino episode, where he calls on Capraia and Gorgona, islands at the mouth of the Arno, to rise up and dam the river so that it may overflow and drown the inhabitants of Pisa who have been guilty of this crime." Yates was interested in the development of the figure of Ugolino in the art of the eighteenth and nineteenth century, after Richardson.[21] It is interesting to see that she has no admiration for Pierino himself, whom she calls "the pseudo-Michelangelo," which is in no sense fair or true. Deeply influenced though he was, Pierino was not trying to pass his work off as Michelangelo's. Nor is it his fault that in the eighteenth century both his major reliefs were attributed to the master. Pierino himself had long since evaporated from memory. If a sculpture was perceived as having quality, why not give it an ambitious attribution?

This brings us back to Jonathan Richardson in 1719. Having told the Ugolino story first in the prose of Villani, then in the poetry of Dante, he now describes "a bas-relief I have seen in the hands of Mr. Trench, a modest and ingenious painter, lately arrived from his long studies in Italy." And this relief—he doesn't say what medium it is in—he believes to be by Michelangelo. "Michelangelo was the fittest man that ever lived to cut, or paint this story; if I had wished to see it represented in sculpture, or Painting, I should have fixed upon this hand. He was a Dante in his way, and he read him perpetually."[22]

But Richardson, for all his admiration of the relief, thinks that a painting would carry the subject much further:

And could we see the same story painted by the same great master, it will easily be conceived that this must carry the matter still further . . . these would have shown us the pale and livid flesh of the dead and dying figures, the redness of the eyes, and the bluish lips of the Count, the darkness, and horror of the prison and other circumstances, besides the habits (for in the bas-relief all the figures are naked as more proper to sculpture) these might be contrived so as to express the quality of the persons the more to excite our pity, as well as to enrich the picture by their variety.

And this passage leads us to Richardson's great point, his expression of the new *paragone*, or comparison of the relative merits of the arts:

Thus history begins, poetry raises higher, not by embellishing the story, but by additions purely poetical: sculpture goes yet farther, and Painting completes and perfects, and that only can; and here ends, this is the utmost limits of human power in the communication of ideas.[23]

Michelangelo never painted Ugolino, but if he had that would have been the ultimate. Because painting itself is the ultimate. This argument was felt as a challenge by Joshua Reynolds who, in 1773, exhibited a version of the Ugolino story in which he depicts the moment on the first morning, when the prisoners expect food to arrive, but instead hear the creaking of locks and bolts. Reynolds's Ugolino is said to derive from the prophet Aminadab on the Sistine ceiling.

Now just as the poetic translations of the Ugolino passage began to pile up in the eighteenth century (and by the end of the nineteenth there were an astonishing twenty-seven of them) so the pictorial versions came thick and fast. Yates takes us through the tradition, from Fuseli's version, which was criticized at the time for having "the appearance of a man who, having in a fit of frenzy destroyed the young female who lies across his knees, has just returned to his sense of reason and remorse at the act he has just perpetrated . . ." Blake defended Fuseli's Count as "a man of wonder and admiration, of resentment against man and devil and of humiliation before God; prayer and parental affection fill the figure from head to foot." And Blake added his own versions, as did Flaxman.

On the European continent, Richardson's work was influential but not always agreed with, of course. Lessing says in the *Laocoon* that Dante's story of Ugolino is "loathsome, horrible and disgusting, and as such thoroughly unfit for painting." That was in 1766, before Reynolds's pioneering attempt. Falconet, the French sculptor and writer, knew the Reynolds from an engraving, and he wrote in 1781: "Mr. Reynolds has made an expressive picture. It is true that he has not done Ugolino devouring his hands, crawling on all fours; he has known how to choose from the Poet." Maybe this passage came like a challenge, years later, to Carpeaux, who chose the finger-biting episode. Carpeaux, incidentally, could have seen a terracotta version of Pierino's relief in Florence at

the Palazzo della Gherardesca, where it would still have been attributed to Michelangelo. But for the inspiration for his celebrated group he began with another Michelangelo figure, the statue of Lorenzo de' Medici in San Lorenzo.[24] The first French painter to take up Richardson's challenge was the obscure Davidian, Fortuné Dufau, whose canvas, exhibited in 1800, was later re-signed and had a long career (until 1968) as the work of David.[25]

Frances Yates ended her account of the transformations of Ugolino with Rodin's *Thinker* on the grounds that it was influenced by Carpeaux. But Rodin seems to have been interested in Dante's story from an early age—there is a version of Ugolino dating from the Brussels period—and he made a bronze group later to correspond with the other episode in the tale that Falconet thought inappropriate: indeed Vasari's incorrect description of the Pierino relief describes this Rodin group well—"The father in a pitiful and miserable attitude, blind and heavy with grief, and groping over the wretched bodies of his sons stretched upon the ground." I do not know whether Rodin intended his sculpture to be displayed in this way, but at the Rodin Museum in Paris the figures are placed upon an island in a pool, reenacting the solution dreamt up between Pierino and Luca Martini.

One would expect that the "Michelangelo" that Richardson had seen in the hands of Mr. Trench would have acquired some celebrity. In fact it passed again into obscurity—but the grandest obscurity conceivable. It seems to have gravitated to Chatsworth, where its presumed authorship, and perhaps its subject were forgotten, for it was let in to an oval marble plinth which had been commandeered to bear the weight of Canova's colossal bust of Napoleon. Perhaps it seemed like an allegory of the miseries caused by war. It became known among the ducal staff as "The Hag," and I was told that "we had to turn it around not long ago when they found out what it was"—which I took to mean that the relief had been considered too off-putting to show. It was the art historian Charles Avery who recognized its quality, during a routine valuation, when it chanced to catch the sun.[26]

Pierino had seen some sketch-models by Michelangelo, Vasari tells us, of Samson slaying the Philistine. He suggested the subject to Luca, who ordered the marble from Carrara, and Pierino produced a group which

now stands in the courtyard of the Palazzo Vecchio. Vasari tells us that Pierino began to carve it "and carried it well on, imitating Michelangelo in cutting his conception and design little by little out of the stone, without spoiling it or making any sort of error." It was his largest and most ambitious piece so far, and it was the last work he completed.

It looks forward, even though it is designed for a niche and is not a fully rounded composition, to the great groups of Giambologna, a sculptor born in the same year as Pierino, who arrived in Florence and first attracted attention in the year of Pierino's death, 1553 (although his first commission from the Medici was not until seven years later). It is Giambologna who in the end fills the gap left by Pierino's early death, and I make the comparison in order simply to point out the precocity of Pierino. One is hard put to piece together an oeuvre, let alone a style, from the first thirty years of Giambologna's life. But Pierino already had a style by his late teens.

One sees its final flowering in the unfinished depiction of *Pisa Restored* or, as it is also known, *Cosimo Expelling the Vices from Pisa*. It is based on a reading of Michelangelo, but is rendered in a sweet calligraphy that is quite its own. The relief, which hangs in the Vatican Pinacoteca, once belonged to the eighteenth-century sculptor and restorer Cavaceppi, who attributed it to Michelangelo on the grounds that it contains a profile of the master himself. Vasari makes a point of saying that it was left unfinished, and it is not known whether Luca Martini got someone to complete it, or whether even it was Cavaceppi who put the last touches to it. I can't help feeling that the person who did so was responsible for the glaring error at the centre of the composition, where Pisa herself is being helped up, but not by Cosimo. In a study for this relief, a drawing which Vasari owned and which is also now at Chatsworth, you can see what had been intended. Cosimo helps Pisa to her feet. But here the arm which should perform that task is being raised in a gesture of command, expelling the odd collection of vices from Pisa, vices which are depicted with the same tender care as the virtues coming in on the left, vices and virtues alike carrying these beautiful serpentine-lidded urns, which Pierino loved to design and invent, and which remind us once again of his goldsmith's training (indeed the whole of this relief could be imagined executed in gold or silver). And these strange allegorical figures join the procession with

the heroes of Pierino's world—Cosimo himself of course, and Luca Martini, and Michelangelo, and Tribolo carrying the figure of a river god, and in the top left-hand corner, facing the viewer, Pierino himself, carrying a wrapped object on his shoulder which, it has been ingeniously suggested, might be this very relief.

He was working on this, and on a tomb in Pescia for which he had completed only a male nude figure (in a manner which would soon be no longer possible in the religious climate of the time—it was too sensuous, too adoring of the nude physique)—he was working on these two projects when the duke sent Luca Martini to Genoa, and Luca

both because he loved Vinci, and also in order to give him some diversion and recreation, and to enable him to see Genoa, took him with him on the journey . . . But soon he was attacked by fever, and, to increase his distress, at the same time his friend was taken away from him; perchance to provide a way in which fate might be fulfilled in the life of Vinci.

Vasari alludes, in that phrase, to the prophecy of his genius and early death. Perhaps Luca seized on the story for his own comfort. At the very least, it does not seem fanciful to detect Luca's self-reproach pulsing through the last passage of Vasari's life. Luca parted from his sick friend, to the great grief of both of them, recommending him to the care of a friend, although Pierino was very unwilling to remain in Genoa. It seems that in his fever he conceived a desire to get back to Pisa at all costs, and so

. . . having caused an assistant of his own, called Tiberio Cavalieri, to come from Pisa, with his help he had himself carried to Livorno by water, and from Livorno to Pisa in a litter. Arriving in Pisa at the twenty-second hour in the evening, all exhausted and broken by the journey, the sea-voyage, and the fever, during the night he had no repose, and the next morning, at the break of day, he passed to the other life, not having yet reached the age of twenty-three.

Bernini at Harvard/Chicago Baroque

Gianlorenzo Bernini was not an entirely nice man, and nor was his little brother, Luigi. One morning in 1638 Bernini saw Luigi leaving the house of his, Bernini's, mistress, who accompanied him to the door, Charles Avery tells us, in *Bernini: Genius of the Baroque*, "in a suggestively dishevelled state." Bernini, like most sculptors, was a strong man. He chased his little brother to their workplace at St. Peter's, and went at him with a crowbar, breaking a couple of his ribs. Then he pursued him home, sword in hand. When his mother closed the door against him, Bernini broke it down. Meanwhile Luigi had taken refuge in Santa Maria Maggiore. Once again Bernini pursued him, but finally gave up beating on the door.

While all this was going on, Bernini had sent a servant to the house of his mistress, the beautiful Costanza Bonarelli, with instructions to disfigure her. The servant found Costanza in bed and slashed her with a razor. Bernini, who had painted a double portrait of himself and his mistress, went home and cut her face out of the painting. He had been, we are told, fiercely in love with her (she was the wife of one of his employees), and one can well believe this from the beautiful bust he carved of her, which he proceeded to send into exile (it is now in the Bargello). Bernini was fined 3000 scudi (the price of one of his busts) for disfiguring Costanza, but the Pope waived the fine; the servant took the rap, and went into exile. Luigi meanwhile prudently sloped off to Bologna, where he worked on a Bernini project for an altar.

Theirs was a family firm, and as a family firm they stood or fell together. Bernini's father was a Florentine sculptor who had worked

in Naples. Bernini thought of himself as Florentine, while those who took a dim view of him called him Neapolitan. Years later, Luigi was working alongside his brother again, overseeing the reconstruction of the Scala Regia, the ceremonial staircase which leads from St. Peter's Square up into the Vatican Palace. At the end of the first corridor, and at the foot of the main staircase, is Bernini's statue of Constantine experiencing his vision of the Cross. Behind this statue is another, darker staircase. Here Luigi took a boy who was working on the site and brutally sodomized him, leaving him with sixteen broken bones. Once again, the family name was in disgrace. Bernini had to pay 2000 scudi to the boy's father, and 24,000 scudi to the public treasury.

He clearly pulled out all the stops in his defense of Luigi, for he persuaded Queen Christina of Sweden (in Rome, having renounced her throne and embraced the Catholic faith) to speak on his behalf. T. A. Marder, from whose account of the Scala Regia, *Bernini's Scala Regia at the Vatican Palace*, we learn all these details, has his doubts as to whether the Queen's defense of sodomy can have been correctly reported in the contemporary document he quotes: she argued that "since sodomy today is no longer a Florentine delicacy but well nigh universal, and especially a dish of princes, so the sodomites particularly in Rome have protectors and defenders of high standing, it being a delicacy enjoyed in Rome by great and small alike."

This somewhat startling frankness cannot have put the matter entirely to rest, since we also learn, turning back to Avery's book (the best and only up-to-date introduction to Bernini in print), that Bernini, as a result of this scandal, agreed to carve his statue of the Blessed Ludovica Albertoni free of charge. He was a pious man (the statue in question is a depiction of a pious woman's death), and one might guess that piety was associated in Bernini's mind with proximity to power. He was ruthless, competitive, and ambitious; and his ambition led him straight into the orbit of the popes. There his reputation, though always pre-eminent, was never entirely secure. Among the sculptors of the day, Alessandro Algardi, born in the same year, 1598, was often considered Bernini's equal. It was in architecture that his capabilities were most often criticized and doubted, and Marder discusses at length a set of drawings for the piazza of St. Peter's in which some contemporary

architect has criticized Bernini's plans, step by step, and (it would seem) cogently enough for Bernini to take note of some criticisms. He suffered some notable professional setbacks. His equestrian statues of Constantine and of Louis XIV were both considered failures. His plans for the Louvre were scrapped. Most humiliatingly, his projected bell towers for the façade of St. Peter's turned out to be too taxing for their foundations, and work had to be stopped when cracks appeared in the walls. The marble statue called *Time Unveiling Truth* (only *Truth* herself was completed) was intended as the sculptor's great act of self-justification.

Bernini knew what it was like to fall from grace. When we read a contemporary judgment on him by one of his enemies, we should bear this in mind. "That dragon who ceaselessly guards the orchards of the Hesperides," wrote Giovanni Battista Passeri, "made sure that no one else should snatch the golden apples of papal favour, and spat poison everywhere, and was always planting prickly thorns of slander along the path that led to rich rewards." Jennifer Montagu, who quotes this passage in her monograph on Algardi, says that it would have been hard, even at the time, to say whether it was true.[1] It is hard to prove malice when a judgment might have been made out of ingrained aesthetic prejudice.

Rome was a snakepit, anyway. So too was Paris, the only other city in which Bernini worked. For the months he was there, we have an almost daily record of his conversation, set down by Chantelou.[2] Bernini was a great man, and his opinion was continually sought. Often he expressed himself tactfully, but when he didn't, it was quite certain that what he had said would be used against him. One could imagine exactly the same familiar process taking place in Rome. If we say that Bernini, for most of his life, effortlessly dominated the artistic scene, that is not how it would have seemed to Bernini. He dominated, but by great effort. No doubt he felt he could never relax his guard.

It is astonishing to me that no one since Stanislao Fraschetti in 1900 has written a biography of Bernini. Fine scholars have done great work on the subject. His drawings and sculptures (but not the terracotta sketch models) have been cataloged. The great ensembles, such as the Cornaro Chapel in Rome with the *Ecstasy of St. Teresa*, have been carefully examined. Marder's account of the Scala Regia is the latest of such

studies: most of its amazing detail is aimed at the specialist architectural historian, although the last three chapters, about the Constantine statue and the iconography of the ensemble, have a broader interest. But no one seems to have thought it worthwhile to accord the artist a full-dress biography.

A great deal is known about him. He lived mainly on fruit and was much feared for his anger. The sight of water—the Seine at evening—calmed him. He was not quite the first caricaturist, but he was perhaps the first to caricature such elevated figures as cardinals, princes, or popes. Great princes "enjoyed the joke with him, even regarding their own faces, and showed the drawings to others of equal rank."[3] When this was mentioned in Paris, the term caricature had itself to be explained to the court, the genre being unknown in France.

He wrote plays, one of which has survived, and acted in them. He designed sets and stage machinery and special effects. One night, Milton was in the audience. Bernini was well known for spectacular theatrical stunts, such as a play in which the swollen waters of the Tiber flooded its banks and seemed about to drench the audience, before disappearing down a concealed sluice. In another, a set caught fire, apparently through the inadvertence of an actor; but the burnt backdrop revealed a further set behind it, and the action of the play continued.

Such pyrotechnics were famous in their time and capture the imagination today, but Bernini was also, in his pronouncements on theater, a critic of stage machinery, its complication, and inefficiency. The plays he put on at his own house, he would say, cost him no more than a few cents. He wanted to mount a play *about* stage machinery. There was a great deal of this kind of self-reference in his theater. In one production, the curtain fell (we are told that in his theater the curtain fell rather than rose on a scene—a trick which always works well in modern theater too: the released curtain drops swiftly to the ground and is whisked away to the side) on a stage beyond which the audience could see a fictive audience watching another play; eventually the real audience would be permitted to learn something of what the fictive audience was witnessing.

In his work as an artist-impresario, Bernini much resembles Inigo Jones, but unlike Jones's stage designs, none of Bernini's work for the theater has survived. A short intermezzo called *La Fiera di Farfa*, which

became famous, depicted a small-town fair. The music exists. It is much like Monteverdi. The text interweaves all the sounds of the fair, like the English settings of the Cries of London.[4]

Bernini loved the psychology of perception, as it is now called, and many of his pronouncements can be placed in this category. He said that a portrait of a man wearing clothes all of one color would seem larger than a portrait of the same man wearing clothes of different colors. He said that if one were to make a figure of a man holding one hand to his chest and the other raised in the air, the hand held in the air would have to be made larger than the hand held to the chest, because the surrounding air would eat into the dimensions of the hand. When he produced a series of sketches, he would always, through vanity, tend to prefer the last sketch he had completed. In order to counteract this, he would do something to make the sketches look strange, such as examining them upside down or through tinted spectacles.

He pointed out that, in ordinary life, if someone suddenly turned white, one would say that he was not himself. It is hard to recognize someone who has had a bag of flour poured over him. In consequence, when one is making a portrait in marble, one has to resort to various compensatory measures in order to adjust to the alienating effect of the loss of color.

When he was carving his portrait of Louis XIV, the courtiers giggled at the way Bernini stalked around the king, observing him from all angles; and Louis himself had a hard time keeping a straight face. Bernini sketched the king standing, motionless; he sketched him sitting; he himself sat at the feet of the king to draw him from below—a view which is extremely familiar, since the resultant bust is always photographed from below, and was designed to be placed high, so that it has a commanding presence. Bernini not only posed the king, he also sketched him at work in the council of ministers, so that he could become familiar with the living features. He said that the human face was at its most characteristic either just before, or just after, speaking. If the artists of France learnt any one thing from Bernini, it was this last maxim: time and again, especially in the eighteenth century, a portrait relies for its vividness on a mouth slightly open, as if about to speak.

He made sketches. He made models. What these preliminary procedures did was fix in his memory the nature of the task ahead of him.

Once he could remember what his task was, he could ignore the sketches, and the models. They had served their purpose, as far as *he* was concerned.

He carved his portrait of Louis under the eyes of the whole court. When it was said that the bust lacked the characteristic lock of hair fallen over the forehead, Bernini replied at first that a sculptor cannot do what a painter can—he cannot show the forehead as seen through the hair. Every art has its own limitations. He was also wont to point out that the difference between a sculptor and a painter is that a sculptor cannot change his mind. On this occasion, however, he did change his mind, cutting into the forehead to allow for the lock of hair. This story tells us two very characteristic things about Bernini: he *did* listen to criticism, even when he had a ready answer; and he did always bear in mind that he was not creating a phrenological replica of a head, as defined by the measurements of calipers, but an object which would create the illusion of a living human being. If those who knew the king well thought that the curl was so characteristic, then it might be worth rethinking the whole surface of the forehead, in order to accommodate it.

Bernini did not invent the Baroque, nor indeed did he invent Baroque sculpture. As Bruce Boucher implies in his introductory account, *Italian Baroque Sculpture*, the revolution had its origins in painting. Furthermore, there were stirrings of something new in the works of older sculptors such as Stefano Maderno and Francesco Mochi. The examples Boucher gives are chosen for their originality of composition and theatricality of impact. Visitors to the Chicago exhibition, *Bernini's Rome*, can check out Mochi in the Art Institute's permanent collection: there is an extraordinary white marble head of the young John the Baptist—a work which used to be ascribed to Bernini himself, as did a Mochi bust of Cardinal Antonio Barberini, now in the Toledo Museum of Art, Ohio.

It is indeed quite possible to attribute too much to Bernini. Many visitors leave Rome under the impression that he built St. Peter's (or those bits of it not by Michelangelo). Others (tour operators included) think that he carved the Trevi Fountain. But I have to confess myself shocked by Jennifer Montagu's argument, in an essay called "Bernini Sculptures not by Bernini," that, while the design and most of the

execution of the *Apollo and Daphne* are by Bernini himself, the "meta-morphosis of the block of marble into delicate roots and twigs, and into floating tresses, was largely the work of Giuliano Finelli."[5] The evidence for this comes mainly from sources Montagu states to be hostile to Bernini, but it is taken up by Boucher: "Of course, Bernini did not carve the *Apollo and Daphne* alone. Giuliano Finelli (1601–1657) was responsible for some of the more dazzling passages of tendrils and sprouting leaves . . ." Dazzling passages of tendrils? Daphne is turning into a laurel, not a sweet pea, a tree (as per Ovid), not a climbing plant.

Charles Avery, who quotes Montagu at length on this point, con-cludes that Bernini "succumbed to the temptation of claiming as all his own work virtuoso passages of carving that ethically he perhaps ought to have declared as the *morceau de réception* of the gifted newcomer." But a passage, even a brilliant passage, on someone else's sculpture can hardly be termed—even in a loose figurative sense—a *morceau de réception*.

Returning to Montagu's article we find that she has apportioned the "roots and twigs and floating tresses" to Finelli on the grounds that they demonstrate the kind of use of the sculptor's drill at which he elsewhere excelled. Finelli, Montagu tells us, grew tired of seeing his triumphs enriching another, and so "left Bernini's studio and set up on his own, seeking the opportunity to demonstrate that it was he who had produced these admired carvings." But what was the outcome? Montagu adds in a footnote that "in his independent work [Finelli] does not achieve (and probably did not seek) the extraordinary finesse Bernini required of him." In other words, brilliant though he might have been, he was not as brilliant without Bernini as he had been under his instructions. If so, it seems wrong to speculate (for that is all that it amounts to) that the virtuoso passages in this famous group can be attributed to someone other than Bernini.

2

The Neapolitan sculptor LORENZO BERNINI (1598–1680), whose works occupy the concluding chapter in the history of Roman Art, flourished up to the close of the 17th century. He is everywhere in evidence at Rome, where

he executed numerous *Fountains*, the *Colonnades* in the Piazza di San Pietro, the *Baldacchino* in St. Peter's, the *Scala Regia* in the Vatican, the *Statues on the Ponte Sant' Angelo*, the *Daphne* in the Villa Borghese, the *St. Theresa* in the Santa Maria della Vittoria, etc. It is superfluous to bid the beholder beware of being led captive by art essentially flimsy and meretricious; rather perhaps it is necessary, as a set off against the now prevailing depreciation of Bernini's works, to plead the important historical significance they possess amidst all their too conspicuous defects; to bear in mind that throughout the course of nearly a century they were regarded as the most brilliant production of that period and were very generally imitated.

<div style="text-align: right">

Central Italy and Rome by Karl Baedeker (1909)

</div>

Bernini knew, or at least said, that after his death his reputation would wane. But whether he realized how far it would wane is another matter. He had been the most famous artist in Europe. By the mid-nineteenth century he was a villain. Charles Eliot Norton, later to become the first Professor of Fine Arts at Harvard, published his *Notes of Travel and Study in Italy* in 1860.[6] At the climax of this work Norton tells us that Savonarola's Bonfires of the Vanities had been a good thing, that the burning of Savonarola had triggered a decline in Italian civilization, and that—this is the last sentence of the book—"For two hundred years Italy has lain dead." Here is Norton on the age of the Baroque:

Raphael and Michael Angelo were the forerunners of decay . . . The spirit of the earlier artists was incongruous with the worldly pomp and selfish display of the capital of the Popes; but Michel [sic] Angelo's genius gave just expression to the character of the Papacy in its period of greatest splendor and Bernini is the fit representative of its weakness and decline. The eye is wearied and discouraged by the constant repetition of monuments of Art which, the more skilful and elaborate they may be, only the more exhibit the absence of noble design and elevated thought . . . Simplicity is banished and modesty proscribed. Instead of being the minister of truth, the purifier of affections, the revealer of the beauty of God, Art was degraded to the service of ambition and caprice, of luxury and pomp, until it became utterly corrupt and false.

That is what Norton and his friend Ruskin believed. This is what Norton, a pessimist, taught generations of young men at Harvard. When the Fogg was founded, on a bequest made in 1891, Norton successfully

<div style="text-align: center">

95

</div>

argued that it should be "a well-fitted art laboratory, for the study and comparison of facts relating to art and artists." And when the museum began to collect original works of art, it concentrated for years on building up a collection of early Italian panel paintings, until eventually people began to feel that enough was enough. Arthur Kingsley Porter, the great medievalist who on becoming Professor of Fine Arts at Harvard used his salary as an unofficial purchase fund for the museum (most of the early curators seem also to have been collectors), expressed his impatience thus in 1918:

Characteristic of this America of ours are the waves of fashion that sweep through the country. There is a danger in this jerky, intense way of doing things, even when the excitement is directed towards some object in itself entirely laudable. It is therefore with some mixed feelings that we must regard the rise in the field of art of a distinct fad for Italian primitives. We may concede that the present popularity of the Giotteschi in many ways gives cause for optimism. It is impossible not to feel that a taste for Giotto, if sincere, represents an immeasurable intellectual and artistic advance over the taste for Barbison [sic] and Fragonard, which it supplants. Yet American fads have a way of blighting and befouling all they touch. The swarm of locusts flies away leaving the verdure sere, the flowers deprived of their freshness.[7]

I quote this in order to show that Richard Norton, the son of Charles Eliot Norton, was not alone in his exasperation, and was not merely attacking what his father stood for (although there may have been an element of that in it, for all I know), when he began his 1914 essay on Bernini with the observation that

Whereas our grandfathers and our great-grandfathers held Carracci and Guido and others of the same time in high esteem, we are now taught that these later men are of little value or interest in comparison with the artists of the fifteenth century, and even the most halting and stuttering "Primitive" is held of more worth than the more able masters of the seventeenth century.[8]

Richard Norton had done something quite extraordinary. In 1905 he had gone to Rome and purchased from the director of the Galleria Borghese, Giovanni Piancastelli, a collection of twenty-seven clay sculptures, twenty-five of which were later deemed to be "by or in the

manner of Gian Lorenzo Bernini." Norton is described as having been "a discreet dealer." So discreet is he in his essay, that he does not say that it was he who purchased the collection and sold it to the Brandegee family, of Faulkner Farm, Brookline, Massachusetts. What he does say is that it is

extremely fortunate that their present owner realized their great beauty and extreme interest and added them to the artistic treasures stored in America, where they will serve in ages to come to show students and sculptors a clear reflection of the mind of one of the world's greatest artists.

The phrasing here contains perhaps a hint that, in due course, the terracottas would find their way into a museum. The sumptuous production of Norton's book, with its heliotype plates, suggests to me that the writing of the essay and its publication were all part of that happy symbiosis whereby curators and collectors have advanced each other's interests in America. In 1937, Mrs. Edward D. Brandegee sold her terracottas to the Fogg, which carefully stored them away. They are the greatest and most various representation of the work of any of the major Italian sculptors in any American collection, but they were not displayed at first, and in recent years only a few have been on show at any one time. In this, their fate closely resembles that of the Farsetti collection of Italian terracottas in the Hermitage, thirty-five of which have been sent for exhibition in Chicago. Neither of these great collections has been easily visible until recently. Neither has been particularly well known to scholars. Important facts about both collections have only recently come to light. In many respects, this is a new field of research.

<center>3</center>

If one thinks of a terracotta as an essentially French thing, with a high degree of finish, a surface sponged smooth, the color of pale biscuit, a delicate and fine object to be placed on a Louis Quinze commode— that is not what we are talking about in this context. We are talking about what is classed in the old inventories as a *primo pensiero* or first thought—sometimes even as just a *pensiero*.

It is a three-dimensional sketch, in some ways resembling the little wax models which Italian sculptors also made, but with this difference— in nearly all cases it is built up without an armature. It is going to be fired, and an armature would split the clay. So a clay sketch-model will if necessary be given a simple exoskeleton to support it while it dries. If a limb projects in the way that, for instance, Bernini's St. Longinus thrusts out his arms (arms that in the finished marble would have to be carved from separate blocks of stone, in defiance of the strong tradition that a statue should derive from one block alone), the arms will need wooden struts to support them, and these struts may well leave a little mark on the surface of the clay.

A model like this is not supposed to be finished. The artist is talking to himself and to his assistants. He is not talking to a patron or client. Bernini takes a thumbnail and presses it into the clay. Nailprint and fingerprint remain. In one case, at the back of the neck, the curve of the thumbnail is used to indicate the curve of the neck. But in other parts of the same surface the thumbprints are simply a consequence of the pressing of the clay into shape—they are not meant to be "read." The fingerprints are not sponged off, nor are the marks of the various tools erased. Whereas in a finished marble sculpture every toolmark will have been left for a purpose (giving various textures to different areas of surface, so that they will respond variously to light), in a sketch-model the tools are used haphazardly, as they come to hand.

Modeling is not, as is sometimes thought, essentially a process of addition. It is a conversation between addition and subtraction. The clay is added, then gouged out. The folds of the drapery—which are the abstract, emotional language of the Baroque—are deeply, deeply gouged. There is nothing remotely tentative about the process. With a Renaissance terracotta, one can usually be pretty sure that the drapery implies a garment which could be tailored without a problem. They think of the garment first, then of the effect it can make.

Bernini thinks of the effect first. He is not a clothes designer—why should he be? He is thinking of the meaning of ecstasy. And he is thinking fast. Although there are some places on the models where the addition of clay implies an afterthought, several hours later, for the most part what is conveyed in the *pensieri* is the speed of execution. He is expressing himself in a shorthand which his assistants can read without a problem.

Sometimes there are marks on the models, cut into the wet clay, giving a rough scale to allow for an enlargement. At other points on the surface, measurements have been taken with calipers, giving, say, the distance between the foot and the elbow. By searching for these paired indentations the researcher can come extremely close to the daily details of studio practice. Some of the bases are cut off the stand with wire. Some have been placed on a tray of sand, so that they can be moved without being squished.

One is not to imagine a modern art school, with a kiln handy in the corner. Rather the economy of the community resembles those peasant villages where the household sends the meat down to the baker's shop to be roasted in his oven. The sculptors, in other words, lived in association with kiln workers whose chief job was making pots and tiles. The low heat at which the sketch-models were fired suggests that the firing of these sketches was something that could be fitted in, cheaply, alongside the major business of the kiln.

One can tell that an object is fired at a low heat both by the comparative softness of the clay and by the fact that, under a certain temperature, minute organic forms of fossils will remain intact. Subjected to a higher heat they would disappear. Firing at a low heat reduces the chance of disaster, but it leaves an object which is extremely fragile. At the laboratory of the Fogg (for Charles Eliot Norton's dream came true, and the Fogg both possesses and constitutes "A well-fitted art laboratory, for the study and comparison of facts relating to art and artists") — where I was shown the Brandegee collection before it went on display — a large terracotta fragment, a saint's head, was being examined. Because it was an irregularly shaped object, it was placed on a glass dish containing small clear vinyl beads, which arranged themselves, after the manner of a beanbag, in order to support the terracotta along all its contours.

The "study and comparison of facts" included the building up of an archive of fingerprints, and the analysis of these prints by the FBI in the hope of perhaps identifying Bernini's. (Two prints did indeed match, and on models made some thirty years apart.) It is not known how useful this research will prove, but the Fogg hopes to build up information from Italian terracottas all over the world. Fingerprints are one part of this. Another new line of inquiry is into the mineral composition of the

clay. It might be that the local Roman clay, which came from the Valle d'Inferno, not far from the Vatican, has a sufficiently distinctive composition to assist in establishing the provenance and authenticity of a piece.

<div align="center">4</div>

It is good to ask of a work of art three questions: What is it? Where does it come from? And why is it here? The third of these questions is a way of asking: Are works of art distributed at random around the world, or is their location an aspect of their meaning? Might a drawing in London just as well be in Vienna, or is there some significance about its being in London, in a certain building, in the company of other drawings?

Terracotta working models are such rare survivors—especially in comparison with drawings—that the existence of an old *collection* of them is inevitably full of meaning. The eighteenth-century sculptor and restorer Bartolomeo Cavaceppi built up a collection with which he hoped to found an academy. He had 7300 drawings: these are now for the most part in Berlin. He had, by comparison, around a couple of hundred terracotta sketch-models, and that was a large collection. The Brandegee terracottas, it was recently established, come from Cavaceppi's collection, as do a group of models in the Palazzo Venezia in Rome. So what we are looking at at Harvard is a fragment of an eighteenth-century vision of what was exemplary in art.[9]

The Chicago exhibition, so beautifully mounted and lit, comes from the Hermitage. It had been in the Palazzo Farsetti, a private museum in Venice. In 1782 the future Tsar Paul I came incognito with his wife, traveling in Europe under the pseudonym the Count and Countess Severni ("Of the North"). Everyone knew who they were. They saw the museum and wanted to buy the collection, but the Venetian government refused to allow the sale. The Tsar did not forget, however. The Republic of Venice fell in 1797. The then owner of the collection was a passionate botanist, whose garden was ruining him. He sold.

In 1992, when a slightly different choice from the same collection went to Italy, it was shown under the title *Alle Origini di Canova.*

Strangely enough, this title was just as appropriate as Chicago's *Bernini's Rome*, for the models were studied in Venice by the young Canova, along with the rest of the sculptures and casts in the Farsetti collection. What the Italian exhibition asked the visitor to remember, then, was the early education of the preeminent neoclassicist sculptor. The young Canova was an enthusiast for the Baroque. And indeed, when we look at the address and verve with which he habitually made his own models in terracotta, that astonishing decisiveness can easily remind us of Bernini.

The Farsetti collection had been formed in Rome by Abbot Filippo Farsetti, a rich man who decided to turn his palace into an academy of drawing. He had permission to make casts from the antiques, and he also collected small-scale models of classical statues, including a series by Stefano Maderno. For him to have put together a collection of, again, a couple of hundred items, he must have gone the rounds of the artists' studios. Charles Avery says he bought from Cavaceppi, but Sergei Androsov, in the Chicago catalog, does not echo this view.

What Farsetti could have found, in Rome around 1750, of the models made in the previous century (he attempted in fact to collect as far back as to Michelangelo) would have been valued objects preserved by artists as exemplary. We know that the Bernini family let their collection go to rack and ruin, so it is most likely that the Bernini terracottas Farsetti found came from the collection of Giulio Cartari, Bernini's pupil. We can see also, from a eulogistic address delivered at the opening of the Farsetti museum, that the intention of the collection was to persuade the young artists of Venice, as Androsov says, "to study the classical heritage—from the masters of antiquity to Bernini, François Duquesnoy, Pierre Legros, Nicolas Poussin, Annibale Carracci, and Guido Reni."

It would be impossible to guess, from the excellent selection in Chicago, that this was the classical program. It is a perception that only comes from the posing of the question: Why are these objects here (in the Hermitage)? In Chicago, the answer is that these objects are here in celebration of Bernini and Algardi's four-hundredth birthdays, and to show us what the standard is for the Baroque terracotta. Here (among first thoughts, developed sketches, and presentation models by various artists) is Algardi's executioner, designed for the altar on which Luigi

Bernini was working, when he skulked in Bologna after the unfortunate business with his brother's mistress. And here is a model of the Blessed Ludovica Albertoni, made to get the family out of that other unfortunate scrape.

After Chicago, I went to Detroit, and saw the model of the Cathedra Petri, made to show the Pope how Bernini proposed to encase St. Peter's very throne. The angels flanking this throne have been broken off the terracotta, clearly deliberately, by Bernini, and been replaced in stucco. As if after a conversation with the Pontiff, who had made some objection, Bernini, being a consummate courtier as well as an artist, had said: Of course, as your Holiness wishes, I shall change the angels at once. What looks at first like an imperfection in the piece becomes, as you reflect on it, the most vivid invitation to insight. This is what these terracottas do for us. Here, they say, is how all that great art was made.

Who Was Thomas Jones?

I

The traveling exhibition *In the Light of Italy* featured half a dozen luminous oil sketches of Naples made in the 1780s by Thomas Jones. A further two of these extraordinary studies, in which the artist seems to compose his scene at random, and to lavish his attention on the mundane details of crumbling walls and rooftops of indeterminate age, were included in the Tate's *Grand Tour* show. In both exhibitions, Jones was paired with a scarcely less remarkable artist, Pierre-Henri de Valenciennes: in London we saw his twin views of a rooftop with a clothesline at two different times of day; in Brooklyn there were views in and around Rome, and another of these twinned views of the same site under different conditions of light—*Rocca di Papa in the Mist* and *Rocca di Papa under Clouds*.

The sketches were roughly contemporary, but there is no evidence that either artist knew the other's work. The two men have this important feature in common, that they did their sketches in oil on paper, a technique which aids speed of execution, since oil paint dries swiftly on paper. The paint is applied directly. There is no preliminary drawing, and so the technique is quite different from that used by both artists when they sketched with pen or pencil on paper, composing the elements of the scene in strong, calligraphic outline (even when these outlines were later to be painted over in watercolor). The oil sketch on paper is entirely a matter of brushwork, a study in light and color.

A further thing the oil sketches of Jones and Valenciennes have in common is that they were only discovered in this century. Valenciennes

had once been well known as the leader of a neoclassical school of landscape artists, but his reputation was at its nadir when the bequest of the Princesse Louise de Croÿ came to the Louvre in 1930 and the Italian landscape sketches (which had all been in the same single collection since their purchase by the princess's ancestor, the Comte de l'Espine, in 1819) were exhibited for the first time. People discovered that, insipid as they thought his finished works to be, Valenciennes was, in private, a "devoted realist." This gave, as Peter Galassi explains in *Corot in Italy*, a new perspective for understanding Corot's early work.[1]

But Jones had never been well known in his lifetime, and only one of his large, mythological landscapes ever made it into one of the great collections. By happy chance, this one exceptional painting is also currently touring the United States, and the curious can catch up with it next in Toledo, Ohio, where it is appearing in the exhibition *British Art Treasures from Russian Imperial Collections in the Hermitage*.[2] It was bought by Catherine II, and shows a stormy landscape with Dido and Aeneas (Jones was not a figure painter, so the figures were supplied by his friend John Hamilton Mortimer). Another of these stormy, sublime landscapes (into which Mortimer inserted a scene from *The Winter's Tale*) was bought from Jones by Sir George Beaumont, the landowner, painter, and collector. Presumably Wordsworth and Coleridge would have known this picture.

Just how obscure and little valued as an artist Jones was until the middle of this century may be gauged with almost forensic accuracy from the introduction Paul Oppé wrote to his edition of Jones's *Memoirs*, in which he quotes, apparently unquestioningly, Joseph Farington's judgment that Jones's paintings were "very cold—like China," and includes the faint praise that "by the time that Jones reached Naples he could find a picture in a landscape and note it with a spirited touch."[3] The reason why this is such a good indicator is that Oppé himself was a great expert on British watercolors (his vast collection of at least 3000 items has just been acquired by the Tate) and would certainly have recognized Jones's originality if there had been any evidence available. Oppé was interested in Jones's *Memoirs* for the light they shed on other painters and on the world of the Grand Tour, and he was quite right. The *Memoirs* are vividly

written, with many curious touches, as for instance, the description of the scene painter Nicholas Dall, who "dyed of Discontent & despair from the reflection that when all the houses in the Kingdom were full of Pictures,—which he thought, in a short time, would be the case— there would be no room for any more."

Three years after the publication of Jones's memoirs, in 1954, an auction at Christie's included "The property of a Lady whose husband was a descendant of Thomas Jones, a pupil of Richard Wilson, R.A."[4] This catalog provides further forensic evidence. Nearly all the lots were snapped up by the great drawings expert James Byam Shaw, working for the London dealer Colnaghi. These were the now-famous oil sketches, making their first public appearance. Not one of them fetched as much as twenty guineas. Afterward John Gere, who began collecting oil sketches in 1956, would kick himself for not having made any purchases at this sale, for not having seen the significance of these apparently unique works. It was only, he later recalled, after seeing the sketches by Valenciennes in the Louvre and comparing them with one of the same artist's full-scale idealized paintings, and after reading an article by Lionello Venturi on the Croÿ bequest (it had been published in the *Art Quarterly* in 1941, but Gere did not read it until 1955)—only after all this that he began to see that

the sketches were paintings of a unique kind, resembling drawings (my own professional field) in their freshness, their informality, their directness of vision, and their emphasis on effects of light and atmosphere, but having a resonance of color beyond the reach of all but the greatest watercolorists.[5]

Oppé clearly felt the same, for it was in 1954–5 that he purchased the four Joneses (three of them oil sketches) which have now passed with his collection into the Tate. And it was in 1954 that K. T. Parker at the Ashmolean Museum in Oxford bought the dreamy Neapolitan oil sketch which, to the modern eye, reads like a study in rectangles, a construction of receding planes of light.

By now, then, we have four well-known names "on the case"—Oppé, Gere, Parker, and Byam Shaw—but it was not until 1970 that Ralph Edwards organized the first exhibition devoted to Jones's work, and the oil sketch itself began to gain definition as a subject. What had held

people back—it turns out in retrospect—was a question of taxonomy. As Gere wrote:

These small paintings, usually on paper, are not pictures in the sense of having been intended for exhibition and for display on the walls of picture galleries or private houses. They were not even meant to be framed. They were part of an artist's working-material, kept in a portfolio in his studio and shown only to pupils and fellow-artists. Curators of paintings dismissed them as not being pictures in the true sense, since they had the function of drawings; curators of drawings tended to reject them because of their technique. The landscape oil-sketch was thus relegated to the critical limbo from which it has only recently emerged.[6]

This question of taxonomy must have arisen when the National Gallery in London purchased its Thomas Jones sketch *Wall in Naples* (shown in the *Light of Italy* exhibition—it is the one showing nothing but pockmarked wall, two uninformative windows, and some washing on a balcony). The National Gallery does not, in principle, collect works on paper (apart from very, very grand cartoons by Leonardo da Vinci or the Carracci) and even, quite recently, divested itself of some drawings, sending them in the direction of the British Museum. But this small clothesline in Naples must have seemed more desirable than sticking to principle.

The sketch in question had been seen in America before the National Gallery acquired it: it was one of the star items in a show put on by the Museum of Modern Art in New York in 1981, curated by Peter Galassi and called *Before Photography: Painting and the Invention of Photography* (appreciatively reviewed in the *New York Review of Books* by Charles Rosen and Henri Zerner). The same pair of rooftop studies by Valenciennes I mentioned earlier were also in this show, appealing to the taste of anyone with an affection for Edward Hopper, seeming to confound our sense of eighteenth-century decorum and composition, and illustrating the thesis of the exhibition, which was that (as Rosen and Zerner summed it up)

the freedom and directness of photography, in order to be communicated, depended on certain modes of presentation, certain methods of cropping and points of view, that were already developed earlier in a particular kind of painting and taken over by photography.[7]

Jones's *Wall in Naples* was thus presented as a forerunner of such photographs as Auguste Salzmann's *Jerusalem, the Temple Wall, West Side* (1853–4), in which the subject of the photograph is nothing but the huge rugged stones and the plants in their interstices.

It seems to have been an excellent exhibition, and the catalog essay remains thrilling. Galassi's subsequent career (writing his book on Corot while becoming curator of photography at MOMA) can be seen as a heroic rebellion against the vices of taxonomy. While there may be sound practical, curatorial reasons for storing works on paper in one place, oil paintings in another, and photographs in yet another, the brain itself is a place where all these items may be set side by side.[8] Galassi is guest curator of *In the Light of Italy*, which builds on and exemplifies the work of his Corot book, while adding (and this shows how the subject of oil sketches is still expanding) interesting new material. In 1991 it was known that Claude-Joseph Vernet had produced oil sketches on canvas, but none had been found. Item two in the catalog is the first such sketch to be identified.

2

A sketch made by an Englishman in Rome around 1650 shows a box designed for painting trips in the countryside.[9] The opened lid provided the easel, onto which the paper would have been pinned. There is a section for "pincils," a word which one must be attentive to in texts from this period, since it normally seems to mean paintbrushes (*pinceaux*). There is a section for an "oyle glasse" and one for paint rags, but the majority of the base of the box accommodates the palette. Since no provision is made for pigments, it is suggested that the artist would charge his palette with paint before setting off out of town—a recipe for disaster, one might think. A century later, Alexander Cozens jots down a diagram of a box for open-air painting, which is interpreted by Philip Conisbee, the curator of *In the Light of Italy*, as showing "paper mounted in the center of a rectangular board, which serves both as easel and paintbox. It is surrounded by twenty small pots for containing and mixing pigments . . ." This seems to imply that the whole contraption is kept horizontal, and one can't help wondering whether the blobs

Conisbee interprets as paint pots are not simply piles of pigment. In the studio, it was traditional practice for the artist or his assistant to set the palette at the beginning of the day, laying on the pigments in a given, preferred order. So perhaps it would not have seemed odd to take a ready-charged palette out into the countryside. Perhaps it would have felt odd to work in any other way.

Oil paint in tubes is an American invention, pioneered by John Rand in 1841. Preceding generations might (if rich enough) have used oil paint from glass syringes, but these were expensive and hard to refill. In Jones's day, ready-prepared oil paint was available and came in little pigskin bladders. You punctured the bladder with a tin tack, squeezed out the required amount, and then attempted to replace the tack in its hole. This process was fraught with danger, particularly so (apparently) in the case of Prussian blue, which had a nasty habit of exploding all over your clothes.[10]

That some painters still mixed their own colors, or had them made up according to secret recipes, is shown by a letter from the eighteenth-century English landscape painter Sawrey Gilpin to his father, in which he has been permitted to divulge Alexander Cozens's "method of painting with tacky colours," the secret being: *Let Your colours be ground up with a mixture, of two parts fatt oil, & one Venice Turpentine.*"[11] And there is a moving piece of evidence of the care that Jones himself took with his pigments in the flyleaf of a sketchbook in the National Museum of Wales, where the artist has tried out samples of the different qualities of vermilion and crimson lake. Vermilion was apparently an unstable pigment, and one can see the way the oil has separated from it and spread into the surrounding paper. Beside each dab of color Jones has carefully noted the price, which varies between one carlino and eight carlini an ounce. (The sketchbook also includes a shopping list for food, while the British Museum sketchbook has a recipe for onion soup.)[12]

Enough has been said to indicate that the assembling of equipment for open-air oil sketching would have been an interesting, complex problem. What happened when the painter arrived at his picturesque location on the Campagna was exactly what happens when a photographer today drops in on some remote barrio in the so-called developing

world: one is surrounded by children. Jones describes a painting trip in which the children turn nasty and are about to pelt the artists with stones, until they are bribed with copper coins. On another occasion, in the tufa quarries near Naples, he is congratulating himself on finding a scene just like a Salvator Rosa when he comes across some Rosa-style *banditti* butchering the carcass of an ass. Clearly these sketching trips were not for the fainthearted.

Nevertheless, oil sketching from nature is a practice dating back to the seventeenth century, recommended in 1708 by Roger de Piles in his *Cours de peinture par principes*:

Others have painted with oil colors on strong paper of medium tint,[13] and have found the method convenient, in that the absorption of the colors by the paper makes it easy to put color over color, even if different, one from the other. For this purpose they carry a flat box that comfortably contains their palette, their brushes, some oil, and some colors. This method, which in truth requires a certain amount of paraphernalia, is without doubt the best for extracting from nature a maximum of detail with a maximum of accuracy, above all if, after the work is dry and varnished, one wishes to return to the scene to retouch the main things and finish them after Nature.[14]

And in the 1750s, we have perhaps a surprise witness, Sir Joshua Reynolds, advising a marine painter:

I would recommend you, above all things, to paint from Nature, instead of drawing; to carry your palette and pencils to the waterside. This was the practice of Vernet, whom I knew in Rome: he showed me his studies in colours, which struck me very much for the truth which those works only have which are produced while the impression is warm from Nature . . .

And in another source we read that Claude-Joseph Vernet always painted from Nature, "despite the difficulty of carrying with himself the necessary materials, and of placing himself so as to be able to work quietly. He had the courage to overcome those obstacles . . ." From Vernet himself we learn that, when making these sketches, "one must copy as exactly as possible, as much in respect to form as to color, and not believe that improvement comes from adding or subtracting; one will be able to do that later in the studio . . ."[15]

Vernet is reminding the reader what the point of sketching is not: it

is not to create a composition for a large finished canvas (although one has to say that the newly discovered oil sketch is composed quite conventionally). It is to acquire one of the elements from which a composition will later be made.

The emphasis on the difficulties Vernet faced reminds us of one practical and non-pictorial reason for all the rooftop views by Thomas Jones with the blank walls and their unremarkable windows: they were painted from positions where the artist could work relatively undisturbed, without spectators gawping over his shoulder or insolent children refusing to get out of the way. Some of the city views are painted from either the rooms or the rooftop terrace of his lodgings or his studio. There he could lay out his equipment at ease, and be alone. In return for this advantage he was obliged to accept the discipline of painting whatever lay before him, however crazy the composition might seem— he knew that he was not making a composition, he was undergoing an exercise.

We love the fact that, when a church cupola is in the view, we may only get to see a fraction of it, the church itself being in dead ground. This is the opposite of the topographical sketch as practiced in Italy by an artist like Israel Sylvestre, who would have made sure that the church was fully visible, to the extent of rearranging the surrounding landscape or buildings. But Jones was a topographical artist when wearing another hat, and even in the Naples sketches there is, now, a topographical interest, since the area in which Jones worked was torn down soon after.[16]

It has become customary to say that, since the sketches are devoid of human beings, the viewer himself enters the scene as the sole spectator. This is indeed the effect. The cause is that Jones avoided figure painting because he was no good at it. He lacked the apprenticeship in this and in portraiture because he lacked the money. Portraiture was good business, and you had to buy your way in. All Jones could afford to buy his way into was the art of the landscape—an art that supported neither him nor his master, Richard Wilson.

3

Thomas Jones was born in 1742, the second son of a landowning family in Wales. For two years he studied at Oxford, at Jesus College (still to this day a college with strong Welsh connections), and if his patron in these studies had not suddenly died intestate he would have become a clergyman. The next plan, cooked up by two of his clergy cousins, was to send him to sea. Jones's father mournfully put this proposal to him, but Jones was outraged:

I found out that those two parsons had accidentally fallen into Company, at some Tavern or Coffee house, with the Master of a Ship bound for *Barbadoes* and had clap'd up a kind of bargain to bind me apprentice to him, and so pack me off for the West Indies, merely & for no other purpose but that they might have an opportunity of making a jolly party to Portsmouth—No—thought I—these pampered Priests shall never for the sake of a Jaunt of pleasure, degrade me into a Cabin-boy, after having been a member of the University two years—[17]

Instead he followed his own wishes and went to London to study at William Shipley's drawing school in the Strand, where he was "reduced to the humiliating Situation of copying drawings of Ears, Eyes, mouths & Noses among a group of little boys half my age who had the start of me by two or three years." In 1762 he was admitted to the Academy for Drawing in St. Martin's Lane, but the crucial move was to an apprenticeship with Richard Wilson, the Welsh landscape painter, then declining into drink.

My bargain with Wilson was to give him fifty Guineas for two Years—The first year I was to be confined entirely to making Drawings with black and White Chalks on paper of Middle Tint, either from his Studies and Pictures, or from Nature—This, he said, was to ground me in the principles of Light & Shade, without being dazzled and misled by the flutter of Colours—He did not approve of *tinted* Drawings and consequently did not encourage his Pupils in the practise—which, he s'd hurt the eye for fine Colouring.[18]

Wilson was not a hard taskmaster. If he found his pupils fooling around he would merely shake his head and say: "Gentlemen—this is not the

way to rival Claude." Jones left him at the end of the two years, having copied his landscapes often enough to have become infected by the desire to visit Italy—infected to such an extent that he even painted an Italian view of his own in advance of making the tour. The painting which ended up in the Hermitage was done in 1769.

Jones's most ambitious essay in the Sublime was another large, stormy landscape called *The Bard*, illustrating Gray's poem of the same title, a Pindaric ode founded, in Gray's words, upon the "Tradition current in Wales, that EDWARD THE FIRST, when he compleated the conquest of that country, ordered all the Bards, that fell into his hands, to be put to death." Jones takes off from the following passage:

> *On a rock, whose haughty brow*
> *Frowns o'er old Conway's foaming flood,*
> *Robed in a sable garb of woe,*
> *With haggard eyes the Poet stood;*
> *(Loose his beard, and hoary hair*
> *Stream'd, like a meteor, to the troubled air)* . . .

Gray's poem is one of the foundation stones of Romanticism, and this passage shows us how that movement was created. The last two lines have their poetic roots in Milton; visually, they are intended to remind the reader of Italian painting at its most sublime. Gray said in a note that the image was taken "from a well-known picture of Raphael, representing the Supreme Being in the vision of Ezekiel," of which he knew two versions. But he also told his editor Mason that "Moses breaking the tablets of the law, by Parmigianino, was a figure which Mr. Gray used to say came still nearer to his meaning than the picture of Raphael." This is a striking observation: Gray had spent only one day in Parma, where the Moses is to be found, in 1739. In 1757, after hearing John Parry play the Welsh harp in Cambridge, he was moved to complete his poem, which had been begun not long before. Presumably he knew reproductions of the Parmigianino design.

Italian painting thus inspires the idea of what ancient Wales would have been like. Jones as it were picks up the aesthetic instruction, and uses the poem as inspiration for a further painting (just as Blake would do later). And so the Welsh bard acquires an image traceable back, in the end, to Michelangelo.

Jones's *Bard* now hangs in the National Museum of Wales, in an extraordinary gallery which was recently refurbished to show paintings and other works of art illustrating the connection between Wales and the Grand Tour. You might think this a small subject. It turns out not to be. Not only is Richard Wilson there as a major artist of the Italianizing persuasion. There is also one of the major shop-till-you-drop patrons, in the shape of Sir Watkin Williams-Wynn (he dropped at the age of forty, having run up debts of £160,000), who commissioned Robert Adam to build and furnish his London house, Wynn House (20 St. James's Square). The occasion for the refurbishment at Cardiff was the museum's acquisition of Adam's beautiful pea-green organ, originally made for Wynn House. This now takes its place alongside paintings that once belonged to Sir Watkin, as well as Adam silver of the most imposing kind, Adam furniture, and some Derby porcelain believed to have been decorated with Welsh views by Jones. The effect is both sumptuously varied and intellectually concentrated—achieving more in one large room than the Tate's (fine enough) *Grand Tour* show did in several.

Unlike later versions of the Celtic revival, such as for instance the movement in which Yeats took part, the eighteenth-century Welsh version of nationalist resurgence sprang from exactly the same roots as eighteenth-century classicism. People like Jones and Sir Watkin developed an interest in Welsh antiquity which arose as a natural consequence of their interest in, say, Tivoli or Pompeii. The part of the British eighteenth-century brain that loved stormy scenes around Stonehenge was the same part that wanted to moon around the ruined tombs in the Campagna.

The Bard was exhibited in 1774. When it failed to sell, Jones gave it away to a friend. Lawrence Gowing, whose Walter Neurath lecture of 1985 is the best thing yet written on Jones, remarks:

To have given *The Bard* away Jones must have valued friendship more than ambition. The truth is that retiring, unconceited people are ill-equipped to generate and foster a sense of their own artistic destiny. The other kind—I often have Matisse in mind—understand that their own self-importance is almost the most important part of their equipment.[19]

And Gowing has a fine quote from Constable to support this: "Take

away a painter's egotism and he will never paint again." Gowing's essay is particularly fascinating because it is so shot through with Gowing's own autobiography. What Gowing loves to trace in Jones is his failure and the consequences of failure. He had failed to get into portraiture, for which he obviously was not suited. "When his attempts at the Sublime were defeated he must again have felt a secret consolation." This is leading us to the idea that, as Gowing puts it, "Originality may be the recourse of a talent that has failed, as likely as not, in its social fulfillment, failed to find an audience, failed to satisfy its possessor."

Jones convinced his parents to allow him to go to Rome by means of a threat: if not Rome, he would accompany Captain Cook on his voyage to the South Seas. Although startling, this is a very good threat: either project would be appropriate for a man in his mid-thirties who considered his life as an artist hitherto a failure. He arrived in Rome in 1777, and the first thing he describes is being led to his lodgings by a roundabout route, in order to avoid the English Coffee House (presumably the company could not be seen until they had washed off the grime of the road). When they eventually sally forth from their lodgings, Jones finds the English Coffee House to be

a filthy vaulted room, the walls of which were painted with Sphinxes, Obelisks and Pyramids, from capricious designs of *Piranesi*, and fitter to adorn the inside of an Egyptian-Sepulchre, than a room of social conversation—Here—seated round a brazier of hot embers placed in the Center, we endeavoured to amuse ourselves for an hour or two over a Cup of Coffee or glass of Punch and then grope out our way home darkling, in Solitude and Silence—[20]

And, as a typical Protestant, he is appalled to find his bedroom to be like a chapel, with "walls hung with dirty dismal pictures of weeping Magdelene, bloody *Ecce Homo*, dead-Christs and fainting Madonnas." But, strikingly enough, that first visit to the English Coffee House brought him together with no fewer than a dozen of his friends from London. The foreign artistic community in Rome, which lived in the vicinity of the Spanish Steps, had these regular national meeting places. The German *Stammtisch* apparently survives to this day.

Among Jones's British acquaintances was John Robert Cozens, the son of Alexander, to whom Jones refers as "little Cousins." When it came

to patronage, "little Cousins" had the advantage over Jones because, it would seem, the rich dilettante William Beckford had been infatuated with his father. One could imagine that Beckford's letters to Alexander Cozens were the model for Virginia Woolf's prose style in *Orlando*:

Think too of the life you led in your early years, when every month was marked by some great spectacle or splendid feast, where you still retain a faint memory of gilded halls, bright lights, & a long train of nobles led by the Empress, & moving majestically like a solemn procession to Polish measures. Is the mournful sight of Peter the Great's funeral forgotten, when you kissed his pale hand. Remember your happy excursions in the shadowy meads, the Tents of the Elephants, the Marble rocks of Norway . . .[21]

"Little Cousins" was engaged to follow Beckford's entourage across Europe, and to provide mementos of his patron's "solitude." There was a price to pay, however. Cozens made drawings of his proposed paintings, and waited on Beckford's approval before proceeding to the finished work.

Jones knew all about that price you had to pay, as an artist, and he dearly wanted to pay the price. He wanted a patron, and he moved to Naples in order to be near Sir William Hamilton.[22] But someone in the Hamilton entourage seemed to make trouble—or perhaps, as Jones doesn't say, but as I often suspect, his Welshness was held against him. Perhaps he was thought ridiculous—a Welsh painter with a Danish common-law wife, picked up along the way.

Jones began to feel ashamed:

Looking upon my self as deserted by my Countrymen—the depression of my Spirits was such, that I endeavoured avoiding as much as possible those places where I was mostly to meet them—The greater part of my Excursions abroad were mournful and Solitary—The various picturesque Scenes of Nature still had their Charms, & I made Studies of them with ye same Ardour as ever— it was the immediate pleasure of the Moment—not from any Expectation of a future pecuniary Recompence, for the feeble glimmering hopes that remained of that sort were dying fast away—[23]

So it is out of this depression, this homesickness, which in those days was known as "the Swiss disease," that the incomparable sketches of Naples emerge. Beckford sweeps through, praises Jones's paintings, and

vanishes. Hamilton finally pays a visit, but when Jones asks if he can accompany him on a trip south to inspect earthquake damage, he is, to his mortification, refused. What he has been showing these great men is an art which, no doubt, seemed out of date; what he has been tidying away before their visits, they would never have thought of as great painting. He was about 170 years ahead of his time.

His father died, and Jones went back to London, where he tried to make a living faking Wilsons and Zuccarellis and passing them off on the auction market. But his enemies fingered him and he failed even as a faker. Then his older brother predeceased him and he became the squire. He had made an honest woman of his Danish wife, and he had two daughters. He had entered into his inheritance. And so in time he invited a friend, an Italian artist he had met in Rome, Francesco Renaldi, to come and paint the family portrait in 1797. This painting hangs alongside the Joneses in Cardiff today. The wife is at the spinning wheel, like a good Welsh wife. The daughters are at the spinet, together with (perhaps) Thomas Jones's younger brother, who *did* become a clergyman. Jones himself stands before an easel, with his palette, his mahlstick, and his "pincils." On the floor in the foreground is a portfolio, which it took two centuries to open.

Degas in the Evening

I

"At death," wrote Larkin, "you break up: the bits that were you/Start speeding away from each other for ever . . ." Degas died in September 1917, and the bits that belonged to him started speeding away from each other soon after. He had thought of trying to keep them together, in a museum of his own, but that fantasy had not survived the trip in 1903 to the Gustave Moreau museum, which gave him the sinister feeling of being in a family vault. He had thought of giving the best of them to the Louvre—then, he said, he would go and sit in front of them and contemplate what a fine thing he had done for his nation. But that noble urge never bore fruit, and anyway he later came to despise the Louvre, as we shall see.

So it happened that in the end everything came under the hammer— works that he had painted in his youth, and had never let go of; works he had produced in old age, and that few had ever seen; paintings, drawings, and prints he had collected—a spiritual hoard. It took three of the greatest firms in the field—Bernheim-Jeune, Durand-Ruel, and Vollard—to catalog this material and organize its dispersal in seven auctions. When the first of those catalogs went out, showing the quality of Degas's collection, everyone could see that this was an event of exceptional importance.

In England, Bloomsbury swung into effective action. Roger Fry showed the catalog to Sir Charles Holmes, the director of the National Gallery, whose funds had been cut off during the course of the Great War.[1] Duncan Grant and Vanessa Bell bent the ear of Maynard Keynes, who was then at the Treasury. And Keynes had one of his brilliant ideas.[2]

Under the current agreements with the French Treasury, the British were entitled to offset British government expenditure in France against their already huge loans to the French government. Since there was very little prospect of these loans being repaid until the distant future, and since there was even some question of the interest being paid in the short term, it made sense—so Keynes argued—for some of the payment to be converted, as it were, into pictures. The British government would ask the French to place the franc equivalent of £20,000 to the credit of the British Embassy in Paris. Holmes would then sneak across to Paris and spend this French money on French masterpieces.

It was an imaginative way to be planning at that stage of the war, for between Degas's death and the first sale of his collection on March 26, 1918, the Russians had withdrawn from the fighting, leaving the Germans in a position to advance on Paris, which was now within the range of their heavy guns. The entire Degas collection came close to destruction when the house opposite Durand-Ruel's gallery was shelled a couple of days before the sale. To a conventional mind, this might seem the wrong time to go shopping. And certainly to many conventional minds of that era it would be the wrong time to go shopping for modern French art. Lord Redesdale, the grandfather of the Mitford sisters, called it a "degraded craze" in a memorandum he wrote in 1914 to his fellow trustees of the National Gallery: "I should as soon expect to hear of a Mormon service in St. Paul's Cathedral as to see an exhibition of the works of the modern French Art-Rebels in the sacred precincts of Trafalgar Square."

Keynes's proposal, however, found favor with Lord Curzon. Conveniently enough, Holmes would be able to join Keynes and Austen Chamberlain and other members of the International Financial Mission on their way to the Inter Ally Conference in Paris, which coincided with the auction. This would be his cover. But he also shaved off his mustache and donned a pair of spectacles before making his way to Charing Cross. The Mission crossed the Channel with a destroyer escort and a silver airship overhead. Three days before, the British troops had been driven back from their trenches near the Somme, and when Holmes and the others passed by train through Amiens, the city was

under German bombardment. Holmes felt something of a thrill at being on "a very feeble kind of active service."

He checked in at the Crillon, then went, with Chamberlain and Keynes, to the preview of the sale at Georges Petit's auction rooms. Chamberlain was sympathetic to most of Holmes's proposed purchases, except the El Greco. This was a small version of *Saint Ildefonso* (now at the National Gallery in Washington), which, as Degas had noted with pleasure after purchasing it, used to hang over Millet's bed. Chamberlain said, jocularly but worryingly, that if Holmes purchased the El Greco he would hesitate about signing the check. None the less, Holmes made a mental calculation that he should be prepared to pay up to £3000 for it.

Paris auctions were bizarre practices for Holmes, and despite some careful coaching he found it disconcerting, on the day, that the auctioneers did not take the lots in numerical order but darted instead around the catalog, in order to give prominence to minor items, and to keep the bidders on their toes. Adding to the tension was the fact that, an hour into the proceedings, shells began to fall: the Germans had aimed "Big Bertha" at Paris. "There was quite a considerable rush to the door," says Holmes, "at least one prominent Paris dealer being among the fugitives."

This kept some, but not all, prices low. The Ingres portrait *M. de Norvins* went to the National Gallery for a third of what Holmes had been prepared to pay for it, but he had to fight for a large Delacroix, *Baron Schwiter*, and in so doing he antagonized the room. People stood up and looked at him. They said, "It's for the Louvre, Monsieur" and "You are fighting against the Louvre." Holmes took the view that it was better to face a little trouble now than to suffer permanent regret for funking, and he went on to buy some pieces of Manet's *Execution of Maximilian*, an early Corot, and "several other useful things." The next day he was not so lucky, being outbid on several lots, including the El Greco, and even—perhaps through wearing those spectacles— buying certain drawings by mistake.

Holmes was not, apparently, a reckless man. He bought twenty-seven items in the two days, including drawings for the British Museum, but Keynes could not persuade him to bid for a small Cézanne study of apples—so Keynes purchased it himself. In all, Holmes spent just over

half his allocation, £11,780, and yet tells us that he failed to get the best Gauguins. One has to remember that he would not have been praised— might well have been sacked—for buying Gauguins at too high a price. He notes with satisfaction that the one he bought, *A Vase of Flowers*, was accepted by the Trustees on his return.

Keynes pitched in and helped pack up the purchases, which wasn't easy since everyone was trying to leave Paris, and packing cases were hard to find. So were seats on trains, but fortunately, the Inter Ally Conference being over, the Mission had a carriage booked on the evening train to Boulogne. The conference had been a farce, but on the first day of the Degas sale, while the British Army was still in retreat, the British and French military leaders met in Doullens, and the British generals, without consulting the War Cabinet, agreed to accept the military command of General Foch. Defeat was in the air but General Foch had said: "Why aren't you fighting? I would fight without a break, I would fight in front of Amiens . . . I would fight all the time."[3] It was the low point, but it was also the turning point, of the war.

Holmes, Keynes, and Chamberlain trundled back past Amiens, eating strange meals such as a breakfast of chocolate, bread, and sauternes, looking over some of the purchases, discussing interest payments, trout fishing, and "whether America would not soon possess all the gold in the world, while Europe would only have paper." At Boulogne, the Delacroix in its huge case was hoisted on board and stacked "in comparative shelter"—that is, it made the Channel crossing on deck. They went in convoy with two hospital ships, and at Folkestone they had to wait an hour in rough seas while the wounded disembarked. Then Holmes found that the railway van was too small for the Delacroix, which would have to follow by the next train. That night, he awaited it at his club in London. He had secured a handcart and four porters, and two lanterns. The case arrived, and the group set off from Charing Cross up the side of Trafalgar Square, reaching the National Gallery at 11:20 PM.

Chamberlain, meanwhile, had driven Keynes to Charleston. Vanessa Bell wrote the next day to Roger Fry:

Maynard came back suddenly and unexpectedly late last night having been dropped off at the bottom of the lane by Austen Chamberlain in a government

motor, and said he had left a Cézanne by the roadside! Duncan rushed off to get it and you can imagine how exciting it all was . . . I believe it is to be kept a secret about the National Gallery pictures, till after the war.[4]

A couple of weeks later, on April 15, Virginia Woolf went to see Keynes in London at 46 Gordon Square:

Nessa left the room and reappeared with a small parcel about the size of a large slab of chocolate. On one side are painted 6 apples by Cézanne.[5] Roger very nearly lost his senses. I've never seen such a sight of intoxication. He was like a bee on a sunflower. Imagine snow falling outside, a wind like there is in the Tube, an atmosphere of yellow grains of dust, and all of us gloating upon these apples. They really are very superb. The longer one looks the larger and heavier and greener and redder they become. The artists amused me very much, discussing whether he'd used veridian or emerald green, and Roger knowing the day, practically the hour, they were done by some brush mark in the background.[6]

A little bit of Degas had made its way safely to Bloomsbury.

2

Degas's great collecting phase belongs to the last decade of the nineteenth century, while the expression "beyond Impressionism" (the title of the recent London show, *Degas: Beyond Impressionism*, would have irritated Degas) refers to everything the artist did between the eighth and last Impressionist show in Paris in 1886 and his death over thirty years later. The other exhibition, *Degas as a Collector*, brought together over forty objects which Degas had once owned, including such far-flung delights as Cézanne's *Bather with Outstretched Arm*, now in the collection of Jasper Johns, a van Gogh still life from Chicago's holdings, and a Daumier from Wales.

Ann Dumas, one of the curators of the exhibition, wrote the catalog, in which she emphasizes the focus Degas gave to his collecting. She seems to have established that the artist could, had he wanted to, have afforded to purchase Old Master drawings. But this was not to be his field. It is hard to measure what Degas could or could not afford. Having

spent many years working off the debts of his family bank, he *felt* he was always on the verge of penury, even in the period under consideration, when his paintings began to fetch large sums. Probably he never really knew what his situation was. He assigned to his dealer Paul Durand-Ruel the task of acting as his banker, and simply applied for money as he needed it. The fact that his estate in the end raised over ten million francs does not mean that he ever felt rich.

He acquired works of art in two main ways, by purchases and by exchanges with friends. Both sorts of acquisition tell us a great deal about Degas as an artist and a man. The celebrated *Young Girl Arranging Her Hair* by Mary Cassatt (Washington, National Gallery) hung in his apartment—one of his exchanges. It is a most Degas-like painting, and yet Degas, who was sensitive to being ripped off, clearly felt that the relationship between Cassatt's and his own work was perfectly proper. Her overt homage was not unwelcome. But many of the other exchanges have unpleasant stories attached.

In Lisbon there is a Degas portrait that was identified by Theodore Reff as depicting Henri Michel-Lévy, a minor Impressionist. In this disturbing study, the artist apparently leans in the corner against one of his pictures, while a bonneted mannequin lies at his feet. Degas and Michel-Lévy swapped portraits of each other, and Michel-Lévy, though he was apparently not hard up, later sold his Degas for a large sum. Degas told him: "You have done a despicable thing; you knew very well that I couldn't sell your portrait." It is a merciless remark (Michel-Lévy has indeed apparently more or less disappeared as a painter, although the photograph Reff shows of his work looks decorative enough) but one cannot deny that Degas had cause for complaint. Perhaps as the years went by, Michel-Lévy looked in the picture as in a mirror and saw what Reff describes—"a withdrawn and disillusioned man," a failure. Perhaps he did not like this.[7]

There are so many stories of Degas breaking up with friends—with George Moore, the Irish writer, with the painter Jacques-Emile Blanche, with Manet (temporarily)—that one cannot help thinking that Degas was predisposed to expect his friendships to end in some kind of betrayal. And then there was also the Dreyfus Affair, which not only divided Degas from his many Jewish friends but also split the whole artistic

community. It began in 1894 and by the next year Degas was so nationalistic and anti-Semitic as to put his friendship with the family of Ludovic Halévy (the famous librettist) under strain. In the autumn of 1897, Degas came to dine at Halévy's for the last time. Ludovic's son Daniel described the scene:

Degas remained silent . . . His lips were closed; he looked upwards almost constantly as though cutting himself off from the company that surrounded him. Had he spoken it would no doubt have been in defense of the army, the army whose traditions and virtues he held so high, and which was now being insulted by our intellectual theorizing. Not a word came from those closed lips, and at the end of the dinner Degas disappeared. The next morning my mother read without comment a letter addressed to her and, hesitating to accept its significance, she handed it in silence to my brother Elie. My brother said, "It is the language of exasperation."[8]

Degas's character seems to have been like one of those tapestries in which certain colors fade over the years, leaving others wrongly predominant. No doubt the exasperation had always been there, but it finally took over from what so many of his friends and admirers had valued—his intelligence. "That beautiful intelligence had faded away some time ago," wrote Mary Cassatt after the funeral.

But because these stories of his great hatreds and rages are so striking, they get in the way of the *preceding* stories of great friendships. Henri Loyrette calls one of the chapters of his Degas biography *"Ainsi fait l'homme qui veut finir et mourir tout seul, sans bonheur aucun"* (That's the behavior of someone who wants to finish up and die all alone, without any happiness).[9] One turns eagerly to find the author of this perceptive description of the late Degas. It is Degas himself in middle age, in one of his letters, apologizing for not having inquired about the condition of a friend's sick wife.

Degas valued loyalty, and was known as loyal, and his collection itself displays a quality of loyalty—loyalty to the friends he admired or was able to support with occasional purchases, and loyalty to the French tradition of the nineteenth century from which he sprang: Delacroix, Ingres, and Daumier were the artists he revered, the three great drafts-men. The star paintings, the ones he daydreamed about giving to the Louvre, were the Ingres portraits of M. and Mme. Leblanc (which

Durand-Ruel, in that first auction, secured for the Metropolitan Museum in New York). With Ingres and Delacroix he went for focus—sketches and studies for works he admired. With Daumier he went comprehensive—he owned 1800 lithographs. With Manet he tried to assemble the complete graphic work, and to reassemble the cut-up canvas of *The Execution of Maximilian*.

And then there was that opposing tendency—not disloyal, exactly, but guaranteed to undermine the friendships that he cherished. It was a desire to shut himself off, to barricade himself against his friends, to suppress everything around himself and, once he had achieved utter solitude, to annihilate himself, to kill himself with disgust. That is the feeling he described at the age of fifty, when he felt blocked and impotent.[10] But he had a quarter century of working life ahead of him, and over thirty years of plain old living to endure.

<div align="center">3</div>

A short time ago, while pursuing some research in the Kessler diaries at the Deutsches Literaturarchiv in Marbach, I noticed that Kessler had met Degas at Vollard's place in Paris, and had made a detailed record of the evening's conversation. (It is printed below.) There is, of course, no shortage of anecdotes about Degas, but a great number of the most famous ones were set down many years after the event and have of course the unreliability of much-repeated tales. You can see the process at work in the evening Kessler describes—an evening of avid scandal-mongering, in which favorite stories are rehearsed, and witticisms recycled, and old hobbyhorses brought out yet again. Those wonderful books about Degas by Vollard and Valéry,[11] which have been comprehensively plundered by later writers, are full of privileged glimpses and vivid unreliability. But Kessler's account is at least set down, as is clear from its detail, within hours of the conversation it records with such evident distaste.

Harry Graf Kessler (born 1868) kept a diary from 1880, when he was a prep-school boy in Ascot, to his death in exile in France in 1937. He was trilingual, and the diary begins in English before turning suddenly and without explanation to German, but he seems to have tried to

record important conversations in their original language. When Maillol or Vuillard or Rodin speaks, he will usually be recorded in French. The diaries thus form a large and only partially tapped resource for scholars of art as well as political history. They are currently being transcribed by the Projekt Harry Graf Kessler in Marbach, with the intention of making them available on CD-ROM. I have based my own translation on a provisional text from this work in progress, and I am grateful to Eberhard Fuchs and the Projekt for permission to reproduce it here.

Kessler began life in European high society, and was a very conventional young man, with all the prejudices one would expect. His first encounter with modern French art at the 1890 Salon des Indépendants was not a success. He records "violet trees in a red field beneath a yellow sky, women with their faces all covered with red spots as if they had the measles, trees looking like a battle of demented serpents; I have never seen anything so terrible in my most painful nightmares . . ."[12] But in a few years he was to become one of the most prominent champions in Germany of this kind of painting, which was why he would have been a welcome guest at Vollard's shop.

The dinners in Vollard's cellar, as Vollard himself tells us in his memoirs,[13] were an institution. Bonnard painted one such evening, in which Kessler is present. The cellar lay beneath the shop in the rue Laffitte. It was divided between kitchen and dining room, and regularly became extremely hot. The main course was always chicken curry.

Degas tells Kessler he has come from the Gare du Nord. If he set out from his own home in the rue Victor-Massé, this would mean he had done two sides of a triangle, since a brief walk down the rue des Martyrs would have brought him directly into the rue Laffitte. But riding on the omnibus was a favorite pastime of Degas's old age—clearly he was whiling away the time before dinner, enjoying the experience of hurtling down the rue de Lafayette.

Degas's complaint that the painter Forain, who was late, wouldn't have kept a duchess waiting reminds us of the theory that a part of Degas's problem was that he wanted to be treated like nobility. Also, one of his sisters *was* a duchess of sorts (a Neapolitan duchess), so it is a bit like saying "Forain wouldn't dare treat my sister like this."

Forain was one of the colleagues to whom Degas was drawn closer as a result of the Dreyfus Affair, which estranged him from his Jewish and Dreyfusard friends. Forain and Caran d'Ache had founded the violently anti-Semitic magazine *Psst . . . !* A week after the conversation at Vollard's, Vuillard tells Kessler what Forain said at the beginning of the Affair: "*Nous sommes du bon côté: les 'cons' sont avec nous*" (We are on the right side: the "assholes" are with us). Vuillard had a low opinion of Forain as a painter: "*Il n'a jamais fait que de l'enluminure*," he told Kessler: he had never done more than illumination, he was essentially an illustrator.[14] Degas is known to have shared this low opinion. Forain paints, he said, "with his hand in my pocket."

Forain arrives late at Vollard's and keeps the company waiting for his news, in which he takes an evidently malicious pleasure. The story concerns a row which to this day has never been fully elucidated, between the Prince de Wagram, a fantastic, Proustian figure mentioned in *Le Côté de Guermantes* as "a young prince who liked impressionists and driving," and the art-dealing brothers, the Bernheims.

Alexandre Berthier, the Prince de Wagram (1883–1918), was a phenomenal bulk-buyer of great art: he is said to have owned fifty Renoirs, forty-seven van Goghs, forty Monets, twenty-eight Cézannes, and so on, all of them acquired in a very brief period between 1905 and the month before Kessler's visit to Vollard. He had most of the galleries in Europe working for him, and he went into partnership with the Bernheim brothers and their cousin Jos Hessel as a sleeping director, under an agreement drawn up in January 1907 and registered on February 12. By April he was disillusioned.

According to Apollinaire, who published a short article on the subject, the Bernheims would buy a painting for 10,000 francs but tell the prince it had cost 50,000. Wagram tested their honesty by arranging for a painting to be sold to them—this at least was the story. It didn't stand up in court, and an amicable settlement was reached a year later. But Wagram had many other accounts to settle with other dealers, and from 1909 on the collection began to be sold. A large proportion of it is now dispersed throughout the great American museums.[15]

Vollard and Bonnard do not share Forain's glee at the imminent fall of the Bernheims, for the good reason that Vollard has his own partnership deals with them (they had collaborated, in the previous year, in

the purchase of Cézanne's estate) while Bonnard had, up to a couple of days before the evening Kessler describes, been exhibiting ten canvases in one of the Bernheim shows.

The pitiless cynicism of Forain's attitude to the Jews seems to contrast with the choleric outburst by Degas. But note the precise occasion for that first outburst. It is the contemplation of the story, passed on by Forain, of Bernheim *père*'s helping the defeated French soldiers in Belgium after the Prussian victory at Sedan. It is the thought that a Jew would have seen France's loss of honor, would have pitied it, would have helped French soldiers to abandon their uniforms and flee. This sense that the great issue for Degas is the honor of France and of its army takes us straight back to the spirit of the Dreyfus Affair, which was supposed to be essentially over in 1899 (although Dreyfus was not formally cleared until 1906).

Linda Nochlin asks, in her essay on Degas's anti-Semitism,[16] whether Degas would have made any connection between his actual experience of his many Jewish friends and the virulent sentiments of the anti-Semitic literature he had his housekeeper read to him at breakfast. One supposes, on the evidence here presented, that he could perfectly well have. In recounting a quarrel over money between the Bernheims and the Prince de Wagram, Forain certainly takes the line that the Bernheims are in the right and that the Prince de Wagram is a swindler—but that doesn't help the Bernheims either with Forain or with Degas. Nochlin is persuasive in her analysis of the "status anxiety" behind Degas's anti-Semitism. Degas's antecedents were not noble but had pretensions to nobility when they wrote their name de Gas. One sees the anxiety in his fear that if education becomes general, his position as an artist will be undermined; so the villains who are promoting education must be Protestants and Jews.

The high degree of sexual anxiety around the table is most striking. Kessler as a homosexual would have had most to fear from the conversation about how one can detect a man's sexual preferences. And yet there is a curiously needling element to the talk for Degas as well. After all, no one has found "traces" of any romantic involvement with women in Degas's biography; where does Forain's formulation—if you don't like women, you certainly like men—leave Degas, who was known as

a misogynist (although of course he had many female friends)? Forain's rather rough mockery of José María Sert for chickening out of a marriage for fear of congenital Neapolitan pox has its double edge for Degas, whose family were part Neapolitan and who suffered a congenital defect of some kind that was turning him blind.

Degas's mention of Wilde reminds us that he knew Wilde in the days before his fall. Oscar had said to him once, "You know how well known you are in England?" and Degas had replied: "Fortunately less so than you."[17] Degas's wit, when he was witty, had been of that sort, sharp and fearless, brutal if need be. Valéry's epithets for him at Henri Rouart's Friday evenings—"faithful, sparkling, unbearable"—describe him at the period when he was still thought good company. But even Valéry gave up on Degas as he became "more fierce, more absolute and unbearable." That Kessler should not have maintained the acquaintance is hardly surprising. He had embarked upon it just too late.

4

The extract from Harry Graf Kessler's diary follows:

Paris 19 June 1907 Wednesday

Early from London to Paris. Ate at Vollard's. He had arranged a dinner to bring me together with Degas. Beside us there were Forain, Bonnard and Sert,[18] and three women, of whom two were referred to as "Mademoiselle": one a small French brunette, Mlle. Georges, the other a Russian who came in her automobile and had the allure of a great lover from the Comédie Française, half *grande dame*, half *grande cocotte*. The honors were done by Mme. Levell, a Creole[19] from Jamaica, mature but attractively gay, and with red artificial roses in her hair—Degas cannot bear fresh flowers.

Degas, whom I had never seen, surprised me with the nobility and purity of his expression. He looks like a distinguished grandfather, or rather the face is that of a man of the world—but the eye—the eye is that of an apostle untouched by the world. The incipient blindness, which almost excludes the use of his eyes, adds something harmonious to this naiveté. In demeanor he was alternately taciturn and agitated.

He directed his first wrath against Forain, who was not on time: "If this were a duchess's, he'd be well on time. He's becoming *genreux* [Kessler's note: snobbish], very snobbish—Forain." Since he cannot bear waiting and always demands to eat at exactly half past seven, we went to table without Forain. It was explained to Degas that Forain always came late, even with duchesses. "Why? He has an automobile. Me, I only ever take the omnibus and I don't arrive late." He took this occasion to explain that he had arrived in the neighborhood five minutes early from the Gare du Nord. "I wanted to take the opportunity to go and check my watch against those in Guérin's, in the rue du Helder, but I couldn't find it any more. Has he moved, Guérin?" None of the oldest of those present knew anything about Guérin, who, as it turned out, had had his shop nearby during the Second Empire.

After a sharply spiced Negro curry, Vollard's speciality,[20] which Degas refused with abhorrence, Forain arrived, the most unrestrained joy suffusing his smooth-shaven old malicious actor's face. At first he left all questions unanswered as to why he was so happy. "At this moment I am eating. I'm not here for anyone, as Maître Jacques says." After he had sated himself with an enormous pile of rice with pepper, saffron, and curried meat, he blurted out: "But you don't know the news, ladies and gentlemen? Must I be the one to inform you? Well, the Hand of Justice has swept down on our old friends the Bernheims.[21] The experts are at their house. The Prince de Wagram is claiming three million from them. What's his charge against them? Forgery— forged documents, false inventories, swindling."

Everyone: "What? Is Wagram breaking the contract that he signed?"

Forain: "Wagram signed it, but Rothschild had second thoughts [*a réfléchi*]."

Vollard and Bonnard looked gloomy at this, but Forain became even merrier. He was asked whether the Bernheims' misfortune was the cause of his good spirits. "Yes, perhaps. Although, basically, in this matter I am *for* the Bernheims and *against* the Prince. When you bear the name of Wagram, you don't accuse others of swindling. You're a swindler yourself. And then the Bernheims have always been very good with me. But that doesn't stop them from being Jews."

Sert quoted what the old Bernheim said once to Forain: "You know very well, Monsieur Forain, one is only good at selling things one likes."

Forain confirmed this, and continued: "One day, I was chatting with Bernheim *père*, and he said to me: 'You see, Monsieur Forain, I too am a

patriot, but I don't like war. When I was on the battlefield at Sedan, and I saw all those poor people to whom we gave old clothes so they could pass the frontier, I had enough of war.' At that, I asked him: 'But tell me, Monsieur Bernheim, what the devil you were doing on the battlefield at Sedan?' And he replied: 'You see, Monsieur Forain, we were not yet French in those days. We were Belgians. We were following the ambulances.' "[22]

Degas, who up to now had listened silently, roared out: "How can you 'chat' with people like that? Come on—with a Belgian Jew who's a naturalized Frenchman? It's as if you wanted to chat with a hyena, a boa constrictor. These people aren't of the same humanity as us."

The conversation turned to the visit that Vollard, the Creole woman, and others wanted to make to a young painter, Chaplin,[23] in the Ile St. Louis, on Saturday. Forain: "The one with gold drapes in the john?"

The Creole woman: "I'm astonished you should start there, monsieur. *Everything* is refined, with him. He has such a beautiful mouth."

"Yes, I know—small moustache, pretty mouth. You did well to choose a Saturday. You should go there at midnight, at the sabbath hour, the hour for unnatural orgies."

Vollard: "Indeed, it has always seemed to me there was a slight lack of women at his place."

The Creole woman: "Vollard, how do you know?"

Vollard: "Well, you never see any traces."

The Creole woman: "What *traces*? What do you mean? Explain yourself."

Forain, joining in: "But why do you expect there to be any traces of women at his place? He's a *tapette* [Kessler's note: a passive pederast]."

The Creole woman: "Before destroying a reputation, it seems to me you should at least have the beginnings of a proof. How do you know what you are saying?"

Forain: "I don't *know* anything, but it shows: his little goatee, his stacked heels—a man doesn't make himself beautiful like that in order to please women. And then, he doesn't like women. And when you don't like women, you like men. That's certain."

Degas: "It's like that Englishman who came to die in a hotel in the rue des Beaux Arts—what was his name?"

Forain: "You mean Oscar Wilde, old Oscar. But with him it was different. He was your old-fashioned pederast [*c'était le beau pédé*]. He didn't want to please men. He was active, whereas Chaplin . . ."[24]

The Creole woman: "Well, I'm sure what you say is not true. It's *quite the contrary.*"

Forain, loud and triumphant: "Let's see, how can you know that? There would be only one proof. . . (looking at her sharply) Then you're his mistress?"

Sert intervened and turned the conversation to the Besnard family.[25] He asked Degas if he had already heard what a trick Vollard had played on Besnard in connection with the Cézanne monument. Vollard told of his trap and quoted Besnard's *mot* about Cézanne. "He's a beautiful, bitter fruit [*C'est un beau fruit saumâtre*]."

The Creole woman asked Degas if he had seen Besnard's catalogue with the introduction by his wife. Degas: "One wonders how Besnard could have put up with this woman, how he still exists, how he isn't even lower than he already is. A woman who writes a preface for her husband's catalogue—I ask you if that's not shameful."

Forain: "And after he has screwed five children out of her guts [*il lui a foutu cinq enfants dans les boyaux*]."

The Creole woman: "They should put a woman like that in a cage at the zoo."

Degas: "My *mot* sums him up—'He flies with *our* wings.' "[26]

Forain: "But there's Sert, who's a 'survivor' from the Besnard family. He nearly became the son-in-law, but he's afraid of the pox."

Sert protests: "No, no, it's not true. And anyway, the young girl is charming."

Forain: "Yes, I know, the young girl is very pretty. I'm not accusing her of having *caught* the pox. She has congenital pox. It's known. They all have the pox, the Neapolitan pox, the young girl like the rest of them."

They discussed whether Blanche[27] was a pederast; then the old eccentric Cabaner "who was a platonic pederast" as Forain explained. He told how Cabaner, the musician and intimate friend of Cézanne, had bought a picture from Cézanne, a landscape with naked men (now belonging to Caillebotte) and showed it to X [Kessler: I've forgotten the name] in order to convert him to Cézanne. "Yes," said X, "it's *beautiful like the overture of L'Africaine.*"[28] "You should have seen Cabaner's eyes."[29]

Degas to Sert: "We used to possess, in Cabaner, a Zurbarán, the living replica of the portrait of Zurbarán."

Forain: "During the Siege, we sometimes used to go, Cabaner and I, to dine in a little restaurant near Montmartre. One day when you could hear in the distance, as usual, the monotonous noise of the guns, Cabaner looks at

me with his eyes fixed and says, 'Still the Prussians?' I say to him, 'Of course, who the devil do you want it to be?' And he replies: 'I thought, perhaps, *the other people.*' "[30]

We had now reached the sweet course, an orange marmalade prepared according to a Negro recipe. Degas ate it with a kind of voracious enthusiasm: "It's deliciously bitter, deliciously bitter." He had the cook called in, to attest to his approbation, and added that she should cut the skin of the fruit slightly smaller, that would be even better. "But it's deliciously bitter, deliciously bitter," he kept repeating.[31]

Then it became too hot in the cellar and we went up into the shop. I spoke with Degas about his friendship with my aunt, Lady Colthurst. That was the only moment I saw something good in his expression.

Then Sert came and tried to interest him in a plan for a picture gallery in Barcelona. Degas became quite furious, fulminated against the popularization of art and the limitless increase in exhibitions, pictures, and artists. "Truly, with all that, the profession of the artist becomes disgusting. Today they want everyone to have taste in the way one has clothes—a vest, pants, ankle-boots. It's shameful! We're at the stage when they've given orders to the Paris garrison to take a detachment of soldiers, each week, to visit the Louvre, *conducted by a non-commissioned officer!* I just ask you what business soldiers have in the Louvre, and conducted by a non-commissioned officer? Isn't that shameful, shameful?"

The Louvre itself he thought not so good as before "since they began to shift the pictures. Does one shift a picture? You don't move the altars around in a church. The pictures in a museum are like altars. The light in which you see them, all that is part of it. Put the Gioconda in the middle of the panel and it ceases to be the Gioconda. But go and try telling that to the curators, who are failed journalists, barbarians, brutes."

At this moment he looked down and saw how the beautiful Levell, who was sitting on the table next to him, wiggled her foot. With a sudden darkening expression Degas ordered her: "Stop that, madame. *Stop that, madame!*" and she, thinking it a joke, laughed and wiggled her foot again. "No, stop that. It's impossible for me to see that. It makes me feel sick. They say that X had a wife who did that for thirty years and he could never correct it! And that made him feel sick, like me, for thirty years!"

Then he continued his invective against the popularization of art and the Intelligentsia in general—"The Intelligentsia with a capital I. The Intelligentsia

corrupts the people."[32] To the young Russian woman: "You too, you are going to corrupt your people now, by education, mademoiselle. It's Jews and Protestants who do that, who destroy whole races with education. Obligatory instruction—it's an infamy. There!"

Forain, who sat among the skirts of the three women as if in a basket, from his corner: "Monsieur Degas, I am of your opinion. I am an obscurantist."

Degas: "You should do something against instruction, Forain."

Next they spoke about Edwards,[33] the owner of *Matin*, who is Turkish, and about his various marriages. Someone asked Forain, if a Turk married a Catholic woman, if it was like a marriage between Catholics and Protestants. Forain said no. "Clearly our Holy Mother Church has less repugnance for a Turk than for a Protestant. Still, however, it happens . . ." So Forain explained, in his role as expert authority on religious matters.

Staying on Church affairs, Sert told how in certain Galician villages, where the whole male population spends a long time at sea, nearly all the children are the priest's. Forain, with excitement: "Ah no, ah no, you offend against our Holy Mother Church. You will burn for that. What you say is an infamy. It is not true."

Sert roared out that he knew what he was talking about, etc.

Forain: "Look, there's not a word of truth in it. The priests in Spain are all pederasts."

Then Forain became sentimental and told brothel stories from his youth, in particular how he had had a truly tender relationship with a prostitute from the bordello "le Monthyon," so that he would go with her, on her day off, to breakfast at her aunt's: "Because I'm tender, me." Mme. Levell, against whom he leaned with one arm, confirmed this: "It's true, he says that laughingly but it's true. There's a tender side to Forain."

Then the portrait of the "Mistress of van Gogh" was brought out (naked in stockings on a bearskin).[34] Degas noisily turned his chair around and turned his back to the picture. Forain, who had one hand on Mlle. Georges's knee: "I find what's well done are the hairs"—the pubic hairs, which van Gogh had painted in very bold detail.

Degas, who now looked at the painting with one eye, told how this morning he had seen a market woman lift up a bunch of carrots and by chance she had held them against her hair. The color of her hair was almost exactly the same as that of the carrots. Forain: "You'd have done them with the same crayon, eh? She should be astride a famous squirrel, as they say—that one." For the

rest, he found naked women disgusting. In the Cercle Hoche (?) they recently had women dancing naked, "but I left before the end. I went off to excite myself with clothed women."

Then they told some lesbian stories and around 11 Degas took out his watch and left.

Thus the new "truly French mentality." Sert asked me, as we left, how I found Degas as a person. I said: "A fanatical, maniacal fool."

Degas in Chicago

I

A week after his dismaying evening with Degas in June 1907, Count Harry Kessler was back again for dinner in Vollard's cellar, to meet one of those artists with whom Degas was no longer on speaking terms: Renoir. Eight years before, in 1899, the two old men had been good friends: they had both fallen in love with the same Cézanne watercolor, at Vollard's, and had drawn lots to determine who should buy it. Degas had won. In November the same year, Renoir, feeling the pinch, had decided to sell a Degas pastel he had acquired from the Caillebotte estate. Degas had sent him a letter of such impertinence that the falling out had been for good.

On this occasion, Kessler and Renoir appear to have hit it off immediately. They shared an admiration for Maillol's work, and so had something to talk about. Renoir had seemed at first sickly and senile, suffering badly from the rheumatism that had made his fingers look like tree roots, but as soon as he spoke he became, for Kessler, "a sort of Prince Charming," captivatingly fresh and young, with the manner of a twenty-year-old.

The company was similar to the previous week's: Bonnard, José María Sert, Mlle. Georges, and the "Creole woman," Mme. Levell, along with the painter Maxime Dethomas (1867–1929) and another of Vollard's colonial friends, the poet Paul-Jean Toulet (1867–1920). Vollard tried to set the tone for the evening, with a story about a man who kills his wife by kicking her in the stomach, but earned a rebuke from Renoir, who told him that his story wasn't funny. It *wanted* to be funny, but it wasn't.

135

The story had come from Octave Mirbeau, whom Vollard believed the greatest writer of their day. Renoir thought Mirbeau a brute, with his continual need for the excessive:

He's like this butcher who was in Switzerland and saw two mountains. One was four thousand meters, the other three thousand. Naturally he found the one of four thousand meters more beautiful than the other. Mirbeau needs mountains of twelve thousand meters in the landscape. He doesn't see that beauty is everywhere—on this table, in this glass, just as much as anywhere else . . . You have to find beauty everywhere; that's what the poet does. But Mirbeau, if he wants to paint an apple, it's not enough for it to be of normal size. He has to have it *like that*.

Renoir's tree-root hands described an apple half a meter wide. He recognized that Mirbeau had talent, that he was a searcher after truth, but . . . "It's the same story with Courbet," Renoir went on: "For him, Realism meant painting the head of a peasant woman. As soon as you wanted to paint something pretty, that was no longer Realism. That was called Idealism."

At this point, Sert, misunderstanding Renoir's point, tried to defend Idealism, saying that one wasn't always obliged to paint reality.

"Who paints Truth?" asked Renoir. "I've never even been able to render an eye exactly. And if one *did* render the truth, perhaps it wouldn't please us. That's my quarrel with Degas, who faulted us for calling ourselves Impressionists. He wanted to call himself a Realist. But Impressionist is much more accurate and much more modest."

They were eating a palm salad, made from the fleshy section at the top of the tree—a surprising dish to find in Paris, even today. Renoir was warming to his theme:

Every artist puts something of himself into what he does, whether he wants to be a Realist or not. Look, take Velázquez and Goya, who were both of them Realists. But when Velázquez paints the members of the Royal family, they all become noblemen, because Velázquez himself was a nobleman. But Goya, when he painted the Royal family—he made them look like a butcher's family in their Sunday best, like savages, dressed up in gilded costumes with epaulettes. Everyone puts something of himself [into a painting]. What survives of the artist is the feeling which he gives by means of objects.

And he went on to compare Hogarth with Chardin, and to praise him as the greatest painter of the English School.

So Impressionism, for Renoir, was as much about the impression rendered as the impression received. It was the feeling put into the painting which made it distinctive, and it was the Degas of the later years, more than the *soi-disant* Realist, whom Renoir truly admired. And at the head of Richard Kendall's catalog to the current Degas show in Chicago, it is a remark of Renoir's to Vollard, on a different occasion, that is given pride of place: "If Degas had died at fifty, he would have been remembered as an excellent painter, no more: it is after his fiftieth year that his work broadened out and that he really became Degas." And again, when Renoir made the remark, "To think that we're living in an age that has produced a sculptor to equal the ancients! But there's no danger of *his* ever getting commissions," Vollard took him as first referring to Rodin. Renoir said impatiently:

Who said anything about Rodin? Why, Degas is the greatest living sculptor! You should have seen that bas-relief of his . . . He just let it crumble to pieces . . . It was beautiful as an antique. And that ballet dancer in wax! . . . the mouth . . . just a suggestion, but what drawing![1]

And Renoir never withdrew this admiration for Degas, even if Vollard was obliged to invite the two grand old men on different nights.

2

Actually there was no quarrel between Renoir and Degas when it came to the conception of Realism. If anything, Degas was less of a Realist than Renoir, if by Realism we imagine a process whereby the painter sits down in front of his subject and attempts to render faithfully what he sees in front of him. Degas stormed around Paris in old age, fulminating against *plein-air* painters: he thought they should be dispersed with a whiff of grapeshot. He told Daniel Halévy in 1904: "Beauty is a mystery, but no one knows it any more. The recipes, the secrets are forgotten. A young man is set in the middle of a field and told, 'Paint.' And he paints a sincere farm. It's idiotic."[2]

Degas once said that if he were to found an art school, he would rent a house with six floors. He would put the model and the beginners under the roof. As the student progressed he would move to a lower floor, until finally he reached street level. Every time the student wished to consult the model, he would be obliged to climb to the sixth floor again, then redescend.[3]

So a training in art was a training of the memory. A course of this kind actually existed in the Paris of Degas's day. It was run by Horace Lecoq de Boisbaudran, on lines even stricter than those imagined by Degas. One began by drawing a straight line, of a given length, from memory. The next lesson was to draw a square, and the third, a circle in a square. One could not progress beyond any stage unless one had acquired the previous lesson's skill—the drawing by memory, always freehand of course, of a given curve, of given dimensions. One progressed through the memorizing of drawings, engravings, or lithographs. One progressed from fragments of human heads to the head itself seen in different aspects, and everything was analyzed first in outline, only later with any shading.

And only at this stage in Lecoq's course would his students have been allowed into Degas's imaginary school, to draw from the nude, from memory. At weekends Lecoq would take his most advanced students (who included artists as various as Rodin and Fantin-Latour) to the countryside near Paris, where they bathed in a pond. They found a garden with high walls, where their models could dance around in the buff, and the students were told: remember this gesture, this dance movement, because you will not see it again. And it was on the following Mondays that they would go to their drawing boards and set down what they had seen. But none of this had any necessary connection with Realism—the reverse might be more true. Lecoq wanted his students to forget, where necessary, the common imperfections of his models.

An academy exercise of the nineteenth century, by comparison, is a form of realism. These imperfect nudes, with their creased flesh and their period facial hair, bring with them a strong whiff of the real life of the studio. They have a melancholy beauty, for those who can bear so much imperfection (Nureyev's apartment in Paris was full of them), so many naked bodies crying out for clothes. Only the poses—which

were of course the point of the exercise—are dead. Indeed it is hardly right to class them as poses. Posing is an activity, but these bodies are draped over their supports—cubes and wedges, packing cases, and what look like slabs of cheese to help a foot to maintain the proper angle. Every hand would have tired long since, without the dowel peg set at the right height, or the meaningless staff to clutch. These bodies are not doing what they pretend—*that* was the objection to them. When they seem beautiful today, it is as disappointed people, waiting for their release.

Lecoq's system was designed to capture the spirit and freedom of the body in motion. He rented disused rooms in the Palais de Justice, where he had classically dressed models moving around for his students to observe, and to commit to their memory. His method survives in the accounts of Rodin's studio practice, in which the nude models (men and women on different days, as in a public bathhouse) were left to their own devices, to wander around, stand, or sit as they liked, until Rodin saw something out of the corner of his eye, something that struck him as particularly fresh.

And the success of that method can be seen in the most famous pose of all—the most frequently misremembered pose in art, that of *The Thinker*. The cartoonists always get this wrong. George Bernard Shaw, who went to the lengths of posing for a photographer as the nude *Thinker*, gets it wrong.[4] Everyone thinks that *The Thinker* has his right elbow on his right knee, or his left on his left, whereas the pose is much more difficult and idiosyncratic than that. The right elbow is placed just short of the *left* knee—a pose which forces the back into its sharp forward angle and brings the whole center of gravity so far forward that the figure almost overbalances. Even allowing for the weight of the base, this is liable to happen, and apparently the way those in the trade can easily tell a bad cast of *The Thinker* is simply by giving it a forward push and seeing if it topples.

The point is not Realism. The point is expressiveness. *The Thinker's* pose expresses the effort of thought. The pose that Degas observed in his portrait of Manet as he listened to his wife's music has a similar dynamism. Manet lies back in the sofa. His right knee has sought contact with his right elbow, while his right hand plays with his

mustache, and his right foot (he is wearing spats) catches the edge of the upholstery. His left hand is in his trouser pocket and his left foot has disappeared—intimately enough, but not scandalously so—under his wife's dress.

Everyone found the portrait uncannily like Manet. Degas could have remembered the pose, in part, by expressing it verbally, running through its constituent elements, as in the previous paragraph. Memory of this kind requires rehearsal, and rehearsal requires some form of annotation, which may well be verbal. This was Whistler's method. A friend described walking with him past Chelsea Hospital when Whistler suddenly stood still, having seen something he should like to paint. The friend offered his sketchbook, but Whistler refused. He remained silent for a while, then said: "Now see if I have learned it." Then Whistler recited a full description of the scene, the scene which he had committed to memory and would be able to set down the next day.

The grammar of Lecoq's method of annotation was based on geometry—one committed shapes, outlines to memory—although he had a separate system for the recollection of color. Degas's grammar came from a study of other artists, and he used to claim that Ingres had advised him never to study from nature. In his *école imaginaire*, he would have forced the best students to exhaust themselves, and perhaps humiliate themselves a little as well, by climbing six floors to the beginners' level, where they would make their mental annotations and then descend six floors (going past all the intermediate classes) before returning to their drawing boards.

But throughout the last years of his working life he himself remained at the beginners' level, in a studio under the roof, and this is where his models sat for him.

3

He lived on three floors of a house in the rue Victor-Massé. On the second floor he kept most of his collection, in a vast bare room which few ever saw—a room crammed full of paintings on easels, the "museum" of his early work and that of his predecessors and friends. Also on this floor, Degas slept and had his dressing room. An honored

guest might well be allowed into the bedroom, to be left alone for a few minutes to contemplate one of the loveliest of the portraits (now in the Musée d'Orsay), Degas's father listening to the guitarist Lorenzo Pagans.

The third floor, where the housekeeper Zoé slept, was the apartment proper, furnished in bourgeois style with expensive rugs, the family furniture, a silk-covered chaise longue, paintings by Manet and Mary Cassatt. This was the floor on which one was entertained, where Valéry consumed all that Dundee marmalade and that plain macaroni. As long as Degas maintained a social life—and Richard Kendall is at pains to point out that he did so for longer, and to a greater extent, than is sometimes imagined—it was here that he did so. Respectability was the theme.

Whereas on the fourth floor, the studio, Degas would only allow Zoé to clean a route from the door to the dais where the models worked. They would beg her at least to dust the bench where they were to put their clothes, but she was under strict orders: cleaning only shifted the dust around, and Degas would have none of it. Renoir had once rented this studio. For Degas's purposes it was essential that not too much light should be allowed in. The north-facing windows were draped with a linen curtain, and the clutter of furniture further diffused the light.

Strong light troubled Degas, and he was obliged to wear tinted glasses in the street. There is a temptation, then, to suppose that the very strong colors of the pastels are a compensation for the extremely poor lighting in which the photophobic Degas worked. I don't believe this had more than a marginal influence. After all, Degas had consciously chosen pastel itself in preference over oil, and must have done so for the sake of certain colorific effects, most notably the fact that, despite areas of smudging and working over, a large proportion of color in one of his pastels is as it would have come from the supplier. That is the challenge of the medium. If he hadn't welcomed it, he was not obliged to restrict himself. But we saw a glimpse of what attracted Degas in the previous chapter, where he describes the woman lifting a bunch of carrots, and the carrots are the same color as her hair. Carrot was one of the colors Degas found valuable.

The walls of the studio were painted some kind of chestnut brown, and the place was full of props with which to mock up the scenes he worked on so often: the tubs, the towels, the bathrobes (in disgusting condition, according to Valéry), the bench for the ballet dancers, and so forth. One wonders again and again why on earth Degas actually needed such prosaic and familiar objects for the kind of work he was doing in the later years, in which the execution takes off from the theme, in which no great value is set on loyalty to specifics. Degas of all people knew what a tub looked like, by this stage in his career. And it was he who preached that the model was dispensable.

One could easily imagine, though, that Degas worked with models for the sake of the companionship—they went from painter to painter, and brought gossip with them, if the artist was in a talking mood. Or perhaps the arrival of the model, along with the routine of the lighting of the stove, the setting up of the backdrop, and so forth, served as a stimulus to work, in the way that, Degas said, his sculptures did: they were not intended as finished objects in themselves, they were ways of getting started.

Of course, every artist is entitled to an odd way of working. If it works, it *works*. Vollard, walking along the street, noticed a horse being hoisted into an artist's studio. Degas's horse paintings were devised in the studio, using wax models made by the artist. It seems, to my way of thinking, an almost scandalous procedure. But then a great deal about these sculptures is tinged by scandal.

4

We are used to seeing Degas sculptures around the museums of the world, and used, perhaps, to the idea that these bronzes were only cast after the artist's death, and that they therefore have not benefited from the kind of attentions that a sculptor would normally bestow on a work of art, after it comes from the foundry. The finish of the various figures (there are seventy-four in all) varies sharply, from an almost black patina to the rich chestnut color of the *Dancer looking at the sole of her right foot* (*Degas: Beyond Impressionism*; cat. 82, Chicago, Ursula and R. Stanley Johnson Collection), which so vividly conjures up the cracked wax

original. It is said that the various different finishes were designed to imitate the condition of the wax originals. For a long time it was thought these originals had been destroyed during the casting process, that their *cire* had been *perdue*. Not so. In 1955 the majority turned up and were exhibited in the Knoedler Galleries in New York. Paul Mellon bought them, presented some to the Louvre, some to the National Gallery in Washington and the Virginia Museum of Fine Arts, Richmond. The remainder are promised to Washington.

It was still thought that the edition of twenty-two of each of the figures was taken directly from the wax originals. Again this was not true, and in 1976 a complete set "turned up" again, which proved to be the bronze *modèles* from which all the other bronzes had been cast. These were exhibited at the Lefevre Gallery in London. John Rewald wrote the introduction to the catalog, in which he says that he had seen this set in Hébrard, the founder's, cellar years before, but had not realized its significance. "It is regrettable," he wrote, "that, through sheer negligence, no mention was ever made of this set," which he describes as "*master casts.*"

You would have had to be quite attentive to the wording to realize its implication—indeed, I have the original publicity handout from the Lefevre show, which underplays the *modèle* set's significance. But if the *modèles* are master casts, it follows that all the other Degas bronzes are after-casts, or *surmoulages*. Quite why Rewald doesn't state that clearly, I do not know, but in 1995 a (possibly) definitive account of the state of affairs was published in the August issue of *Apollo*. The master casts, which were bought by Norton Simon and are now in Pasadena, are one single set which was kept by the Hébrard firm for itself. They differ from all other Degas bronzes in having greater surface detail and in being 1.5 to 3 percent larger than the second-generation casts. It also turns out that there are substantially fewer of these genuine second-generation casts around the world than was previously thought. Sara Campbell of the Norton Simon Museum tracked down references to 1300 of them, as opposed to the theoretical 1600-plus there would have been if the edition had been complete. Finally, the casting of these pieces took place between 1919 and 1932, and not during the three-year span originally thought. As a result of Campbell's researches there is now an atlas of Degas sculptures. But the upshot in sum is: if you want to see

the real things, be nice to the Mellons; if you want to see the bronzes cast from the real things, go to Pasadena.

At every stage of the production and reproduction of the sculptures, there are questions to be raised about the nature of a work of art. Degas, who made them, said they weren't works of art, and that they would anyway not outlive him because they would just crumble away. Renoir said they *were* works of art of the highest order. Mrs. Havemeyer, who bought a complete set of the second-generation casts, bequeathed them in 1929 to the Metropolitan Museum, whose embarrassment was evident from an article in the museum's *Bulletin* of 1946, which called Degas's "clay studies" the "principal amusement" of his old age, which "cannot be considered as serious works in sculpture in the academic sense of the word." And: "It has been remarked by certain critics that the duplication of these unfinished sketches in twenty sets of bronzes . . . is rather too plainly a franc-stretching gesture on the part of the [artist's] heirs."[5] (Was it during this period of neglect by the museum that one of Mrs. Havemeyer's set went missing?)

In several cases, Degas's sculptures may be taken to be quite other than an amusement in old age. Obviously the *Little dancer aged fourteen*, which the artist exhibited, counts as a finished work of art, and was greeted with much admiration in 1881. At least three other figures were cast in plaster, in preparation for casting in bronze.[6] Then there is the *Head supported by a hand*, which Theodore Reff, in his essay "The Morbid Content of Degas' Sculpture," convincingly re-identifies as a memorial portrait of Perie Bartholomé, the wife of Degas's sculptor friend. And there is the lost relief to which Renoir referred, which he had found as handsome as an antiquity. A small wax relief sketch survives (it is in Washington), from which it is hard to tell what has recently been discovered, that *Picking Apples* was originally planned as a memorial to Degas's niece, Marie Fevre. If it reminded Renoir of an antiquity, that is probably because it looked like a sarcophagus relief. Jacques-Emile Blanche, who saw it in December 1881, described "a new sculpture he has made: a little girl half reclining in a coffin, eating fruit; beside her, a bench where the child's family can come to weep (for it is a tomb)."[7]

Enough is known about the seriousness of Degas's sculptural endeavors to cast doubt on the artist's remark in an interview in 1897 that

"the only reason that I made wax figures of animals and humans was for my own satisfaction, not to take time off from painting and drawing but in order to give my paintings and drawings greater expression, greater ardor and more life. They are exercises to get me going; documentary, preparatory motions, nothing more. None of this is intended for sale . . ."

One section of the Chicago exhibition is devoted to a comparison between the sculpted figures and the same poses as they appear in drawings and pastels. The correspondences have been very well chosen, and yet Richard Kendall is careful to indicate that we do not know when the sculptures were made, and therefore what the precise working process was. It seems plain to me that by the period covered in this exhibition, Degas had ceased toying with what was once an ambition—to produce work as a sculptor. The thought of casting anything in bronze inhibited him—it was too grand, too permanent. But he was an inveterate modeler—never, it seems, a carver—and he found satisfaction in linking his modeling with his other work.

Reff, who is one of those who compares Degas to Leonardo, points to a contradiction in his personality between technical innovator and amateur scientist on the one hand and disenchanted dreamer and reactionary on the other. He allowed his works to be ruined by his indifference, even by something as penny-pinching and obtuse as a stinginess with modeling clay—plasteline or Plasticine. Radiographs have confirmed that he would eke out this material with pieces of cork, which would sometimes come to the surface. One of his models recorded the frustration this would cause him: "I must be an idiot to have put corks in this figure! Imbecile that I am, with my mania for wanting to make economies of two coppers! There is my [sic] back entirely destroyed! Oh, why did I thrust myself into sculpture at my age?"[8]

5

Degas first exhibited in Chicago in 1893, with two paintings in the World's Columbian Exposition. But Mrs. Potter Palmer, who collected French paintings for the picture gallery of her house on Lake Shore Drive, owned only six works by Degas (as opposed to ninety-odd

Monets), so Chicago got off to a slower start than New York and Philadelphia, where the Havemeyers and Cassatts lived. Nevertheless, Chicago collectors did like Degas, although their taste ran to nothing that was less than respectable. Over the years, through bequests and acquisitions, the Art Institute's collection grew until in the 1980s it could claim to be the largest and most representative collection of Degas after the Louvre and the Met.[9]

When the National Gallery in London got together with the Art Institute to organize a show devoted to the late work, they were faced with the problem that many collections are unwilling to lend pastels, on account of their fragility. France, for instance, has an almost complete ban on lending pastels (but not, curiously enough, on borrowing them), and there are consequently no French loans in the current show. But Chicago has, in Harriet Stratis, an expert on pastel conservation, and the two institutions were able to devise a method for transporting the works (a system of crates within crates) which cut out vibration. Quite apart from its artistic significance, the putting together of the exhibition is something of a technical triumph, and a triumph of persuasion. Very few requests for loans were turned down, and the organizers anyway took care not to request any particularly fragile work.

But pastel is not necessarily as fragile as some fear, and many of Degas's works in the medium are apparently quite robust objects. It could so easily have happened, as with the sculpture, that the artist himself had made the works impermanent, but fortunately enough the Leonardo side, the crazy scientist in Degas, got the method right on this occasion. Whatever recipe or recipes he used for fixative (essentially, a solution of shellac in white spirit) worked, and held, and did not discolor—although it might slightly have muted the pigment. Degas possessed what Walter Sickert described as a "ball syringe," perhaps some variant on a perfume spray or gardener's Flit gun, with which he fixed and refixed the work as he went along. So each discrete layer of pigment—and these visible layers are essential to the technique—is sandwiched between layers of shellac or some other transparent matte substance, culminating in a rough surface appearance which Sickert compares to that of a cork bath mat.

Aware that some suppliers' pigments had proved impermanent, Degas, according to Vollard, used to soak the sticks of pastel in water and

leave them in the sun. He went in for newfangled colors manufactured by Henri Roché. As Kendall says, "The scintillating ultramarines, violets, yellow-greens and oranges of *Dancers* (cat. 23) might be an advertisement for Roché's latest products or the achievements of modern chemistry, while the tangerine highlights of *Two dancers on a bench* (cat. 30) seem like a celebration of a new, electrically intense pigment." Although pastel itself has strong eighteenth-century associations as a technique, in Degas's version it has a swanky modernity. J.-K. Huysmans referred to Degas's "neologisms of colour."

One unexpected eighteenth-century practice revived by Degas is the use of more than one piece of paper for a picture. Degas sets out with one plan, then seems to change his mind completely about the dimensions of the composition. He starts work on tracing paper, pinned to a board. Then he changes his mind and adds another strip of tracing paper to enlarge the composition. Having reached some stage of certainty, he unpins the pieces of paper, rolls them up, puts on his coat and hat and the blue-tinted glasses he has to wear in the street, and goes off to one of the framing merchants—often a certain Père Lézin—who can be trusted to glue the tracing paper to cardboard, bringing the edges together in a neat butt joint with no overlap.

Perhaps this had the psychological advantage of "getting him out of the house," but it seems an odd, complex, and one would have thought intolerably self-revealing procedure, since it advertises every change of mind. On the other hand, it perhaps liberated the artist from uncertainty. One can imagine him saying to himself, as he played around with different strips of paper, "If this were a canvas I wouldn't be able to do this." And there are two canvases in the show—the *Nude woman drying herself* from Brooklyn (cat. 9) and the National Gallery's *Combing the hair* (cat. 42)—that are left unfinished, through some kind of crippling indecision. Of course the subsequent history of painting has accustomed us to the "look" of both works, and we find them immensely striking. (*Combing the hair* used to belong to Matisse.) But Degas no doubt thought of them as failures, and they remain unsigned.

Another unsigned work, the highly sculptural pastel called *The Bathers* (cat. 88), is perhaps the grandest item in Chicago's Degas collection (see illustration), and one could observe it making a great impact in

London. It began life as a rectangular composition, but was made almost square by the addition of strips of paper above and below. Degas started with one piece of tracing paper, on which he traced two nude women from a previous pastel. Then he turned the tracing paper over to reverse the image and added a third figure, no doubt from memory, apparently based on an early copy he had made of a warrior from the foreground of Michelangelo's lost *Battle of Cascina*. Oddly enough, although Degas intends a woman, and has given the slight indication of a breast, this figure retains something of its maleness, and makes one wonder at first quite what is going on.

In the background, at the center of the composition, is a semi-submerged version of the background figure in Manet's *Déjeuner sur l'herbe* (which was originally known as *Le Bain*)—a woman bathing in the river. The woman on the left sits on the riverbank, while the strange monumental central figure appears to be rolling around on a rug. The Michelangelo figure is putting on her stockings—just as in the *Battle of Cascina* he was girding himself up to face the enemy. But at this stage of the concoction of the composition, Degas began to have doubts—maybe a bit more sky, maybe more foreground. And soon it was time to reach for the hat and the tinted spectacles, and go to a shop a couple of streets away in the rue Fontaine to get the whole composition mounted on board. But afterward Degas made only the slightest attempt to unify the three elements of the picture, the three pieces of paper.

That he was addicted to difficulty is an old observation. When Yeats writes—

> The fascination of what's difficult
> Has dried the sap out of my veins . . .

—we feel that, if he is able to write the lines, they cannot quite be true. But Degas seems to have known what was coming, and the price he was going to pay. He renounced portraiture, equestrian scenes, brothel and cabaret scenes, and narrowed the obsession down to the nude and the dance, or even nude dancers. He had his props—the tub, the stale tutus, the ballet shoes, the horrible old towels—and his portfolios crammed with drawings. He had his crumbling statuary and, on days when there was no model, he would draw one of his dancers, then

turn the statuette by a few degrees and draw it again, so that he had two dancers; turn it again, and then there was a plausible threesome.

He loved macaroni. Nobody explained to him that you don't eat Dundee marmalade neat. The Jews and the Protestants were destroying France. He looked at his watch. There was a good watchmaker once in the rue du Helder, a good *French* watchmaker—they'd know what time it was. The dust came off the pastel. It spread up his fingers, everywhere. He didn't button up his trousers properly. He didn't "close the carriage doors." He could hardly see.

Art was the product of "a series of operations." If he dropped off *The Bathers* at Adam Dupré's shop, he could guarantee a good butt joint. Then he could walk to the Gare du Nord and take the omnibus down to the opera. At Guérin's he could find out what time it was. It was a very good thing, a very good thing, that he had managed to find such a perfect ball syringe for his purposes. Chialiva had told him the secret of a good fixative.

He sprayed the pastel again. The time was the twentieth century. Zoé had to leave. He knew he was going to be alone with his art. But he had always foreseen this. He had known what was coming. His friends deserted him. They were Jews and Protestants. He hadn't drawn men for years. There was only one subject, but art was the product of a series of operations: one washed in the river, one sat on the bank and dried, one rolled around on the rug (the little hussy!), and one put on her stockings and prepared to face the enemy.

In 1912 the house in the rue Victor-Massé was pulled down, and Degas's life came to an end in a cloud of rubble and dust. Five years later he died.

Seurat and the Sewers

In 1857 Charles Daubigny went to Asnières, on the north-west outskirts of Paris, and bought himself a flat-bottomed rowing boat which had been fitted out as a ferry, and which he could use as a traveling studio. Together with a friend, and with his son as cabin boy (for the boat was large enough to need at least two oarsmen), he took a trip down the Seine, which he recorded for the amusement of family and friends in a series of drawings, some of which he later worked up into etchings, published in 1862 as *Voyage en Bateau*. The series begins with the dinner before departure from Asnières, which is shown as taking place in a modest, timeless-looking inn, under a vine or some sort of pergola.

And so the idyll begins—but it is a comic idyll, its adventures and discomforts being the whole point of the story. The most familiar of the etchings, "Le Bateau-Atelier," may hardly seem comic when taken out of context. The painter is seen from the depths of the covered section of the boat, framed against the light, working with a portable paintbox-cum-easel at one of the riverscapes for which he became famous. However, the objects around him—the bedding, the water jug, the string of onions, the frying pan, the coffee pot—are all part of the developing story (we have seen several of them before, earlier in the series) and contribute to the novelty, the cozy incongruity of the improvised boat-studio. On the back of one of the stacked canvases is written the word *Réalisme*. These are the lengths you have to go to, the etching says, in pursuit of the realist motif. This is what goes on in the artist's world, as it were behind the scenes. This is what you don't see in the finished picture (as Daubigny conceived it).

Satire and burlesque have often provided a home for realistic observations that could not somehow be accommodated in the "higher" forms of art. It was not that Daubigny was utterly averse to depicting modern life. In 1860 he published an admirable, detailed etching of a steam-powered threshing machine, with a publisher's note to the effect that "M. Daubigny sees in agriculture, in work, in a word, the vigorous and virile expression of truth in art." In 1866 he drew the Crystal Palace. He painted the grimy tugboats of London and Le Havre. For the Seurat show in London, *Seurat and the Bathers*, the organizers borrowed from Brooklyn a Daubigny view of *The Seine at Mantes* which clearly shows, in the distance, a smoking factory chimney. But this is not a typical Daubigny riverscape.

Typical rather is a sense of nature modified, but only gently so, by human effort; of architecture, where it features at all, well patinated by time; of rural labor seen, if not *sub specie aeternitatis*, then at least in its traditional aspect. It is not that one should forget about the history of France when looking at Daubigny or the landscapes of the Barbizon school. On the contrary, one should be aware of what is being sought out on these idyllic excursions. It is pointed out in the Washington DC, exhibition, *Impressionists on the Seine*, that since Paris was provided with running water (a process completed by the time of Baron Haussmann's resignation in 1870),

the need for bathing and laundry establishments *in* the river decreased every year. Consequently it becomes clear why the washerwomen of Daumier who trudged toward the Seine with huge bundles of clothes and linens were replaced in the 1870s by Degas's laundresses who worked indoors in establishments that were fed by piped water . . .

But Daubigny seemed to find no difficulty, in his potterings up and down the Seine and its tributaries, in finding women washing their clothes in the river. The countryside is seen as custodian of practices that are dying out in the city.

The etchings of *Voyage en Bateau* achieve their comic effect by being more frank about the vicissitudes of modern river life than the paintings were able to be. In "Gare aux vapeurs" (Watch out for the steamboats) we see how the little boat-studio is rocked in the wash of the newfangled paddle steamers. Having been privy to the discomforts of the trip, we

are finally shown, in the last of the etchings, how the artist surrenders to modern comforts by making the return journey by railway, while the boat-studio gets tugged back to Asnières by steam. There would be no question of rowing the thing all the way back upstream.

And what of Asnières itself, the point of departure? One would hardly guess from Daubigny's etching that it was (and still is) only ten minutes by rail from the Gare St.-Lazare. A couple of cartoons by Doré, published the year before Daubigny's view, show what was happening to this part of the Parisian outskirts. Both depict the same view of Asnières railroad station. In the first ("L'Arrivée à Asnières") the stationmaster is almost knocked aside by the rush of weekend trippers, eager to sample the delights of the river—the boating, the dancing, the drinking. In the second ("Le Retour à Paris") the visitors are so fagged out at the end of the day that the same stationmaster has to bark orders at them to get them back on the platform as the Paris train approaches.

The Seine, which looks quite purposeful on its way through the center of Paris, is in fact meandering, and it turns back on itself to loiter along the far side of the Bois de Boulogne, creating a series of islands, the last of which is La Grande Jatte, before passing Asnières on the one side, Clichy on the other. Asnières was thus the first of a series of riverside resorts served by the Gare St.-Lazare, and being the first it enjoyed the most fragile ecology. Within ten years of Daubigny's etched idyll, when Monet sat down on the Clichy bank and painted what had happened to Asnières, the countryside had disappeared under villas (most of which have since made way for larger developments).

By now, the painters who came to Asnières did so in order to find the kind of industrial riverscape that interested them. They came like Monet in 1875 to paint men unloading coal from the barges. They came like van Gogh, Signac, and Emil Bernard to paint the railway bridge (conveniently, the first such bridge along the western railroad line), the road bridge, or the coal crane at Clichy.

What they didn't come for anymore was the bathing. After the days of Baron Haussmann, nobody who wasn't desperate would have wanted to bathe at Asnières.

2

Just as the provision of piped water changed the lives of the washer-women and the artists of Paris, so its necessary counterpart, the sewage system, has played its part in art history.[1] Haussmann did not invent his system from scratch. He inherited a scheme in which the main collector sewer on the Right Bank followed the route of the rue de Rivoli. This main collector was the recipient of all the foul water from the houses and streets—carrying everything except the night soil, which was sup-posed to be collected from the cesspits periodically and carted off for use as fertilizer. The plan had been that all the Right Bank sewage would flow westward beneath the rue de Rivoli to the Place de la Concorde, and then continue toward an outlet into the Seine, just opposite where the Eiffel Tower now stands. But the problem that exercised Hauss-mann for many months was that, since there was no great distance in height between the sewer and the river, whenever there was flood weather the sewer would back up. In London, this problem was made worse by the tidal nature of the river. A gravitational sewage system would have backed up all the time, and so Sir Joseph Bazalgette was obliged to devise a set of powerful pumping stations which sucked up all the effluent into high-level reservoirs, to release it only at low tide.

The solution for Paris came to Haussmann (he claimed) after a sleepless night studying the map. Because of that loop in the river, it would be possible to direct the sewage not in a westerly but in a northerly direction. Entering the Seine much farther downstream, it would benefit from the seven-foot drop between the river in central Paris and its level at Asnières. Furthermore the Left Bank collector, which follows the bank of the river itself, could be diverted under the Seine by means of a siphon at the Pont de l'Alma, then up again on the Right Bank, along the Champs-Elysées to the Place de l'Etoile. Meanwhile the Right Bank sewage, turning right off the rue de Rivoli at the Place de la Concorde, would be nipping along to the Madeleine, and thence by means of the boulevard Malesherbes to a point at which, meeting up with its sister sewage from the Left Bank, it would form the Asnières collector, a kind of super-sewer, a veritable underground river to be kept dredged by boats, a river which, finally entering the Seine at

Asnières, was found to be depositing annually 154,000 tons of solids and 77,000 tons of dissolved matter into the river: mud, sand, gravel from Haussmann's macadam streets, and what David Pinkney describes as "organic matter, chiefly the leavings of curb side garbage collections and the less than perfect system of removing horse droppings."[2]

This great collector sewer, which Haussmann (in order to flatter the imperial fantasies of Napoleon III) called the Cloaca Maxima of Paris, began to flow onto the pages of art history when T. J. Clark, in his admirable study *The Painting of Modern Life*, asked the question where "the lumpish boys" are supposed to be bathing in Seurat's *Une Baignade à Asnières* (called *The Bathers* at the current London exhibition). He answered that they were opposite the mouth of the great collector sewer, and at a time when, quoting a contemporary source:

More than 120,000 cubic meters of solids have accumulated at the collector's mouth; several hundred square meters are covered with a bizarre vegetation, which gives off a disgusting smell. In the current heatwave, the town of Clichy possesses a veritable Pontine Marshes of its own.[3]

Doubt has since been cast on the accuracy of this startlingly revolting thought, and I have taken the trouble to double-check, both at Asnières and in the Paris sewers themselves. Ever since the Franco-Prussian War, when the population of Paris became aware that the new sewers made them vulnerable to enemy attack underground, the map of the sewage system has been considered sensitive information; and when I asked the bookshop attendant in the sewer museum he informed me that he could not sell me such a map "for reasons of the security of France." Nevertheless from the maps on display in the museum itself it is perfectly clear that the Asnières collector used to debouch into the Seine just by the railway bridge. That is to say, in the very center of Seurat's composition, about six inches to the left of the head of the carrot-haired boy on the bank.

But it was mischievous of Clark to leave us with the implication that the boys are bathing in undiluted sewage. They are several hundred yards upstream of the collector, and their *baignade*, their bathing place, which is also a place for washing horses, is actually, as the National Gallery catalog makes clear, in Courbevoie rather than Asnières. Seurat's bathers

were taking advantage of the last (comparatively) unpolluted stretch of the Seine. It was the holiday-makers farther downstream—at the resorts favored by the Impressionists, such as Argenteuil, Chatou, and Bougi-val—who were prepared to take whatever muck Paris could throw at them. But hygiene is very much a matter of perception. As we say in England: what the eye doesn't see, the heart doesn't grieve over.

<div align="center">3</div>

This practice of looking at paintings and asking questions about public hygiene, or town planning, or (shall we say?) the laws governing singing in public places, the history of the secret service, the nuances of class behavior—this broad approach to the elucidation of art through social history has given particularly rich results when applied to French painting of the nineteenth century. The social issues, the intellectual debates to be elucidated, the impact of revolutions and of revolutionary thought—the idea that at the heart of the matter is the birth of modern society—that is what makes these inquiries by Clark, by Robert Herbert or Linda Nochlin, so particularly interesting.

It is a type of inquiry which has been good for the fortunes of certain artists who, in addition to their intrinsic merits as painters, have extra evidential value: Caillebotte, for instance, has been favored by this type of inquiry, because his works tend to be socially illuminating in a way that a flower piece by Fantin-Latour is perhaps not. Certain artists demand examination because they were considered important in their own day. One is obliged to look at Puvis de Chavannes in order to understand why a contemporary observer thought that Seurat was copying him. But there are many more reasons for looking at Puvis. Rather more recherché is the figure of Jean-François Raffaëlli, who specialized in marginal figures. Paul Smith, in his study of Seurat, reproduces Raffaëlli's *Rag-picker lighting his pipe* and juxtaposes it with a contemporary response by Robert Caze:

Here is a poor, exhausted man, who has been ruined by Poubelle but who nevertheless preserves the appearance of a citizen in a capital which is becoming Anglicized.

One can see at once that the painting is a considered display of sympathy for a poor man. What is fresh and unexpected is the radical point of view which mourns the fact that this man has been ruined by the introduction by Poubelle (whose name became the French word for dustbin) of regular rubbish collection, and that this measure is seen as part of the Anglicization of Paris (the sewers too were of English inspiration, with their ingenious, elliptical, friction-reducing cross-section pipes). To ask of Seurat's bathers what their political meaning is, or whether they indeed ever had any political meaning, seems quite appropriate. I notice that the historians who ask these sorts of questions tend to trace their intellectual ancestry back to Meyer Schapiro, who wrote in his 1937 essay on Abstract Art:

Early Impressionism, too, had a moral aspect. In its unconventionalized, unregulated vision, in its discovery of a constantly changing phenomenal outdoor world of which the shapes depended on the momentary position of the casual or mobile spectator, there was an implicit criticism of symbolic social and domestic formalities, or at least a norm opposed to these. It is remarkable how many pictures we have in early Impressionism of informal and spontaneous sociability, of breakfasts, picnics, promenades, boating trips, holidays and vacation travel. These urban idylls not only present the objective forms of bourgeois recreation in the 1860's and 1870's; they also reflect in the very choice of subjects and in the new esthetic devices the conception of art as solely a field of individual enjoyment, without reference to ideas and motives, and they presuppose the cultivation of these pleasures as the highest field of freedom for an enlightened bourgeois detached from the official beliefs of his class.[4]

If this was the point of departure for T. J. Clark, he traveled a long way from it without necessarily losing the spirit in which those lines were written. Pictures of spontaneous sociability, indeed, but time and again one is struck by the ingenious contrivances by which those pictures of spontaneity are achieved. Herbert quotes Degas: "A painting is a thing which requires as much trickery, malice, and vice as the perpetration of a crime; make counterfeits and add a touch of nature."[5]

Impressionists on the Seine reproduces the old annotated photograph of Renoir's *Luncheon of the Boating Party*, which explains who the various

models were. What no one can definitively explain is the relation of the models to their representation in the picture. It was certainly not painted in a single session, and is unlikely to represent an individual event. People seem to have come down to Chatou (twenty minutes from the Gare St.-Germain) and posed for the painter as and when available. One, a cocotte, was scraped out and replaced by Renoir's future wife. The young man in the foreground is annotated as being Caillebotte, but a portrait *très rajeuni*. Was Renoir flattering his model (a potential purchaser) or simply using him as one would any model?

Eliza Rathbone in the catalog tells us that the young man talking to Charles Ephrussi in the background is Jules Laforgue. It would have been nice to be told where this identification comes from, since it seems to have been unknown to the late David Arkell,[6] Laforgue's biographer, or to any of the other sources I have been able to consult. Renoir began his painting in the summer of 1880, and had sold it to Durand-Ruel by February 14, 1881. Laforgue started working for Ephrussi five months later, and it is normally from that period that his acquaintance with Impressionism, on which he was to write so perceptively, is said to have begun. It makes rather a difference to our understanding of Laforgue's experience if he had had the opportunity to see Renoir at work on one of his grandest compositions.

Charles Ephrussi (often said to have provided one of the models for Proust's Swann, although George Painter in his biography hardly gives much evidence for this proposition) was a collector and scholar, and at the time a collaborator on the *Gazette des Beaux-Arts*. Laforgue in 1880 could only have been known for his aspirations as a writer on art, rather than any achievement; and he was yet to take himself seriously as a poet. Ephrussi did something which should cause us to raise an eyebrow at least: first he hired Laforgue to work as his secretary, when he was preparing his book on Dürer; then, when the book was out, he commissioned Laforgue to review it for the *Gazette des Beaux-Arts*. Laforgue obliged with some well-informed praise. It was his first appearance in Ephrussi's journal.

Though Ephrussi was Laforgue's patron, he was not sympathetic to his ambitions to write on aesthetics, and Laforgue's efforts in this direction went into the bottom drawer. His celebrated essay on Impressionism was written not for Ephrussi but for some unidentified German

magazine (and only published posthumously in French).[7] For Laforgue, the Impressionist was an artist gifted with the ability to cast off ancient and tenacious prejudices to do with drawing, perspective, and the lighting of the atelier. The Impressionist could abandon these old ways of seeing, forget about contour and replace it with vibrations and contrasts of color; he could forget about perspective in favor of these same vibrations and contrasts, forget about studio lighting and go instead for *plein air*, by which he meant not what the Barbizon painters had meant but any object or being in its own proper atmosphere: rooms lit by candlelight, streets, corridors lit by gas. Laforgue wrote:

In a landscape bathed with light, in which entities are modeled as if in colored grisaille, the academic painter sees nothing but white light spreading everywhere, while the Impressionist sees it bathing everything not in dead whiteness, but in a thousand conflicting vibrations, in rich prismatic decompositions of color. Where the academic sees only lines at the edges of things, holding modeling in place, the Impressionist sees real living lines, without geometrical form, built from thousands of irregular touches which, at a distance, give the thing life.

Often when Laforgue is talking of the Impressionists, by whom he means preeminently Monet and Pissarro (he had his reservations about a certain porcelain effect in Renoir's finish), one could be forgiven for thinking of Seurat:

. . . Everything is obtained by means of a thousand small touches, dancing off in all directions like so many straws of color—each struggling for survival in the overall impression. No more isolated melodies, the whole thing is a symphony, which itself is life, living and changing, like the "forest voices" of Wagner's theories, each struggling for existence in the great voice of the forest, just as the Unconscious, the law of the world, is the great melodic voice resulting from the symphony of consciousness of races and individuals. Such is the principle of the Impressionist school of *plein air*.[8]

Laforgue and Seurat studied art under the same teacher, although well before either of them would have known how to express himself in this way. Seurat was the only painter present at Laforgue's funeral. He was a year older than Laforgue, and survived him by less than four years. As far as I can see, they had little contact in adult life, and yet one could imagine them sharing more than a memory of art school.

That feeling that the whole academic approach to drawing, to line, must be jettisoned in favor of the real living line, made from a thousand irregular touches—would not Laforgue have recognized at once what Seurat's drawings set out to achieve, those drawings with no line but in the texture of the paper, those "irradiated" images, where the figure has no outline but rather a kind of halo establishing form, those Egyptian profiles of the figures on the Grande Jatte, Laforgue who spent most of his short adult life in Germany, where he studied the Egyptian antiquities in Berlin, where he imbibed Wagner and conceived for painting a Wagnerian ideal. Laforgue who, homesick in Baden-Baden, complained that "Nature here is posing too much. Oh how I long for the sickly Bièvre river, the thin vine-shoots and the vacant lots!" and who wrote to the artist Max Klinger: "Love Paris, I implore you, and especially the suburban landscapes like the Bièvre."[9]

The Bièvre River is to Paris what the Fleet River is to London—but unlike the Fleet it was only covered over early this century. It was the last open sewer in the city that Laforgue was recommending. The Bièvre had already been diverted into that collector of the Left Bank, which was known in fact as the Collector of the Bièvre, and which thereby made its extraordinary underground journey from the southeast of Paris to Asnières in the northwest.

And Seurat chose for his masterpiece, the painting of bathers with which he hoped to enter the Salon, to confer grandeur upon a view of the gas works and the zinc factory at Clichy, and to treat them not as an encroachment on the scene but as a worthy subject for contemplation. As for his bathers, the London catalog calls them

extraordinarily equivocal. We are shown half-naked young men, stripped off for a swim. Yet they do not act in "manly" ways: running, diving, swimming. They are not strapping figures; there is nothing tactile, sensuous, or detailed about the rendition of their bodies. None of them attracts the viewer's gaze by eye contact, for this is a bashful, bachelor, fundamentally decorous painting, pioneering a highly individual path between the ideal and natural beauty.

One might say indeed that the indifference of the subject seems welcome to the painter, that it is one of the things that makes the idyll possible. They demand nothing, and especially not our sympathy. Eerily enough, the painting appears to have no designs upon us.

The Secrets of Maillol

<div align="center">I</div>

A pyramid can be a cruelly deceptive thing—a promise of immortality, a pledge of permanence, an earnest of fame. I. M. Pei's pyramid—with its three subsidiary pyramids and its flat-based, triangular, minimalist fountains—may have solved for a generation or so the question of what to put at the heart of the Louvre, how to fill the Cour Napoléon. But nobody who has glanced at the history of this space can possibly feel that this solution will last forever, or even for very long. To believe this would be to subscribe to some theory of the death of the history of taste.

For the Louvre is continually transforming itself—why should it suddenly stop now? Skip back a couple of generations and we find the Cour Napoléon (from 1907 to 1933) home to a "Campo Santo," with trees and flower beds and monuments to the great—statues of Corot, Poussin, Houdon, Watteau, Puget, names that were never expected to suffer any casual slight.[1] Also on this prestigious spot stood an American work, Paul W. Bartlett's monument to Lafayette, which had been erected "by the schoolchildren of the United States," and was a project of the Daughters of the American Revolution.[2]

At the entrance to the courtyard was a substantial monument, 24 meters high, to the republican leader Léon Gambetta (1838–82), for which 280,000 citizens, of France and all its colonies, had subscribed. It was in stone and bronze, and its allegorical figures—Strength, Truth, Democracy—were melted down during the Vichy regime. After the war, its stone remnants were put in storage, later to be re-erected behind the *mairie* of the 20th *arrondissement*, with the euphemistic inscription:

"Detail of the Gambetta monument." The word "detail" in this context means that Gambetta has been deprived of his left arm, while two of his companions have mislaid their heads.

Near where Gambetta once stood, Pei has accommodated the square's only ground-level statue—a replica in lead of Bernini's marble equestrian figure of Louis XIV. He could hardly have chosen a better *memento mori*, a better antidote to the hubris of sculptor and architect. For Bernini was one of Pei's predecessors on the job—he spent the summer of 1665 designing an extension to the Louvre, only to find his plans frustrated and rejected through the intrigues of the court.[3] When his equestrian statue arrived in Versailles, the king hated it so much that at first he wanted to have it smashed into pieces. It was banished to a far corner of the garden. Bernini had represented Louis as having mounted, like Hercules, the steep hill of virtue and glory. (The hill, of course, supported the weight of the horse.) In 1688, a mere three years after the statue's arrival at Versailles, the sculptor Girardon took his chisel to the hill of glory and transformed it into lambent flames. The headgear, too, he changed, turning the French king into the Roman hero Marcus Curtius. As a result of this ingenious editing, a figure which was once climbing a hill is now jumping into an abyss.[4]

Leaving the Cour Napoléon, we approach the small triumphal arch of the Carrousel, which once served as the entrance to the Tuileries Palace. The palace itself was deliberately torched in 1871, left in ruins for a decade and then, amazingly enough, razed to the ground. The Jardin du Carrousel has just been laid out afresh by Jacques Wirz, with handsome yew hedges and notices to tell you that these hedges will have reached their appropriate height in time for the millennium. Indeed all the gardens from Pei's pyramid to the Place de la Concorde will have been done over by then. When I walked round in February 1996, the old quincunxes of sweet chestnuts were being felled in the Tuileries, and there were further notices to explain just what was being done and why—to forestall, no doubt, the outrage people feel at the destruction of a tree.

What remains of Le Nôtre's Tuileries gardens is essentially the layout of the two great ponds and their subsidiaries, and the terraces that flank the space; a very few of the earliest statues remain, but none, of course,

of the original plantings. They have been transformed again and again as is inevitable in a formal garden.

Less inevitable is the bloody history of the statues in this century. Some were destroyed for political reasons. The occupying Germans took out a monument to the First World War nurse Edith Cavell. The Vichy government, on a patriotic pretext (the recycling of non-ferrous metals), destroyed a large number of works which, as the Louvre study already cited put it, expressed a particular idea of the nineteenth-century Left, that "every citizen can become a hero." Just as the French Revolution decapitated the saints of the church portals, so the Vichy government sent the famous men of the nineteenth century to be melted down. General Leclerc's division did further damage, during the liberation of Paris, and the 1950s took their toll as the gardens were used for various festivities.[5]

Then came André Malraux, minister of cultural affairs from 1959 to 1969, and the clean-out began in earnest. It is ironic that the prejudices of Malraux should have combined with the destructive zeal of Pierre Pradel, conservator of sculpture at the Louvre, at a moment in history when the nineteenth century was just about to be reassessed, when the Gare d'Orsay was just about to be conserved and made into a museum. The first plans for the Musée d'Orsay were made in 1973, within Malraux's lifetime. But the mind-set of Malraux and Pradel seems to belong to a completely different era.

It is not that the sculptures they threw out would all, otherwise, be on display in the Musée d'Orsay by now. What shocks the authors of the Louvre survey is that Pradel, charged as he was with *conserving* this collection of work, should instead have dispersed and destroyed it. Everything from 1820 to around 1900, judged from Pradel's "scientific point of view," was valueless and should be sent to the provinces. Perhaps certain of the better things could be used to occupy "the upper parts of certain Paris monuments, to fill empty niches"—but the rest, with very few exceptions, were to go, and not just to go but to be struck from the inventories.

Robert Doisneau must have had an affection for all this familiar statuary, for he had photographed the marbles of the Tuileries in wartime, when they lay in a protective trench, and he has a picture dated 1964 showing the departure of three of these doomed pieces.

The photograph is entitled "Removal of the statues from the Ed. Guillaume garden to make way for the Maillols." From the Louvre study one learns that the figure on the left has been destroyed, that the one in the middle was sent to Amboise and is now missing, while the one on the right languishes in a state of general erosion in Maubeuge—about as near to a Belgian exile as one could get.★

2

At the time of these glyptic purges, Lucien Maillol, the sculptor's son, and Dina Vierny, who inherited the Maillol estate, approached Malraux with an offer. Concerned about the neglect and poor placing of Maillol's *Monument to Cézanne*, then in the Tuileries, they proposed to donate a lead cast of it, and have the original transferred to the Musée National d'Art Moderne. The discussion went further. Vierny, who as a young woman had been Maillol's model and the obsession of his final years, possessed the plaster originals of the sculptor's major figures. These she would put at the disposal of the state, which would make casts of them. A Maillol museum would be created in the Jardin du Carrousel. A Maillol museum in the open air—eighteen pieces in all—at the very heart of Paris! One can hardly think of a more prestigious location.

From the start, the deal was to be exclusive. Maillol alone was to enjoy this space, and indeed when a stray Rodin ventured onto the turf it was chased off, by a protest from Vierny, within forty-eight hours. And the exclusiveness of the deal, and the readiness of the state to pay for the casts (not a small matter—a proposal to cast Rodin's *Burghers of Calais* for the Tuileries in 1975 came to nothing when the foundry presented an estimate of 936,000 francs)—these are striking evidence of, at least, Malraux's conviction of Maillol's greatness.

Those who have their misgivings about Rodin's work will nevertheless be happy to concede that, given the mythic status of Rodin and the unparalleled fame of certain of his creations, a Rodin museum (or

★ From left to right, they are *Truth* by Pierre-Jules Cavelier, *Susannah Bathing* by Antonio Galli, and Félix Charpentier's *Woman with a Sponge.*

two or three)[6] is well justified. Those for whom Maillol's hefty nude women are more hilarious than classic might well think it excessive that Maillol also has three museums to his name: the Carrousel garden, one in his hometown of Banyuls (south of Perpignan, near the Spanish border), and the new one which opened in Paris in 1995 in the rue de Grenelle.

But France is generous, if haphazard, in its allotting of museums to sculptors, and Paris has museums for Rodin, Maillol, Zadkine, Bourdelle, and Picasso. David Sylvester mentioned in the *New York Review of Books* (April 4, 1996) the protracted row over Brancusi's bequest of his studio and its contents to the nation. In the winter of 1997, for the fiftieth anniversary of this legacy and the twentieth anniversary of the Pompidou Centre, a replica atelier, with its own little garden, was opened, and the public are able to view Brancusi's studio, without, however, being able to enter it.

It seems in general to help, certainly if you are a Dead Male Sculptor, if you possess a determined female friend of great character. Rodin had one such in the writer Judith Cladel (who published biographies of both Rodin and Maillol).[7] She it was who persuaded the government not to allow the Hôtel Biron and its garden to be sold for redevelopment, but to found a museum there in the year before Rodin's death. She also gathered and made inventories of the thousands of drawings scattered around the artist's studios. And she performed thoughtful tasks such as persuading Rodin to marry his mistress of fifty years, Rose Beuret, shortly before Rose's death. ("You always have such good ideas," said Rodin to Judith when she brought the matter up.) This allowed Rose to die happily, but it also was designed to ensure that Rose became heir, and that Rodin's estate, which had been bequeathed to the nation, would not instead go to some hidden mistress who might be lurking somewhere with a will tucked into her suspenders.

Mutatis mutandis, Maillol appears to have had a similar doughty supporter in Vierny. Not only did she persuade Malraux to hand over the Carrousel garden. She also, in 1995, opened her own foundation and Maillol Museum not far from the Rodin Museum, in the Faubourg Saint-Germain.

★

The façade of the Hôtel Bouchardon could not be grander. It consists of the Fountain of the Four Seasons which the sculptor Edme Bouchardon created in the mid-eighteenth century and which was known as "*la trompeuse*," the deceiving woman, because, for all its wealth of statuary and ornamentation, it had only four small faucets to provide water for the neighborhood. Behind this beautiful semicircular structure lies a distinctly unclassical warren of rooms, which have been adapted to display various collections that are the product of Vierny's work, first as a model (she posed for Maillol, Matisse, Bonnard, and Dufy) and later as a gallery owner.

There is a representative collection of Duchamp's ready-mades, including the porcelain urinal signed R. Mutt. There are naive paintings from this century, abstract paintings, contemporary work from Russia, including a sizable installation. There is space for temporary exhibitions. And then there is the large and absolutely representative collection of Maillol's paintings, drawings, sculptures, and maquettes, his work in pottery, his tapestries, the furniture he carved and decorated—everything, including a small mock-up of an atelier, with some of those plaster originals.

What Vierny appears not yet to have done is to make the Maillol papers available to scholars. This is apparent both from Bertrand Lorquin's short book, *Aristide Maillol*, and from the essays in the catalog of the German exhibition, *Aristide Maillol*, edited by Ursel Berger and Jörg Zutter. Lorquin, with one major exception, tells the story much as we know it from other published sources. The relative absence of original information is surprising and intriguing really, since Lorquin is both head of the Maillol Museum and Vierny's son. The German catalog, by contrast, is full of original work, and it draws heavily on one great unpublished source: the early diaries of Count Harry Kessler, the rich German collector who was Maillol's most important patron. These diaries have been published only for the inter-war years, but Kessler kept a journal most of his life (1868–1937) and carefully recorded his conversations with Maillol over a period of thirty years, beginning in 1904.[8]

Kessler appears never to have met Vierny, although he met another of Maillol's young girlfriends, and it is a great pity that Vierny herself has not seen fit to publish her memoirs, since she has a remarkable story to tell. What follows has been put together from Kessler and a number

of published sources, including the memoirs of the Nazi sculptor Arno Breker, who saved Vierny's life.[9] Breker's memoirs are egregiously written, and come with a health warning. Nevertheless, they are supported in essential outline by at least three sources, including Maillol himself. My intention is simply to demonstrate what an interesting biography of Maillol could be written, once the archive is opened. But maybe we shall have to be patient. After all, the Rodin archive was made available to scholars only in 1973, and besides, there is no obligation on Vierny's part to set out her private life for the benefit of scholars. Her museum alone makes one feel, from time to time, an intruder.

3

As sexual beings, Rodin and Maillol were alike in this: they were utterly devoted to the female body, and this devotion intensified with old age. In sculpture, Rodin's women were the first to reveal their full sex (as opposed to a euphemistic version of the *mons veneris*). No one had opened her legs like this—certainly no one had opened her legs in the manner of Iris, Messenger of the Gods. Ruth Butler in her biography of Rodin quotes a tribute from the feminist writer Aurel:

If there is any art in the world that has ceased to be unisexual, that calls upon human sensibility, that is women's as well as men's, if there is an art drenched with feminine force, one that draws an extra keenness from that, that has violence, a spur, an art that is the male child of woman, it's Rodin's . . . Our mothers told us, "Men like weakness!" But this man prefers force . . . In Rodin's presence, a woman dares to be free and to give up pretending. She ceases playing at being prey, the sweet plaything that costs dearly and yields up smiles for Monsieur. She can embrace her grandeur and her autocracy. She looks grand in her nobility by which humanity mounts to its true nature. She becomes an animal.[10]

This is the Rodin who encouraged his female models to roll around on the studio floor pleasuring themselves and each other.

But there was a complementary side to Rodin. After all, his reputation had been founded on a series of scrupulously observed male nudes, and founded also upon a new relationship between sculptor and model. The model played an active part in devising the pose. Auguste Neyt,

the Flemish soldier who posed for the statue eventually known as *The Age of Bronze*, had, he later said, "to go through all kinds of poses every day in order to get the muscles right. Rodin did not want any of the muscles to be exaggerated, he wanted naturalness." So they worked together two, three, four hours a day, for more than a year, over which time they became good friends.[11]

What was established was a form of intimacy, but one would hesitate to describe the transaction between the two men as homoerotic. It was a collaboration, not a seduction. To call it homoerotic would be to stretch the term beyond its useful meaning. Rodin wanted to portray universal man, as a physical, sexual, spiritual being. That was his subject, not his furtive agenda. He was deeply involved in the portrayal of the male nude, perhaps at first because he saw it as a peak to be conquered, a way of securing a place among the immortals of art.

Later, when he wished to express the notion of genius, he was so drawn by the belief that genius and sexual potency were intimately connected that he devised a pose for Balzac in which the left hand grasped the right wrist, while the right hand grasped the erect penis. This is the figure known as *Balzac "F" Athlete* (there is a cast of it in Brooklyn), which was then wrapped in a dressing gown to create the final monument. How sculptor and model arrived at it (or whether the model was required to demonstrate an erection) we do not know. One feels though that Rodin was engaged in portraying the man of genius enjoying his own potency, not the man of genius as an object of lust.[12]

However one defines Rodin's interest in male sexuality, Maillol didn't share it. That chip was missing. Maillol liked portraying Woman; he knew early on in his career as a sculptor what he meant by Woman, and the rest of his life was spent in variations on that theme. Other sculptors flailed about, looking for new ways of idealizing the feminine. Maillol knew exactly what *he* meant by the ideal. "Sculpture," he once said, "is a masculine art. It has to be strong. Without that, it's nothing."[13] And so when he made women, he made strong women.

And every subject turned into the same thing. There is a story, perhaps apocryphal, about the commission to Maillol for the monument to the French revolutionary leader Louis Auguste Blanqui (1805–81). Maillol was approached by Clemenceau. The sculptor asked what sort

of man he would be commemorating. "Clemenceau launched into an hour-long account of Blanqui's revolutionary career and the numerous years he had spent in prison for his ideals, at the end of which he asked the sculptor what his idea was for the monument. 'I'll make you a nice big woman's ass and I'll call it *Liberty in Chains*.' Delighted with this reply, Clemenceau immediately presented him with the seven thousand francs the committee had been collecting."[14]

Maillol is also supposed to have scandalized the committee by saying that his wife (his early model for his nudes) was better looking than Blanqui anyway. Clearly there were many jokes made about the fact that whatever commission you put Maillol's way, the result would be one of these hefty women. The Mediterranean is a woman. Thought is a woman. All the seasons are women. The Ile-de-France is a woman. And they are all recognizably Maillol women. Once, when teased about the Blanqui memorial, he said: "Faced with the monument to Julius II, do you think about Julius II or about Michelangelo?"[15] Faced with a Maillol, we are clearly supposed to think about Maillol.

Maillol was one of an impressively large group of artists who were influenced to turn in the direction of sculpture by Rodin's retrospective show, which coincided with the Exposition Universelle of 1900.[16] Earlier he had been a painter, one of the Nabis, and he developed a strong interest in the arts and crafts, designing tapestries whose production he oversaw himself. Born in 1861, he was well into his forties before success came his way, but when it came it came immediately and in very full measure. Rodin thought Maillol a genius. The critics Octave Mirbeau and Julius Meier-Graefe were soon onto his case. André Gide wrote of the terracotta *La Méditerranée*:

She is beautiful. She has no meaning. This is a work of silence. I believe one must go far back in the history of art to find such a perfect disregard of everything which could detract from the manifestation of beauty.

And he made the most extravagant comparisons between Maillol and Rodin and the great figures of past and legend.[17]

What these early admirers saw was a quality which Maillol himself wanted them to see—an ancient simplicity, something that reminded them of ancient Greece and, more specifically, of archaic, simple qualities

in Greek art, something essential. Maillol could imagine his figures rolling around on the ocean bed, ground down by the action of water and sand, until they reached their essential form, after centuries of abrasion. Such a process would, he thought, destroy the essence of a Rodin, but reveal the essence of a Maillol.

And one has to remember that what the early critics praised in Maillol was the small-scale work, because nothing on a large scale yet existed. Mirbeau expressed the hope that one day it might, and that there might be buildings worthy of accommodating such sculptures. As yet, however, what was being admired was in large part the promise of a new sculpture. One supposes that Rodin (though not an envious man, a generous promoter of others' work) could admire Maillol as his successor because nothing had been stolen from him, and nothing was done in a hostile spirit. Maillol had never worked for Rodin, and did not have to rebel. But he had to *distinguish* his work from Rodin's. Practically all his conversations with Kessler about sculpture are of the form: I do this, whereas Rodin does that.

4

When Rodin, Mirbeau, Maurice Denis, and Gide all brought Maillol's work to the attention of Count Harry Kessler, they did both patron and sculptor a great service. Maillol had always lived on the brink, and his recent work in tapestry for Princess Bibesco had had to come to a halt because his eyes could not take the strain. One has to remember that Maillol had known what it was like to be on the verge of starvation. Now a rich patron came his way, and he put himself out to please.

Kessler was the son of an ennobled industrialist. His schooling had been in Paris, then at a prep school near Ascot which readied its charges for Eton, and finally in Germany, culminating in military training in Potsdam. He was trilingual, and moved restlessly between his three homelands, but it was his German identity that meant most to him. Because he was painted by Munch, and was known in the twenties as the Red Count, because he patronized artists such as Grosz, Beckmann, and Heartfield, one imagines him as having been more of a revolutionary than he was. In fact, he was proud of his nobility, he was a Prussian

conservative in the time we are talking about, and he shared many of the prejudices of his caste.

But he was deeply queer, and most probably deeply repressed. He certainly does not want the reader of his diaries to know what he was up to, when he was up to something, and his biographer Peter Grupp supposes that there were probably only two long-term sexual liaisons in his life. Kessler's emotional energy was directed toward art, both as a patron and as a would-be writer. In the latter role he was deeply disappointed, and his ambitions were at times an embarrassment to his associates. Hofmannsthal and Kessler spent a weekend sketching out the scenario for *Der Rosenkavalier*, which Hofmannsthal went off and wrote, and which he wanted to dedicate to H.K., "the hidden friend." Kessler was deeply hurt. He thought he had been the co-author of the script. He thought he had dramatic gifts which perfectly complemented those of Hofmannsthal, that *Rosenkavalier* could not have been written without him. Hofmannsthal found all this absurd and self-deluding, and Kessler's discovery that his friend had no regard for him as an artist brought their friendship to an end.[18]

The story of Kessler and Maillol has no such tragedy—Kessler obviously could not suppose himself to be a sculptor. The comedy of their friendship derived from the fact that Kessler, early on, identified the one disappointing defect in Maillol (his utter lack of interest in the male nude), and set about remedying it. Maillol was a peasant, more or less, a Catalan from the Roussillon coast—a Phoenician, if you like, practically speaking an ancient Greek. Everyone (not just Kessler) goes on about the ancient Greekness, the Mediterranean quality of Maillol's art and of his homeland.[19] And yet, amazingly enough, there were no *kouroi*, no comely youths, in his repertoire.

Kessler bought his first Maillols, a couple of small bronzes, in 1903. The next year he met the artist, on August 21, and soon commissioned an enlargement of *La Méditerranée*, the first large-scale commission Maillol received. On August 25, Kessler is back at Maillol's studio on the outskirts of Paris, and he pops the key question: Why does Maillol always do female figures and not men? "Oh," says Maillol, "because I don't have a model. Now Rodin—*he* can pay for as many models as he wants; but us other artists—we usually have to make use of our wives."

This is a feeble enough excuse—Rodin was poor as a church mouse during his early career; it was only much later that he adopted the habit of having more than one model wandering around the studio, to provide inspiration for poses. Still, Kessler notes down the reply, and the wheels start to turn in his mind. A week later, he and Maillol set out for London, where they are to visit the Elgin marbles. They talk about Rodin. Maillol says how well Rodin does the details—a leg, a forefinger—

but the ensemble, the great lines, that's all the same to him. When he shows antiquities—he has beautiful fragments at his place—he sometimes says, "It's decorative." And he passes by. He's not interested in that. It's decorative! Me, I'm quite the opposite—that's my point of departure, from the great, decorative line. When you view a Rodin from afar, it's small, very small. But sculpture forms part of the air all around it. Rodin has a Buddha at his place, well placed on a socle, in his garden, in front of a circle of small shrubs. Well, it's as big as that [showing it very small] and yet it's as big as the sky. It's immense. It fills everything.

They stop at Calais to view the *Burghers*, which Maillol has never seen. "It's good," says Maillol, "it's very good. Who was it who told me it was badly done? It's badly placed, that's all. That's obvious. You have to see it from close to"—the *Burghers* had been placed too high, with railing around—"it's not decorative. But how well Rodin has expressed what he wanted to say . . ." And he later, at the Cecil Hotel, sends Rodin a postcard of appreciation.

Maillol speaks of how he came to look at antiquities. "I wanted to see how the ancients came to terms with reality. I looked at a woman's head outside, in the street, then I went into the Louvre and looked at an antiquity, and I saw how they had come to extract the beauty from life. When I look at an antiquity it always seems to me that it must be very easy to make sculpture. But when I look at modern sculpture, it seems complicated, difficult."[20]

The next day, during their visit to the British Museum, Maillol relates a remark of Odilon Redon's that had pleased him. He had said of one of Maillol's sculptures that it was "severe and voluptuous." That was the quality he sought, but that he should also consciously feel that one must start and end with something decorative—that is a little more surprising.

In the evening, Kessler takes Maillol down to Whitechapel to watch the boxing. This is a favorite pastime of Kessler's—he has been there only the previous month, noting that the excitement of the crowd was in proportion to the amount of blood spilled. Now Maillol gets excited too: "I'd never have believed that would thrill me like that. This is the way one ought to see the nude, not with some wretched model making conventional gestures." And he sketches away, saying finally:

I've worked a lot tonight, and learnt a lot. I will make a group of fighters like that. But before the fight—when they are facing each other. That's how one should do them—in repose. I'm happy to have seen that. It's given me the idea, how to do nude men. Without that, in our day, it's hard to see the right way to do the nude male.

The next morning, after an early trip to the National Gallery, they breakfast at the Savoy, and Maillol returns to the subject of the boxers:

That'll stay with me. I'll never forget that. It's not like those pimps in Paris—you felt they were really into it, that their passions were truly involved, a young race who fought together for exercise like the Greeks of Homer. They weren't men, they were gods: They had that expression—their necks were so proud, so beautiful, and then those mouths, those terrible open mouths, which seemed to give out flames . . .

And on and on. Whether Maillol really meant it, or just knew that this was what Kessler wanted to hear, is unclear. But it is hard to believe him when he says, in conclusion, that from now on he will only do men, that there's something wrong with women:

With women there's something round and soft. Men are more beautiful. But what I'd always lacked was the way to use them. With a woman—one gesture and it's immediately a statue. With a man, a gesture is ridiculous. But now I've seen, yesterday, those fighters—that's a subject.

And if this weren't enough to whet the count's appetite, Maillol concluded: "And then there's another, a young shepherd who looks at his thighs and finds himself to be beautiful . . ."

Later the same month Kessler was back in London again, and back in Whitechapel for the boxing, noting the names of some possible models: "For Maillol I noted Tom Denver, Fred Wilson, Danny Moore,

George Davis (8 sh.)."[21] Eight shillings, one supposes, being some negotiated price for a modeling session . . . or something. Later in the diary, we find Kessler going off to Whitechapel even when the boxing's not on. He just wanders the streets and the public houses, or so he says. He must have cut quite a figure.

<div align="center">5</div>

The idea that Maillol had brought up, of the young shepherd who looks at his thighs and finds himself to be beautiful, did, however, bear fruit. You could see this as a description of the woodcut *Hylas in the Fountain*, which Maillol made as one of his illustrations to Virgil's *Eclogues* (a Kessler commission), or as the germ of the idea for a statue of Narcissus, which began to be executed in 1907. Maillol was now working on at least four projects for Kessler, for two of which he required a model. One was the relief called *Desire*, in which a man attempts to embrace a woman. The other was the Narcissus. Maillol spoke to Kessler of his difficulty in finding a model. He didn't want an Italian, he said, because they were too pretty, but rather what he wanted was a young French peasant, a bit squarish, eighteen or seventeen years old. The trouble with French peasants, he said, was that they didn't like posing in the nude. As for the relief, he added jokingly, if he couldn't find a model he'd pose for it himself.[22]

Kessler needed no prompting. Within a fortnight he had found a young cyclist and jockey by the name of Gaston Colin. Maillol agreed that he would pay him five francs a day, and Kessler would pay "the remainder." But a few days later, the count is clearly shocked: Maillol has made good progress with the relief, but he has only used Colin for the head; for the body of the male he has chosen a model called Gaborian—a good-for-nothing prizefighter from St.-Germain. Still, Kessler tells Maillol that this nude is nearer to nature than his earlier work. Maillol:

But, that's of no importance. What's important is that there should be some feeling [*sentiment*] in it. There are some delicious primitive things that have very little of nature in them. But they've worked so much and they've worked

<div align="center">173</div>

to express the feeling, which has become something exquisite. Feeling replaces knowledge . . .

Then Maillol shows Kessler the nude study of little Colin. "I'll shorten the legs a little," he says, "and I'll strengthen the arms, but this (indicating the chest) and the back are quite pretty. Look, it's curious, he has breasts just like a young girl."[23]

Now Kessler begins to visit Maillol regularly, armed with his camera, and as Colin poses—nude but for his shoes and socks—Kessler prowls around the studio recording the sessions and pasting the photos in his diary. The notion of Narcissus has been forgotten. Maillol has clearly sensed that what Kessler wants is a portrait of Colin, and he comes up with a justification for it. The ancient Greeks, after all, used to put up statues in honor of their athletes. This will be a statue in honor of a racing cyclist.

Sculptor and patron examine the model, and discuss the difficulties of the art. They peer closely at the pit of his stomach: "Every instant it's different," says Maillol, "look here. Now it's like this . . . and in an instant it's completely changed—there's nothing left. You have to look really close to be able to do anything at all."[24] Or, looking at the left side of the thoracic cavity: "Look here, you'd say there was an enormous muscle, but if you look really close, you can't see a thing. Nature makes its effects with nothing, and then sculptors (holding a great lump of clay in his hand) do it like *that*. What you need to work with is almost nothing. Only, it takes a long time to find it."[25]

In between sessions, Kessler was conducting an elaborate courtship of Colin, taking him on trips to Fontainebleau, and Barbizon, going swimming, getting Colin to drive him to the châteaux of the Loire, and eventually visiting the Channel Islands in his company. But none of the love affair goes into the diary. Only art is talked about.[26]

When the bronze of *The Cyclist* was cast by Bingen, Cladel tells us that Kessler arrived at the foundry, saw the cast—which had only just cooled and was waiting to be chiseled—and found it so beautiful just as it was that he jumped in his car and took it straight to show Maillol. Shortly afterward Bingen arrived in a panic, saying the statue had been stolen. "There it is," said Maillol, "an admirable cast. Someone took it, did they? A good thing too, otherwise you would have ruined it with your file."[27]

6

One of the problems Maillol often discussed with Kessler was the placing of a sculpture. It seems that it was important for him to know where a thing was going to go, before he could decide what it was going to be. "In another age," he said, "sculpture had a place. The sculptor knew for whom he was working."[28]

In a sense, although Kessler was always trying to lure Maillol in some inappropriate direction, he did provide, directly and indirectly, the answer to this problem. Kessler helped introduce Maillol to an international clientele who were, nevertheless, a close-knit group. As the German catalog points out, many of them were clients of the interior designer Henry van de Velde (another Kessler protégé). The photographs of Kessler's apartment in Berlin and his home in Weimar are interesting because they show what the ideal ensemble was for this group: furnishings by van de Velde, sculptures by Maillol, paintings by Maurice Denis—that would be the target, the Look. It would go very well in the German villas of the period, and in a spacious Berlin apartment. At its very grandest it was found in the music salon of the Morosov Palace in Moscow, for which Maillol made his *Four Seasons* and Denis painted his cycle *The Story of Psyche*.

This bringing together of geniuses from different fields was a Kessler speciality, an obsession. He was that kind of patron, and that kind of patron is fine when he knows what he is up to (finding the right librettist for a composer, the right translator for a certain poet, and so forth) but in for a disappointment if the impetus is simply to bring Genius A together with Genius B and see what happens. It's okay if all you are expecting is an interesting dinner party, but if your assembled geniuses are supposed to do something extraordinary—to perform, to mate, to sparkle in some sublime way—this is a recipe for embarrassment.

Kessler had the idea that if he could get Maillol, Hofmannsthal, van de Velde, Denis, and the painter József Rippl-Rónai *all together* in Greece—well, it would be like Raphael's *School of Athens*. It would be extraordinary. It would—well, it would—well . . . you know . . . (sharp intake of breath) it would be *extraordinary*.

He managed to get Maillol and Hofmannsthal to agree.[29] In April 1908 he and Maillol set out from Marseille, saw Naples and Pompeii, and by the time they arrived in Athens were getting along famously, particularly since Maillol (being, as previously noted, essentially an ancient Greek himself) felt at home in the landscape since it was just like that of Banyuls. But Hofmannsthal, meeting up with them, found it impossible to get on. Their conversation was in French. He couldn't enthuse about the Greek landscape. He was disappointed.

And he made a terrible mistake. Hofmannsthal borrowed a book from Kessler's luggage without asking, and Kessler went into such hysterics that one wonders whether Hofmannsthal had come within an ace of finding some incriminating item, some photograph of Colin, some Whitechapel keepsake. Kessler couldn't believe that he had allowed anyone who was so far from being a gentleman to come anywhere near him; he could only explain the difference between his sense of tact and Hofmannsthal's as coming from the racial difference between them. It was a Jewish thing. (Hofmannsthal had, in fact, one Jewish grandparent.) Although this quarrel was patched up, Hofmannsthal left Greece ten days early.

Kessler asked Maillol what was the concrete reason why they had both loved Greece. Maillol said: "That's very simple: it is the place in the world where everything I love was created . . ." Kessler said that *das Griechentum* represented for him a world view in which every feeling, every thought had its place, nothing was forbidden or ruled out.

Toward the end of the stay, Maillol, who knew how to sing for his supper, began sketching the bathers on the beach. Then he decided he would model a figure, and they persuaded a youth called Angelos to pose. A studio was improvised, clay found from an ancient, traditional source, and Maillol modeled his second male nude. (By this time Kessler seems to have run out of film.)

When it was all over, and the two men parted company in Naples, and Kessler had at least had the privilege of introducing his sculptor to some of the archaic masterpieces of Greece, and had ordered a bronze of Angelos and had bought marble for a life-sized statue of Colin— when, in other words, much had been achieved, Kessler lapsed back into an exhausted rage. For a while, he couldn't bear Maillol, the way his peasant origin was always coming through. Maillol was always eating

with his fingers and spitting bones onto the carpet. He walked like a peasant, with long careful strides, scouring the ground right and left, as if looking for some fruit or weed. He had a peasant's eye for the main chance whenever it came to money—he always let other people pay, for carriages, drinks, entrance tickets, and so forth. And it wasn't that Kessler minded paying. It was the way Maillol had of forcing others to cough up, the little tricks and dodges he discovered, so as never to be there when money had to be put on the table, and the pleasure he took in these petty triumphs. Really one had to conclude, Kessler wrote, that he belonged to another level of society.[30]

Of course, there must be another side to this story. Maillol must have a point of view, must occasionally—one guesses—think: oh no, not again, when Kessler has one of his enthusiasms, when Maillol sees himself maneuvered into yet another encounter with the male nude.

The last of these was potentially, for Kessler, the most spectacular. There was a plan to erect a Nietzsche memorial in Weimar (Nietzsche was behind Kessler's philhellenism) which would have a temple and a statue of the superman. And who better to model for the superman than Nijinsky, and who better to make the model than Maillol? Indeed, who else would be capable of executing such a commission?

Maillol began making difficulties. "Have you seen him naked?" he objected. "Is he not plump? What's beautiful for other people often isn't for the artist, if he has an idea in his head. The model has to correspond to the idea that the artist wishes to execute."[31] But when he saw Nijinsky onstage, he admitted that he was the embodiment of Eros.

Diaghilev and Kessler brought Nijinsky to the studio, but Nijinsky was too self-conscious to model in front of them, and they had to leave. Maillol made sketches, one of which is in the Berlin exhibition, but the project soon after fell through—much to Maillol's relief.[32]

7

Kessler was a bibliophile and publisher of luxury editions. Maillol, with his arts and crafts background, was in sympathy with this side of his patron's interests, and he spent some time researching a method of

making fine paper. The result was so successful that Kessler set up a business producing the art paper, for which Maillol designed a watermark with their initials: MK. The factory was near Maillol's studio in Marly-le-Roi, and was run by the sculptor's nephew.

In 1914, Kessler (whose full-scale *La Méditerranée* had still not been finished) sent a telegram to Maillol apparently warning him to bury this statue, since war was approaching. In the atmosphere of the times, this was taken to indicate treacherous intent on Maillol's part. At the beginning of January 1915, Arsène Alexandre wrote an article called "Their Artists, Spies and Secrets," in which he revealed that Maillol's studio in Marly had been found to be lined with concrete (presumably proof that it was really a bunker), and the story was taken up by Léon Daudet in *Action Française*. "The war will rid us," he said, "among other things, of the art of Munich, of the German second-hand espionage trade which managed the sale of pictures and objects of art here in Paris."[33] The paper mill was burned to the ground, and Maillol was nearly killed. He spent the war in an agony of apprehension about his son, who was a flier, and was practically unable to work. After the war, he did very little work for a while excepting on war memorials.

Maillol and Kessler did not meet up again until 1922, and from then on their collaboration was confined to work on the luxury editions which Kessler was producing at his Cranach Press in Weimar. Kessler would come to see Maillol in Banyuls, and would simply sit over him until the woodcuts were done. He regretted treating a great artist in this manner, but it appeared to be the only way of getting work out of him.

By 1930 Maillol's marriage was getting rough. His wife was extremely jealous of a young model, Lucile Passavant, with whom Maillol was working, and she was right to be jealous. Maillol was besotted, and when Kessler invited him to Weimar, Maillol accepted on behalf of himself and Lucile. Kessler had no scruples about deceiving Clotilde Maillol: "For the past thirty years his wife has, with her insane jealousy, stood in his way and prevented him from ever having an acceptable model. He has had to make do with all sorts of random photographs and magazines devoted to nudes."[34]

A few days after Kessler wrote this, Clotilde caught Maillol and Lucile together in some sort of embrace. She rushed into the studio and tore

up the large nude studies of Lucile, then went dark red in the face and passed out. It took Maillol and Clotilde's sister four hours to bring her to, but when they did so she was, according to Maillol, as sweet as a lamb. Clearly she had appalled herself by her own behavior.

So now the two old men set off on their adventures again; this time it was Maillol who was being given the alibi for an affair. They were seen off from Paris by his son Lucien. At Reims, by arrangement, they were joined by Lucile. Kessler was keen to show off a little of Germany, and if there is any touching moment in his published diary it is the scene at Frankfurt where Kessler shows Maillol the stadium:

We sat on the terrace overlooking the swimming pools and watched the bathing and sunbathers. Maillol was in raptures about the unabashed nudity. He continually drew my attention to the splendid bodies of girls, young men and boys. "If I lived in Frankfurt, I would spend my days here drawing. Lucien must absolutely see this." I explained to him that this is indicative of only a part of a new vitality, a fresh outlook on life, which since the war has successfully come to the fore. People really want to *live* in the sense of enjoying light, the sun, happiness and the health of their bodies. It is not restricted to a small and exclusive circle, but is a mass movement which has stirred all of German youth.[35]

Kessler when he said this had less than three years left to live in Germany. In March 1933 he would leave from Frankfurt, and find out in Paris that he could never safely return. In 1937, practically destitute, his property sold and his collections dispersed, he would die in exile in France. But just for the moment he still had the highest of hopes. Maillol, Lucile, and he went out to the Römerstadt, the newly built housing project, the first of its kind and size in Germany, designed by Ernst May using the cheap new methods of prefabrication. Maillol, he says, was practically speechless with astonishment and delight, having always thought modern architecture somewhat cold. Kessler says:

I explained to him once more that this architecture is simply an expression of the same new vitality which impels youngsters to practice sport and nudity. It lends warmth in the same way as medieval buildings gained such from the Catholic interpretation of life. This German architecture cannot be understood unless it is visualized as part of an entirely new *Weltanschauung*.

8

The affair with Lucile did not last. She ceased modeling for Maillol and was married by 1932, when she brought her husband to visit him, and wept to see the studio again.

Two years later, the architect J. C. Dondel told Maillol that he knew a girl who bore a strange resemblance to his work. Maillol wrote to Dina Vierny saying: "Madame, it appears that you resemble both a Maillol and a Renoir. I will content myself with a Renoir." And he invited her to visit Marly-le-Roi. Vierny was born in 1919, a daughter of a pianist and composer from a Russian Jewish family, a friend of Saint-Exupéry. She was fifteen when she went along to visit Maillol, and found him receiving Gide, van Dongen, and Vuillard. Approaching the first man she saw with a beard, she introduced herself to van Dongen by mistake. Maillol, as we are informed by the catalog of the Fondation Dina Vierny, wanted to work immediately. In the person of Dina, he had "found the figure which he had within himself, the figure which rests upon the beauty of the body . . ." This corrects an earlier, perhaps prim account, according to which she modeled only her head for two years before he asked her to pose nude.[36] According to this earlier account, Dina returned to Marly in 1935, spending her holidays in a small commercial hotel not far from the Maillol family house. In 1938, when Maillol closed his atelier in Marly, Dina followed him to Banyuls and took lodgings next door. What Clotilde thought of this arrangement can be imagined.

Maillol, in addition to his house in Banyuls itself, had inherited a property up in the mountains known as La Métairie, and it was here that he began to live and work. Clotilde later told Arno Breker, at a time when Dina was under arrest for anti-Nazi activities (but who is to say whether Breker is reliable?):

If you knew how much I suffered when Dina Vierny lived with us! God be praised! she's gone! and I can sleep more peacefully! . . . They were always outside, at the Métairie. Even if he was painting a landscape, she had to be with him! Hey! What do you say to that? Me, I couldn't go so far, because of my legs. That's why what happened at La Métairie remains a riddle for me. Don't do anything to bring her back. I've heard fragments of conversation

between Maillol and his visitors, where they were saying that you were going to bring back Dina . . .[37]

What was happening at La Métairie is the stuff of legend. The critic Waldemar George tells us that Dina went there every day, returning at sunset; that she and Maillol together read the classics of Greece and Rome, *Les Chants de Maldoror, Les Fleurs du Mal*, Mallarmé, Valéry; that Maillol read Freud, Heidegger, and Sartre (this sounds improbable), but that he could not agree with what he read, and that some of the books bored him (this sounds more probable).

George also tells us that Dina joined the Comité de Secours Américain pour Intellectuels Antifascistes, and, since they were living close to the Spanish border, was able to help Franz Werfel, and Golo and Heinrich Mann, to escape, that she also traveled into Occupied France and brought friends to Marseille, and that she was with André Breton when he left by this means. Lorquin, who is normally somewhat stingy with documentation, tells us that Maillol had shown Dina the route from Puig del Mas (where La Métairie was) across to Port Bou, and that the first escape network set up was known as the Maillol network. And he provides a letter from the Varian Fry Papers at Columbia University to support this claim.[38]

The defensiveness of Lorquin's tone is apparently due to the fact that Maillol has been accused, as he had been in the previous war, of collaborating with the Germans. The basis for this accusation was that in 1942, when Breker, the official sculptor of the Third Reich, opened an exhibition in Paris at the Orangerie, Maillol made the mistake of accepting an invitation, "mainly because it gave him an opportunity to cross over into the occupied zone and visit his studio at Marly-le-Roi to check on the state of the sculptures he had been obliged to abandon there. He was totally unaware of the significance of this act, which was bitterly held against him."

One can accept this. Maillol was over eighty at the time, and had known Breker for years, since 1927. One might even accept that Maillol was a "pacifist and a humanist" without any affinity for Hitler's regime (although Kessler says that during the Spanish Civil War he was an avid supporter of the "rebels"—that is, the fascists). But unless he tells the whole story—and explains about the arrest and release of Dina Vierny,

his mother—Lorquin cannot expect his defense of Maillol to do anything more than raise doubts in the reader's mind. According to Breker, Vierny was already under arrest when Maillol went to Paris. Maybe this is not true, but one wonders.

Waldemar George says that the Vichy government was informed about Vierny's activities with the refugees and that she was confined to her house by order. Managing to escape, she left for Paris. In 1943 she was arrested by the Gestapo and held for six months in the Fresne prison, "only escaping deportation by a miracle." Afterward, she couldn't get back to Banyuls, so remained in Paris till the liberation.

Everything up to the words "Fresne prison" in this account appears to be true. In 1990, a letter of Maillol's, dated October 5, 1943, appeared at auction in Berlin. It is addressed to the writer Hans Franck:

. . . I've had my founder in Paris [Rudier] told to tell M. Breker to try to release my model Dina Vierny who had been arrested by the German authorities . . . but he wrote yesterday to tell me he has not informed Breker . . . Since you know where he is could you be kind enough to tell him how desolated I am not to be able to finish my statue (*L'Harmonie*)—he's the only one who can obtain that from the German authorities . . . I feel sure that my friend Breker will do all that he can . . .[39]

This proves that Breker was approached by Maillol to secure Dina's release, but makes it seem likely that she had only been arrested in 1943, and that the trip to the Paris exhibition in 1942 was not made under the shadow of Dina's imprisonment. Whether we are to believe Breker that Maillol, at a formal dinner at the Lapérouse restaurant, made a speech to the effect that Breker was the Michelangelo of Germany—this is another matter.

(Breker, a master of kitsch prose as well as sculpture, describes his reaction: "This word had fallen. I must have had a feeling identical to the one experienced by a young girl when she undoes her dress for the first time, arousing the enthusiasm of her cavalier: 'Divine goodness! What a marvellous breast!' and who does not know how to respond other than by blushing and lowering her eyelids.")

At all events, Maillol had given Breker a propaganda coup by visiting his show, and he was right to think that the Nazi sculptor owed him one. And Breker, as it were, was a broker. He likes boasting of the

influence he had and was able to use—he says, for instance, that a word of his in the ear of General Müller saved Picasso from arrest. He points out that the charges against Vierny were very serious: helping refugees, working with Communists, cross-border currency deals, and so forth. Also he points out, with some relish, that she was a Russian of the Jewish faith, and that if he didn't act quickly she might be put on "a convoy leaving for the East."

What Maillol had on his side was his fame and the fact that Speer was an enthusiast for his work, Breker says, adding, untruthfully, that Speer had offered him a commission for a large fountain. A sketch for this had met with Hitler's approval and preparations were under way. Hitler, too, was a Maillol fan, says Breker.

Whatever words Breker had with the Gestapo turned out to be effective, and Breker received assurances that the release would be arranged. He chose this time to travel down to Banyuls and get Maillol to sit for him, a favor which the old man could hardly have refused. When the bust was finished, Breker, who had been informed of the time of Vierny's release, still (by his own account) didn't let Maillol know. Instead he acceded to Maillol's repeated requests to be taken back to Paris, and he arranged that they would lunch with Rudier, Maillol's and Breker's founder, and his wife at a small restaurant in the Avenue Matignon, near the house, says Breker, where Heine died.

An officer called Lange was due to pick up Vierny from Fresne prison and bring her straight to the restaurant—presumably (this is all I can guess) as a way of demonstrating his power and usefulness to Rudier and Maillol while at the same time showing that he had responded to their request. Aperitifs were drunk, and the meal ordered. Finally Vierny appeared and simply took her seat at the table between Maillol and Breker and ordered her meal. Breker says that afterward he insisted on taking her home, and that outside she broke down completely. He told her that she must go straight back to Banyuls and not continue her Communist activities, for she would certainly be watched by the Gestapo: one more misdemeanor and she would be killed. Breker also put the story about that if Vierny did anything else wrong, his, Breker's, life would be in danger.

Vierny did go back to Banyuls, but only a week later. She stayed

there awhile, as we know from Henri Frère, a friend and neighbor who recorded extensive conversations with Maillol, but finally she left and no doubt was indeed in Paris at the time of the liberation on August 25, 1944. (There is even a story that Maillol told Vierny she must thank Breker properly for saving her life, and that she went up north in order to do just that, and tracked him down.) To the distress of his father, Lucien Maillol was arrested by the local purge committee, for having been a member of the *milice*, and was jailed in Perpignan. On September 15, 1944, Maillol went to plead on his son's behalf. Friends found him later, "wandering like a soul in torment," and persuaded him to go and stay in the country with Dufy. On the way, they had a car accident. Maillol was hurt on the chin, and in the next days he began to lose the will to live. Frère describes his slow death, a classic case of turning one's face to the wall.[40]

According to Waldemar George, when the radio and the papers announced Maillol's death, on September 27, Vierny wanted to go to the Tuileries to place some flowers at Maillol's monument to Cézanne. But the Tuileries was held as a military post, and she was unable to get in.

Maillol had done her proud: he had saved her life, and he had made her joint executor, with Lucien, of his estate. When Clotilde Maillol died in 1952, Lucien apparently handed over complete control to Dina. She had her gallery already, and she was no doubt better at business than Lucien. In the next few years, she bought up everything by Maillol that she could afford, and she founded the museums I have already described. Maillol had done her proud, and you could say that she has returned the compliment handsomely. It is amazing to go to the Carrousel garden, and to think how all that effort has spanned a century; what Rodin did for Maillol, what Kessler and Maillol did for each other, what Maillol did for Vierny, what Malraux did for Vierny, and what Vierny did for Maillol, to round the story off.

Becoming Picasso

<div align="center">I</div>

So the *New Yorker*, like one of those ferocious patriotic ladies in the First World War, has handed Picasso the white feather. He was "a coward, who sat out two wars while his friends were suffering and dying," although, the passage continues, less certainly, "he may have been right to do this in the First War, but he did it again, in the same way, in the Second . . ."[1]

Picasso was born in 1881. To accuse a man of cowardice for not having joined up in 1939, when he was in his late fifties, strikes me as a complete novelty, and it would have been a novelty to those Allied soldiers who, on the liberation of Paris, flocked to Picasso's studio as a place of pilgrimage. Picasso could have "sat out" the war in New York, but chose not to do so, even though he was one of the most famous antifascists of his day. Picasso was also a Spaniard and a pacifist. Whether you think that he should have felt obliged to fight for France in the First World War depends on whether you think he might be entitled to his pacifism—whether you think that all pacifists are cowards.

The man in the long skirt with the cloche hat, doling out these white feathers to the artists of the past, and hitting them over the head with his parasol, is Adam Gopnik, the author of the *New Yorker* article. Gopnik's own writing on Picasso comes across, over the years, as an unstable compound of calculated big-cheese worship and exasperation. A decade and a half ago, he wrote as the proselytizing star pupil of William Rubin, whose forthcoming lectures and insights he was permitted to flag.[2]

By 1989, although Rubin was still "a great historian," his researches

<div align="center">185</div>

into Cubism were seen by Gopnik as irrelevant and obsessive: "Whatever minor anomalies and surprises may remain to be found, this looks like a case where all the returns are in."[3] And in the latest episode of this tale of disillusionment and remorse, Rubin, still "the greatest of Picasso scholars," gets treated ironically as "a man of . . . intimidating aplomb, born to lead orchestras or armored divisions," but nevertheless a fool who fusses over absurd minutiae, while the young Gopnik, in a disgusting disavowal, is portrayed as a consumer of carrion:

Like many young art historians of my generation, I did a little feeding on Picasso's corpse. We couldn't help it: it was the biggest body on the beach, the washed-up whale, and we needed a meal.

What does this mean? That his generation were careerists who just had to get on by whatever means came to hand? As so often with Gopnik, the bad style leads the sense by the nose, and this affected remorse comes across as smug.

Gopnik's unfolding purpose seems to be to tell his old teacher that his life has been spent in vain. In order to soften the blow, he offers up an indictment of John Richardson's biography, *A Life of Picasso*, which he calls ill written (and he is on such thin ice here: he is the author of the judgment that Picasso's Cadaqués paintings "look like pictures that Whistler might have produced had he given up pastels for an X-ray machine"), exculpatory, and shallow in its assessment of the art. But he spoils the effect by his triumphant conclusion that Picasso "may very well turn out to be this century's Ingres—a master draftsman, with a single, reiterated erotic vision, who became the little god of the academies and had . . . no artistic conscience at all." The author of this remark is more worried about his own academic past than he is about his critical conscience.

One could imagine a situation in which Picasso's reputation sank, just as Rodin's did earlier this century. The history of taste is full of such reversals. But even if Picasso's reputation sank to zero, he is hardly likely to disappear as a historical figure: one would still have to know about Picasso in order to understand the history of other people's painting, other people's sculpture, etchings, ceramics, design. He would become—this future, unbearable Picasso—a figure like Sir Walter Scott

or Victor Hugo, whose books remained familiar through other media even when they were not read. Even if, say, *Guernica* became absurd or incomprehensible as a painting, there remains the fact that the other day the Germans paid damages to Guernica itself. I doubt if that would have happened had Picasso's painting not kept the Guernica incident notorious. That is one of many reasons why it was always shallow of Tom Wolfe to call Picasso this century's Bouguereau. It was a shallow remark, but it meant something. Gopnik's revision of it means nothing at all.

To return to the question of Picasso's cowardice: John Richardson, who is clear-sighted about his subject's human shortcomings, does not seem to think that a failure to enlist in the Foreign Legion was one of them. On the contrary, he thinks that Apollinaire's eagerness to fight for France (he was an Italian national) was part of his tragedy. Apollinaire had been imprisoned over the "affair of the statuettes," in which objects had been taken from the Louvre with his alleged complicity, and was keen to purge the stain of his misdeeds. Picasso was not required to join up, and he obviously did not feel obliged to make either himself or his art more acceptable in the eyes of French chauvinism by gestures of that sort. He saw his prime responsibility as being toward his art, and he was quite right.

It is a cozy vice for a non-combatant from a different age to make himself a connoisseur of other people's valor. Braque fought. Picasso did not. But it was not this that came between them. Most of those who fought had no choice in the matter. Léger, for instance, features in Richardson as "one of the more gallant of the Montparnasse artists. Until he was gassed in 1917 and invalided out of the army, Léger was a sapper in the engineering corps and constantly in the thick of action: Verdun, Aisne, Argonne."[4] But Léger was desperate not to fight in 1914, and his letters from the front show a man consistently keen to get away from the fighting, always on the lookout for the legitimate ticket of leave (as when he wistfully remarks that the workshops of the camouflage division, which he wants to join, are near that famous bar, the Lapin Agile). Christian Derouet, in his introduction to Léger's letters, paints a quite different picture of the artist from Richardson, implying that he was something not far short of a malingerer. Derouet

says that Léger's job—he was only briefly a sapper and spent most of his time as a stretcher-bearer, a *brancardier*—was "often only a sordid chore." This judgment seems both ungenerous and wildly lacking in imagination.[5]

There is a fundamental divide between those who have been subject to military discipline on the battlefield and those who have not, but even within the former category there will be a wide discrepancy in suffering. Léger implicitly acknowledges this in his letters when he describes soldiers emerging from the trenches, where they have spent weeks on end without relief. He seems to recognize that they have been through something he can only guess at. But he also knows full well that his friend back home, Louis Poughon—the man to whom he makes so many requests for influence to be exerted on his behalf—is never going to understand what he, Léger, has been through:

I am sure that this war will have taught me to live. I believe that I shall not squander another minute the way I used to squander entire months, because I shall see things in their "value," their true absolute value, in God's name! I know the value of every object, do you understand, Louis, my friend? I know what bread is, what wood is, what socks are, etc. Do you know that? No, you can't know that because you have not made war. Do you know what it is to have fear take over your whole body and tear you away from a secure shelter and throw you out against death like an imbecile? No, you can't know that, you haven't made war. You will remain a man of "before the war" and that will be your punishment, Louis, my old friend, and me, despite my 34 years, despite my life already begun, like my work, which this tragedy has broken in two, I am nevertheless still young enough, still alive enough to be, me too, if the God of my mother permits it, to be, you understand, of the great generation *after the war*![6]

Léger used trickery to remain in hospital for the last year of the war, but one would have to be something of a Spartan mother to call him a coward for that, considering he had just been through Verdun. As for the idea that Picasso should perhaps have volunteered for Verdun, I doubt if Léger himself would have seen the sense of it. He only ever volunteered in the opposite direction.

2

That Richardson never intended definitive status for his biography—
whatever the word might mean in such a context—is clear to anyone
who has bothered to read the note on "Principal Sources" in Volume
One. Not all collections of papers can be consulted, and some of the
items in the Picasso archive itself are yet to be declassified. The interest
of Richardson's book is in any case a personal one. When Richardson
was living with Douglas Cooper in the 1950s, he got to know many
of the principal actors in this story, including Picasso and Braque (about
whom he wrote a short book which still reads well, as does his celebrated
essay on Manet).

The relationship with Cooper was both a source of education for
Richardson and, as it turned out, a handicap, for Cooper did his
best to undermine the younger man's self-confidence. When the two
quarreled, and Richardson went off to work at Christie's, in due course
running its New York office, what had once been a very promising
writing career was shelved for a while. Richardson as a scholarly writer
has no Middle Period to speak of, only the authoritative early works
such as the excellent essays in the *Burlington Magazine*, and this great
late flowering.

In the two volumes of the Picasso biography so far, what we have is a
splendid making up for lost time. There is the careful revision of the
published sources, debunking some and rebunking others. There is the
material that comes directly from Picasso, with whom Richardson got
on better than Cooper did (Cooper would irritate with niggling inquiries,
while Richardson was ready to entertain with gossip). At times, I believe,
we also hear the tones, and maybe some of the prejudices, of Cooper
himself (to whose memory the first volume was dedicated, Cooper and
Richardson having eventually become reconciled, although Picasso in
his last years banned Cooper from his house).

At times, Richardson's contempt is on display. I don't think it right
to call him antifeminist. He is anti-Arianna Stassinopoulos Huffington,
herself a prominent antifeminist and author of the forgotten tract *The
Female Woman*. He is anti any attempt to foist what he sees as a premature

politicizing onto Picasso, and this makes him rather tough on someone called Patricia Dee Leighten. He is rather reluctant to let Picasso ever go to bed with a bloke, no doubt rightly, but since it is also built into Picasso's psychology that he requires the adoration of male homosexuals, one does sometimes idly wonder whether there might not, at some stage, have been the occasional experiment in that direction.

He is particularly anti—and this I believe to be a Douglas Cooper leitmotif—the "Salon Cubists" Albert Gleizes and Jean Metzinger, so anti that the other day I paid a visit to the Musée d'Art Moderne in the Trocadéro to find out what they had done wrong. It was of course not simply a matter of their adaptation of Cubist style to an essentially decorative purpose. It was also the extraordinary act of appropriation whereby they decided that *they* had invented Cubism. One can still buy Metzinger's memoirs, *Le Cubisme etait né*, which mentions Picasso only in passing and Braque not at all, and their jointly written *Du Cubisme* (first published in 1912), in which Picasso and Braque are vouchsafed one illustration each, while Gleizes and Metzinger together enjoy eight.[7] Their view was that only those who had exhibited with them in the Salon des Indépendants had the right to be called Cubists. Picasso during all this period was exhibiting more abroad than in France, and he was avoiding the Salons. So he was really, in this view, quite marginal.

The vanity and self-deception of the minor artists of the period is illustrated in the story Cocteau tells of going round studios with Picasso only to find doors locked against them while the painters hurriedly hid their recent works in case Picasso stole one of their latest inventions. It is not that one doubts that Picasso might well have seen fit to borrow whatever came in handy. The vanity is rather in the belief that there might be so much lying around for Picasso to steal, so much that wasn't, more likely, stolen from him in the first place. Richardson has an interesting detailed account of the quarrel between Picasso and Diego Rivera, which illustrates the process at work: Picasso had indeed borrowed a pictorial device, but only from a painting overwhelmingly indebted to Picasso himself.

Richardson is not exculpatory or amoral in his attitude toward Picasso. He likes the story he is telling to be good, and if it contains bad, or monstrous, behavior, we are going to be let in on it. He is

pretty much unshockable, which is just as well when one is dealing with characters like Cocteau and his fashionable circle, who diverted themselves at the beginning of World War I by designing for themselves outlandish uniforms (like deep-sea divers' or Argentine policemen's) and popping off to the war in ambulance units equipped with showers. Cocteau, we are told, "supervised this facility, photographing and on occasion seducing the Zouaves and Senegalese sharpshooters, and even writing a poem about them, called 'La Douche.' Eventually there was a scandal. Outraged by Cocteau's passion for one of his men, a jealous *goumier* (Moroccan) sergeant threatened to hack the flirtatious poet to pieces." A far cry, one feels, from the war as Léger knew it.

The need to compress the enormous amount of information involved— even in a biography on this scale—suits Richardson's style very well. Consider the following sentence, describing the uncle of Daniel-Henry Kahnweiler, the dealer: "Sir Siegmund [Neumann] was one of those Edwardian tycoons whose lavish hospitality—dinners of ortolans, baby lambs' tongues and *foie gras en croûte*, followed by cigars and stock market tips—prompted Edward VII to reward his hosts with knighthoods and invitations to shoot at Sandringham." There is a great deal of social history packed in here, and, to the English ear at least, the placing of the word "Sandringham" at the climax of such a sentence is both comic and revealing: this is exactly, one feels, what Sandringham was all about.

As with the first volume, the second installment is self-contained and generously self-explanatory. A character appears—say, for example, Annette Rosenshine, best friend and cousin of Alice B. Toklas. She has a cleft palate and a harelip and a deteriorating psyche. Gertrude Stein begins subjecting her to amateur analysis. She gets worse. Then both Stein and Toklas (who have fallen in love) drop her. She is traumatized but, in Richardson's view, saved by this betrayal. She goes back to San Francisco in 1908, dropping out of the story. Except that there is a footnote:

After World War I, Annette returned to Europe. Alice saw that Gertrude shunned her, but it no longer mattered: she was on her way to Zurich to have Dr. Jung undo the damage done by "Dr." Stein. Later Annette did a stint with Gurdjieff, and in the 1960s ended up in Berkeley, where she found not only a following among the students but an analyst who gave her LSD therapy.

Of course neither Annette Rosenshine (with her appetite for therapy) nor Sir Siegmund Neumann has anything directly to do with Picasso. It is the speed with which these marginal characters make their impression that is so admirable. As for the treatment of the major characters and themes, I found with Volume One, and the sensation is no less with the present volume, that as I read it my education simply advanced by one great step. It is like being in a clock tower when one of the big cogwheels moves forward by one notch—a great, simple, fundamental event.

3

One could organize a whole exhibition (it might be called "A Century of Sucking Up") out of the portraits that painters have done in order to cement or improve their relationships with their dealers. There are forerunners of course—Titian did one, and so did Courbet—but the genre as such really gets going with van Gogh (Père Tanguy and Alexander Reid) and is developed by Renoir (members of the Durand-Ruel family). One supposes that the rise of the genre coincides with the decline of the aristocratic patron, and the diminishing importance of the academy in the lives of the artists. If this imaginary exhibition were organized by subject, the hero would undoubtedly be Ambroise Vollard. Picasso once said to Françoise Gilot:

The most beautiful woman who ever lived never had her portrait painted, drawn, or engraved any oftener than Vollard—by Cézanne, Renoir, Rouault, Bonnard, Forain, almost everybody, in fact. I think they all did him through a sense of competition, each one wanting to do him better than the others. He had the vanity of a woman, that man. Renoir did him as a toreador, stealing *my* stuff, really. But my Cubist portrait of him is the best one of them all.[8]

If the exhibition were laid out according to schools, then the British room (from Orpen's Duveen to Hockney's Kasmin) would be pretty good, while the American section would round it off nicely (Schnabel's Mary Boone, painted on broken plates) and there would be a special lifetime award for Jasper Johns, who, during the whole of his artistic

38. *Saint Ambrose*, *c.* 1645, terracotta
by Gian Lorenzo Bernini, in the State
Hermitage Museum, St Petersburg

39. *Constantine the Great*, *c.* 1654, terracotta
by Gian Lorenzo Bernini, in the State
Hermitage Museum, St Petersburg

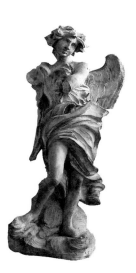

40. *Angel with the Superscription*,
1668–9, terracotta by
Gian Lorenzo Bernini, in the
State Hermitage Museum,
St Petersburg

41. *Angel with the Superscription*,
1668–9, terracotta by Gian Lorenzo
Bernini, in the State Hermitage
Museum, St Petersburg

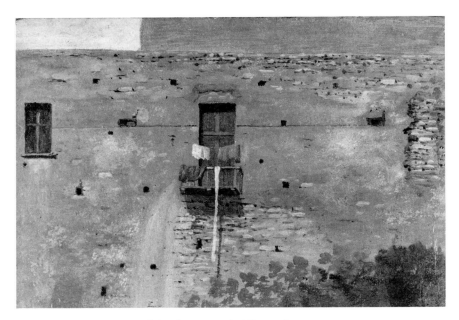

42. *Wall in Naples*, *c.* 1782, oil sketch on paper by Thomas Jones, in the National Gallery, London

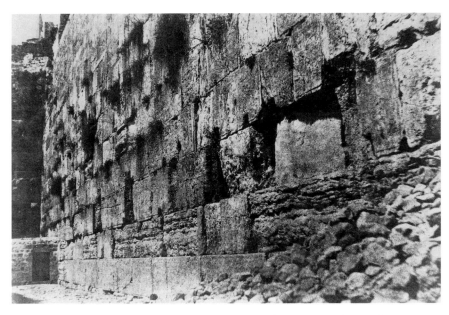

43. *Enclosure of Temple, West Side Heit-El-Morharby, Jerusalem*, 1853–4, salt print from a paper negative by Auguste Salzmann, in The Museum of Modern Art, New York

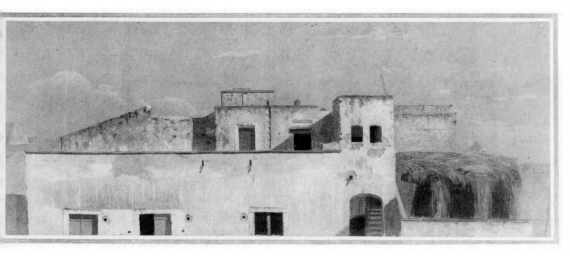

44. *Rooftops, Naples*, 1782, oil sketch on paper by Thomas
Jones, in the Ashmolean Museum, Oxford

45. An Egyptian decoration surmounted by a bull, for the Caffè della Inglesi,
Rome, engraving by Piranesi, from *Diverse Manière*, published 1769

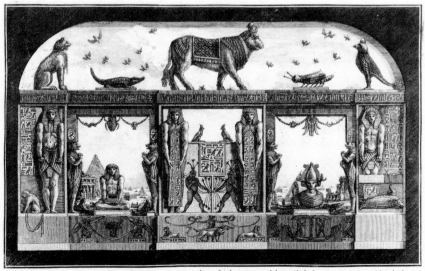

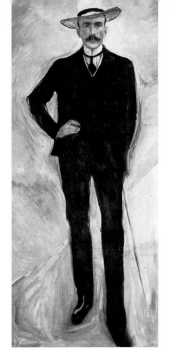

46. Sir Charles Holmes

47. *Harry Graf Kessler*, 1906, oil on canvas by Edvard Munch, in the Nationalgalerie, Berlin

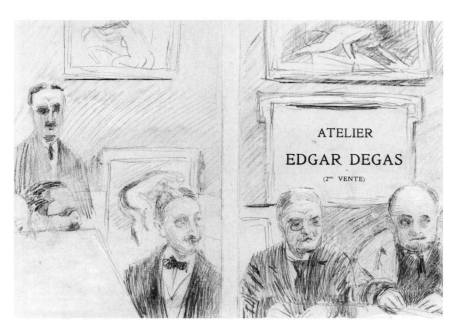

48. *The Auctioneers at the Edgar Degas Atelier Sale*, 1918, graphite and black, red and white chalk, drawing by Paul Helleu

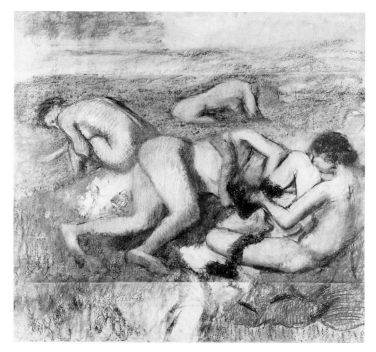

49. *The Bathers*, *c*.1895–1905, pastel and charcoal on tracing paper, pieced and mounted on board by Edgar Degas, in the Art Institute of Chicago, Gift of Nathan Cummings, 1955.495

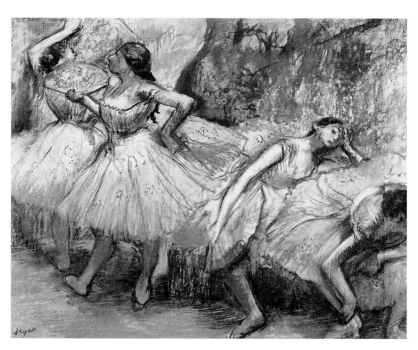

50. *Dancers*, *c*.1895–1900, pastel and charcoal on tracing paper mounted on board by Edgar Degas, in the Corporate Art Collection, the Reader's Digest Association, Inc.

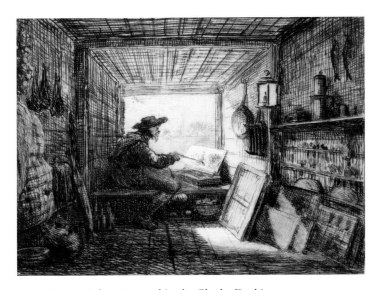

51. *Le Bateau-Atelier*, 1862, etching by Charles Daubigny,
in the British Museum, London

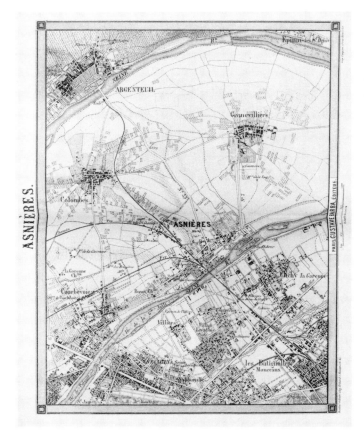

52. Map showing
Asnières, from Émile de
Labédollière's *Histoire
des environs du Nouveau
Paris*, 1861

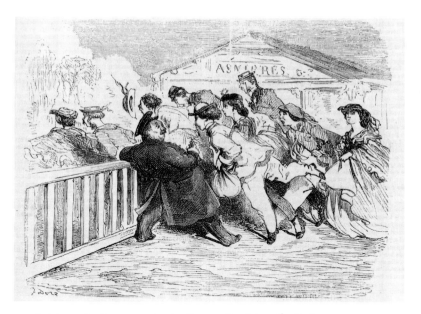

53. *Arriving at Asnières*, engraving by Gustave Doré from Émile de Labédollière's *Histoire des environs du Nouveau Paris*, 1861

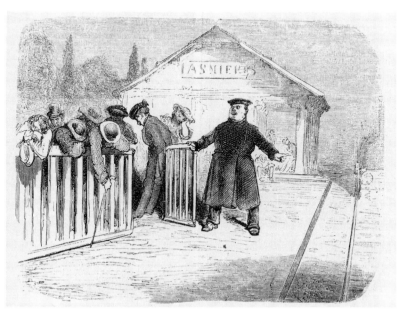

54. *The Return to Paris*, engraving by Gustave Doré from Émile de Labédollière's *Histoire des environs du Nouveau Paris*, 1861

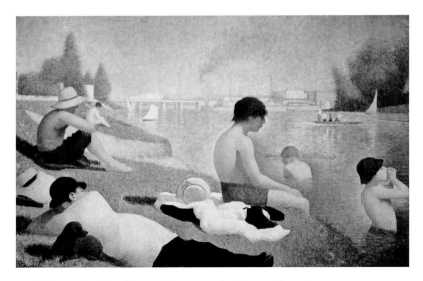

55. *Bathers at Asnières*, 1883–4, oil on canvas by Georges Seurat,
in the Tate Gallery, London

56. *Luncheon of the Boating Party*, 1880–81, oil on canvas by Pierre Auguste
Renoir, in The Phillips Collection, Washington, DC

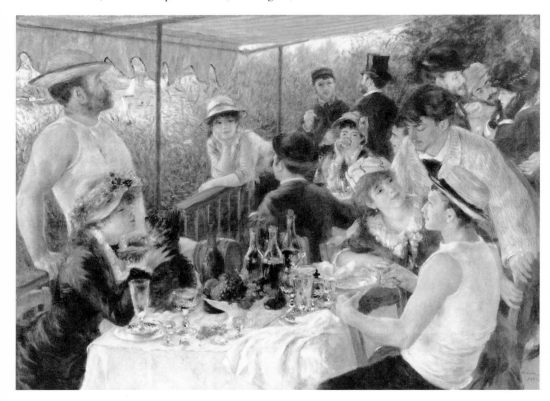

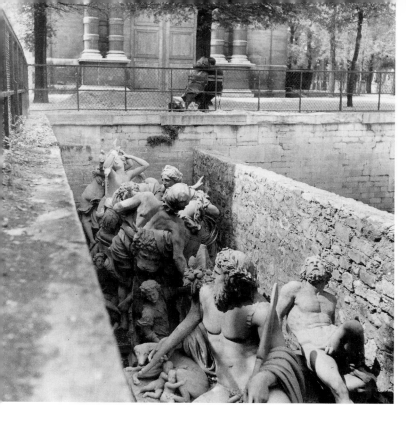

57. Ancient statues
from the Jardin des
Tuileries, Paris, put in
a trench during World
War II, photograph
by Robert Doisneau

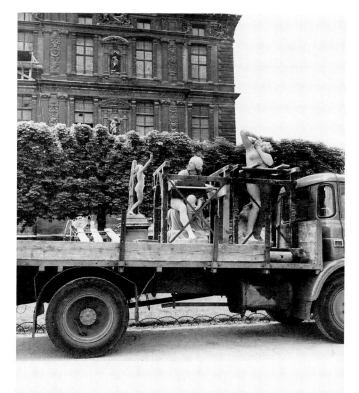

58. Removal of statues
from the Jardin des
Tuileries, Paris,
to make room for
Maillols in 1964,
photograph by Robert
Doisneau

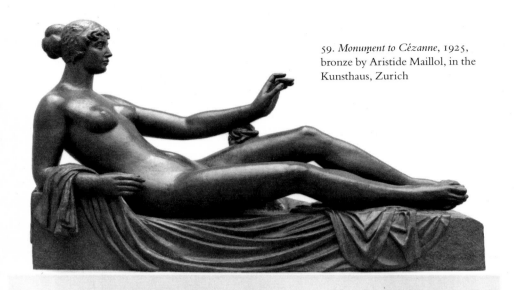

59. *Monument to Cézanne*, 1925,
bronze by Aristide Maillol, in the
Kunsthaus, Zurich

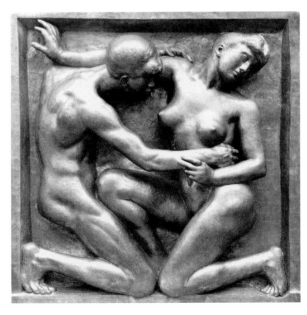

60. *Desire*, 1907, lead relief by Aristide
Maillol, in the Museum Boijmans
Van Beuningen, Rotterdam

62. Maillol in Delphi, 1908, photograph
by Harry Graf Kessler

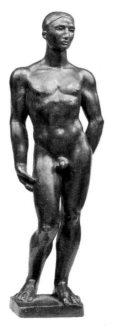

63. The salon in the flat of Harry Graf Kessler,
Weimar, with the sculpture *Cycliste* by Maillol and
the painting *Forest with Hyacinths* by Maurice Denis

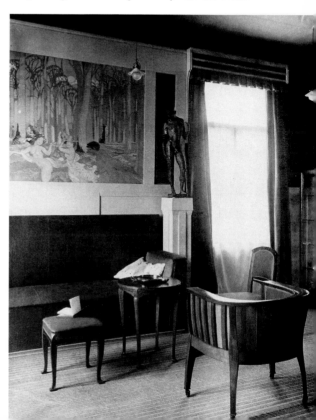

61. *Young Man*, 1908–30,
bronze by Aristide Maillol,
in a private collection

64. Léger (left) in the trenches,
1916, in a private collection

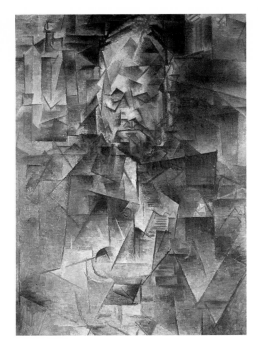

65. *Portrait of Ambroise Vollard*, 1910, oil on canvas
by Pablo Picasso, in the Pushkin State Museum
of Fine Arts, Moscow

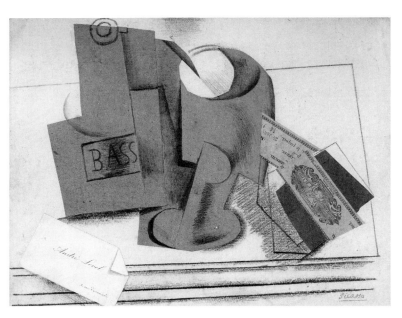

66. *Bottle of Bass, Wineglass, Packet of Tobacco and Visiting Card*,
1914, oil on canvas by Pablo Picasso, in the Musée National
d'Art Moderne, Paris

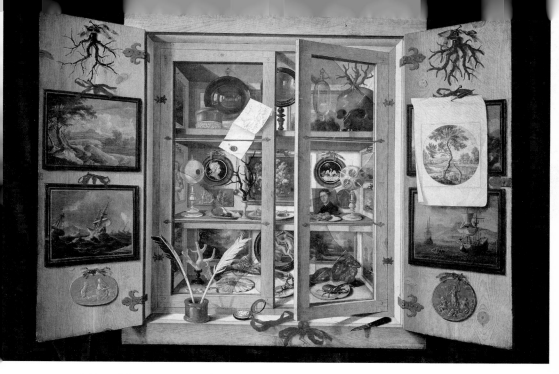

67. *Cabinet of Curiosities*, trompe l'oeil painting attributed to
Domenico Remps, late seventeenth century, in the Museo
dell'Opificio delle Pietre Dure, Florence

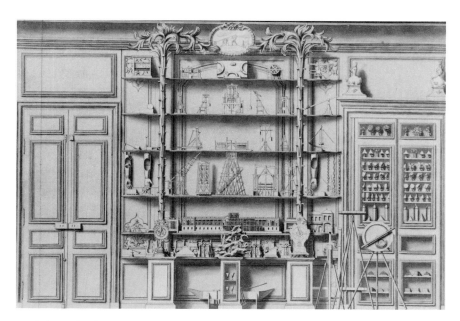

68. Cabinet de Physique et Mécanique, 1739–40, from a series of eight
pen and wash on paper drawings of the *Cabinet de Curiosité de M. Bonnier
de la Mosson* (1702–44) by Jean- Baptiste Courtonne

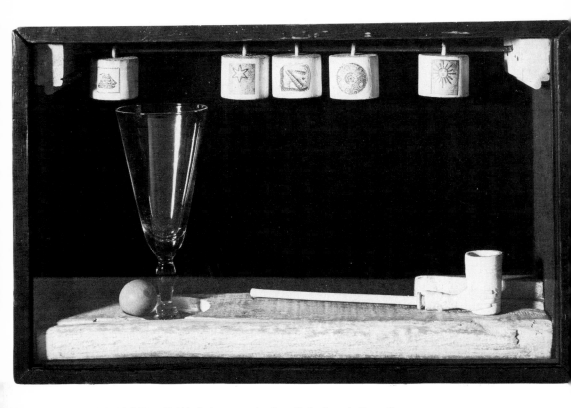

69. *Untitled (Soap Bubble Set)*, 1949, mixed media by Joseph Cornell, in a private collection

70. Rauschenburg
exposing blue print
paper to light source,
West 96th Street,
New York, spring 1951,
photograph by
Wallace Kirkland.
The Wallace Kirkland
Collection in the
State Historical Society
of Wisconsin
(WHi(x3)51046)

71. *Soundings*,
silkscreen ink on
plexiglass with
electrical components,
1968, by Robert
Rauschenburg in
the Museen der Stadt,
Cologne

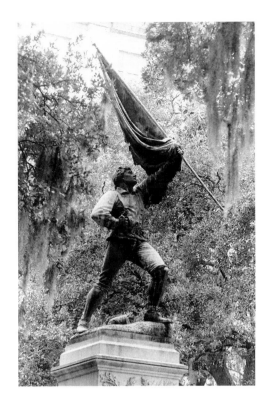

72. Jasper monument,
Savannah, Georgia, erected
in 1888, by Alexander Doyle

73. *Target with Plaster
Casts*, 1955, encaustic and
collage on canvas with
objects by Jasper Johns in a
private collection

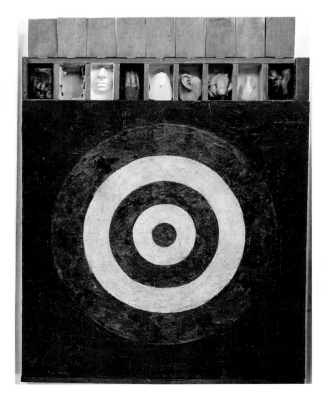

career, appears to have represented only three recognizable faces: himself (on another plate), the Mona Lisa, and Leo Castelli.

But if the exhibition were done artist by artist, the master of the dealer portrait would undoubtedly emerge as Picasso. At the time of his first Paris exhibition he did both his dealers (Pere Mañach and Vollard), plus the reviewers who had been persuaded to turn in good notices. From that time on, until he stopped needing to, and *realized* he no longer needed to, he did everyone. One of Picasso's most frightful paintings (*Madame Paul Rosenberg and Her Daughter*) is a sucking-up portrait, but then so are the distinguished Cubist portraits of 1910—of Vollard, Kahnweiler, and Wilhelm Uhde. A year before, Picasso had painted (from photographs, apparently) the horrible Clovis Sagot, the most ruthless and pitiless of the small-time dealers. That he should have made these portraits during the height of his Cubist period is striking. Both Richardson and Michael C. FitzGerald (another Picasso scholar with a Christie's background) suggest that he used the time spent on these sittings to strengthen his relations with those three, and Richardson adds, in his cool way, that if he did his finest portraits of dealers rather than the poets who were his closest friends, that is because he needed the dealers as much as, if not more than, the poets.

William Rubin, in his catalog to the show *Picasso and Portraiture* which opened at MOMA and closes this month at the Grand Palais, acknowledges FitzGerald's suggestion, but thinks it does not go far enough.

The 1910 portraits coincided with a moment in the artist's career when, as a result of the radicality of his thinking, the thread connecting his pictures to the visual world seems nearest to breaking. In order to test just how abstract he could be and still communicate an individualized subject, Picasso needed sharply etched, salient models, who would not disappear into types and generalized symbols in the manner of "passive" still-life and landscape motifs.[9]

There is something comic in the idea that Picasso might have woken up and thought: Who do I know who is sufficiently sharply etched and salient not to end up, when I have painted his portrait, looking like a mandolin and a bowl of fruit?

Rubin is capable of the most extraordinarily slack writing, and is at

his worst when discussing the history of portraiture (see page 18 of the "Portraiture" catalog) and what distinguishes the modernist portrait from those of what he calls the Old Masters. He thinks that between the Renaissance and modern times, the "portrait situation" remained "fairly stable," that the relative wealth of the sitters meant that there was a "psychosocial" distance between them and the painters, which tended to "diminish dialogue and intimacy and encouraged the painter to concentrate on externals: facial features, costumes, and accessories symbolizing the sitter's formal place in the world." In parentheses he tell us that "because of their own renown, Leonardo, Titian, Rubens, Velázquez, and a few other great masters constituted exceptions— though only partial ones—to this rule." None the less he concedes that "the finest portrait painters managed to make great paintings" but, still, "portraiture, in anything less than outstanding hands, was usually the most boring of Old Master genres (as art-sensitive visitors to the 'stately homes' will readily attest)."

This does not sound particularly "art-sensitive" to me. To begin with, it appears to have been written by somebody not in the least curious about the history of art of previous centuries. Secondly, if the problem for those Old Master painters was their social distance from their sitters, then one would expect the history of the self-portrait, where the social standing of artist and sitter is identical, to be quite different from that of portraiture in general. If it was a drawback for the Old Masters, when they painted portraits, that they were obliged to concentrate on "facial features," then I suppose one could expect the self-portraitist to concentrate on something less "external"—tonsils and adenoids, perhaps.

<p style="text-align:center">4</p>

A still life from 1914 called *Bottle of Bass, Wineglass, Packet of Tobacco, and Visiting Card* (none of the titles of Picasso's paintings are his) bears the visiting card of André Level, a businessman of extraordinary perception who organized what has been described as the first mutual fund; it was called "La Peau de l'Ours," the skin of the bear (an allusion to La Fontaine), and involved a group of investors contributing 250

francs each a year, which would be invested speculatively in modern paintings. At the end of ten years the whole collection would be sold, but before then the paintings would hang in the homes of shareholders.

At the time the fund began, Matisse had been trying to get together a group of backers to support him in a similar way, and he may well have been the originator of the idea. Level had twelve partners, and he began investing in 1904. Ten years later, as if to prove that the fund had matured on schedule, it had become almost impossible for him to buy the kind of works he had originally set out to acquire. A fancy catalog was printed and the sale took place in March 1914.

Shortly before the sale, the investors made what sounds like a rather noble decision: they agreed that 20 percent of the proceeds should go to the artists whose works made up the fund (to be divided between them in proportion to prices raised). This principle entered French law six years later and was known as *droit de suite*: when a modern artist's work is resold in France, a small proportion of the proceeds is payable to him or his estate. This has recently become a topical issue, since the European Community, when it harmonizes laws like those on copyright, tends to level up rather than level down. If *droit de suite* were extended to England, according to the chairman of Christie's, Lord Hindlip, speaking in the House of Lords, that would be the end of London as a center for the modern art market, because no Japanese collector would wish to pay the extra 2 percent.[10]

So "La Peau de l'Ours" may be responsible, one day, for closing down Christie's London operations. More immediately, it was responsible during the decade of its purchases for a change of attitude by dealers toward artists like Picasso and Matisse: someone was buying their work regularly and systematically. And when the sale took place, it was Picasso's *Saltimbanques* that proved the star, selling for 12,650 francs. Michael FitzGerald, whose book *Making Modernism: Picasso and the Creation of the Market for Twentieth-Century Art* was published in 1995[11] (some, but by no means all, of his research is incorporated in Richardson's Volume Two), made a calculation that in 1991 values this would be the equivalent of $4.18 million. Whatever the mathematics of the matter, and the difficulties of establishing equivalents in buying power, it was clear that Picasso had passed on to a new level of existence. From around 1909 he had not lacked money, although he did not know

for certain that he had achieved financial security. But the still life with André Level's visiting card was a gift from Picasso to Level in acknowledgment of his indebtedness. Picasso's personal share of the proceeds was just under 4,000 francs.

It is significant that the purchaser of the *Saltimbanques* was a German, Heinrich Thannhauser from Munich, since the market which Kahnweiler had cultivated for Picasso was very much a German affair, and this was noted by French chauvinist writers, who accused the Germans of buying Cubist works in order to undermine the morale of the French. There was an atmosphere of cultural paranoia at the time which was not so unlike the atmosphere later created in Germany under the Nazis. If, by 1917 when Richardson's Volume Two ends, Picasso was wealthy but not secure in his wealth, that is not so surprising. Two major dealers, Kahnweiler and Uhde, had their stock confiscated during the war. The Russian Revolution would put an end to the great St. Petersburg collections. Even after the war, when the French government sold off the Kahnweiler and Uhde stock as having been the property of enemy aliens, the artists affected were furious, afraid (wrongly as it turned out) that the market would be flooded and their prices would fall.

I have seen it claimed that the chapters in Richardson (both volumes) about collectors and dealers are nothing more than an eccentric and amusing extra. On the contrary, I think that both Richardson and FitzGerald are absolutely right in pursuing their researches in this direction. Kahnweiler, Picasso's first real dealer, had a very strong point of view about Cubism itself. Léonce Rosenberg, who briefly replaced him, circularized his artists, telling them not to have anything to do with the Ballets Russes. Paul Rosenberg, who with Georges Wildenstein took Picasso over and sold his works in association with a gallery mainly dealing in Old Masters, may well be said to have contributed to the way—and this would be the important thing—that Picasso thought about himself. Richardson's Volume Three will have to deal first of all with the "duchess period" in which Picasso was obligingly turning out portraits of Madame Wildenstein and Madame Rosenberg in Biarritz.

The whole question of who dealt in what and who collected what leads straight to the fundamental artistic issue: who could have seen

what, where, and when. In 1913 there was an exhibition in Berlin called *Picasso and Negerplastiken*, consisting of paintings and drawings relating Picasso's work to tribal sculpture. No copy of the catalog has survived, but the exhibition toured Dresden, Vienna, Zurich, and Basel. It has dropped out of history. Nobody knows what the tribal sculptures involved were.

Finally, I think Richardson right to emphasize that, in our perception of the history of Picasso's fame, we can easily forget the role played by German collectors and dealers, because none of those early collections has survived. If it wasn't the First World War or inflation that did them in, it was the campaign against degenerate art and the persecution of the Jews. The paintings that Kahnweiler sold to Germany ended up, most of them, in America. But one should not forget this chapter in their history.

5

The "affair of the statuettes" already referred to was not, in fact, about statuettes at all, but about some Iberian stone heads of the fifth to third century BC. Géry Pieret, a bisexual Belgian con man and psychopath, stole them from the Louvre in 1907. (When he told Marie Laurencin, "I'm going to the Louvre. Do you want anything?" she thought he was referring to the department store, the Magasin du Louvre.) He seems to have sold two to Picasso and another to Apollinaire. Four years later, after the disappearance of the *Mona Lisa* from the Louvre, Pieret boasted to a newspaper about how easy it had been to steal from. The police were alerted. Apollinaire and Picasso went into a panic. Apollinaire was briefly jailed. Picasso appears to have disclaimed all knowledge of Apollinaire and somehow to have got off scot free.

Two of the statuettes in question were on show recently near Copenhagen at the Louisiana Museum, in a charming exhibition called *Picasso and the Mediterranean*. They are not so remarkable as works of art— nothing to compare with the tribal art which Picasso also collected, or with the wonderful tiny bronze statuettes, also Iberian and from the same period, which look like reductions of Giacomettis. They remind

one, though, of the interest that was growing during that period, not so much in the grand art of the classical period as in the primitive, the folkloric, the modest and crude artifact. Such work included little Etruscan or Sardinian bronzes, Cretan pottery figures, and preeminently the Cycladic art which, when excavated in the nineteenth century, would have gone into the archaeological museums but would never have been considered as art. I asked some scholars from the Ny Carlsberg Glyptotek when the first Cycladic figures arrived in Denmark, and they said that it was around the 1830s. I then asked when Cycladic art first began to be faked, and they said around 1920. That gives a rough idea of the time it took for the taste in Cycladic art to be created.

It is worth remembering that, just as it is *possible* that one day Picasso's reputation will go into an eclipse, so it is possible that one day the taste for Cycladic art will be quite forgotten. This is not as mad as it sounds. There is a very good precedent in the story of Tanagra figurines — painted terracotta statuettes, mostly from third-century BC Greece. Around the turn of the century, very few people would have understood the expression "a chaste, Cycladic beauty," but a large number would have known and employed such phrases as "a lyrical beauty, Tanagra-like in its delicacy." Count Harry Kessler, who thought that the Tanagra figurines were the sculptural equivalent of Anacreon's poetry, would spend hours in the museums gazing at the cases full of Tanagras. He couldn't do so now because large numbers of them are in the storerooms and are fakes.[12]

And just as Tanagra only held its own as a category of beauty between the 1870s and the first decades of this century, so too the Mediterranean as a category has its own history, its rise and decline. Byron, who knew the Mediterranean so well, would never have known about its myth, because he thought in imperial terms and would have identified with the spirit of Greece or the spirit of Rome. But the Mediterranean myth has to do with what lives on, in the imagination, all around the shores of that sea. It is a *Blut und Boden* myth. In the Mediterranean any nationality is interchangeable: Maillol was a Catalan of peasant stock, and it was a commonplace to say of him, "He is a Catalan, practically an ancient Greek."

★

Jean Leymarie, in his essay in the Copenhagen catalog, is clearly still a believer in the myth when he writes, "The soil of the Mediterranean is poor but it has produced brave seamen to sail its waters and resilient folk to work its land; Picasso never forgot what he learnt from them." And "The *corrida* brought him closer to the solar and nocturnal pulse of the ancient Mediterranean: the rites and ceremonies of Crete; the cult of Mithras and the legend of Theseus." And "The radiant sea, upon whose stormy, roiling waters Man mastered the metrics of the cosmos through *catharsis*, remains the irreplaceable fountainhead of Metre and Beauty." Tériade, the Parisian Greek critic, took Odysseus Elytis to see Picasso's sculptures, and Elytis wrote: "I felt suddenly jealous that these great symbols of the South, these archetypes descended from the mists of time, had not been made on an island in the Aegean, where in former times Man's fingers dared to model solid matter with a clumsiness that cannot lie."

If this kind of writing makes you want to throw up, I quite agree. Not every Greek was obliged to write like that. I looked through Cavafy again the other day to see if the Mediterranean had affected him similarly, but of course Cavafy's antiquity is urban and realistic, peopled with civil servants and minor officials. Another Parisian Greek, Picasso's friend Jean Moréas, "the Ronsard of Symbolism," is held to have been one of the founders of the myth, with his Ecole Romane. John Richardson describes him memorably: "This flamboyant but grubby dandy, made grubbier by the cheap black dye that rubbed off his hair and moustache onto his monocle and gold-ringed fingers . . ."

Christian Zervos, philosopher of Greek origin, author of a thesis on Plotinus, who became the editor of *Cahiers d'Art* and cataloger of Picasso's oeuvre, caused a great scandal, we are told, with a book on Greek art published in 1933. The scandal? His earliest illustrations began in the third millennium BC, and that was considered barbaric.

I bought recently a couple of issues of *Cahiers d'Art* (they do not come cheap) to see what Zervos's aesthetic program was like. It is wonderfully consistent. The first issue, Number 6 of 1929, begins with an account by Zervos of the paintings that Picasso has been making up to the July of the same year. The next piece is on Cycladic idols, followed by one on Fauvism and on pre-Orthodox Slavic art. The last essay is on the railway workshops at Freyssinet, with beautiful

photographs of metal industrial windows. The book reviews include
an attack on Gaudí's architecture for dishonoring the city of Barcelona.

The following issue begins with a piece by Tériade, bringing us bang
up to date with what Matisse has been doing, followed by early Cypriot
terracottas, Ummayad mosaics, a rightly forgotten painter called Cossío,
the architecture and town planning of Joseph Gočar in Czechoslovakia,
and archaeology in the Middle Euphrates. The issue ends with a letter
endorsing the attack on Gaudí as being against the principles of modern
architecture as espoused by the magazine.

The interest, in other words, was in the very latest in art, and the
very earliest, and pretty well nothing in between. Antiquity is the source
of the modern principles of beauty, and the Mediterranean is the source
of antiquity.

Think of a barren slope, some fractured torso, and a distant view of
the sea. Add a peasant. Throw in a goat. You've got the Mediterranean.
It's all a cliché now but it wasn't always a cliché. There wasn't always
a perfume called "Kouros."[13] The Mediterranean had to be invented,
nurtured, and campaigned for. Leymarie mentions the Spanish philos-
opher Eugenio d'Ors, who reflected that the ideal basis for a redemptive
mythos for Catalonia might be none other than "the discovery of
the 'Mediterranean.' " Richardson has many references to it scattered
around Volume One, mostly to do with Moréas's Ecole Romane, and
with Maillol and the Spanish sculptors Manolo, Gargallo, and Casanovas,
and with the earlier Puvis de Chavannes and his "huge visions of a drab
Arcadia dotted with groups of models in stilted poses" which are the
ancestors of those naked youths Picasso painted around 1906.

Robert Rosenblum, during the conference which ended the Den-
mark exhibition, revived an amusing theory when he displayed, side
by side, Picasso's *The Pipes of Pan* and the photograph by Baron von
Gloeden that has the same subject and composition. The idea that von
Gloeden's photographs, which strike us today as homosexual pornogra-
phy, might have been a source for Picasso, takes some getting used to.
But Rosenblum had other examples. Presumably in his next volume
Richardson will have to return to the theme of the Mediterranean,
since it underpins so much of Picasso's post-Cubist imagery, so much
of his classicism. Who is the preeminent artist in the Mediterranean
myth? It is the sculptor. Who is the preeminent craftsman? It is the

potter. What was the Picasso sculpture that Elytis wished had been made in the Aegean? It was a goat. What must be killed? Bulls and Minotaurs must be killed. This is the world we are heading for, which Picasso made so much his own. This is the labyrinth into which we shall follow Richardson.

Joseph Cornell: "Monuments to Every Moment"

Just as the human brain contains in its anatomy the history of its own development, so the art of Joseph Cornell, which is based on obsessive collecting, contains within itself a history of the obsession to collect. It has its *Schatzkammer*, its *Kunstkammer*, and its *Wunderkammer*—its treasure chamber, art chamber, and wonder chamber. Here are jewels, here are portraits of princes and princesses, here are curiosities and marvels from the natural world—excepting that virtually none of it is real. These diamonds are ice cubes, these ice cubes are plastic, these paintings, even these illustrations, are photostats. Cornell and artists like him (for he was not a lone, exceptional figure) resurrected the spirit of the *Wunderkammer* while eliminating all of its intellectual basis, chucking out its meaning in order to allow new meanings to flow in.

The other artists, perhaps, saw these new meanings as having their origins in the subconscious. But, as Deborah Solomon's biography, *Utopia Parkway*, suggests, Cornell disliked or feared the subconscious. He hoped to effect a separation between sensibility and sexuality, and to offer us a history of the former, to the exclusion of the latter. But that—like his ambition to receive and bestow an innocent love—proved to be a hopeless hope. Even Cornell's most devoted admirers—perhaps especially them, if they are vulnerable to disillusionment—must sometimes turn away from a certain shadow box wishing they had not seen it, or experience acute anxiety in seeing one of his short films, even though the materials of the collage seem perfectly innocent. Suddenly the pathology glints from the depths. Suddenly this history lets slip an unpleasant secret.

I

The prologue to Joseph Cornell may be swiftly related. It begins and ends in Europe, and since what put an end to it is the same spirit as founded American independence (it was the Enlightenment that made the *Wunderkammer* look foolish) there are no American institutions that have their roots directly in this tradition. The cathedrals and churches of Europe were our first museums, and not only for what was collected in their treasuries do they deserve the title. The ancient sculptures in metal and stone that were displayed in Pisa or in Venice were beautiful objects held by the church on the community's behalf. Curiosities might also find their way into churches—skeletons of whales or incredible fish. That Walrus tusk from which the Bury St. Edmunds Cross at the Cloisters in New York was eventually carved had probably sat in some church treasury for three or four centuries before being adapted for liturgical use. The gems and cameos which Abbot Suger collected for Saint-Denis were the same class of object of which Lorenzo de' Medici made a collection—one cannot easily separate sacred from secular in the context of the *Schatzkammer*.

Next came the *studiolo* of the humanist prince—a small room, typically, devoted to the private contemplation of treasures—quite distinct in meaning and function from anything that can be called a gallery. The Gubbio *studiolo* in the Metropolitan Museum is only five by seven paces large. These rooms were like treasure chests turned inside out (the one in Florence is actually in the shape of a treasure chest), with cupboards containing the treasure, or *trompe l'oeil* panels implying its presence, and the intimacy of the *studiolo* is what links it to the *Wunderkammer*. The *Kunst* that went into a *Kunstkammer* was small, even miniature: the idea was to cram as much of it as possible into a small space, so that a single room, or even a single piece of furniture (a *Kunstschrank* or art-cupboard) could contain material representative of the whole world. When Marcel Duchamp made his *Box in a Valise* (Joseph Cornell assisted him), which were designed to hold reproductions of the most important of his life's work, he was reinterpreting the Renaissance *Kunstschrank*.

Two exhibitions in Europe recently have looked at the world of the

cabinet of curiosities. The first, which had its origin in Denmark, came to Bonn under the title *Wunderkammer des Abendlandes*. It was one of the most beautifully presented exhibitions one could possibly conceive: great care had been taken to show each class of objects (the shells, bottled or dried specimens, antiquities, ethnographical curiosities) in an appropriate cabinet or cupboard, and to create rooms which reflected the function and character of earlier spaces (the anatomy theatre was particularly bewitching). Of course it was impossible not to be reminded constantly of Cornell's work, and while the exhibition did not explicitly refer to it, the catalog discusses at some length the "surrealist look," pointing out that André Breton's atelier was like a *Wunderkammer* from the Renaissance, with objects from nature, from the street, from the flea market, alongside works of art and ethnographica.[1]

A second, huge exhibition under the title *Tous les Savoirs du Monde* took place in Paris, ending in April of 1997. Divided between the old and the new Bibliothèque Nationale, it illustrated the entire history of encyclopedic knowledge, and devoted a section to "the inventory of the wonders of the world," that is, the cabinet of curiosities. A fine *trompe l'oeil* painting attributed to Domenico Remps shows what the simplest of such cabinets would have looked like, with skull, lens, convex mirror (Parmigianino's self-portrait in a convex mirror is a quintessential example of *Kunstkammer* art), medals, plaquettes, turned ivory balls-within-balls, corals, dried beetles, and an erotic painting. The greatest surviving cabinet itself was also—part of it—on display. This is the *Kunstschrank* of Philippe Hainhofer, which the people of Augsburg presented to Gustavus Adolphus (it is now in Uppsala) and which still retains a high percentage of its original contents: miniature mathematical and astronomical instruments, tool kits for the apothecary, the barber, and the surgeon, distorting mirrors, games, and a tiny automatic virginal.

The fascination with machines and instruments, which Cornell, like Duchamp, would reinterpret (making boxes which were machines with no purpose), is common to this whole tradition and could be seen most beautifully in the illustration of the last of the great cabinets in the tradition, the cabinet of Joseph Bonnier de la Mosson (1702–44), which burst out of the narrow confines I have described hitherto, and occupied an *enfilade* of rooms. Unfortunately the catalog does not reproduce all

the pen-and-wash drawings by Jean-Baptiste Courtonne, which record this set of nine rooms. Laid end to end, the drawings alone run to ten meters. The rooms, which were in the Hôtel de Lude in Paris, were nine in number (the *boiseries* of one still exist, in the Musée d'Histoire Naturelle), of great rococo elegance, devoted respectively to anatomy, a laboratory, a pharmacy, "drugs" (this was unfinished), a lathe room, a room for bottled specimens, one for mechanics and physics, and a library.

Whether Bonnier de la Mosson and his aristocratic friends actually spent much time in the lathe room may be doubted. But the importance attached to contraptions may be gauged from an allegorical painting commissioned for his *Cabinet de physique* from Jacques de Lajoue, which shows a lofty sun-filled room open to the outside world. In the room the sun has illumined shelves full of model cranes and water wheels and a type of bridge. Outside, in the distance, the same kind of crane is at work and a bridge is being built: mechanical theory is proving useful.

2

The Enlightenment made the *Wunderkammer* look foolish, both by the light it shed on its superstitions, and more importantly by the way it extended the sheer range of knowledge, to the point where the ambition to compress all natural knowledge into a single chamber seemed wildly absurd. The architecture of museums tells the story in brief: the first purpose-built museum, the Ashmolean in Oxford (1683), is the size of a modest town house, and the collection occupied only one floor. A hundred years later, the Museum Fridericianum in Kassel is the size of a palace, and a century after that one had to go beyond the city walls to find space to lay out those twin palaces of Vienna, its art museum and its museum of natural history. And this elephantiasis afflicted not only Vienna, but London too, and Paris and Berlin—all the great capitals of the nineteenth century. Specialization split up the contents of the *Wunderkammer*: ethnography went in one direction, natural history in another, art, numismatics, and the other components all found their specialized environments.

Rebellion came from an unusual source. From the Cabinet des

Médailles in Paris (which, incidentally, holds many of the surviving treasures from the great *Schatzkammer* of Saint-Denis) a group led by the dissident Surrealist numismatist Georges Bataille joined forces with the assistant director of the ethnography museum at the Trocadéro, Georges-Henri Rivière, to produce a magazine called *Documents*, which advertised a mixture of "doctrines, archaeology, fine arts and ethnography"—a rubric under which anything at all could be considered.[2] High art could be mocked, the ephemeral exalted.

Robert Desnos would wax lyrical over the covers of popular novels such as *Fantômas*, Michel Leiris would review the Fox Movietone Follies of 1929, Georges Bataille would discuss the shape of women's bodies in the previous century. Here was an illustrated article about the big toe. Here too the marvelous photographs by Karl Blossfeld, in which a flower or seed-head or the unfolding frond of a fern, magnified several times, is made into an object of wonderment. Here are Eli Lotar's photographs of the abattoirs of La Villette, where André Masson, an ally of Bataille's, went to draw. Here in a footnote by Desnos one comes across the germ of the whole career of Claes Oldenburg: Desnos regrets that "no one has ever raised a statue to certain everyday instruments such as the casserole, the bottle, the wheel, the wheelbarrow . . ." He longs for an effigy in marble of a locomotive (a few weeks ago one such was unveiled in the north of England, but in brick rather than marble), of the gas lamp or ball bearings. "Figurative sculpture would have everything to gain from enterprises as perfectly idiotic, in the proper sense of the term."[3]

In *Documents* Raymond Queneau finds a book called *What a Life!* published in London in 1911, which seems to have arrived independently at the collage technique used by Max Ernst (but for sweetly comic purposes—a tradition which continues today), and this takes its place beside a discussion of the art of the Solomon Islands and a statement by Juan Gris on his relation to Cubism. Freaks of nature, as illustrated in engravings by F. Regnault from the eighteenth century, are considered alongside the contemporary sculptor Jacques Lipchitz, Picasso (the magazine's hero), and neolithic figurines from Japan. There is in *Documents* a devotion to popular culture, particularly anything involving black Americans, and a delight in moving, without batting an eyelid, from something impenetrably obscure (like gnostic numismatics) to

Metro-Goldwyn-Mayer's latest *Hollywood Revue* (Hollywood being considered, ethnologically, as a place of pilgrimage).

The authors, these Surrealist ethnologists, set out to shock, and of course today they tend to delight or intrigue rather than shock. The two volumes of *Documents* (1929–30) constitute a rebellion against specialization, a reinterpretation of the encyclopedic spirit. Everything the authors consider is a "document"—one brings the same inquiring spirit to bear on the big toe as on the latest Picasso. But much of it must have been tongue in cheek—or at least the higher tongue in the higher cheek.

<div align="center">3</div>

Joseph Cornell differs from the Surrealists in that he never sets out to shock, and when he does shock it is always a sign of a fault in the art. He is an uneven artist, but prolific enough for these failures not to matter unless they tinge our sense of the whole *oeuvre*. Cornell is never tongue in cheek, and he is never camp—surprisingly enough, since he had camp friends with whom he shared recherché interests in typically camp love objects. He does not revel in his obsessions. He suffers them.

The obsessions are not decorative in themselves. When we look at the letters Cornell sent to the objects of his admiration—dancers, movie stars, innocent and unavailable women—we see them now as by-products of his art. But for the original recipients they might sometimes have been not at all charming. One can sympathize with the girl who screamed and thought she was being attacked when Cornell suddenly offered her a bunch of flowers. Audrey Hepburn sent back the box she received from Cornell. Clearly she did not understand what the gift meant. One imagines that innumerable letters from him, with their collage marginalia and their Apollinairean typography, must have been dropped straight into the bin when they arrived; until it becomes clear they are by Cornell they closely resemble the letters of the mad.

Another way Cornell differs from Duchamp or Max Ernst is that his collages and boxes and his collage films constitute the only art he

practices. He has not given up drawing or painting, or laid it aside for the moment, in order to do this. This is all he has ever done by way of art, all he can do, and all he wants to do. There is no superb act of renunciation involved, and no implied criticism of any other artist. There is only the desire to excite wonder in this particular way: by creating something which resembles a child's museum, since for a child a museum can be legitimately made out of a quite limited number of traditional objects—shells, for instance, and dried seaweed.

One of the leading collectors of Cornell, Lindy Bergman of Chicago, told me that she and her husband Edwin began by collecting shells, before moving on to art. In such forms of collecting, the taste of the child and that of the seventeenth-century *curioso* perfectly coincide. When the child's museum is contained in a box, the notion of the museum overlaps with that of theater. The shadow boxes take their inspiration from nineteenth-century children's miniature theaters, but they are not the only sort of boxes Cornell devised. The jewel caskets already mentioned have a different meaning and association, leading back to the notion of a treasury. Then there are the Cornell boxes resembling an apothecary's chest, full of bottles in compartments, but the bottles containing anything other than drugs—pictures, objects, mysterious substances.

Cornell's ambition as an artist was several steps ahead of his technique as a carpenter, and at first he received help in the construction of his boxes. One would never say, however, that they are much more than competently made. It is the idea, rather than the craftsmanship, that excites. A round box, the size of a Shaker work box, has a single peephole on the side. Bringing the eye to the peephole, one sees a forest of thimbles set on pins. The thimbles tremble as you hold the box. The interior walls of the box have been lined with pieces of mirror, so that the forest of thimbles should stretch forever. And so it does, but the mirrors have not been cut or applied with anything like perfect precision. One imagines that an artist today, more accustomed to delegate technically demanding work, would have had it made so that it would have been perfect. The same concept would have led to a different box.

To activate his "sand fountain" for my benefit, a major collector of Cornell, Robert Lehrman in Washington, DC, picked it off the shelf,

inverted it, gave it a good shake, tried it out again, shook it again, manhandling the object in a manner which would have alarmed me if he had been anything other than the owner. The problem, he explained to me, was that the sand was deliberately mixed with some larger impurities, so that the flow was supposed to be somewhat discontinuous, rather than like an egg timer. One inverted the box to return all the sand to its chamber. Then as one watched, it poured down into a broken goblet. When the goblet was full and the sand was overflowing, that was the sand fountain in action. But of course it is perfectly possible that in the course of this shaking and inverting the broken glass goblet could come unstuck.

This means that in order to see any of Cornell's kinetic objects as they were supposed to be seen, you need to visit a collector rather than a museum. With the best will in the world, a curator cannot simply play with his objects in the way that a collector is entitled to do. These toys do not belong to him.

So Cornell's interactive boxes must die a little on entering the museum. A further difference between the collection and the museum is that the collection, at least in the examples I have seen, will be on a much more intimate scale. The corridor in which the Bergmans kept many of the Cornells they later gave to the Art Institute of Chicago is not an imposing space. Unpacked in the museum, the Bergman collection gives the impression of having come from a palace. But that is simply because a different method of display is in operation.

Cornell himself made his boxes in his basement in Queens, and stored them in the garage and in a disused fridge. As far as I can see, he did not display them around the house, and he was certainly ambiguous about the whole business of selling them or giving them away (sometimes he took them back). When he learned quite how many of his works the Bergmans had acquired (they gave more than thirty to the Art Institute), Cornell became upset and thought they had too many. But the Bergmans' collecting was prolific. Over the years, 1300 works of art were acquired by them, and sold or given away as the collection changed direction or refined itself. But all this took place within the setting of a family apartment.

Mr. Lehrman apologized as he showed me into his study, because

he was just about to move, and certain items—a table, a rug—had already gone. I would have to imagine the way it had been. And indeed I could imagine, since what I was seeing was a modern reinterpretation of the *studiolo*. To the works of art, most of them by Cornell, had been added objects and instruments suggested by those in Cornell's compositions and books of a complementary nature. If a fragment of a star chart was featured in one of Cornell's boxes, one could look it up in a book nearby. If his elaborate construction, *L'Egypte de Mlle Cléo de Mérode: Cours Elementaire d'Histoire Naturelle* (a tribute to one of those nineteenth-century dancers) mimicked the form of a medicine chest, there was a real chest not far away, of similar construction. Even the additional modern comforts of the den, the recessed wine rack, the wet bar, seemed to fall well within the idiom. Here was a place for private contemplation of the beautiful and curious. The important thing was to stay alone with these boxes for a while, spend a weekend in their company, reading a book, allowing them to exert their slow influence.

Handling these objects in private collections, or having them handled on my behalf by a white-gloved curator at the Smithsonian's National Museum of American Art (an extremely appropriate building, being the old Patent Office: it used to house, and still has part of, a set of scale models of machinery submitted for patent—if you look at the engravings on the walls of the museum's café, what you see is an enormous version of the chamber that Joseph Bonnier de la Mosson devoted to mechanics and physics), I could not help feeling sympathy for all the conservators who are going to keep these fragile assemblages in proper condition. It is surprising enough that the photostats have not yet faded. But what of all the other materials—what are they and where did they come from? What kind of scholar could track them all down?

The art historian Dawn Ades has written a forthcoming account of the Bergman collection, in which a material description is furnished for each of the boxes, in summary form but often running to a hundred parts or so, and followed by the usual details of provenance and so forth, before each critical entry.[4] It is very well done. But if one were to go into full detail—if one were to ask where the colored sands came from, or who manufactured the one-and-a-quarter-inch plastic ice cubes— the work would never end. No doubt one would need to be a historian

of modeling shops (my guess is that some of the materials would have come from kits for electric trains), pet shops (colored sands and chippings were used in aquariums), as well as the more often invoked dime stores and the street barrows. To demand such a history of ephemera seems like a contradiction in terms.

That Cornell knew his boxes were fragile can be deduced from his habit of pasting instructions on the back, explaining which bits should be mobile and how they were supposed to work. But what these objects are, he gives no indication.

4

Some of them have more than a whiff of the illicit. A marble slide, for instance, has for me a strong flavor of the illicit world of the schoolboy. One made a marble slide in one of those old-fashioned desks with hinged lids. The desks had a hole in the top right-hand corner (for the inkwell) and another inside to facilitate cleaning. The ideal marble slide ran from the inkwell hole to the cleaning hole and was made out of a complicated arrangement of books, rulers, protractors, and so forth (a slide rule if you were rich and brainy). It was constructed furtively, while the teacher was writing on the blackboard. One maintained a look of innocent concentration, while furtively placing the marble in the hole, and listening to its progress to and fro down book backs, rulers, and so forth. The innocent look was essential because, if the teacher heard the marble, he might yet be unsure where the noise was coming from.

A perfect marble slide was one which, when the teacher fell into a rage and went round the room flinging open the desks, would look like an innocent arrangement of books. Cornell's *Penny Arcade Portrait of Lauren Bacall* and the related Medici slot machines are essentially marble slides; the Bacall box is a silent version, in others the ball when inserted rang various bells. And of course the association of Bacall with the world of the arcade and the slot machine reminds one of those fairground machines which offered a glimpse of Jayne Mansfield or Gina Lollobrigida without any, or many, clothes on. A kaleidoscope offers an innocent vision of abstract, symmetrical beauty, and a peep

show like the one I described, with its forest of thimbles, is a kind of kaleidoscope. But peep shows in general have a more ambiguous reputation, as has the verb "to peep."

At the age of thirteen, Cornell put on a show for his family and charged one pin for admission. A ticket for this show survives:

> *COMBINATION TICKET*
> *ENTITLES BEARER TO:*
> *"The Professional Burglar"*
> *Relic Museum*
> *Candy*
> *Shadow Plays*

According to Cornell's sisters, the show "centered on a metal safe that contained a chained loaf of bread."[5]

The term "relic museum" is appropriate, as Deborah Solomon points out in her biography, for much of Cornell's art, particularly when his relics derive from that unknowable world of romantic ballet. Suggestively, Solomon tells us that Cornell found the actual experience of ballet too overwhelming, that there was too much to see all at once, and that he preferred to stay at home and fantasize about performances. This would go well with his preference, as a collector of records, for not unwrapping his purchases, and it goes with his desire for the unattainable woman, and with the tendency of his real-life romantic obsessions to evaporate. Cornell had an interest in stories such as *Paul and Virginia* (surely the worst novel ever written) by Bernardin de Saint Pierre, in which two children are brought up as brother and sister in an edenic valley in the tropics, with only their (single) mothers and one slave each for company. Puberty brings this fantasy to a mercifully tragic close. Then there is the waif mentioned by De Quincey in *Confessions of an English Opium Eater*, a sixteen-year-old streetwalker in Oxford Street—and no doubt the ancestress of many a figure in early film. The innocent waif, the virginal ballet dancer, the screen idol, public object of desire—these were the targets of Cornell's obsessions. But what he was to do with such women, were he to make a conquest, was not obvious.

★

Late in his life, and particularly after his mother had left the house in Flushing, Cornell began to have occasional assistants and lodgers. This could be a disquieting experience for those involved. One can understand the fear felt by Pat Johanson when she went down to Cornell's basement and found *Playboys* and girlie magazines, alongside, as Deborah Solomon tells us, "shoeboxes filled with little plastic dolls from Woolworth's, with arms in one box and legs in another and torsos in another." It is the same disquiet one feels in the presence of certain of the boxes which use dolls—the doll lost in the thicket, the doll displayed among mirrors, somehow like an Amsterdam prostitute. It is related to the disquiet one feels when Cornell's films use footage of children, and even when the footage is curious old material that Cornell has found, it seems to be reused in an obsessive and hostile way (Solomon does not think so, but a small group who were recently shown the Museum of Modern Art's comprehensive Cornell film collection all felt the same unease).

Along with the assistants and lodgers, Cornell began to attract young women who were prepared to explore whatever it might be he had in mind to do with them. He wanted to see their bodies. He wanted to sit on the side of the bed with them. He wanted to get in the bath with them. He wanted to talk about Katherine Mansfield and Middleton Murry and Gurdjieff. And he wanted . . . well, oral sex. But that's as far as he wanted things to go, and as far as the oral sex went he seems to have left things a little too late. On the whole, if we overlook the bit about Gurdjieff, it does not seem too outlandish as a shopping list of desires, and as Solomon points out, the only person who seems ever to have been hurt in all this sad yearning was Cornell himself.

He was recognized early on by the European Surrealists as their preeminent American fellow spirit, but it is worth being reminded by Solomon's biography that Cornell outlived the Surrealist moment to be taken up by Neo-Romantics who have since rather dropped from view. Then he was a friend of the Abstract Expressionists, and would have exhibited with them more if he had not been so averse to being "hurried" into putting on a show. His reputation, slow though it might have been to get established, never went into decline. John Ashbery tells us that Robert Rauschenberg looked

long and deeply at Cornell's work before his show . . . in 1954. It may seem a long way from the prim, whitewashed emptiness of Cornell's hotels to Rauschenberg's grubby urban palimpsests, but the lesson is the same in each case: the object and its nimbus of sensations, wrapped in one package, thrust at the viewer, here, now, inescapable. Largely through the medium of Rauschenberg's influence, one suspects, Cornell's work is having further repercussions today [1967], not only on whole schools of assemblagists, but more recently in the radical simplicity of artists like Robert Morris, Donald Judd, Sol LeWitt, or Ronald Bladen.[6]

One might guess from Jasper Johns's early *Construction with Toy Piano* (1954) that among the work which Johns destroyed as he kicked over his traces there could have been further evidence of Cornell's influence, as there is in his targets with their boxed plaster casts.

There have been numerous tributes from poets, from Marianne Moore's friendship and correspondence, to Elizabeth Bishop's imitation of his work and her translation of Octavio Paz's poem for Cornell, which evokes the boxes as "Monuments to every moment,/refuse of every moment, used:/cages for infinity." Frank O'Hara wrote a poem called "Joseph Cornell," in two rectangular stanzas, the first beginning "Into a sweeping meticulously-/detailed disaster the violet/light pours."

Cornell was an artist whom other artists have been happy to take seriously, even revere, not least, perhaps, because he hardly seemed a threat. He was not hogging the limelight, or even seeking anything of the kind, although he was by no means averse to success in principle. But he could only sample it in homeopathic doses. He did not set out as a painter, but by the time he had hit his stride he had devised a large number of things to do with paint, and it will be a part of the conservationist's job in the future to look at any surface in a Cornell box and ask: Is this what the artist wanted to achieve? How did he achieve it? Or, if this is the result of aging, would it be considered a welcome result? Cornell was never a draftsman, but he pioneered every kind of composition from what may be put in a pill box or a pigeonhole to what may be shuffled around in a dossier and the aleatoric arrangements of half-submerged objects loose in a sandbox.

The only artist really to feel threatened was Salvador Dali, who interrupted a showing of Cornell's film *Rose Hobart* with cries of "*Salaud*

et encore salaud!" The film was a radical, but primitive, reediting of a forgotten work called *East of Borneo*, which treated someone else's footage as "documents" for a collage. When asked why he had knocked over the projector and created such a scene, Dali could only say: "My idea for a film is exactly that, and I was going to propose it to someone who would pay to have it made. It isn't that I could say Cornell stole my idea. I never wrote it or told anyone, but it is as *if* he had stolen it."[7] A more robust artist would have thought this a handsome tribute to his gift. But Cornell was simply aghast, and it made him extremely reluctant ever to show his films again.[8]

Rauschenberg: The Voracious Ego

What sort of an artist, what sort of a person is Robert Rauschenberg? Walter Hopps, in the catalog he edited with Susan Davidson for the exhibition *Robert Rauschenberg: A Retrospective*, kicks off with a startling comparison: Rauschenberg's "inventive skills and democratic spirit" recall those of Benjamin Franklin. It turns out that Rauschenberg admires Franklin and once described to Hopps a particularly beautiful experiment of his:

Franklin cut narrow sticks of a uniform size and material and painted each a different color along the visible spectrum, progressing from red to violet. On a clear winter day, he carefully inserted them to an equal depth in a snowbank and then observed their movement as the sun's heat was absorbed by each stick. The sticks sank in the snow at varying rates, providing an artful demonstration of the physical properties of color.

A farther-fetched comparison strikes me as more apt. Rauschenberg, with his long record of theatrical work of all kinds, resembles Gianlorenzo Bernini, who, as John Evelyn tells us in an often quoted passage, "gave a public opera (for so they call shows of that kind), wherein he painted the scenes, cut the statues, invented the engines, composed the music, writ the comedy, and built the theatre."[1] Bernini, like Rauschenberg, was a great pusher-back of technical boundaries: in his productions one might see a fire onstage, or a realistic sunrise, or one might be threatened by a flood. He designed carnival cars and firework displays. In this turning of his hand to many different tasks, he resembles his artistic forebears of the Renaissance. But he was the last of his line. What strikes us today as novel in Rauschenberg—that vat of voice-activated bubbling drillers' mud, that frieze of chairs which would

fully light up only at the sound of the magic word "Om"—would have been comprehensible to Bernini as displays of ingenuity, like those musical fountains or devilish garden water-spurts.

When Bernini traveled abroad he was accompanied—just like Rauschenberg—by a retinue. His arrival in France was treated as a diplomatic event of the greatest importance. One thinks of Rauschenberg with his ROCI (Rauschenberg Overseas Culture Interchange) project, which he announced before ambassadors at the United Nations, and which gratuitously and voluntarily established him as an official artist to be met (in such countries as have them) by official artists and by dignitaries of state. Bernini, who prided himself on the friendship of popes, was graciously allowed to be on familiar terms with Louis XIV. It was his greatness as an artist that entitled him to such familiarity. When Queen Christina of Sweden, on arrival in Rome in 1654,

desired to honor him by going to see him at work in his house, he received her in the same rough and soiled dress he usually wore when working the marble and which, being an artist's dress, he held to be the most appropriate in which to receive that great lady. Her Majesty, who, with sublime understanding instantly perceived this beautiful finesse, enlarged on his *concetto* not only in thought but in actually touching his dress with her own hand as a sign of her admiration for his art.[2]

Rauschenberg, dining in Cuba at the Palace of the Revolution, got on so well with Castro that Castro invited the artist and his entourage to spend the weekend at his personal guest house. Rauschenberg's immediate response was to invite Castro to his home on Captiva Island, Florida. How Castro laughed! "This is the first time in twenty-nine years I have been invited to the United States," he said. "But if I were to vacation on your island in Florida, what would I do there? Are there not tires and refrigerators and automobiles on the bottom of the ocean?" "No," said Rauschenberg, "there are fish and I will cook for you."[3]

It seems like the retelling of an ancient story—and so it is. The monarch, when he meets the great artist, must treat him like a peer, and expect to be so treated in return. Charles V picks up the brush that Titian has dropped. Queen Christina instantly understands the compliment that is being paid to her, and touches the dusty smock. Castro, if he invites Rauschenberg home, should expect the compliment

to be returned. Or at least (since both participants know that the conversation is entirely unrealistic) he should acknowledge the beauty of the *concetto*.

Rauschenberg's sense of his own worth (both as an artist and, indeed, as a cook) seems, from all accounts, to be something quite other than self-importance, and one is at a loss to guess where it comes from. Nothing in the early biography quite prepares one for it. Hampered during his early education by undiagnosed dyslexia, Rauschenberg was the nonachieving son of an intimidating, disappointed father. Of all the stories told about him (many of which are evidently tinged with his own benign brand of self-mythologizing), none stays with one so dreadfully as the account that has him returning home in 1945 to Port Arthur, Texas, at the end of his naval service, only to find that his family had moved house without bothering to tell him. Rauschenberg was not returning from the theater of war, but he had had a rough and mentally taxing job in a psychiatric unit. Now here he was confronting a houseful of strangers, and too embarrassed to turn to his other relatives to find out where his family had gone.

One is hardly surprised to learn that, having managed to locate his new home, Rauschenberg did not stay there long; nor is it odd to find him, in due course, changing his first name from Milton to Bob, and thereafter to Robert. Nineteen forty-five must have been a kind of Year Zero for him, when everything had to be begun afresh. And he was a classic beneficiary of the GI Bill, proceeding by leaps and bounds from the Kansas City Art Institute, to Paris, to Black Mountain— greedy for any education on offer.

And quick to benefit, when one thinks that the first of his works to be acquired by a public institution were photographs dating from 1949 and 1951, bought by Edward Steichen in 1952 for the Museum of Modern Art. The earlier of these is a rich study in blackness, showing the interior of an old horse-drawn carriage. In common with most of his early photographs, the image is squarish—he used a Rolleicord and didn't like to crop. As he said in a later interview,

Photography is like diamond cutting. If you miss you miss. There is no difference with painting. If you don't cut you have to accept the whole image.

You wait until life is in the frame, then you have the permission to click. I like the adventure of waiting until the whole frame is full.

In the early photograph which Steichen chose, the blackness has almost filled the frame.

Another early success came with the blueprints which Rauschenberg made with his then wife, Susan Weil, in which a nude model was laid on a large sheet of paper, and sunlamps played over the body, creating lyrical and unpredictable effects of shadow and contour. It seems surprising that any of these immediately pleasing works should have survived in such fresh condition. Not only have they survived. The process of their creation was recorded by *Life* magazine in April 1951 ("Although the Rauschenbergs make blueprints for fun, they hope to turn them into screen and wallpaper designs"). Steichen exhibited one at MOMA, in a show called *Abstraction in Photography*, and Bonwit Teller featured them in a window display. The process might be considered as an art form, or as frankly commercial.

It belongs to a series of investigations of different types of work on paper, like the "urban frottages" on which Jasper Johns collaborated, or Rauschenberg's *This is the First Half of a Print Designed to Exist in Passing Time* (in which the woodblock was successively gouged away), or a project recalled by Robert Creeley, in which butcher paper was laid on the floor of the art school entrance, to be marked by the students' footprints. The *Automobile Tire Print* of 1953 was made on a scroll of twenty sheets of paper mounted on fabric. John Cage drove his Model A Ford along the scroll, while Rauschenberg inked the tire as it proceeded. Rauschenberg: "He did a beautiful job, but I consider it my print." Cage: "But which one of us drove the car?"

Already in these early works, many common future patterns are set: the delight in collaboration, the use of cheap materials (the blueprint sheets were bought on sale, being the ends of rolls), the incorporation of some extra dimension such as time. "Cy + Roman Steps," a series of five photographs in which the body but not the face of Cy Twombly advances into view on the Spanish Steps, seems both an account of "the adventure of waiting until the whole frame is full" and an amused variation on the wrongly posed tourist photograph. Seen at the

Guggenheim in their chosen scale of 20 by 16 inches, the photographs contrast the Roman patina of the steps with the very American (particularly for the period when this style was not yet international) jeans-and-shirtsleeve order of the advancing figure, on whose midriff the camera ends up concentrating.

Rauschenberg has fun—he always seems to be having fun, and this quality is what was originally held against him. This is why, however early he might have attracted attention as a photographer, or in the commercial art of window-dressing, he had to wait much longer for success, or serious esteem, as a painter. It is not that the ambition wasn't there from the start. On the contrary, the more the evidence is piled up in front of us, the stronger the ambition seems to be. This is something that is easy to miss in Calvin Tomkins's 1980 biography,[4] which in turn takes part of its tone from Rauschenberg's own way of depicting himself as a sort of holy fool. On the one hand, he must go through life not knowing what he is doing. On the other hand, somehow, he must know very well indeed what he is doing, or he wouldn't have achieved what he has.

For an idea of the way Rauschenberg's painting life began, one can turn not to the Guggenheim catalog but to Walter Hopps's 1991 *Robert Rauschenberg: The Early 1950s*, which did a thorough job of reconstructing and documenting the first phase of his mature work.[5] In the navy, he had made portraits of his friends, and it was English portraiture which had first inspired him to take painting seriously. Hopps reproduces a convincing *Self Portrait* from around 1948, which he likens in style to the work of Marsden Hartley. But anything of that kind seems to have stopped after Rauschenberg's arrival at Black Mountain College and his studying painting and drawing, not so happily, with Josef Albers.

The earliest work, exhibited in a one-man show at Betty Parsons Gallery, is the product of a divided desire: on the one hand, he emulates the Abstract Expressionists (and is precocious in so doing); on the other, he cannot wait to mess around with found material. The former tendency seems connected with his residual religious feelings. *Crucifixion and Reflection*, a study in off-white (but with some Hebrew newspaper text showing through), may perfectly well be taken as just that: a meditation

on the Cross. The latter tendency is seen in a collage since repainted, *Should Love Come First?*: a scrap of the title page of a magazine article ("my problem . . . should love come first") with a footprint below, and below that a printed dance diagram for (Hopps admirably informs us) the progressive waltz, male position. This seems executed in a teasing spirit, and one suspects that several private jokes are embedded in the collage, as there surely are in *22 The Lily White*. The next word in the song from which the title is taken is "boys"—but instead of boys the canvas features numbers. Phone numbers? Military numbers? Meaningless numbers?

When nothing in his first show sold, Rauschenberg moved into his black and white phase, in which several of the black paintings were obliterations of previous collages, while the white paintings tended to be fresh canvases with the paint so flatly applied that, when he wished to re-create them, Rauschenberg simply authorized Brice Marden to paint canvases of the same dimension with the same paint. The point was not the paint itself but what happened in the looking at it. "A canvas is never empty," Rauschenberg later wrote.

I transcribe a letter from Rauschenberg to Betty Parsons, postmarked October 18, 1951, since it gives such a good idea of the young dyslexic artist's enthusiasm for what he thought he was up to:

Dear Betty,

I have since putting on shoes sobered up from summer puberty and moonlit smells. Have felt that my head and heart move through something quite different than the hot dust the earth threw at me. the results are a group of paintings that I consider almost an emergency. they bear the contraditions that deserves them a place with other outstanding paintings and yet they are not Art because they take you to a place in painting art has not been. (therefore it is) that is the the pulse and movement the truth of the lies in our peculiar preoccupation. they are large white (1 white as 1 GOD) canvases organized and selected with the experience of time and resented with the innocense of a virgin. Dealing with the suspense, excitement and body of an organic silence, the restriction and freedom of absence, the plastic fullness of nothing, the point a circle begins and ends. they are a natural response to the current pressures of the faithless and a promoter of intuitional optimism It is completely irrelevent that I am making them—*Today* is their creater.

I will be in N.Y. Nov. 1st. and will forfeit all right to ever show again for their being given a chance to be considered for this year's calender.

Love Bob

I think of you often Brave woman, Hello to Monica.

It didn't work. Betty Parsons didn't take these paintings, and in time, when he had had enough of black and white, Rauschenberg moved on to red—not pure pigment but reds applied with fierce freedom. And it was through that door that he entered the world of his famous combines, in which he allowed the two aspects of his nature to fight it out—the expressionist painter vs. the collagist devoted to image and symbol.

A friend who has worked with him draws a contrast between the intelligence of Rauschenberg and that of Jasper Johns. Johns, one feels, is a case of learning acquired with great effort and application; Rauschenberg's intelligence is natural and spontaneous. Setting himself a problem of immense, willed complexity (in his technological works, the demands of the artwork were often way ahead of the state of technology at the time, and had to wait some years before the right solution was discovered), he will astonish his collaborators by his ability to visualize, say, the interactions of a proposed set of rotating, overlapping images. In Billy Klüver's catalog essay, which is one of the most interesting (because most informative), we see some of the problems to do with *Solstice* being resolved. The piece is a system of sliding plexiglass doors, made at a time when these were not widely used in America. So much effort has gone into the technical design of the piece that after a while one of the collaborators begins to get nervous that Rauschenberg hasn't yet shown any sign of choosing the images that will go on the transparent doors.

I mentioned this to him . . . and he said, "Yes, you're right. Let's get started with it now. Come along with me." Well, he had these racks and racks of silkscreens downstairs in the cellar and on the first floor, and he started to systematically pull out screens. He put two into one pile, three in the next, stacking the piles along the wall. Then he'd say to me, "Hold that one up, Robby," and I'd hold it up. And he'd say, "All right, move that one over to

pile one, and take that one and move it here." In a matter of two hours' time, he had composed the whole thing as far as the selection of screens.

Two hours to choose around a hundred images, but how many hours and how much organization to build up the archive of images in the first place?

In around five hundred objects on exhibition in New York, it is impossible even to guess how many images are involved (quite apart from found objects: familiar pieces of packaging, exotic flour sacks, wrecked machinery). There are the early photos. Then there are works using collage, silkscreen, and solvent, transfers of found images (often from *Scientific American*). A proportion of them are the obvious icons of their time: Kennedy's face, astronauts, the Statue of Liberty. And there are quotations from the old masters. But the majority of images, representing the unconsidered visual world in which we actually live and work, are not so easily classified. Brice Marden, when he was working for Rauschenberg, used to attempt to research images for him. Often a week of work would turn up a pile of offerings which were never used, whereas Rauschenberg himself, in a single evening, could turn up dozens. Then Rauschenberg returns to taking his own photographs, both for their own sake (as in the wonderful study of the plaster Botticelli in the saleroom window) and to enrich his stock of images. Today, much of that process of selection can be done with the help of a computer, but it was not always so. Even for an artist whose working practice is rooted in the instinctual and the aleatoric, there must be a fund of material from which to draw, an archive. Time and again, one wonders: How did he find that? For instance, one composition is built around the image of a smashed bicycle rickshaw on a dump. But in the places where they use such transport, a bicycle rickshaw is a valuable object, a means of livelihood in itself, and one would expect a smashed rickshaw to be instantly patched up and recycled.

One turns from such bold, legible compositions to those soft, mysterious, and scarcely fathomable works such as the illustrations to Dante—an exhibition in themselves, although not all of them are on display. Rauschenberg uses a technique where solvent, probably lighter fluid,

is applied to the image source (for instance, a magazine illustration), which is then placed face down on the paper, and it would appear that a blunt pencil is next rubbed along the back of the image source. The effect of this is to produce a calligraphic line, as in a drawing, which is also a vehicle for a faint photographic image. I went back again and again to these, but it seemed impossible to concentrate in the context— if concentration were indeed required. Perhaps a casual going back again is more appropriate. Here is Rauschenberg trying to do in prose what he does in a picture:

I find it nearly impossible free ice to write about Jeepaxle my work. The concept I planetarium struggle to deal with ketchup is opposed to the logical community lift tab inherent in language horses and communication. My fascination with images open 24 hrs. is based on the complex interlocking if disparate visual facts heated pool that have no respect for grammar. The form then Denver 39 is second hand to nothing. The work then has a chance to electric service become its own cliché. Luggage. This is the inevitable fate fair ground of any inanimate object freightways by this I mean anything that does not have inconsistency as a possibility built-in.

And the statement ends: "It is extremely important that art be unjusti-fiable."

This was written in 1963 for an anthology called *Pop Art Redefined*, and it was composed while on the road with the Merce Cunningham Dance Company—the inconsequential words coming from signs or sights seen along the way. It is impressive to see that, at this stage in his career when his reputation is about to be confirmed by the 1964 grand prize at the Venice Biennale, Rauschenberg is not simply collaborating from a distance (as one might design a set, which others would build) but on the road day and night, stage-managing the performances, creating sets out of objects found along the way, and prepared to commit himself for a six-month world tour. This was when Rauschenberg was perfecting his Bernini-esque *uomo universale* act. He had become a lighting designer, a choreographer, a performer even. He had taught himself to rollerskate and had created the performance piece *Pelican* (part of which can be seen on film at the SoHo Guggenheim), in which he skates so memorably with a reversed parachute fixed to his back.

★

And so it was that he arrived in Venice on the eve of the Biennale as a stage manager. But when he won the prize, he made the mistake of giving an interview in which he said that "the Merce Cunningham Dance Company is my biggest canvas." This did not go down well with Cunningham. Cage said later: "I didn't think it was proper for Bob to say that. In all my connection with Merce, I have given him the stage and I have stayed in the curtains. Bob didn't do that."

There is a faint echo of the smoldering row that followed this remark, and that led in the end to Rauschenberg and his friend, the dancer Steve Paxton, leaving the company at the end of the tour, in the article that Paxton has written for the Guggenheim catalog. Paxton describes how Rauschenberg, in the days before black plastic dance floors, would conduct a very thorough survey of the condition of each new floor they encountered. "He said that it was for the sake of the costumes. We knew better. He loved this company and shuddered if one of the dancers got a staple in mid-move." He describes the self-effacing quality of the lighting Rauschenberg designed, his unrivaled knowledge of the Cunningham repertoire, and his control of every aspect of how it was seen.

A Merce Cunningham Dance Company performance is a well-orchestrated noncollaboration. The thesis is that the music, the dance, and the decor each exists on its own terms, and they are shuffled into the experience of the audience, each "hand" being unique. The planning for the presentation of this thesis was thorough, and the curtains rose on time, even if Rauschenberg had to be up all night.

One can see from all this what the problem would have been. It was the insatiability of Rauschenberg's vision. What he had said to the interviewer was not incorrect: his attitude to the performance was the same as his attitude to the canvas, and no doubt that was his strength, but it was a strength which was not in the habit of perceiving any boundaries. Rome was never big enough to hold two Berninis, and neither was the Merce Cunningham Dance Company.

Paxton quotes Rauschenberg as saying, "I tend to see everything," meaning that he sees in a different way from the way we normally see. He does not see just a line of text, he sees a whole paragraph which he must somehow sort through. As if he lacked the mechanism of visual

attention, as if everything he sees appears equally important. And that is the effect, in particular, of the grander paintings such as *Barge*, which aspire to the condition of murals, and in which every part of the composition seems equally demanding. As if in life he simply can't stop seeing things—and wouldn't want to, either, if he could.

Johns: A Banner with a Strange Device

... He declared that he was above all an advocate for American art. He didn't see why we shouldn't produce the greatest works in the world. We were the biggest people, and we ought to have the biggest conceptions. The biggest conceptions of course would bring forth in time the biggest performance. We had to be true to ourselves, to pitch in and not be afraid, to fling Imitation overboard and fix our eyes upon our National Individuality. "I declare," he cried, "there's a career for a man, and I have twenty minds to embrace it on the spot—to be the typical, original, national American artist! It's inspiring!"

Roderick Hudson in *Roderick Hudson*

I

They did not all live in vain, those American sculptors of a century ago. They did not all fall off the cliffs on the path to Interlaken, like Roderick Hudson (or die like Longfellow's inexplicable banner-bearing youth). They survived Europe and they survived those Alps and they came triumphantly back. Masters of skills acquired in Paris and Rome, they returned to a country which looked to them to provide—what they were only too eager to supply—public expressions of spiritual values, the spiritual values of the state. Roderick, Henry James tells us, nearly swamped the gondola with the violence of his response when he perceived "that the only thing worth living for was to make a colossal bronze and set it aloft in the light of a public square." His historical contemporaries felt much the same.

Their successes, it has been noted, were fewer on the private side.[1]

They could not insinuate too much of their marmoreal idealism into people's actual *homes*. They were public artists, which was just as well when there were so many public commissions, so many squares to be filled, so many federal buildings to be adorned, so many dead heroes queuing up for commemoration. They needed all the moral earnestness they could lay their hands on, for such earnestness, we are told, was considered "the very foundation of artistic conscience."[2] "I mean to do the Morning," says Roderick; "I mean to do the Night! I mean to do the Ocean and the Mountains; the Moon and the West Wind. I mean to make a magnificent statue of America!"

Magnificence of a kind they certainly achieved. Augustus Saint-Gaudens thought that the preparations for the World's Columbian Exposition in Chicago in 1893 constituted the greatest gathering of artists since the Italian Renaissance.[3] One may smile at the idea, but those fountains and "lagoons" do indeed look thrilling in the old photographs, and they resemble the great triumphs and ceremonial entrances of the Renaissance in this respect—that these festive assemblages of statues were not made to last. They were fashioned from "staff material," a mixture of plaster and straw or hemp fiber. Such a medium would never survive a northern winter.

Saint-Gaudens survived, through his bronzes, but how many people would have set much store by his work around 1960, the year in which Robert Lowell wrote his poem "For the Union Dead"? The great point of the poem is that Saint-Gaudens's monument on Boston Common to Colonel Shaw and his Negro infantry "sticks like a fishbone/in the city's throat."[4] Like those "stone statues of the abstract Union Soldier" which "grow slimmer and younger each year" (that is, which are being eroded), the monument to Shaw belongs to a different era, a state with different spiritual values. It is being undermined, literally, by car-park excavations. It is "propped by a plank splint" and it shakes. Any moment now, it seems, it could go the same way as the old South Boston Aquarium.

Lowell bestowed a significance upon Saint-Gaudens's work, just as Saint-Gaudens had been called upon to bestow a significance upon Colonel Shaw and his Negro infantry. Bestowing a significance was something Lowell was good at, which is why his admirers, on our first

trips to Boston, like to pay our respects to 91 Revere Street and the Robert Gould Shaw Memorial—watching out, on the way, for those "giant finned cars [nosing] forward like fish" and that "savage servility [sliding] by on grease."

I am not confident that I shall succeed in bestowing a lasting significance upon another of those sculptors of the Jamesian era, Alexander Doyle (1857–1922). His story, as told by the *Dictionary of American Biography*, begins so promisingly, and lets us down with such a bump. His parents were so adventurous as to take him to Italy at age twelve, to study painting, music, and sculpture. He studied in Carrara, Rome, and Florence. He returned to America ready and fit to begin, and, according to his obituary in the *Muncie Star*, "at thirty-three he had done more public monuments than any other sculptor, and was producer of more than a fifth of those standing in the country." He was, in other words, the antitype of Roderick Hudson, "state committees rightly having confidence in his ability to complete his contracts." Yet he too came a cropper, and in a way that James might have appreciated. On the death of his father, Alexander Doyle inherited a limestone quarry in Bedford, Indiana, and he devoted the rest of his working life to its management.

As if life as a successful artist were no more than life in the chrysalis! Or as if filial piety had been lurking in abeyance, waiting to assassinate the talent. Or as if, perhaps, the son had attained a cool and admirable self-knowledge: he knew he had never really been much of an artist, but he had to wait until his father's death before coming out as a businessman.

Some time in the early forties,[5] another father was walking with another son through Madison Square, Savannah, when they stopped at one of Alexander Doyle's statues, a monument to Sergeant William Jasper, and the father told the son that the two of them were named for this man. The father was William Jasper Johns—by most accounts not a very satisfactory parent, who would not really have known his son particularly well, since they had hardly lived together. The son, Jasper Johns, would have read the inscription on the plinth, and learned that Sergeant William Jasper "though mortally wounded rescued the colors of his regiment in the assault on the British lines about this city, October

9th 1779," and that "a century has not dimmed the glory of the Irish American soldier whose last tribute to civil liberty was his noble life."

Whether the knowledge that one's parent was named for a hero would make a child alter his view of the man, whether he would suddenly see some latent heroism in him, is hard to tell. Certainly the day lodged in the boy's mind, and left him with an association of his father with the American flag. We know this because Johns came up with it, in a moment of exasperation with an obstinate interviewer (he has faced many such interviewers over the years, sometimes playing them along, often fighting off their interpretations and displaying great ingenuity in the art of saying nothing). Here is the exchange as it fell out.

Paul Taylor: It has been said that the American flag in your paintings is a stand-in for yourself.

Johns: Hm?

PT: People have said that the flag, in your early paintings, represents you. Is that true? Is that how you used the flag?

JJ: I haven't said that. Is that what you're saying?

PT: No, but it has been said about you.

JJ: Well, a lot of things have been said about me.

PT: Nevertheless, I wonder if you think it's true.

JJ: Do we have to go through this about everything that's been said? Do you think something's true just because it's been said?

PT: No, but I would wonder whether this thing is true even if it had never been said.

JJ: That the flag is a stand-in for me?

PT: Yes.

JJ: Where?

PT: In your paintings.

JJ: In my paintings? I don't believe so. The only thing I can think is that in Savannah, Georgia, in a park, there is a statue of Sergeant William Jasper. Once I was walking through this park with my father, and he said we were named for him. Whether that is in fact true or not, I don't know. Sergeant Jasper lost his life raising the American flag over a fort. But according to this story, the flag could just as well be a stand-in for my father as for me.[6]

Savannah's Madison Square has been tidied up since the forties, and additional bronze plaques expand upon this passage of history. We

learn, for instance, that the flag which Sergeant Jasper rescued was not the American flag (as Johns thought) but the colors of the second regiment of the South Carolina Continentals. Fred Orton, who, in *Figuring Jasper Johns*, goes into much detail about both it and the Stars and Stripes, quotes a description: "This flag so gallantly reinstated had been designed by Colonel Moultrie, and consisted of a blue field and white crescent on which was emblazoned the word LIBERTY."[7]

One wonders whether, as father and son looked up at the monument to Sergeant Jasper, they had any sense that what they were looking at counted as a work of art, that it was an example of sculpture. We are told that, in the nineteenth century, only the American sculptors called what they did sculpture; to the general public these creations were known as statues.[8] That they are objects of a certain popular reverence is clear: as I stood for a while in Madison Square, many people took photographs or shot video footage of Doyle's bronze, presumably as an example of a historic monument. They were on their way to or from the house in the neighboring Monterey Square where, as told in the novel-of-fact (and hokum) *Midnight in the Garden of Good and Evil*, Jim Williams shot his boyfriend dead. And this house has another attraction: suitably transformed in the film *Glory*, it stood in as the Boston residence of Colonel Robert Shaw.[9]

So: Savannah stands in for Boston; the Stars and Stripes stands in for Colonel Moultrie's flag; and the flag itself, or *Flag*, stands in, perhaps, for Johns's father. That's enough "standing in" for the moment. Enough coincidence. As I left Madison Square I noticed a small exhibition of Robert Rauschenberg's "photems." In the gallery, a video was playing. Rauschenberg was recalling that, as a young man in the navy, he had been doing a painting for which he needed the color red. So he had used his own blood.

As he told the story, very simply and slowly, a smile of wonderment came over his face. It was as if he was implying that, in his navy days, he was such a greenhorn he didn't know that red paint existed. Or that blood would hardly serve his purpose, once it had dried. I got a powerful sense of Rauschenberg as a plausible rogue, a mythmaker, and thought what fun he must have been as a companion in the fifties, when he and

Johns set out to amaze the world, when they embarked upon their course of self-promotion.

2

Self-promotion is hardly supposed to be an artist's business, but how else is one to live? The story has it that it was Rauschenberg who taught Johns how to survive as an artist, doing only just as much work as was necessary to stay alive. Rauschenberg was working as a window dresser, and he cut Johns in on his practice. They worked for Tiffany and Bonwit Teller. Gene Moore, who was in charge of the displays, says: "I'd tell them what I wanted, and they'd go off and make it. I never knew which one of them did what, they worked so closely together, even sharing the same joint pseudonym, Matson Jones . . . They started using that name when they began to get recognition as artists—they didn't want their commercial work confused with what they considered their real art."[10]

One would like to know more about what their displays looked like, and the MOMA catalog of the Johns exhibition, *Jasper Johns: A Retrospective*, obliges with two photographs of Bonwit Teller windows from 1956. In the first, we see Johns's famous *White Flag* hung as a backdrop to two mannequins, in the second, a painting by Rauschenberg. At the front of each window is laid out a sort of elongated book, and with the aid of a magnifying glass one can just read the words: "Young classic clothes by (illegible); Painting by Jasper Johns, one of the young classic artists who (several words illegible) displays." Something similar is written in Rauschenberg's window.

Presumably these elongated books announcing the artists' virtues were among the objects that Rauschenberg and Johns made in Johns's loft. One imagines that they must have been tickled pink to be able to arrange such promotion for their work, until, as Gene Moore says, they began to realize there was an either/or, either decorative or serious. Then they took their decorative work underground, as it were, producing displays of a mushroom field, tilted paint cans appearing to pour paint on the floor, cave scenes, "recreations in dimension of eighteenth-century still lifes" and "Christmas . . . forest with trees." Three years

later, attacking Rauschenberg, Hilton Kramer said that he saw "no difference between his work and the decorative displays which often grace the windows of Bonwit Teller and Bloomingdale's ... Fundamentally, he shares the window decorator's aesthetic: to tickle the eye, to arrest attention for a momentary dazzle."[11] No doubt Kramer was disingenuous in choosing this comparison.

The photographs remind one in a forceful way how decorative these works were, even before they had been exhibited in any gallery and held up for serious consideration as works of art. Kramer used the term decorative in a derogatory way, but it does not have to be taken as an insult. An artist who fears to be thought decorative has only to remember that medieval manuscript illumination is unquestionably decoration and unquestionably art: the two terms may precisely coincide. But it is striking that these avant-garde paintings were absolutely acceptable as decoration well before their artistic status was discussed.

A similar case is recounted in Carter Ratcliff's new (very handy and readable) book, *The Fate of a Gesture*, which deals with a tradition in American art descending from Jackson Pollock and defined by Ratcliff in a Roderick Hudsonish way as that of artists "driven by the unreasonable belief that to be American is to inherit the infinite." We are told how, in 1950, just after some of Pollock's drip paintings had been exhibited, Cecil Beaton was in town on assignment for *Vogue*. Beaton used Pollock's paintings as backgrounds for a fashion shoot. He had immediately perceived them as decorative, albeit in a newsy, controversial way.[12]

The clever decorator is constantly on the lookout for new sources of decor. He will be delighted to exploit any artist who suits his purposes, and this puts the artist in a quandary. Constantly at pains to distinguish his work from "mere" decoration, he may feel that his integrity is under attack from those who would associate his art with merchandise. The surprising, not to say improbable, story that Jasper Johns, before the current major retrospective, found that a jigsaw puzzle had been made of his *Flag* without his authorization, and that he forced MOMA to destroy all copies of the puzzle, shows some insecurity on Johns's part.[13] Most people by now would assume that *Flag* would stand or fall on its own merits, and not be affected by being turned into a puzzle. Besides,

as another artist in the same position pointed out to me, as long as the jigsaw is well produced, what better way is there of inducing the public to look very carefully at the texture of a painting than to get them to align the jigsaw pieces?

Art has often shaded off into merchandise. An elegant example is given in the catalog of the current Ellsworth Kelly exhibition at the Guggenheim Museum.[14] The slightly older artist, struggling to make ends meet in the early 1950s, designed fabrics which drew directly on his own experiments in which he made a black and white drawing, cut it into pieces, and rearranged the fragments by chance. One could hardly say that the fabric designs (one of them made up into a dashing outfit by Pierre Balmain) cast doubt on the integrity of his art. But they definitely exploit it.

Perhaps the difficulty for Johns arises from the fact that, since his original works are based on puns, metaphors, and transformational tricks, there is a danger of interfering with their effectiveness by transforming them further. Johns is said not to have liked it when, on Flag Day in 1960, his dealer, Leo Castelli, presented President Kennedy with a bronze *Flag*. A friend told him not to worry, but to think of it as a pun on his work.

3

It was typical of the artists of Johns's circle in the fifties that they took a kind of artistic procedure that was, on the face of it, somewhat unpromising, and turned it into something fresh. No doubt Rauschenberg would have replied to Kramer's objection about the window-dressing that a work like *Monogram* (the one with the stuffed goat and the car tire)[15] was indeed constructed like a window display, but why should it not be? Here are three other technical transformations with which Johns was associated early in his career.

Everyone has tried placing a coin under a piece of paper and rubbing it with a pencil. A casual schoolboy trick, it is also, carefully done, an extremely accurate way of recording the surface of a coin or medal, much better than most photographs. The technique became a fad earlier this century in England, as a way of recording medieval brass memorials

in churches. One bought at the cobbler's a stick of black cobbler's wax, and at the stationer's a roll of lining paper, and proceeded, by bicycle usually, to the churches where these brasses were to be found. This was an Educational Hobby and therefore a Good Thing, until it was discovered that the popular brasses were being damaged by all this attention. Then brass-rubbing was abolished by the Church, to be replaced with a pointless hobby of rubbing reproduction brasses.

Nothing could sound less promising for an American artist, but when Johns returned to New York after military service he fell in with the artist Sari Dienes, who (following the example of Max Ernst) went in for "urban frottage"—exactly the brass-rubbing technique but applied to surfaces normally held beneath consideration: "She went around making rubbings of the streets in the early hours of the morning with sheets of paper twelve feet or longer. They were rubbings of manhole covers and things like that."[16] Johns occasionally helped her. This interest in bestowing significance on banal urban surfaces crops up again in Johns, and "frottage" is a word that could be used to denote the process by which *Skin* was produced (Johns apparently smeared himself with grease, rolled over the paper, and then sprinkled it with charcoal dust, producing a sort of Turin shroud negative).

Then there was sculp-metal, a substance regularly advertised in *Art News* in the fifties, not aimed at serious artists so much as amateur modelers. It was and is one of a class of substances that was supposed to make things easy, to cut out the hard grind or the expense of having one's work professionally cast. The ad read: "The new creative medium! sculp-metal. It models like clay—Hardens into metal! 1001 uses in Arts and Crafts. Send 10¢ for handbook 'working in sculp-metal.' Sculp-metal is applied with palette knife or fingers. Pieces air harden; burnish to rich aluminum." The photograph accompanying the ad showed a small metal bust of a child with a bowl cut.[17]

One can guess that most artists would not have been caught dead working in sculp-metal, and that was precisely the attraction for Johns. It was a medium devoid of respectable history, perfect for his banal, dadaist purpose, which was to make a sculpture out of a flashlight (he had some trouble in finding the banal, commonplace flashlight that he had in mind). Later he found he could *paint* in sculp-metal, and no

doubt one reason for the attention that had been paid to Johns's work is that he has alerted other artists to the possibilities of the medium.

The third act of technical rescue-work was carried out on encaustic as a medium. This is often passed over in accounts of Johns's work, or referred to briefly as if we must all understand what is meant by encaustic. Johns is sometimes said to have revived a lost classical technique of painting in hot wax. But in his essay on Johns, Michael Crichton writes that Johns was a "provincial artist from South Carolina, working alone in New York City, following his inner impulses with the only tools he had—a ruthless logical sense, and a remarkable technical virtuosity."[18] This picture of the artist working quite alone, with a technical virtuosity that appears to have come out of thin air, since Johns at this stage "had seen very little art of any sort," is a piece of mythmaking akin to Michelangelo's suppression of his early apprenticeship; the detailed chronology provided by the MOMA catalog informs us that Johns had spent much of his time in the military organizing art exhibitions.

There is a story that, while working at the Marboro bookstore in New York, Johns came across a book about the encaustic method. This would most probably have been a work called *Encaustic Materials and Methods* by Frances Pratt and Becca Fizel (New York: Lear Publications, 1949). From this he would have learned that encaustic, a method in which pigment is mixed with beeswax, applied to the surface, and then burnt into it, was used in antiquity, and that it is the medium of the remarkable Fayum portraits, made in Egypt between the first and fourth centuries AD. The technique was lost, but various attempts were made to recapture it, none of them resulting in anything of great value.

Pratt and Fizel give accounts of no fewer than seventeen contemporary artists working in encaustic, or what they *call* encaustic, but many of these are of the direst quality. One notes James Penney, instructor at the Musen-Williams-Proctor Art Institute in Utica, New York, who produced "the charming and sensitive *Head of Jimmy*," his son, "an excellent likeness . . . done from memory in less than two hours," which looks like the kind of painting one sees hanging from park railings on a Sunday. One notes Professor Salvatore Lascari, who is "understandably enough . . . loath at this particular date to reveal

his secret" but who claims to have cracked the mystery of encaustic wall-painting, a technique which Praxiteles is said to have brought to perfection.

Encaustic Materials and Methods reminds me of those books one comes across as a child in public libraries, full of enthusiastic recommendations for some improbably bright idea—I am thinking of a volume I once read avidly, called *Hay-box Cookery*, which assured readers that the modern housewife was busily lining tea-chests with hay to create an insulated space into which she could pop a bubbling casserole, which she would retrieve a dozen hours or so later, and it would be cooked to perfection! There *were* some serious artists who had experimented with encaustic—Karl Zerbe in Boston is cited, and Diego Rivera, and we are told that the Romanian Surrealist Victor Brauner experimented with beeswax when short of artists' materials during the war—but for the most part one would say that the field was open. And that was what Johns seems to have needed.

Generally speaking, Johns was not the kind of artist who puts himself through an education by studying the works of others. He looked at the works of others in order to cross them off his list, to "fling Imitation overboard." Told that his collages looked like those of Schwitters, he investigated the matter, found the remark just, and stopped working like that at once. Compare him, again, with Ellsworth Kelly. The Kelly catalog informs us about the pictures he knew from reproduction as a child, the volume called *A Treasury of Art Masterpieces* which the army published in 1944 and handed out to soldiers on request, the paintings he copied in the Museum of Fine Arts, Boston, when he was a student under the GI Bill, his studying under the aforementioned Karl Zerbe, his introduction to Max Beckmann, his going to Paris, his delight in the Romanesque, and on and on. It is not a privileged education, but it is a complex and wide-ranging encounter with every sort of art.

Compared with this, Roberta Bernstein's researches in the Johns catalog come up with very little. The early Johns flunks art school twice. He may be interested in a few select geniuses—Leonardo, Cézanne, Picasso—but then who isn't? The story is told that on his first trip to Paris, Johns was concerned to see whether it was true, as he had heard, that Leonardo's St. John was not a very good picture. So he

went to the Louvre, examined the picture, decided it was, on the contrary, very good. And then he went back to his hotel. Looking at anything else, at that time, wasn't on his agenda.

Johns shares Rauschenberg's trick of talking about himself as if he were an idiot savant. Here he is again with Michael Crichton: "I wanted to show what had gone before in a picture, and what was done after. But if you put on a heavy brushstroke in paint, and then add another stroke, the second stroke smears the first, unless the paint is dry. And paint takes too long to dry. I didn't know what to do. Then someone suggested wax."[19] Here is a man who has wanted since the age of five to be an artist, talking as if he only discovered in his mid-twenties that if you put wet paint on wet paint you tend to have problems. This seems a wildly improbable version of events.

Encaustic was a rare technique, but the 1949 handbook lists five suppliers of encaustic materials in New York, including one who offers "an especially designed lightweight hot palette with built-in heating element." I suggest that Johns was drawn to the technique because (a) it was *not oil paint*, and was therefore without intimidating associations, and (b) he discovered it combined so well with newsprint, to produce a collage which looked unlike Schwitters and unlike his Cubist predecessors.

That it was not an easy technique to master is shown by the fate of *Flag*. When this painting was given to MOMA by Philip Johnson it was exhibited with the date 1954. A visitor to the museum wrote in to inquire how the painting could be dated 1954 when it clearly incorporates a Dondi cartoon strip from February 15, 1956. The museum asked Johns, who explained that *Flag* had essentially been finished in 1955, but that it had been damaged during a studio party, and mended later.[20] In 1965, in an interview, Johns was asked about his first *Flag*, whether it existed, and why it hadn't been in any of the shows. He replied that it had been in a show the previous year at the Jewish Museum: "It's a large painting; it belongs to Philip Johnson. It's sort of in bad shape; it tends to fall to pieces."[21] In other words, it was a bit of a technical mess.

The story is regularly told that *Flag* was purchased by Johnson to be given later to the museum, because Alfred Barr was afraid the museum

might be criticized for making an unpatriotic purchase. The question has recently been raised: Why should Barr have been criticized for buying *Flag*, when *White Flag* (which seems to pun on the idea of American surrender) had already been on display in Bonwit Teller without causing offense? After taking a close look at some of the newspaper texts embedded in the stripes, I have a theory about what might have happened.

In 1958, when Johns had his first show at Leo Castelli's, Barr, to Castelli's amazement, spent three hours at the show. According to Ratcliff's account, he returned a few days later with Dorothy Miller, to discuss what MOMA might buy. Near the center of the lowest red stripe of *Flag*, there is part of an advertisement for vaginal deodorant, a photograph showing a Mrs. Nellie Bloom who "(Married—with) pe(ace) of m(ind)." Fred Orton found the rest of this advertisement, along with several other scraps that make up *Flag*, in the *Daily News* of February 15, 1956. Nellie Bloom had married with peace of mind which "only came . . . when she learned the importance of the proper method of douching with a fountain syringe, using an effective yet safe solution like ZONITE . . . an effective antiseptic-germicide that washes away germs and odor-causing waste and is harmless to tissues . . ."[22] My guess is that Dorothy Miller saw some of this text (which has since fallen off or been obscured), and pointed out to the appalled Mr. Barr that here was a ticking bomb.

Barr was anticipating trouble anyway, because he was also thinking of purchasing *Target with Plaster Casts*, which includes a cast of a penis, painted green. (Leo Steinberg: "I did once ask why he had inserted these plaster casts, and his answer was, naturally, that some of the casts happened to be around in the studio."[23] Very funny, as if one might just *happen* to have taken a cast of a penis, without any idea what one was planning to do with it.) The first trouble Barr anticipated was from his acquisitions committee, and so he asked Johns if it would be all right to exhibit *Target with Plaster Casts* with its doors closed. Johns, who had practically never sold anything by then, replied admirably that it would be all right to close the compartments some of the time but not always. In the event, Barr made three purchases, but avoided both the green penis and the red vaginal deodorant. But Johnson was apparently persuaded against his will to buy *Flag* with a view to donating it to

MOMA. Then he grew to like the painting more and more, which is why he wasn't persuaded to hand it over until 1973.[24]

The fact that the early paintings are constructed out of texts receives surprisingly little attention in the Johns literature, but it seems to me an important fact about, for instance, *Map* (1962), which is a gray map of the United States, that on the border between Idaho and Wyoming we find the following text:

Both kinds of orgy, the . . . reduced to the same principle . . . tension. One is likely to be successful, since it attacks the true root of the trouble, and if not accompanied by too-intense feelings of guilt and self-disgust will probably continue to function smoothly. The other kind, that of the rebels, may also, providing the equation of oppression with society is correct, be . . . altogether happy.[25]

What is this? Some kind of analysis of homosexual promiscuity, an analysis of this promiscuity as a form of political rebellion, placed on a gray map of the United States, at a position which might be considered perhaps most oppressive from a homosexual point of view? Why does the mind immediately react with caution against the idea that the text might provide a clue, or the clue, to the meaning of the painting? Does it seem banal to associate the oppressiveness of gray with the oppressiveness of the country? Or does it seem, rather, like a category mistake?

Johns said, in the interview with Walter Hopps quoted earlier, that generally with the collages, whatever printing showed had no significance for him. The interviewer expresses pleasure at the line of newspaper type on a target which clearly says: "A very farsighted man." Johns says, laughing: "I was not aware of that. That's the first I heard of it." One may easily believe that he had forgotten what is anyway not so striking a line, but I simply do not believe that the painter was unaware of the textual material he was using. It may well be, of course, that this material has become more interesting over the years, in the way that a piece of newspaper used to line a drawer acquires interest the longer it is left, but I cannot imagine that it was by accident that a recipe for apple sauce found its way onto *Flag*, along with the reference to the new Rodgers and Hammerstein musical *Pipe Dream*, to Radio

Free Europe and the Voice of the People, "A Famous Hollywood Figure Tells You How To Reduce," "Manuscripts Invited," "Stock Prices Ebb as Market Idles," and the numerous other fragments which build up a picture of life in the United States. It is a painting made out of newspaper, depicting the Stars and Stripes, which is the name of a newspaper. It is a pun, a depository of private jokes.

Just as the *Target with Four Faces* has a newspaper horoscope and an article on astrology, because one of Johns's early patrons was an astrologer, according to Joan Carpenter. And it features a laundry ticket, with soap and bleach checked, and a label with the address and telephone number of the Hotel Bilbao in Tétouan (identical with the eight labels that appear in a Rauschenberg collage of 1952) and a photograph of Billy Graham, along with want ads and stock and commodity prices.

Generally speaking, it appears that when using newsprint for his collages Johns favored amusing details from everyday life, rather than the main political or news headlines. The joke was to construct the sublime *Flag* out of the unsublime quotidian incident. *Flag* is not unpatriotic, it simply aestheticizes the whole panoply of patriotism. It is not a gesture of protest—very far from it. It is a gesture of profound amusement.

4

The biggest conceptions, thought Roderick Hudson, would bring forth the biggest performances—it was enough to pitch in and not be afraid. And there is something of this spirit in Jasper Johns when he describes the key moment in his early career: "Before, whenever anybody asked me what I did, I said I was going to become an artist. Finally I decided that I could be going to become an artist forever, all my life. I decided to stop *becoming* and to *be* an artist."[26] Rather like a Roman emperor waking up one day and deciding that from this day forth he would be a god. As if the decision would guarantee the outcome.

But how *does* one become an artist these days? How is that elevation achieved? Robert Hughes has argued, on more than one occasion, that the prerequisites have not changed: one must learn "drawing from the live model and the natural motif" since "virtually all artists who created

and extended the modernist enterprise between 1890 and 1950, Beck-mann no less than Picasso, Miró and de Kooning as well as Degas or Matisse, were formed by the atelier system and could no more have done without the particular skills it inculcated than an aircraft can fly without an airstrip."[27] The modern artist must, as it were, first serve his time as a pre-modern artist. "The philosophical beauty of Mondrian's squares and grids begins with the empirical beauty of his apple trees."

As an example of the kind of artistic development envisaged by Hughes, one could hardly do better than Ellsworth Kelly. Not only does the artist, as already noted, begin with an extensive study of the Old Masters, he also draws conventional cityscape as in *View of Roxbury* (1948) and still life as in *Sneaker* (1949). The story of his transition to abstraction is told: how, while working away in the Museum of Modern Art in Paris, he suddenly began to find the window frames themselves more interesting than the paintings between them. So he started drawing windows, and then moved on to the awnings in the Avenue Matignon—in a witty geometrical abstraction which seems at the same time realist in spirit.

Kelly never entirely abandoned figurative drawing. Throughout his career he has executed the most elegant studies of plant forms, as if he has never wanted to kiss goodbye to that gift he started out with. But still, what we are being chiefly asked to consider at the Guggenheim is what is on the ramp, the monochrome geometric panels. It stretches credulity to say that the *only* way these could have been arrived at was through contemplation of organic form, that the *only* training that could have come up with these results was the type offered by the Museum of Fine Arts course in Boston. Suppose a mendacious curator were to lead us up the Guggenheim ramp, talking about Kelly's education, and saying how he had learned everything he knew in, for instance, an architect's office—would we immediately guess that we were being misled?

In the broadest, most romantic sense, anything we undergo in life can serve us in our art. In a slightly narrower sense, the study of any art form might serve the artist in another medium: a painter might study harmony and somehow profit from the time spent. But if we are talking in the strict sense of the skills learned in the atelier—whether the

grinding and mixing of colors, or the drawing from life, the preparation of a panel, or the mastery of perspective—these things were taught and learned as they were needed. To say that such skills are needed even if they are later to be jettisoned is to smuggle an unexamined argument into the case. It would be hard to explain to a Renaissance artist why Mondrian had to study an apple tree in order to paint a grid.

In the case of Johns, we have an ambitious young artist whose background has somehow given him an allergy to education. He is anxious, insulted, quick to take offense. He is not the idiot savant he would have us believe, but he is not to be overpromoted either as a systematic thinker. Kirk Varnedoe, who elsewhere seems keen not to exaggerate Johns's philosophical content, over-eggs the pudding by at least a dozen eggs in the following single sentence:

The displacement of Sartre's Existentialism by Merleau-Ponty's phenomenology, the challenges of Continental gestalt psychology to Anglo-Saxon empiricism, the weakening of behaviorist thought in the face of new ideas of language as paradigmatic for understanding cognition and culture—all these intellectual phenomena of the late 1950s provide a surrounding backdrop for Johns's particular pressure on the intersections between seeing and knowing as a central matter of his art, and for the broadly attentive public reception of his self-conscious interplay of the retinal and the mental.

Our view of what happened in Johns's early art is hampered by the fact that at the time he made his famous decision that he had now become an artist, he destroyed all the early work he possessed or could lay his hands on. What little survived that holocaust shows us that it did not differ so radically from what came after it. There is for instance a drawing from the Rauschenberg collection that shows Johns's early affinity for the use of graphite—in this case on paper that seems to have been treated with motor oil.

Once he had become an artist, Johns painted the flags and targets and alphabets that established his early fame. And once he had done these, and looked at them, and seen that they were good—that the conception had brought forth the performance—then Johns made the unusual decision that he needed to be a draftsman, because now he had something to draw. The arrangement of the MOMA show emphasizes

this reversal of the Hughesian paradigm. The paintings come first, the drawings later. The bronzes of the ale cans and the paintbrushes in the Savarin tin come first (and it is typical of Johns that he should delight in using not plain bronze but painted bronze), afterward the various graphic works recapping those themes.

All the drawings on display, even those entitled studies, have a very finished quality. If they were by Michelangelo one would call them presentation drawings (which is what quite a few of them seem to be—things to give friends). There are no sketches, and nothing on display—even the intriguing marginalia about the life cycle of the cicada—looks remotely tentative. Indeed, nothing could be less tentative than the wire coat hanger on which such attention has been bestowed.

When Johns began to make lithographs, he was working for the first time in a classic medium, unmodified, rather than one which he had adapted and made unique for his purposes. Perhaps this just shows growing confidence. But it is also worth recalling that this medium, at the time, was another wide-open field. For some reason American artists in those days tended to frown on lithography. Tatyana Grossman, the founder of Universal Limited Art Editions, had to build up her practice from scratch by touting for trade among the artists she admired. It is wonderful to think of her dropping off the very heavy lithographic stones at Johns's loft (Rauschenberg and a vagrant had to be co-opted to carry them in) on the off-chance that he might be interested. On the first block, Johns summoned the energy and interest to draw a zero. Then he began to elaborate, and some of his later prints use as many as nineteen blocks; and one of his later screen prints uses as many as forty-one screens. The graphic work, for all its high quality, does not for the most part add to the number of original compositions; instead it provides a meditation on what the artist has already achieved. It is as if, at the most elevated level, the artist were doing his own merchandising.

It seems to have been sometime around the late sixties that Johns discovered the potential for drawing on a certain kind of opaque plastic sheet. Presumably the charm of the material derives from the way one can form puddles on its surface, alongside the dramatic sharp lines that it also seems to favor. The earliest of these ink-on-plastic studies is the *Scott Fagan Record* of 1969. The last are the tracings from Cézanne's *Nudes in a Landscape* (the version of the large bathers in the Barnes

Collection); in these, Johns has decided that the ambiguous figure leaning against a tree on the right-hand side of the composition is a man, and he has awarded him a prominent erection. This comes as a comic, cheerful surprise at the end of the show.

The late tracings have not been universally admired. Reading some adverse remarks about them, I suddenly heard again in my head the voice of some teacher from years ago saying "*and no tracing-paper allowed!*" It's that same old trick again of taking some despised or unpromising form or material, and doing a job on it. If the labels had not clearly said "Tracing after Cézanne," but had said "study after," the disapproval might have been less. But Johns has always been dissatisfied by his own ability to draw, which is why he made it his practice to paint first, draw later. If this flies in the face of conventional wisdom, Johns is only acting true to form. And after all, drawing has never been compulsory for genius. Caravaggio didn't draw. Velázquez didn't draw. El Greco left approximately one drawing. And if it seemed a good idea to Jasper Johns to take a piece of his favorite plastic and make a series of tracings of a reproduction of a favorite Cézanne, and if the voice of the critic sounded in his ear saying "You can't do that!" it was correct for the artist to reply, as he must always reply: "Oh can't I then? Just watch me."

Notes

On Statues

1. Lynn Gamwell and Richard Wells, editors, *Sigmund Freud and Art: His Personal Collection of Antiquities* (Abrams, 1989), p. 152.

2. "The 'Uncanny,'" Penguin Freud Library, Vol. 14, p. 355.

3. "The Moses of Michelangelo," Penguin Freud Library, Vol. 14, p. 255.

4. "The Moses of Michelangelo," Penguin Freud Library, Vol. 14, p. 282.

5. Ernest Jones, *Sigmund Freud: Life and Work* (Basic Books, 1957), Vol. 3, p. 221.

6. Exodus 20:4–6.

7. Arnold Schwartzman, *Graven Images: Graphic Motifs of the Jewish Gravestone*, foreword by Chaim Potok (Abrams, 1993), p. 9.

8. "Moses and Monotheism," Penguin Freud Library, Vol. 13, pp. 360, 362.

9. Master Gregorius, *The Marvels of Rome*; see *Journal of Roman Studies* IX, 1919, p. 26. It is quite possible that the reddish tinge in the face was the result of the painting or staining of the marble.

10. Ghiberti, *I Commentarii*, edited by Julius von Schlosser (Berlin, J. Bard, 1912), p. 63.

11. John W. Steyaert, *Late Gothic Sculpture: The Burgundian Netherlands* (Abrams, 1994), p. 23.

12. Margaret Aston, *England's Iconoclasts: Laws Against Images* (Oxford University Press, 1988), pp. 73–4.

13. Richard Krautheimer, *Lorenzo Ghiberti*, second edition (Princeton University Press, 1982), p. 73.

14. R. W. Lightbown, *Secular Goldsmiths' Work in Medieval France: A History* (Society of Antiquaries of London/Thames and Hudson, 1978). On the rarity of early goldsmiths' work see also the *Burlington Magazine*, June 1995, for Timothy Schroder's "A royal Tudor rock-crystal and silver-gilt vase," which describes the only such object of any importance which can be associated with

Henry VIII and which is indisputably of English manufacture. The publication of this vase brings to a total of four the surviving objects from Henry's Jewel House.

15. Gert van der Osten, cited by Jacques Baudouin in *La Sculpture flamboyante* (Paris: Créer, 1983), Vol. 1, "Les Grands imagiers d'Occident," p. 46.

16. Jennifer Montagu, *Roman Baroque Sculpture: The Industry of Art* (Yale University Press, 1989), Chapter 8, p. 192.

17. *Odes*, III, 30.

18. Ernest Jones, *Sigmund Freud*, Vol. 2, p. 15. The Sophocles line is from the last chorus of *Oedipus Tyrannus*.

19. Jacques Baudouin, *La Sculpture flamboyante*, Vol. 3, "En Normandie et Ile-de-France," p. 49.

20. Francis Haskell, *History and its Images* (Yale University Press, 1993), Chap. 9: "The Musée des Monuments Français."

21. "The Collecting of Medieval Works of Art," in Paul Williamson, *Medieval Sculpture and Works of Art*, catalog of the Thyssen-Bornemisza Collection (Sotheby's, 1987).

22. "Michelangelo's Cupid: The End of a Chapter," in John Pope Hennessy, *Essays on Italian Sculpture* (Phaidon, 1968).

23. For these and many other examples see Francis Haskell and Nicholas Penny, *Taste and the Antique: The Lure of Classical Sculpture 1500–1900*, second edition (Yale University Press, 1982).

24. Diary of Gustav Johan Ehrensvärd, 12 April 1780, cited in Gösta Säflund, *Aphrodite Kallipygos* (Stockholm: Almqvist and Wiksell, 1963).

25. Robert Graves, *The Greek Myths*, revised edition (Penguin, 1960), Vol. 1, p. 90.

The Mummy's Secret

Books and exhibitions discussed in this chapter:

Ancient Faces: Mummy Portraits from Ancient Egypt, an exhibition at the British Museum, March 14–July 20, 1997. Catalog of the exhibition by Susan Walker and Morris Bierbrier, with Paul Roberts and John Taylor, British Museum Press.

The Mysterious Fayum Portraits: Faces from Ancient Egypt, by Euphrosyne Doxiadis, Abrams.

Portraits and Masks: Burial Customs in Roman Egypt, edited by Morris Bierbrier, British Museum Press.

1. A. H. Sayce, *Reminiscences* (London: Macmillan, 1923). What Jeremiah says

is: "Thus saith the Lord of Hosts, the God of Israel; Behold, I will send and take Nebuchadrezzar the king of Babylon, my servant, and will set his throne upon these stones that I have hid; and he shall spread his royal pavilion over them."

2. See Margaret S. Drower, *Flinders Petrie: A Life in Archaeology* (1985; University of Wisconsin Press, second edition, 1995).

3. See Euphrosyne Doxiadis, *The Mysterious Fayum Portraits: Faces from Ancient Egypt*, pp. 123–5, for della Valle's account of his discovery.

4. Petrie's unpublished Journal, January 22–9, 1888. I am grateful to the Committee of Management of the Griffith Institute in Oxford for allowing me to read and quote from this document.

5. W. M. Flinders Petrie, *Ten Years' Digging in Egypt: 1881–1891* (London: Religious Tract Society, 1892), p. 100.

6. Dominic Montserrat, "Mummy Portraits: Their Ancient Use and Modern Abuse," a lecture given to the British Museum Society, April 23, 1997.

7. *Illustrated London News*, June 30, 1888, p. 718.

8. Petrie's Journal, February 5–12, 1888.

9. Flinders Petrie, *Ten Years' Digging in Egypt*, p. 99.

10. See Ingeborg Scheibler, *Griechische Malerei der Antike* (Munich: Beck, 1994).

11. *The Colour of Sculpture (1840–1910)*, catalog of the exhibition edited by Andreas Blühm (Zwolle: Waanders Uitgevers, 1996).

12. Petrie's Journal, February 19–26, 1888.

13. Drower, *Flinders Petrie*, p. 303.

14. Drower, *Flinders Petrie*, p. 165.

15. W. M. F. Petrie, *Heal the Land* (Jerusalem: Azriel Printing Press, 1936).

16. Amelia B. Edwards, *Egypt and Its Monuments: Pharaohs, Fellahs and Explorers* (Harper and Bros., 1891).

17. Dominic Montserrat, *Sex and Society in Graeco-Roman Egypt* (Kegan Paul International, 1996).

18. Edwards, *Egypt and Its Monuments*.

19. In his British Museum lecture Montserrat quoted from Georg Ebers, *The Hellenic Portraits from the Fayum at present in the Collection of Herr Graf* (D. Appleton and Co., 1893).

20. See Volume 7 of Eugen-Fischer and Gerhard Kittel, *Forschungen zur Judenfrage: Das Antike Weltjudentum* (Hamburg: Hanseatische Verlagsanstalt, 1943).

21. Petrie's Journal, January 29–February 5, 1888.

22. Petrie's Journal, March 4–10, 1888.

23. See *Egypte Romaine, l'autre Egypte*, catalog of the exhibition at the Museum of Mediterranean Archaeology, Marseille, April 4–July 13, 1997, no. 244.

24. David L. Thompson, *Mummy Portraits in the J. Paul Getty Museum* (Getty Museum Publications, 1976), p. 50.

25. See Dominic Montserrat, "The Representation of Young Males in 'Fayum Portraits,' " *Journal of Egyptian Archaeology*, No. 79 (1993), p. 221.

26. Charles Rufus Morey, *Early Christian Art* (Princeton University Press, 1947), p. 127.

27. Scheibler, *Griechische Malerei der Antike*, p. 75.

Pisanello: The Best of Both Worlds

Books and exhibitions discussed in this chapter:

Pisanello, an exhibition at the Louvre, Paris, May 6–August 5, 1996, and at the Museo di Castelvecchio, Verona, September 7–December 9, 1996.

Pisanello: le peintre aux sept vertus, catalog of the exhibition, edited by Dominique Cordellier, Paris: Réunion des Musées Nationaux.

1. Cesare Bernasconi, *Il Pisano: grand'artefice veronese* . . . (Verona: Civelli, 1862), cited in *Tout l'oeuvre peint de Pisanello*, introduction by Michel Pastoureau (Paris: Flammarion, 1987).

2. For the developing idea of Leonardo's work, see A. Richard Turner, *Inventing Leonardo* (Knopf, 1993).

3. Eastlake's diary is in the National Gallery, London. Thanks to Nicholas Penny for showing me this passage.

4. See Frédéric Reiset, "Une visite aux Musées de Londres en 1876," in the *Gazette des Beaux-Arts*, XV (February 1877).

5. Bernard Berenson, *Italian Painters of the Renaissance* (Phaidon, 1952), p. 138.

6. Berenson, *Italian Painters of the Renaissance*, pp. 143–4.

7. Giovanni Paccagnini, *Pisanello* (Phaidon Press, 1973), p. 51.

8. For a full discussion of these frescoes, their meaning and context, see Joanna Woods-Marsden, *The Gonzaga of Mantua and Pisanello's Arthurian Frescoes* (Princeton University Press, 1988).

9. George R. Potter and Evelyn M. Simpson, editors, *The Sermons of John Donne*, Vol. 2 (University of California Press, 1955), p. 266.

10. Michael Baxandall, *Giotto and the Orators* (Oxford University Press, 1971), p. 82.

11. Baxandall, *Giotto and the Orators*, pp. 92–3.

12. See Luke Syson, "The Circulation of Drawings for Medals in Fifteenth-Century Italy," in *Designs on Posterity: Drawings for Medals*, edited by Mark Jones (London: British Art Medal Trust, 1994).

Verrocchio: The New Cicerone

Books and exhibitions discussed in this chapter:

The Sculptures of Andrea del Verrocchio, by Andrew Butterfield, Yale University Press.

1. W. R. Valentiner, *Studies of Italian Renaissance Sculpture* (London: Phaidon, 1950), p. 182.

2. Within two years of Valentiner's publishing this discovery, the director of the Schlossmuseum exchanged the candelabrum, among other objects, for part of the Guelph Treasure, which included German medieval goldsmiths' work of the highest quality and which, particularly in the political and cultural climate of the time, would have proved irresistible.

3. *Burlington Magazine*, December 1994.

4. *The Stones of Venice*, Part Three.

5. See Anthony Radcliffe, "New Light on Verrocchio's *Beheading of the Baptist*," in *Verrocchio and Late Quattrocento Italian Sculpture*, edited by Steven Bule, et al. (Florence: Casa Editrice Le Lettere, 1992).

6. Apart from a noble patron, the most obvious type of collector of the period would be an artist. Artists and goldsmiths are known to have kept casts of exemplary works, including the Verrocchio cup mentioned by Vasari here.

Leonardo's Nephew

1. See Edward MacCurdy, *The Notebooks of Leonardo da Vinci*, Vol. II (London: Reprint Society, 1954), p. 482.

2. MacCurdy, *The Notebooks of Leonardo da Vinci*, Vol. II, p. 503.

3. Giovanni Agosti, *Bambaia e il Classicismo Lombardo* (Turin: Einaudi, 1990), Chapter 3.

4. All Vasari quotations are from the Everyman edition translated by Gaston de Vere (Knopf, 1996), Vol. 2.

5. The present essay combines a reading of Vasari's Life of Pierino with information in *Pierino da Vinci, Atti della giornata di Studio*, edited by Marco Cianchi (Florence: Beccocci, 1995), hereafter referred to as *Pierino*. I am also indebted to Marco Cianchi for sending me his "Pierino: Life and Works in Brief," in *Italian History and Culture* (1995), pp. 81–110, and to Jonathan Nelson for comments and help.

6. Cianchi, "Pierino: Life and Works," p. 83.

7. Ulrich Middeldorf, *Raccolta di Scritti that is Collected Writings*, Vol. I, 1924–1938 (SPES, Florence, 1979–80).

8. John Pope-Hennessy, *Catalogue of Italian Sculpture in the Victoria and Albert Museum*, Vol. II (London: HMSO, 1964), p. 440.

9. See Holderbaum in *Pierino*, also for a survey of Pierino scholarship.

10. Stuart Currie, "Discerning the sculptural content of Bronzino's early male portraits," in *The Sculpted Object 1400–1700*, edited by Stuart Currie and Peta Motture (London: Scolar Press, 1997).

11. "Un gruppo di bronzetti di Pierino da Vinci del 1547," in *Mitteilungen des Kunsthistorischen Institutes in Florenz*, Vol. XVIII (1974), pp. 251–72.

12. See the essay by Detlev Heikamp in *Pierino*.

13. Translated by J. A. Symonds, it concludes the first book of *The Life of Benvenuto Cellini* (London: Phaidon, 1951).

14. See the essay by Jonathan Nelson in *Pierino*. See also Nelson's "Creative Patronage: Luca Martini and the Renaissance Portrait," in *Mitteilungen des Kunsthistorischen Institutes in Florenz*, Vol. XXXIX (1995), Heft 2/3.

15. See Michael Roche, *Forbidden Friendships: Homosexuality and Male Culture in Renaissance Florence* (Oxford University Press, 1996).

16. Now in Minneapolis Institute of Arts.

17. See Nelson, "Creative Patronage."

18. See Nicholas Penny, *Catalogue of European Sculpture in the Ashmolean Museum (1540 to the Present Day)*, Vol. I, (Oxford, 1992). Penny discusses both the Ugolino relief and the exquisite small bronze male nude, probably intended to depict Adam Tempted.

19. See Nelson's essay in *Pierino*.

20. *Inferno* 33:67–70 translated by Charles Singleton (Princeton University Press).

21. F. A. Yates, "Transformations of Dante's Ugolino," in *Journal of the Warburg and Courtauld Institutes*, XIV (1951), pp. 92–117.

22. See Richardson's *Discourse* (in *The Works of Jonathan Richardson* (London: 1792), p. 186.

23. *Discourse*, p. 187.

24. A sheet of studies from the Art Institute of Chicago is reproduced as color plate 1 in *Jean-Baptiste Carpeaux, Sculptor of the Second Empire* by Anne Middleton Wagner (Yale University Press, 1986).

25. See "Who painted David's Ugolino?" by Robert Rosenblum, *Burlington, Magazine*, CX (November 1968).

26. See Avery's essay in *Pierino*.

Bernini at Harvard/Chicago Baroque

Books and exhibitions discussed in this chapter:

Gian Lorenzo Bernini: Sketches in Clay, installation at the Fogg Museum, Cambridge, Massachusetts.

Bernini's Rome: Italian Baroque Terracottas from the State Hermitage, St. Petersburg, exhibition at the Art Institute, Chicago, February 28–May 3, 1998; Philadelphia Museum of Art, May 16–August 2, 1998.

From the Sculptor's Hand: Italian Baroque Terracottas from the State Hermitage Museum, catalog of the Chicago exhibition organized by Ian Wardropper, Art Institute of Chicago.

Bernini: Genius of the Baroque, by Charles Avery, special photography by David Finn, Bullfinch Press.

Bernini's Scala Regia at the Vatican Palace: Architecture, Sculpture, and Ritual, by T. A. Marder, Cambridge University Press.

Italian Baroque Sculpture, by Bruce Boucher, Thames and Hudson.

1. Jennifer Montagu, *Alessandro Algardi* (Yale University Press, 1985), p. 9.

2. Paul Fréart de Chantelou, *Diary of the Cavaliere Bernini's Visit to France*, edited and introduced by Anthony Blunt (Princeton University Press, 1985).

3. Irving Lavin, "Bernini and the Art of Social Satire," in *Drawings by Gianlorenzo Bernini from the Museum der Bildenden Künste, Leipzig, German Democratic Republic* (The Art Museum/Princeton University Press, 1981).

4. Records of this music, and the score, were included with *Gianlorenzo Bernini: New Aspects of His Life and Thought*, edited by Irving Lavin (Pennsylvania State University Press, 1985). This volume also prints the text of Bernini's surviving comedy, and an essay on his theatrical work by Frederick Hammond.

5. See the volume listed in note 4.

6. Ticknor and Fields, Boston, 1860.

7. Kathryn McClintock, "Academic Collecting at Harvard," in *Medieval Art in America: Patterns of Collecting*, edited by Elizabeth Bradford Smith (Palmer Museum of Art, Pennsylvania State University Press, 1996).

8. Richard Norton, *Bernini and Other Studies in the History of Art* (New York: Macmillan, 1914), p. 3. The Brandegees, in addition to buying the Bernini terracottas *en bloc*, purchased no less than 8200 drawings from Piancastelli's collection of 215,000 sheets. The Cooper-Hewitt Museum of design in New York holds a large number of Piancastelli's drawings. See "Private Collections of Old Master Drawings in America in the Twentieth Century," by Nicholas Turner and Jane Shoaf Turner in *Master Drawings, the Woodner Collection* (London: Royal Academy of Arts, 1987).

9. Maria Giulia Barberini and Carlo Gasparri, editors, *Bartolomeo Cavaceppi, Scultore Romano (1717–1799)* (Rome: Museo del Palazzo di Venezia, 1994).

Who Was Thomas Jones?

Books and exhibitions discussed in this chapter:

In the Light of Italy: Corot and Early Open-air Painting, exhibition at the National Gallery of Art, Washington, DC, May 26–September 2, 1996; the Brooklyn Museum of Art, October 11, 1996–January 12, 1997; and the St. Louis Art Museum, February 21–May 18, 1997.

Corot in Italy: Open-air Painting and the Classical Landscape Tradition, by Peter Galassi, Yale University Press.

In the Light of Italy: Corot and Early Open-air Painting, catalog of the exhibition by Philip Conisbee, Sarah Faunce, and Jeremy Strick, with Peter Galassi, guest curator, National Gallery of Art, Washington/Yale University Press.

Before Photography: Painting and the Invention of Photography, catalog of the exhibition by Peter Galassi, Museum of Modern Art.

1. Peter Galassi, *Corot in Italy*, pp. 8–9.

2. Brian Allen and Larissa Dukelskaya, editors, *British Art Treasures from sian Imperial Collections in the Hermitage*, catalog no. 1 (Yale University Press, 1996).

3. Thomas Jones, *Memoirs*, with an introduction by A. P. Oppé (London: Walpole Society, Vol. 32, 1946–8, 1951).

4. Christie's, July 2, 1954, lots nos. 211–18, 220–23.

5. Philip Conisbee, Sarah Faunce, and Jeremy Strick, *In the Light of Italy*, p. 24. Gere died before he could finish his introduction to the catalog. Galassi quotes from his draft essay.

6. Conisbee, Faunce, and Strick, *In the Light of Italy*, pp. 25–6.

7. *The New York Review of Books*, December 3, 1981, p. 31.

8. Unlike a watercolor, an oil painting left in the dark will suffer from a yellowing of its areas of white pigment. Masterpieces in oils, stored too long in the bank vaults of Switzerland and Japan, will take a couple of weeks in good light to regain some of their vividness. An oil sketch on paper—as long as the paper itself is entirely covered with paint—should benefit from light levels which would be frowned upon in the case of drawings and watercolors. The beneficial bleaching effect of light upon white paint was demonstrated to me at the Tate by the simple act of opening a door: where the white paint on the jamb was normally kept in the dark, it had yellowed.

9. For this sketch by Richard Symonds and the one mentioned below by A. Cozens, see Conisbee, Faunce, and Strick, *In the Light of Italy*, p. 31.

10. My thanks to Ashok Roy of the National Gallery, London, for this information.

11. The whole method is given in the appendix to *Alexander and John Robert Cozens: The Poetry of Landscape*, by Kim Sloan (Yale University Press, 1986). In the same appendix we can see how elaborately Cozens prepared a "light painting oil" to add to any color that does not dry well. The first stage alone reads: "at the Glass House in Water Lane Fleet Street every day except Saturday, Sunday & Monday desire any of the workmen to blow in your presence large Bubbles extremely thin of white flint Glass & let it be crushed into a Sheet of Brown paper, then rub it to a Sheet of Coarse powder." This was eventually mixed with "moderately fat poppy oil."

12. I am grateful to Mark Evans at the National Museum of Wales for showing me Jones's sketchbook, and for sharing his information and ideas, and to Robin Hamlyn at the Tate for showing me the Joneses in the Oppé collection and discussing many of these issues.

13. Jones used, in the oil sketches he made before his Italian journey, what looks like a wrapping paper, very thick and rough. One of the sketches in the Oppé collection is on paper of this kind, which seems to have been crumpled before he used it, as if it had suffered in the knapsack.

14. Quoted in Galassi, *Corot in Italy*, p. 16.

15. Quoted in Galassi, *Corot in Italy*, p. 18.

16. See Anthony Blunt, "Recorders of Vanished Naples: Thomas Jones," in *Country Life*, August 23, 1973.

17. Jones, *Memoirs*, p. 7.

18. Jones, *Memoirs*, p. 9.

19. Lawrence Gowing, *The Originality of Thomas Jones* (Thames and Hudson, 1985).

20. Jones, *Memoirs*, p. 54.

21. Sloan, *Alexander and John Robert Cozens*, p. 2.

22. For a fictional version of their encounter, see Susan Sontag, *The Volcano Lover: A Romance* (Farrar, Straus and Giroux, 1992), p. 120.

23. Jones, *Memoirs*, p. 97.

Degas in the Evening

Books and exhibitions discussed in this chapter:
Degas as a Collector, exhibition at the National Gallery, London, through

August 26, 1996, catalog of the exhibition by Ann Dumas, London: Apollo Magazine Ltd./National Gallery Publications.

Degas: Beyond Impressionism, exhibition at the National Gallery, London, through August, 1996; The Art Institute of Chicago, September 30, 1996–January 5, 1997, catalog of the exhibition by Richard Kendall, London: National Gallery Publications/Yale University Press.

1. See C. J. Holmes, *Self and Partners* (Macmillan, 1936), pp. 335–43.

2. I have relied on "Keynes and the Degas Sale" by Anne Emberton, *History Today* (January 1996), pp. 22–8.

3. See A. J. P. Taylor, *The First World War* (1963; reprinted by Penguin, 1966), p. 218.

4. Cited by Emberton, in "Keynes and the Degas Sale," p. 26.

5. Actually seven.

6. Letter to Nicholas Bagenal, in Nigel Nicolson and Joanne Trautmann, editors, *The Letters of Virginia Woolf, Volume II: 1912–1922* (Harcourt Brace, 1976), p. 230.

7. Theodore Reff, *Degas: The Artist's Mind* (Belknap Press/Harvard University Press, 1987).

8. Daniel Halévy, *My Friend Degas* (Wesleyan University Press, 1964), p. 101.

9. Henri Loyrette, *Degas* (Paris: Fayard, 1991).

10. Loyrette, *Degas*, p. 441.

11. Ambroise Vollard, *Degas: An Intimate Portrait* (Dover, 1986; originally published 1924). "Degas, danse, dessin" is translated by David Paul in Jackson Matthews, editor, *The Collected Works of Paul Valéry*, Vol. 12 (Princeton University Press, 1960).

12. Kessler Diary, April 16, 1890. The first part of this description fits closely to van Gogh's *Olive Orchard* (Number 1853 in Jan Hulsker, *The Complete Van Gogh*, Harrison House/Abrams, 1984). The second clause seems to refer to Seurat, the third to van Gogh again. *The Starry Night* was one of ten van Goghs included in this Salon, along with eleven Seurats (including *Le Chahut* and *Woman Powdering Her Face*). Kessler later owned van Gogh's *Portrait of Doctor Gachet*, now in a bank vault in Japan.

13. Ambroise Vollard, *Recollections of a Picture Dealer* (Dover, 1978).

14. Kessler Diary, June 27, 1907.

15. See *Apollinaire on Art: Essays and Reviews 1902–1918* by Guillaume Apollinaire, edited by Leroy C. Breunig, translated by Susan Suleiman (1972, reprinted by Da Capo), p. 17. Also *Diary of an Art Dealer* by René Gimpel (Farrar, Straus and Giroux, 1966), p. 372. It is impossible to say for certain what Wagram actually owned. He was a slow payer and often left his purchases in the hands of his dealers. John Rewald attempted but failed to unravel the mystery of the

court case, in order to trace the Cézannes in his collection. Anne Distel has provided a detailed account of the Wagram affair in "Renoir's collectors: the pâtissier, the priest and the prince" in the exhibition catalog *Renoir*, edited by John House, Anne Distel, and Lawrence Gowing (Abrams, 1985). I am very grateful to Walter Feilchenfeldt for helping with this passage.

16. "Degas and the Dreyfus Affair: A Portrait of the Artist as an Anti-Semite," in Norman Kleeblatt, editor, *The Dreyfus Affair: Art, Truth, and Justice* (University of California Press, 1987).

17. Richard Ellmann, *Oscar Wilde* (Knopf, 1988), p. 430.

18. José María Sert (1876–1945), Catalan artist and muralist, who worked around the world, decorating the ballroom, the "Sert Room," at the Waldorf-Astoria for the astonishing fee of $150,000 (the murals were dismantled in the 1970s, given away to the dealer who was prepared to remove them, and who later sold them for a huge sum). Degas's comment, on visiting Sert's Paris studio, after a long examination, was: "How very Spanish—and in such a quiet street!" Forain, asked how such overblown murals as Sert's could be transported, said: "Don't worry. They're collapsible."

19. "Creole" meant originally a white person born in the colonies. Vollard, born in La Réunion (in the Indian Ocean), was a Creole, as was Degas's mother, who came from New Orleans.

20. Vollard says in his memoirs that he always served chicken curry, the national dish of La Réunion.

21. Alexandre Bernheim (1839–1915), picture dealer, moved from Brussels to Paris in 1873. His sons, Josse Bernheim-Jeune and Gaston Bernheim de Villers, had turned to dealing in contemporary art around the turn of the century. Their gallery was near Vollard's in rue Laffitte.

22. That is, they were giving out civilian clothes to the French soldiers after the defeat of the French by Prussia in 1870.

23. Apparently Arthur Chaplin (1869–?), a portrait and flower painter who lived in Paris and was the son of Charles Chaplin, who taught Mary Cassatt.

24. Wilde died in 1900.

25. Paul Albert Besnard (1849–1934), highly successful Salon painter. His wife, Charlotte Dubray, was a sculptor.

26. See Paul Valéry, "Degas, danse, dessin": "Of another person who, around 1885, won the acceptance and the taste of the Salon public for a much tempered, second- or third-hand modernism (Degas said): 'He flies with *our* wings.' " (Pléiade edition, Vol. II, p. 1217)

27. Jacques-Emile Blanche, the painter, and his wife were friends of Degas and posed for his camera in 1895, the year of their marriage. According to Léon Daudet, Blanche was impotent and the marriage was accordingly never

consummated. Degas had owned a portrait by Blanche, which was exhibited in *Degas as a Collector*; he returned the work to the artist in protest at Blanche's having exhibited an unauthorized portrait of himself.

28. *L'Africaine* was Meyerbeer's last opera, first produced in Paris in 1865, a year after the composer's death. Presumably the joke is that such music would be anathema to Cabaner.

29. Joachim-Jean-Philippe, known as Ernest, Cabaner (1833–78) was an impoverished composer of highly advanced music who worked as an accompanist in *cafés chantants*. Vollard twice makes clear that Cézanne *gave* his celebrated *Bathers Resting* to Cabaner, from whom it passed to Caillebotte, who tried to bequeath it to the state. It was among works notoriously rejected from his bequest, and must have passed into Vollard's hands. Vollard once rejected an offer of $200,000 for it, but was later forced to accept $70,000 from the odious Albert C. Barnes. It is now in the Barnes Foundation, Merion, Pennsylvania. Presumably it was in the shop at the time this discussion was taking place.

30. In his *Cézanne* (first published 1914), Vollard attributes this story to François Coppée: "During the siege of Paris, when the shells were dropping like rain, Cabaner inquired innocently of Coppée, 'Where do all those bullets come from?' Coppée was stupefied. 'From the enemy, most likely.' 'Is it always the Prussians?' Coppée, beside himself: 'Well, who do you think they are?' Cabaner: 'I don't know . . . perhaps other tribes . . .' "

31. Valéry, a frequent visitor, describes the regular meal at Degas's apartment as veal and macaroni of "rigorous insipidity" followed by "a certain Dundee orange marmalade that I couldn't bear, that I ended by tolerating, and that I believe I no longer detest, *out of fond memory*." Clearly Vollard had laid on the dessert in Degas's honor, and the first course in complete defiance of his known taste.

32. Roy McMullen cites Gide's account of a meeting with Degas, on July 4, 1909, when Degas returns to this theme: "The day we began to write the word 'Intelligence' with a capital 'I,' we were screwed. There is no such entity as Intelligence. There is just intelligence concerning this or that. One should be intelligent only in relation to what one is doing." Roy McMullen, *Degas: His Life, Times, and Work* (Houghton Mifflin, 1984), p. 461. I have translated the word *intelligence* in Kessler as *intelligentsia* because it seems to fit the context, but the passage in Gide contains both meanings.

33. Alfred Edwards (1856–1914), immensely wealthy financier. He was born in Constantinople of an English father and a French-born mother of possible Near Eastern origin. At the time of this conversation he was on his fourth wife, Misia *née* Godebska. Sert was shortly to become Misia's lover, then her husband. It was Forain who introduced the pair, first in 1905, then again some

time later in 1907 when Edwards had become infatuated with the actress Geneviève Lantelme. For the extraordinary story of Misia Sert's life (1872–1950) see Arthur Gold and Robert Fizdale, *Misia* (Knopf, 1980).

34. There are three surviving studies by van Gogh of this subject, thought to be a *pierreuse*, or streetwalker, but in none does she appear to be lying on a bearskin. Kessler saw the version now in the Barnes Foundation (Number 1214 in the Hulsker catalog).

Degas in Chicago

Books and exhibitions discussed in this chapter:

Degas: Beyond Impressionism, exhibition at the National Gallery, London, May 22–August 26, 1996; The Art Institute of Chicago, September 30, 1996–January 5, 1997, catalog of the exhibition by Richard Kendall, National Gallery, London/Art Institute of Chicago/Yale University Press.

1. Ambroise Vollard, *Degas: an Intimate Portrait* (Dover, 1986), p. 59.

2. Richard Kendall, editor, *Degas by Himself* (New York Graphic Society/Little, Brown, 1987), p. 248.

3. Cited by L. D. Luard in the preface to Horace Lecoq de Boisbaudran, *L'Education de la Mémoire Pittoresque et la formation de l'Artiste* (Paris: Laurens, 1920). For this account of Lecoq's method in practice I have used Petra ten-Doesschate Chu, "Lecoq de Boisbaudran and Memory Drawing," in Gabriel P. Weisberg, editor, *The European Realist Tradition* (Indiana University Press, 1982).

4. Ruth Butler, *Rodin: The Shape of Genius* (Yale University Press, 1993), p. 392.

5. John Rewald, *Degas's Complete Sculpture* (San Francisco: Alan Wofsy, 1990), p. 30.

6. One of these is owned by the Mellons. Two other plasters have very recently come to light and were advertised in *Apollo* (September 1995) by the Lefevre Gallery as "The Lost Plasters of Edgar Degas." However, in the catalog that accompanies these sculptures, Richard Kendall makes it clear that while he believes that one of these, a *Dancer looking at the sole of her right foot*, is the cast made for Degas and displayed in the salon of his apartment, the other, a *Spanish Dancer*, seems to be an aftercast of some still missing cast. The two pieces were exhibited in the Paris Biennale until September 29.

7. *Apollo*, August 1995, pp. 64–71.

8. In Shelley Sturman and Daphne Barbour, "The materials of the sculptor: Degas' techniques," *Apollo*, August 1995, p. 54.

9. For a full account of the formation of the Chicago collection see Richard R. Brettell and Suzanne Folds McCullagh, *Degas in the Art Institute of Chicago* (Abrams, 1984).

Seurat and the Sewers

Books and exhibitions discussed in this chapter:

Impressionists on the Seine: A Celebration of Renoir's Luncheon of the Boating Party, exhibition at the Phillips Collection, Washington, DC, September 21, 1996–February 9, 1997, catalog of the exhibition edited by Eliza E. Rathbone, Katherine Rothkopf, Richard R. Brettell, and Charles S. Moffett, Counterpoint.

Seurat and the Bathers, exhibition at the National Gallery, London, July 2–September 28, 1997, catalog of the exhibition by John Leighton and Richard Thompson with David Bomford, Jo Kirby, and Ashok Roy, National Gallery/Yale University Press.

Seurat and the Avant-Garde, by Paul Smith, Yale University Press.

1. See David Pinkney, *Napoleon III and the Rebuilding of Paris* (Princeton University Press, 1958).

2. Pinkney, *Napoleon III and the Rebuilding of Paris*, p. 140.

3. T. J. Clark, *The Painting of Modern Life: Paris in the Art of Manet and His Followers* (Thames and Hudson, 1984).

4. Reprinted in Meyer Schapiro, *Modern Art* (Braziller, 1978), p. 192.

5. Robert L. Herbert, *Impressionism: Art, Leisure and Parisian Society* (Yale University Press, 1988).

6. David Arkell, *Looking for Laforgue: An Informal Biography* (Persea Books, 1979).

7. Jules Laforgue, *Textes de Critique d'Art*, edited by Mireille Dottin (Presses Universitaires de Lille, 1988).

8. Quoted and translated by Clark in *The Painting of Modern Life*, p. 16.

9. Quoted by Arkell in *Looking for Laforgue*, pp. 95 and 135.

The Secrets of Maillol

Books and exhibitions discussed in this chapter:

Fondation Dina Vierny, Musée Maillol, 59–61 rue de Grenelle, Paris, catalog of the museum.

Aristide Maillol, an exhibition at the Georg-Kolbe-Museum, Berlin, January

14–May 5, 1996; continuing on to Musée Cantonal des Beaux-Arts, Lausanne, May 15–September 22; Gerhard-Marcks-Haus, Bremen, October 6–January 13, 1997; and Stadtische Kunsthalle, Mannheim, January 25–March 31, 1997, catalog of the exhibition, edited by Ursel Berger and Jörg Zutter, Prestel.

Aristide Maillol, by Bertrand Lorquin, Skira/Thames and Hudson.

1. For a complete account of the sculptures mentioned, and their fates, see Geneviève Bresc-Bautier and Anne Pingeot, *Sculptures des jardins du Louvre, du Carrousel et des Tuileries* (Paris: Réunion des musées nationaux, 1986), two volumes.

2. It is now on the Cours-la-Reine, near the Grand Palais.

3. For Bernini's Paris journey, the most prestigious official reception of any artist ever, see Rudolf and Margot Wittkower, *Born under Saturn* (Random House, 1963; Norton Library, 1969), pp. 342–3 and 270–73.

4. See Rudolf Wittkower, *Gian Lorenzo Bernini: The Sculptor of the Roman Baroque*, third edition, revised (Cornell University Press/Phaidon Press, 1981), p. 254.

5. For this and the next paragraphs, see Bresc-Bautier and Pingeot, *Sculptures des jardins du Louvre, du Carrousel et des Tuileries*, pp. 156–9.

6. In Paris, Meudon, and Philadelphia.

7. Judith Cladel, *Rodin: sa vie glorieuse, sa vie inconnue* (Paris: Grasset, 1936), and *Aristide Maillol: sa vie, son oeuvre, ses idées* (Paris: Grasset, 1937).

8. Kessler's journals are kept in the Deutsches Literaturarchiv at Marbach. I am grateful to the staff of the archive for allowing me to peruse them. However, in the majority of what follows, I rely on the essays in the German catalog and on a new biography by Peter Grupp, *Harry, Graf Kessler, 1868–1937* (Munich: Beck, 1995); and also on *In the Twenties: The Diaries of Harry Kessler*, with an introduction by Otto Friedrich, translated by Charles Kessler (Holt Rinehart Winston, 1971).

9. Breker published two sets of memoirs: *Im Strahlungsfeld der Ereignisse* (Preussisch-Oldendorf: Schurz, 1972) and *Paris, Hitler et Moi* (Paris: Presses de la Cité, 1970).

10. See p. 441 in Ruth Butler, *Rodin: The Shape of Genius* (Yale University Press, 1993). Aurel was the pseudonym of Aurélie Besset-Mortier, who met Rodin in 1904 and wrote *Rodin devant la femme*, which Butler calls a love poem to Rodin, on the sculptor's death in 1917. Butler's scholarly biography is the product of twenty years' work in the Rodin archive.

11. Butler, *Rodin: The Shape of Genius*, p. 100.

12. This was how Frank Harris, at least, interpreted the Balzac study when he saw it in Rodin's studio.

13. Kessler Diary, August 22, 1907.

14. See Lorquin, pp. 55–6. The reason I doubt this story is that it appears in a different form in Cladel's biography, together with a disavowal by Maillol.

15. Kessler Diary, June 10, 1907.

16. This point is made by Butler, in *Rodin: The Shape of Genius*, pp. 360–61. The French artists who came under Rodin's influence, turning to sculpture, were Maillol, Matisse, and Charles Despiau. The foreign artists included Picasso, González, Manolo, Brancusi, Clara Westhoff (Rilke's wife), Lehmbruck, Lipchitz, Zadkine, and Archipenko.

17. André Gide, "Promenade au Salon d'automne," in *Gazette des Beaux-Arts*, 1905, pp. 475–85. (Cited in Berger and Zutter.)

18. See Grupp, *Harry, Graf Kessler*, pp. 143–5.

19. See John Richardson, *A Life of Picasso* (Random House, 1991), Volume 1, p. 423: "A classical revival in art and letters was sweeping through France, indeed much of Southern Europe. Picasso's Greek friend Moréas had pioneered this trend in literature when he founded his Ecole Romane in the 1890s. And some of the Spanish sculptors in Paris—notably Manolo, Gargallo, and Casanovas—had joined the burgeoning Mediterranean movement." Richardson calls Maillol's *La Méditerranée* "the embodiment of Ecole Romane ideals."

20. Kessler Diary, September 2, 1904.

21. Kessler Diary, September 24, 1904.

22. Kessler Diary, June 10, 1907.

23. Kessler Diary, June 28, 1907.

24. Kessler Diary, July 27, 1904.

25. Kessler Diary, June 10, 1904.

26. The evidence for the relationship between Kessler and Colin comes, rather, from Colin's letters and postcards to Kessler. See Grupp, pp. 138–9.

27. Cladel, *Maillol*, p. 91.

28. Kessler Diary, July 23, 1907.

29. See Sabine Walter's "Graf Kessler, Maillol und Hofmannsthal in Griechenland" in the German catalog.

30. Kessler Diary, June 3, 1908.

31. Kessler Diary, June 10, 1911. Kessler introduced Maillol to Nijinsky onstage in the interval, just before Nijinsky was to dance *Petrushka*, which received its premiere on June 13.

32. See Ursel Berger's "Maillols internationale Karriere" in the German catalog. Berger cites Brassaï's view that Maillol was simply not interested in such a muscular, manly figure. Nijinsky, in his diaries, says that he once sat for Rodin. The old, corrupt edition of the diaries says: "[Rodin] wanted to make a drawing of me, wishing to make a marble statue of me. He looked at my

naked body and found that it was perfect, and therefore destroyed his sketches. I felt he liked me and went away." The new French edition gives the exactly opposite sense: "He wanted to draw me, because he wanted to make a marble statue of me. He looked at my naked body, and found it ill-formed, that's why he crossed out his sketches. I understood he didn't like me, and I left . . ." See *Nijinski Cahiers* (Arles: Actes Sud, 1995). There is a head possibly of Nijinsky by Rodin in the Metropolitan Museum, New York. Maillol told Brassaï in 1937 that Diaghilev forbade Nijinsky to undress for Rodin "who was also prey to masculine charms." But see p. 607 of *Rodin* by Frederic Grunfeld (Oxford, 1987) for a more plausible version of this encounter, in which Rodin falls asleep during the session.

33. These are cited in John Rewald's *Maillol* (Paris: Hypérion, 1939).

34. Entry for May 16, 1930, in *In the Twenties: The Diaries of Harry Kessler*. But Kessler is not necessarily reliable on the character of Clotilde Maillol, who gets as bad a press as Rose Beuret does in most biographies of Rodin.

35. Entry for June 4, 1930, in *In the Twenties: The Diaries of Harry Kessler*.

36. Waldemar George, *Maillol* (Paris: Arted, Editions d'Art, 1971).

37. Breker, *Paris, Hitler et Moi*, p. 225.

38. Lorquin, p. 148 and pp. 183–9.

39. Bassenge auction catalog, No. 56, Part 1, 1990, lot no. 3100.

40. Henri Frère, *Conversations de Maillol* (Geneva: Pierre Cailler, 1956).

Becoming Picasso

Books and exhibitions discussed in this chapter:

A Life of Picasso: Volume II, 1907–1917, by John Richardson, with the collaboration of Marilyn McCully, Random House.

1. See Adam Gopnik, "Escaping Picasso," *New Yorker*, December 16, 1996.

2. See "High and Low: Caricature, Primitivism, and the Cubist Portrait," *Art Journal*, Winter, 1983.

3. See "A Leap in the Dark," *New Yorker*, October 23, 1989.

4. Richardson, *A Life of Picasso*, Vol. II, p. 350.

5. Fernand Léger, *Une Correspondance de guerre* (Les Cahiers du Musée National d'Art Moderne, Paris, 1990), p. 3.

6. Léger, *Une Correspondance de guerre*, p. 35.

7. Both books are published by Editions "Présence," Sisteron.

8. Françoise Gilot and Carlton Lake, *Life with Picasso* (McGraw-Hill, 1964), p. 49.

9. "Reflections on Picasso and Portraiture," in *Picasso and Portraiture: Represen-

tation and Transformation, edited by William Rubin (Museum of Modern Art, 1996), p. 33.

10. See *Daily Telegraph,* December 16, 1996. "Imagine a conversation with the Japanese seller of a £2m Picasso, the bread and butter of our business," noted the noble lord. "I tell him that our charges are 2 percent and that we will charge him expenses of a further 0.5 percent. 'So I will have to pay 2.5 percent to sell my picture in London?' asks our Japanese. 'Not quite,' I have to reply. 'There is also the question of *droit de suite.*' His face clouds and he says, 'So it is 2.5 percent to you and 2 percent to the artist's heirs?' 'Yes that is so,' I add, 'but if it is bought by a European there will be another 5 percent'—and one day that may be 15 percent. 'Well, what about America?' asks the anxious Japanese. 'In America it would be 2.5 percent.' 'And nothing more?' 'Nothing,' I reply. Noble lords will see that this is the end of sales in London by Japanese clients. It will also be the end of the London art market." *Droit de suite* is due to be introduced in 1998.

11. Farrar, Straus and Giroux, 1995.

12. Reynold Higgins, *Tanagra and the Figurines* (Princeton University Press, 1986).

13. An illustration of the change of taste: Kenneth Clark's popular book *The Nude* (1956) illustrates a Kouros with the remark that "the earliest nudes in Greek art . . . are not beautiful." Clark believes that "quite suddenly, in about the year 480, there appears before us the perfect human body, the marble figure from the Akropolis known as the *Ephebe* of Kritios." Clearly the marketers of Kouros as a brand name in toiletries were disciples of Zervos rather than Clark.

Joseph Cornell: "Monuments to Every Moment"

Books and exhibitions discussed in this chapter:

Utopia Parkway: The Life and Work of Joseph Cornell, by Deborah Solomon, Farrar, Straus and Giroux.

Wunderkammer des Abendlandes: Museum und Sammlung im Spiegel der Zeit, exhibition at the Kunst- und Ausstellungshalle, Bonn, November 25, 1994–February 26, 1995, catalog of the exhibition edited by Annesofie Becker and Willie Flindt.

Tours les Savoirs du Monde, Encyclopédies et bibliothèques du Sumer au XXIe siècle, exhibition at the Bibliothèque Nationale (at Tolbiac and at the rue de Richelieu), December 20, 1996–April 6, 1997, catalog of the exhibition, edited by Roland Schaer, Bibliothèque Nationale/Flammarion.

1. See *Wunderkammer des Abendlandes*, pp. 92–3.

2. The two-volume reprint of *Documents* appeared in the series *Les Cahiers de Gradhiva* 19, 1991 (Paris: Editions Jean-Michel Place).

3. *Documents*, Vol. 2, p. 38, footnote 2.

4. Dawn Ades, *Surrealist Art: The Lindy and Edwin Bergman Collection at the Art Institute of Chicago* (published fall 1997 by the Art Institute of Chicago and Thames and Hudson).

5. Solomon, *Utopia Parkway*, p. 18.

6. John Ashbery, *Reported Sightings: Art Chronicles 1957–1987* (Knopf, 1989), p. 17.

7. Julien Levy, *Memoir of an Art Gallery* (Putnam, 1977), p. 231.

8. I am grateful to staff at the Smithsonian, MOMA, and the Art Institute of Chicago, and to Lindy Bergman and Robert Lehrman for generous help with this piece.

Rauschenberg: The Voracious Ego

Books and exhibitions discussed in this chapter:

Robert Rauschenberg: A Retrospective, exhibition at the Guggenheim Museum, September 19, 1997–January 7, 1998, the Guggenheim Museum SoHo, September 19, 1997–January 4, 1998, and the Guggenheim at Ace Gallery, New York, September 19–November 9, 1997; the Menil Collection, Contemporary Arts Museum, and the Museum of Fine Arts in Houston, February 13–May 17, 1998; the Museum Ludwig, Cologne, Germany, June 27–October 11, 1998; and the Guggenheim Museum Bilbao, November 20, 1998–February 26, 1999, catalog of the exhibition by Walter Hopps and Susan Davidson, Guggenheim Museum/Abrams.

1. *Diary and Correspondence of John Evelyn*, edited by William Bray (London: Henry Colburn, 1850), Volume 1, p. 122.

2. Baldinucci, cited in Rudolf and Margot Wittkower, *Born Under Saturn* (Random House, 1963; Norton, 1969), p. 270.

3. See Mary Lynn Kotz, *Rauschenberg/Art and Life* (Abrams, 1990), p. 37.

4. Calvin Tomkins, *Off the Wall: Robert Rauschenberg and the Art World of Our Time* (Doubleday, 1980).

5. The Menil Collection/Houston Fine Arts Press, 1991.

Johns: A Banner with a Strange Device

Books and exhibitions discussed in this chapter:

Jasper Johns: A Retrospective, exhibition at the Museum of Modern Art, New York, October 20, 1996–January 21, 1997, catalog of the exhibition by Kirk Varnedoe, with an essay by Roberta Bernstein, Museum of Modern Art/Abrams.

1. See Daniel Robbins, "Statues to Sculpture: From the Nineties to the Thirties," in *200 Years of American Sculpture* (Godine/Whitney Museum, 1976), pp. 113–14.

2. Robbins, "Statues to Sculpture," p. 115, quoting Adeline Adams, *The Spirit of American Sculpture* (Gilliss, 1923).

3. Wayne Craven, "Images of a Nation in Wood, Marble and Bronze," in *200 Years of American Sculpture*, p. 55. The two essays cited in the catalog are accompanied by several photographs of the Chicago exposition and other fairs and triumphal arches since dismantled.

4. Robert Lowell, *For the Union Dead* (Farrar, Straus and Giroux, 1964).

5. Between 1942 and 1944, according to a note in the MOMA catalog.

6. Paul Taylor, "Jasper Johns," in *Interview* (July 1990), reprinted in *Jasper Johns: Writings, Sketchbook Notes, Interviews*, edited by Kirk Varnedoe and compiled by Christel Hollevoet (Museum of Modern Art/Abrams, 1996).

7. Fred Orton, *Figuring Jasper Johns* (Harvard University Press, 1994), p. 107.

8. Robbins, "Statues to Sculpture," p. 113.

9. John Berendt, *Midnight in the Garden of Good and Evil* (Random House, 1994).

10. MOMA catalog, p. 126.

11. Hilton Kramer, "Month in Review," in *Arts Magazine*, 33, February 1959, cited by Jill Johnston in *Jasper Johns: Privileged Information* (Thames and Hudson, 1996), p. 144.

12. Carter Ratcliff, *The Fate of a Gesture: Jackson Pollock and Postwar American Art* (Farrar, Straus and Giroux, 1996). See also Thomas Crow, *Modern Art in the Common Culture* (Yale University Press, 1996), Chapter 2, which reproduces one of Beaton's test shots.

13. "Jasper junks museum's jigsaws," *New York Post*, October 28, 1996.

14. Diane Waldman, editor, *Ellsworth Kelly: A Retrospective* (Guggenheim Museum, 1996), p. 23.

15. *Monogram* (1955–9) is in the Moderna Museet, Stockholm.

16. Johns, quoted on page 122 of the MOMA catalog, which shows one of Dienes's works.

Notes

17. See the essay by Fred Orton in *Jasper Johns: The Sculptures*, catalog of an exhibition at the Menil Collection, Houston, and Leeds City Art Gallery, 1996, pp. 16–19.

18. See Michael Crichton, *Jasper Johns* (Abrams, 1977; revised 1994), p. 30.

19. Crichton, *Jasper Johns*, p. 30.

20. See Joan Carpenter, "The Infra-Iconography of Jasper Johns," *Art Journal*, Spring 1977.

21. Interview by Walter Hopps, in *Artforum*, Vol. 3, No. 6, March 1965.

22. Orton, *Figuring Jasper Johns*, p. 126.

23. Leo Steinberg, *Other Criteria: Confrontations with Twentieth-Century Art* (Oxford University Press, 1972), p. 35.

24. Ratcliff, *The Fate of a Gesture*, p. 132.

25. My transcription.

26. Crichton, *Jasper Johns*, p. 29.

27. Robert Hughes, *Nothing If Not Critical: Selected Essays on Art and Artists* (Penguin, 1992), p. 11.

Index